INSIDE

NEW YORK'S

ART WORLD

Inside
New York's
Art World

BARBARALEE

DIAMONSTEIN

Published by Rizzoli International Publications, Inc.
712 Fifth Avenue
New York, New York 10019

Designed by Philip Grushkin

Manufactured in the United States of America

LC 79-64991 ISBN 0-8478-0259-0

The book *Inside New York's Art World* is a series
of interviews conducted by
Barbaralee Diamonstein at the New School for
Social Research in New York

Grateful acknowledgement is made to the following for permission to reprint:

Partisan Review/1 1978, Volume XLV, "Pop Art, Money, and the Present Scene:
An Interview with Roy Lichtenstein and Leo Castelli"

Partisan Review/3, 1979, "Inside New York's Art World: An Interview with
Robert Motherwell," © 1979 by Robert Motherwell and Barbaralee Diamonstein

Interview with Thomas B. Hess, © 1979 Estate of Thomas B. Hess and
Barbaralee Diamonstein

Interview with Robert Rauschenberg and Leo Castelli, © 1979 Robert Rauschenberg
and Barbaralee Diamonstein

Interview with Brendan Gill, © 1979 Brendan Gill and Barbaralee Diamonstein

For Sally, Jack, Didi, Fred
and, of course . . . Tim

CONTENTS

INTRODUCTION

In 1974, at a small supper party given by John Everett, president of the New School, I got to talking to the school's vice-president, Al Landa. He asked me what I knew of the school. Other than vague recollections that it was a haven for European scholars driven from their homelands by tyranny and persecution in the Thirties—and the fact that I had once taken a course there in what was still called "underground film"—my knowledge was limited. Nonetheless, Mr. Landa, who knew of the class that I was teaching at Hunter College (Inside New York, which dealt primarily with politics, city and cultural affairs), suggested that I now teach a course at the New School about one of New York City's most tangible assets—its remarkable art world. He quickly arranged for Jerome Liblit, associate dean of the Center for New York City Affairs, to see if we might devise some sort of program. Out of that conversation, with amazing dispatch, grew the course that I have been giving at the New School For Social Research since 1975: Inside New York's Art World, a series of informal conversations with distinguished members of the art community.

Actually, the course's title is a misnomer; New York's art world is the whole world's art world, and has been for more than a generation, ever since the abstract expressionists burst on the scene. The first semester was a hectic one. Starting with the Guggenheim Museum, we moved from museums to galleries to artists' studios. By the second semester, class size had ballooned to almost two hundred, which all but ruled out such itinerancy. From the beginning, it seemed obvious that the interviews should be preserved on audio- and videotape to create a permanent record that would be available to students and to the larger public. Leo Castelli, the gallery owner, and Professor Louis Starr of Columbia University, made this possible, through their kind support and continuing encouragement. In April 1978, and again at the time of publication of this volume, a selection of the videotapes was shown at the Castelli Gallery.

All of the videotapes are stored and distributed by Castelli/Sonnabend. Films, so ably directed by Patti Brundage, who was also responsible for the imaginative organization of the exhibitions. The audiotapes are on file at Columbia University's Oral History Research Department. In addition, *Partisan Review* has published two of the interviews, one a joint conversation with Roy Lichtenstein and Leo Castelli, the other with Robert Motherwell. For everyone involved, the entire enterprise has been a labor of love rather than of commerce. It would not have been possible without such generosity, especially on the part of the interviewees, who shared their thoughts so freely.

The high level of interest in the interviews persuaded me that a wider audience might appreciate them. This book is the result—twenty-seven informal interviews with a significant slice of New York's art world—painters, sculptors, architects, critics, museum directors, gallery owners. In each conversation, I tried to learn how and where they evolved; why they turned to the world of art; what forces helped shape them and their work; their philosophical approaches; their likes and dislikes in art; their roles in art history. The interviewees do not constitute a definitive group, perhaps not even a representative one; but any group that includes the likes of Robert Motherwell and Robert Rauschenberg, Louise Nevelson and Tom Hess, Philip Johnson and I.M. Pei, Ivan Karp and Christo, surely qualifies as a fascinating one.

Of course, spoken and written words lead very different lives, and translating oral interviews into print can be very tricky. Some of the interviewees are far more articulate than others, explaining themselves and their theories with grace, clarity, and succinctness. Others grope through several false starts before finally saying what they want to say. Still others are far better artists than talkers; they never quite manage to make their points, circling around them, getting close, but never quite arriving. Yet in every case, I think, these interviews have a vigor, a spontaneity, a special life that more than compensates for any shortcomings the spoken word may have. All of the photographs in this volume have been taken directly from the videotapes of the interviews.

While the transcripts have been edited for space reasons, and in some cases, to make certain passages somewhat clearer to the reader, the words that appear here are very close to the words as they were spoken. I hope you will agree that, taken together, they help comprise a vital, informal history of one of the most exciting artistic periods in memory.

Barbaralee Diamonstein
New York City
27 June 1979

INSIDE

NEW YORK'S

ART WORLD

Barbaralee
Diamonstein
and . . .

Edward Larrabee Barnes

(Architect. Born Chicago, Illinois, 1915)

BLDD: One of the most distinguished contemporary architects is Edward Larrabee Barnes. He combines the perceptive eye of an artist with the practicality of an engineer. The result? Designs that bring sensibility, new dignity and intelligence to our cities.

Today there is no longer a sense of a single style in architecture. There is no one proper way to design a building. In an age where pluralism seems to prevail, both in art and in architecture, what would you say defines quality in architecture?

ELB: Essentially, architecture is solving problems for people. That's in a broad sense, a sense of providing some sort of spiritual surroundings and an expression of what is going on in the building.

I think the question of style—the style you use—is somewhat irrelevant. To me the appropriateness of a building for its site, for its place, for its use, is what really lasts, not a fashionable style of the moment, not a veneer. I know that this sounds like an old functionalist, but it's taking function in the broadest sense. If you are doing a church obviously the functions are far deeper than the way you get in and out—and I think that's true of every building.

BLDD: You became interested in landscape architecture early in your career. Can you tell us about the restoration of the New York Botanical Gardens and the Conservatory Greenhouse, and why you were chosen for that project?

ELB: They interviewed quite a few architects. The theory was that they were going to tear down what was left of the glass greenhouse in the Bronx and replace it with a new modern greenhouse. About half the architects, all my friends, said, "You can't do that, you have to save the building." And others said, "Tear it down."

As it happened, they picked me, and after a great deal of analysis we decided to adapt their program to the old greenhouse. This beautiful greenhouse is really the last of the great glass buildings in the United

States. It's a building type which has almost vanished, and it was a terribly important one to save. It comes from a period of formality and elegance. You sometimes see vestiges in Central Park of that era, when people were more leisurely, when men courted and ladies wore hats.

The credit for the greenhouse should go to the original architect. It's not absolutely certain who he was, but I think his name was Cobb, and as far as we know he was a company architect for Lord and Burnham, who still exist, making greenhouses. He is the one who should be given credit for building a series of pavilions linked by greenhouse necks. It's a charming building, and we were very lucky to be able to bring it back.

BLDD: Why is an architect as distinguished as you are willing to restore the work of another architect? Is there a growing responsiveness to restoration in the architectural community?

ELB: I think all of us have become much more interested in saving old buildings. Essentially, anyone creative is on a kind of ego trip, to use a hackneyed phrase. I, for example, every other year take piano lessons, in an attempt to lose myself in the intense study of one piece. Restoration is a similar experience. A relief from listening to yourself by losing yourself in something else.

I think it was that way for the office in general. For me it was a nice

feeling to bring out another person's idea, to restore something—nice as a contrast to everything else I was doing, which tended to be selfish.

BLDD: Did it encourage you to recycle any other structure? And what do you think of that growing movement?

ELB: I wouldn't want the whole office to go that way. At Columbia, architectural students are now trained to do research for restoration and for what is called adaptive recycling and adaptive reuse. I think that this is an aspect of architecture which will grow rapidly and help to broaden the spectrum of our profession.

BLDD: The world of art concerns you, and that has manifested itself in your designs for the Walker Art Center in Minneapolis, the Scaife Gallery (which is an addition to the Carnegie Institute in Pittsburgh), the Marlborough Gallery in New York, the Wichita Art Museum in Kansas, the Fine Arts and Indian Museum in Santa Fe, the Fort Lauderdale Museum of the Arts in Florida, the Dallas Museum of Fine Arts in Texas. There will be a gallery in the new IBM Building, and in the Asia House (that contains the Asia Society Galleries) as well. I can't think of anyone who has designed more spaces and places to exhibit works of art. How did all that begin?

ELB: It all began with the job at the Walker Art Center in Minneapolis, which was just a marvelous job.

Minneapolis has two museums. One of them is very Establishment and the trustees there tend to be over fifty, maybe over sixty. The Walker trustees, all in their late thirties and early forties, are interested in experimental movements. The well-established museum draws off the safe shows, and the residue really forces Walker to an extreme position, somewhere to the left of SoHo. It was a wonderful experience to work with such a lively board and with Martin Friedman, the director.

BLDD: What was the response of the artists to that design?

ELB: At the opening several artists said extremely nice things about it. There are too many museums, if you think about it, like the Guggenheim, which upstage the art entirely. It is hard to put on a show at the Guggenheim that *looks* different from the last show, and it's very difficult to forget the architecture.

The question then is, are you really trying to build anonymous space? I think the basic elements in architecture—museum architecture—have to do with the proportions of a room and the quality of light, and the way you move through spaces—those three things. If you simply make a white space, a box of white space which is of the right proportions, and then put paintings in it, the artists will like it.

BLDD: But it's not what the architects like, generally.

ELB: No, I think many architects feel that the most important thing in

the collection is going to be their building. Let us say you are a painter and you find yourself hanging on a corrugated concrete wall. The wall will be too busy to do justice to the painting. You don't see commercial galleries using anything but the simplest recessive materials, *and* good lighting. They may not always use white, but they are essentially working with the quality of reflected light.

I am beginning to collect some sketches by artists. I have a sketch by David von Schlegell, who simply drew a huge piece of sculpture in the kind of space that he thought it should sit in. Of course he wanted containment. He didn't want his piece out in open space. He wanted a reference wall here and a sense of weight there but did not want detail on the wall or any distracting colors.

In talking to Isamu Noguchi, who knew I was doing a museum, I found that he thought of his piece in a white space, and as severe a white space as possible, contained, not in the open.

BLDD: So how would you describe your chief consideration in designing museum space?

ELB: As I said before, I think that the three important things are quality of light, proportion of the room, and movement through the space. I usually start with flow. To me that's more important than form.

You can learn a lot from Disneyworld about flow and the story line and architecture as a sequential experience. With all their pop and plastic they do care about what happens to you, they do manipulate you, and you do have a sense of entrance, a sense of being carried along and taken through, and that experience has a time sequence. Architects must be very conscious of the time sequence experience in museums.

BLDD: Do you think that natural light is the best way to view art? And how do you accomplish that in a formal museum setting?

ELB: I like natural light, but commercial galleries almost invariably are obliged to use incandescent light, which tends to focus on the art and not on the space. It really makes it very dramatic, the highlighting. But there are ways to do that with daylight. The old European museums had glass ceilings, so that when you came into a room the most brilliant thing was the ceiling, and the wall would be far less bright. If the light is in the ceiling, you see the source.

What we have been doing is admitting daylight in a cove that slashes the wall, so the most brilliant thing is the wall, and that's quite an extraordinary effect. You can wash the wall with daylight without seeing the source, in very much the way you would with incandescent light. The picture I recall most vividly that I *know* is better in daylight is the Monet *Water Lilies* in Pittsburgh. It's a very impressionistic picture, with pinks and oranges, and blues and purples in the water. I was there on a clear

day with blowing cumulus clouds outside, and one moment the gallery was yellow with sunlight, and then, when the sun went under a cloud, it would change to this blue light. As you sat and watched the painting, the blue dots came right at you when the sun went under a cloud, and then they would fade as the yellow light emerged and the other end of the spectrum would come at you. And I asked the man who did the Monet show at the Metropolitan what he thought about daylight for Monet and about changing light, and he said that for impressionist painting you couldn't have anything better than changing light.

BLDD: Your reference to sculpture brings to mind the increased involvement of architects with artists. Willy-nilly that collaboration will flourish, partly because of the widespread mandate of many states and cities that allows a percentage of the cost of construction—generally one-half to one percent—for art or works of art.

How do you see, first, the relationship between art and architecture and, secondly, the future of that collaboration?

ELB: Well, I'd like to preface this by saying that I think there are lots of good attempts, but too often these days you are apt to pass a throw-away rusty pile of things, not necessarily by a great artist, not well sited, temporarily and arbitrarily placed. Art has become more accessible, but also more transient and far less precious (in the good sense).

BLDD: Does it dilute the quality of the art?

ELB: I think it does. The siting of the art is terribly important, the exact piece for the right place, and that's an experience that you don't get too often. We are accustomed to seeing art sort of strewn around, especially with all these new programs, and I think what the discerning eye should be looking for is the right thing in the right place. In our museum in Texas, for example, there are people who feel that all the art ought to be out in the street where people can see it. There are others, myself included, who feel that there should be a wall, that the way you place art is just as important with garden walls as it is indoors, and that separating the sculpture from the parked cars is important.

So placement is really terribly important, and ideally the architects should work together with a sculptor before he arrives at the proportions of the inside space or the courtyard.

BLDD: How important is a building's relationship to its environment? Is that an important consideration in determining a design for the building, at least for you?

ELB: It's terribly important. My education was that architecture was some sort of sculpture, it was put in space, in a Le Corbusier-type white box. Somewhere along the line I went to Iran, and saw mud villages in which the mud of the street would suddenly rise up and become the mud

of the house, and with blowing dust you'd see women in chuddars covered with dust, and dusty herds of sheep and goats. It seemed to me absolutely continuous from the ground to the people to the buildings to the quality of light. I was struck by those villages, and, in Greece, by Mykonos—by the fact that buildings were connected with each other, that they were glued to each other, that they went uphill and down together.

After I came back I began to look immediately for ways in which buildings could run up and down in a continuous line.

You can force things. I designed a dormitory soon after that, which was given to me as a three-story box, but there was a long street in the school, and the dormitory became a serpent which went downhill, down the street. You can't see it all at once, you can't photograph it all at once, you have to walk along it.

The grafting of a building to the land is certainly not new, but I think that it got lost along the way. Frank Lloyd Wright never, never lost it. But there was a generation of International Style architects which forgot it.

I remember a job in Monterey, California. I went all the way across the country thinking about what I was going to do, and of course first of all I thought the building must relate to the Pacific. When I got there, I found that the thing was five hundred yards from the Pacific and you couldn't see the ocean. I thought, how terrible not to be able to sense the sea. I mention this because so often the space you build on, the most serious starting point, is the slope of a rock; the trees and other things on the site come later, and are less important. It's very, very important to see the site in its largest geological context, and not become attached to some minor object and miss the big picture.

BLDD: How did you adapt that philosophy to some of your museum constructions? For example, you have designed a museum in New Mexico as well as one in Pittsburgh. Obviously varying designs must be involved in those two locations.

ELB: Well, for example, it's very hard to go to Santa Fe and not like the adobe construction, which is no longer economic. Old adobe required continual care by Indian squaws, and for all kinds of reasons that's out. But some time in the twenties and thirties they started (I think) a kind of glazing, the way you make a cake, and they "pueblocized" all sorts of buildings with a kind of cement which looks like icing. It's a bit like a Rudolph Valentino set, but very charming. So you have serious Indian buildings where you really feel the weight and simplicity of piles of mud bricks, and then you have these glazed buildings which

look a little like stage sets, but they have the same color, the same soft corners. I haven't yet decided what to do, because clearly the great charm of Santa Fe is its low scale.

BLDD: Will you use a classical Indian shape for the design of the building?

ELB: The building itself, as I said, starts on very functional grounds. It will have a Pueblo and a Navajo collection, and the Pueblo will be shown in a round-shaped kiva. The Pueblos were a farming community, home-loving, introverted, family-oriented. The Navajos were transient, nomadic, always wandering from place to place. They will be on the outside of the circle, they will ricochet around the circle against hard forms, and you will never feel settled. In the Navajo space you will have a sense of movement. When the tribe is defeated and goes into exile in Mexico, the space will compress and get dark and then open up again, so that the character of the Navajo area will be somewhat unsettling. You will have to keep moving, and you will continually meet hard angles. It is definitely a centrifugal society, as opposed to the Pueblo society, which looks inward.

Here you have a case where the architecture has to respond to the philosophy of these two cultures.

BLDD: Let us turn to the character of the space that you have created for New York. Your new design for the IBM Building rejects the International Style, the glass-box design that we see all over Manhattan. How did you arrive at this five-sided, 603-foot-high, green-gray polished granite tower?

ELB: It's a prismatic form. As you rotate around this building, sometimes you will see something which harmonizes with the older buildings, just the end: sometimes you'll see a slab, sometimes you'll see a block, and it will change, as opposed to a simple rectangular building which will not. Certain forms have a quality of changing in light, especially as you move around them.

The problem of change of scale in cities is a very, very tough one. Ideally, I wouldn't change scale, but one has to; think of Trinity Church standing at the end of Wall Street.

BLDD: How does the IBM Building relate to the grid of the city?

ELB: We decided not to set the building back the way they do on Sixth Avenue, but to put it on the sidewalk. This was not just my idea, but a new perception of keeping the street life alive by putting in retail space. Putting banks and airline ticket offices in empty plazas is out. The City Planning Commission and all of the enlightened planners realized that New York has to have an active street life, which means restaurants,

bookstores, flower shops. So our building is packed right up against 57th and right up against Madison, with active retail, a pedestrian arcade through the block, a glass-covered park with magnolia trees.

BLDD: How can those magnolia trees, those beautiful, forty-five-foot-tall trees, survive in that indoor park?

ELB: This is not like the Ford Foundation park, which is maintained at some expense at ordinary working temperature and humidity. The air that heats and cools our garden is the air that you are required by law to throw away. The codes require the architect to pump in fresh air and pump out a certain amount of stale air to guarantee a proper balance.

We take the air that's been pumped out and dump it in the greenhouse park, and that keeps it at a halfway climate, never below 40 and never over 92 degrees. We talked to our friends at the New York Botanical Gardens. We got a weather map of the United States, and found the spot on the map with a matching cycle. It was Williamsburg, Virginia, so we believe we can grow magnolias.

BLDD: That indoor park, even if it is in a private office building, is really a public plaza and a public space. How do you propose that the public use the space?

ELB: I suppose everybody knows that the city allowed IBM to build about six extra floors in exchange for the public park. If you provide something for the public—like a greenhouse park, a plaza, a fountain, or so many benches, or very specially an arcade from street to street—you are allowed to build more floor area. It also means that IBM has to keep that park open until 12:30 at night, and has to police it and keep it clean. The public has a half-acre maintained by IBM, and IBM has the extra floors. This is a pattern which originated in New York and is being adopted by other cities.

BLDD: How much of a building's design is designed by zoning laws rather than by architects?

ELB: Much of the design concern is with filling the zoning envelope. With the IBM Building, we were allowed to cover 40 percent of the lot, and this building covers 39.99 percent. We can change the shape—squeeze it and make it higher, or manipulate it in other ways—but you don't have too much flexibility in the end. You can't cover any more ground. You can make a different shape, a rectangle or a square or a triangle. One tends to think that in a big building, one has artistic freedom. But in fact you are working with a kind of warehouse for people, more akin to the dock buildings in Amsterdam, or the loft buildings in Fall River, Massachusetts. It's a simple building form, with a repetitive base, and it's a working form. In the hierarchy of city structures perhaps it's too bad we don't have more churches. I believe that certain kinds of

buildings, like churches, should be conspicuous. But I have mixed emotions about the validity of office buildings trying to outdo each other.

BLDD: If, as you tell us, zoning laws are influential in shaping a city, do our zoning laws make sense as they are written now?

ELB: We had a recession, and the IBM Building is one of the first after the recession. There will be many more, and the zoning law, producing this kind of bonus and this kind of bulk, is going to be tested. If everybody uses it, I think the city is going to be overbuilt.

There is a simple formula which can be observed: high buildings on the avenues, which are wide, and low buildings on the side streets. That simple formula has not worked, there have been too many exceptions, but imagine what an improvement it would be if all the buildings on the avenues going north and south were high, and the streets, which are narrow and slow and more pedestrian, were kept at the old scale.

BLDD: Perhaps you might tell us how a company like IBM, using your skills and their computer technology, arrived at some conclusions that helped shape the design of this building. Is there something that can be applied here to other buildings as well? What about its energy efficiency?

ELB: I think insulation has changed completely. Thermopane—that is

double glass—is in, and aesthetically that means that the panes can only be so big. Just a few years ago you could have startlingly big sheets of plate glass, so the buildings could look quite extraordinary.

Now we are uniformly going to double glazing and small windows— either punch windows or ribbon windows, as opposed to a Seagram's façade. A totally different texture has to be dealt with.

The insulation is something that I think everybody can understand. IBM is very good at controls: the business of turning off lights, transferring heat from an overheated to an underheated space, eliminating waste and getting the best out of the heating plant.

BLDD: Would you analyze the combination of design features and the use of computers?

ELB: I don't see how you can use computers for anything as inexact or intuitive as design. But, for example, imagine a building as a steel skeleton: you want to know how much the building will flex in a hundred-mile-an-hour wind, at a given grade of steel. It would have taken a month to figure that out in the old days. Now the question can be put into a computer and answered in an hour. So the use of computers in structural engineering means that things are so precise that we can design closer to the safety factor, and as a result buildings are becoming limber. They were overdesigned in the old days. Steel was overdesigned. Nowadays with the computer you can hone down the tonnage of steel and reduce the bracing to the code limits. All the big buildings—the John Hancock or IBM or Citicorp—are limber, moving buildings. It is quite a different concept.

BLDD: You mentioned ribbon windows. Is that one of the innovative design features? How does that work?

ELB: Yes, we felt that we should be able to get fresh air, which might save energy in spring and fall. In the winter there is continuous heat, in the summer continuous air conditioning, but in spring and fall, when the temperature keeps changing and the mechanical plant goes crazy trying to keep up with it, you simply open a window in the old-fashioned way. Our building will have slots under all the windows with a hopper on the sill which can be opened. The slot is four inches wide and runs the length of the room. You lift a little damper on the sill, and the air comes in, but the rain can't come in, the bugs can't come in. It remains to be seen whether it's misused. Of all the things that we are doing this is the most controversial. The fear is that people will use it and leave it open, and the heat will pour out.

BLDD: But since so many other things open and close automatically, why can't that? If the lights go off automatically in a room where there is no one after a certain time, why can't the windows be controlled?

ELB: That's what our mechanical engineers recommended, but first of all it's expensive. I think that it is agreed that they will be locked in summer, locked in winter, and available in the half-seasons. If they are misused they'll have to be locked all year long or automatic controls will have to be added.

BLDD: IBM is the first building under construction after a period of recession. Since that time—quite happily, we hope, for the city—there are a number of very important buildings that are under construction. One of them will be your next-door neighbor, AT&T.

ELB: That's right.

BLDD: I assume it presents certain opportunities and certain problems. It seems a unique opportunity, on one of the most significant streets in the most significant city in the world at this point in time, to go beyond making architectural statements. What kind of coordination exists? Is there any on the ground plans?

ELB: Well, I am in a funny position because we started first, and at first the AT&T site was to be a hotel. I spent a great deal of time working with the hotel people and their architects. In fact we thought almost of having a block party to get everyone together, and I had a feeling that my building would be part of an ongoing plan. The hotel was a little bit ahead of us. But that's New York for you. Now it turns out that *we* are the older one. I have reservations about AT&T. They got a variance to go over the 40-percent limit on lot coverage. There was a rumor that the city gave it to them because they threatened to go to New Jersey if they didn't get it; they had a certain amount of leverage at that period, so their building is close to 60 percent of lot coverage.

Furthermore, they are building very high ceilings. The average ceiling height is a couple of feet higher than our average ceiling height throughout the building, and the result is that with roughly two-thirds of our square footage they are building a building which is higher than ours, with roughly the same bulk on a much smaller lot. I think that the funny top is fine and I like architects to have fun—I am all for it—but what has been overlooked about that building is the bulk, and I feel particularly concerned because the shadow will fall on our greenhouse, so we have to compensate by using gro-lights to light our trees.

BLDD: Does one consult on some of these design problems?

ELB: I think in that case the question of bulk and size was such a big deal that they had their hands full working with the city, and the thought of talking to the architect across the street would be the last thing to enter their minds.

BLDD: What would you recommend for the future, if that kind of major construction ever occurs again side by side?

ELB: The local community boards should be active. For the architect, New York has a very cumbersome system of community board reviews, and it's tough, but I think it produces dividends.

BLDD: Your building is located in a community where there is not really much of a nighttime constituency; it is a commercial area.

ELB: It's amazing, but people do live here. I think the Planning Commission must have the right to make variances, but the important check is the community board, which can raise hell if it wants to. It's rather difficult for an architect on one side of the street to throw bricks at an architect on the other side of the street. It's much easier for the community board to step in and fight. There are architects—young architects—who find community board work interesting and rewarding.

In the end Grand Central Station and other buildings around New York were saved by community action. There is no stronger force, and I think that's where the praise or censure should come from.

BLDD: In addition to retail space in your building, will you also have a gallery?

ELB: An art gallery? Yes, a big underground gallery.

BLDD: What with your art gallery and the AT&T gallery space and the Whitney Museum coming into the Philip Morris Building in the same neighborhood, is the coming fashion a complex of art gallery space in office buildings?

ELB: It's part of the bonus idea. The reason you have the Whitney Museum putting their sculpture in the Philip Morris Building is that Philip Morris is getting the right to build more floors, and so Philip Morris is giving over the most valuable real estate and building a museum for two or three floors, and the Whitney is putting all their sculpture in there.

BLDD: Doesn't everybody benefit that way?

ELB: Everybody benefits unless there are too many big buildings.

You see, I wish that all the big buildings wouldn't move into one little piece of expensive real estate in midtown. It would be marvelous if there were some way of distributing buildings or giving greater bonuses where the city needs bulk, and denying bonuses in the crowded area.

BLDD: Do you foresee that occurring in other parts of the city that need revitalization?

ELB: It's being talked about. Obviously you are not going to get AT&T to build in the Bronx, but there are ways to pressure people to move into less dense areas. If you fly over New York you can see a whole area between Wall Street and midtown which is still relatively low. It seems to be a wonderfully convenient location, and so why not start a new center, with incentives from the city to make it possible. They should cool it in midtown.

BLDD: We've talked about the future direction of zoning laws, but we haven't talked about the future direction of architecture. Where is it going?

ELB: Oh, that's a tough one. I think the current show at the Museum of Modern Art, Transformations in Modern Architecture, presents a kind of panoramic confusion of approaches which can be interpreted as richness, diversity, pluralism, eclecticism—or conversely as uncertainty, confusion, and lack of conviction. I think you'll find architectural students caught between these two visions. On the one hand they tend to be terribly interested in pluralism and historic precedents, but they seem to miss the exhilaration of designing with purpose and direction.

BLDD: Can you tell us something about the design for the new home of the Asia Society?

ELB: This is a case where there are two scales to relate to, and what we have done on Park Avenue is to build a building which follows the general street line, and is more or less the same height as the Union Club. We plan to use red granite for the façade in alternate vertical bands of dull and polished stone. For the pavement we hope to use red sandstone from India.

BLDD: How did you arrive at red Indian sandstone?

ELB: We were tearing down a little row of brownstones, which hurt me very much and I said I'd like to build a building of brownstone. John Rockefeller was alive at that time, and he said why not Indian sandstone. It's a marvelous, glowing, red, not too fiery, but a richer color than brownstone.

BLDD: In terms of Asia House, is the plaza on the 70th Street side a public plaza? And, if so, for the same reasons that you described earlier?

ELB: No. This one does not produce any more building. This is not to get extra height, and the public can only get to it by going through the building. Since the Asian works of art in the Rockefeller Collection are very valuable, there are security considerations. We will have art—sculpture and so on—on this terrace.

BLDD: Will there be art out of doors as well?

ELB: Yes, there will be, and the high-ceilinged second floor would be the gallery.

BLDD: And what is the projected completion date of Asia House?

ELB: For Asia House and IBM, 1981.

BLDD: Excluding your own buildings, which buildings represent for you the highest standards, the most worthwhile values in building design?

ELB: That's a big question. I have to go back to Mies van der Rohe and Le Corbusier and Wright. No one today is as staggeringly great as they were. I think it's very hard to pick anything better than Mies's

Barcelona Pavilion. If you have been to any Wright buildings which are well maintained and lived in, like Taliesin East or West, it's very hard to find buildings we have done that can compare to them. And of course, of the three, Le Corbusier was my idol, the one that we all, when I was in school, imitated and liked best. They were giants.

Of the generation that followed in the United States, I think Louis Kahn was a great architect, and he has some monuments. It may be that the things of the past look greater, but I don't think so. I think there has been a dimensional change. All the architectural leaders were in the revolutionary business of breaking old idols and the new design had to be terribly strong.

We are *not* in a revolutionary period. We are in a period of development and accommodation, so that you don't get much of a cutting edge. No architect today has to cut himself off from society to make a strong statement.

BLDD: Does the work of any young architects particularly interest you?

ELB: I have been intrigued by Bob Venturi, although he is not my style at all. And I have not been intrigued by all the architects who are fooling around with eclecticism. I think to be eclectic—to mix forms—you have to be extremely artistic, poetic, and know what to select. It's like putting together a montage or something. And the principle of eclecticism is selection, and using your eye, if you are going to do mixed styles.

My particular style is very, very simple. But it would be extremely interesting to see the new generation of architects become more complex and more decorative in a poetic way. I think that there is a way not to build simple volumetric architecture, just as there *is* a way to build decoratively. Too often it looks like a fad, it doesn't look very deep, but I think that architects *will* be thinking about that problem.

I like Venturi because I find what he is doing provocative. I could not possibly do it myself, but I always keep up with what he is doing.

BLDD: Among your buildings are there any to which you respond most warmly?

ELB: I like Haystack, which is an arts and crafts school I did in Maine, and I like Walker, the first museum, very much. I think those two I can count on, and then there are two houses I am very fond of.

BLDD: Which buildings in New York do you particularly like, and which do you particularly dislike?

ELB: Let me see. I like the Metropolitan Museum. I don't like one of the recent additions, but I like the great hall—I think it's absolutely marvelous, just terrific, just wonderful. I did like Penn Station better than Grand Central. I like the Guggenheim as a work of art. It is the best thing they have in their collection.

BLDD: And which do you dislike?

ELB: There's much that is dreary and bleak about housing. And it's in this area that you can really touch people and hurt them. Worst are the housing projects. A bleak office building or a bleak warehouse doesn't seem too terrible, but when you have families, children in brick filing cabinets it's pretty awful. I remember Lewis Mumford saying, many years ago, when he came back from Russia and Warsaw, "I've just come back from Russia, and I'll tell you never in my whole trip have I seen anything so cruel to the human spirit as the brick apartment buildings in the Bronx." And I agree—it's just about the bottom. And I guess everyone knows that in St. Louis the Pruitt Houses were actually pulled down because they were so corrupting to the human spirit.

BLDD: What would you like to build that you haven't yet?

ELB: When I was in architectural school, I did my thesis on housing, and I believed in public housing. It never occurred to me that all of my beliefs weren't totally unified—I thought that I could be a left-winger and an architect and that everything would fit. And the way I read Le Corbusier, probably not too accurately, I thought he felt exactly the same way.

Something happened, and I found my profession—most architects found their profession—focusing on the art and the professional side, and politics, whether you were for Adlai Stevenson or George Wallace, bore no relation to architecture at all. I think it's time that somebody did a show on the connection between architecture and social history.

So most of all I would like to build large-scale, low-cost housing in a city or town where one deals with families. This is what I thought I would be doing when I left school, and it never happened.

Romare Bearden

(Painter. Born Charlotte, North Carolina, 1914)

BLDD: Romare Bearden has exhibited his paintings and collages throughout this country and abroad. He is one of the few living artists honored with a retrospective exhibit at the Museum of Modern Art, in 1971. Beginning in March of 1980, there will be another retrospective showing of this artist's work, originating at the Mint Museum in Charlotte, N.C., the city where Mr. Bearden was born, and then going to various museums throughout the United States. Mr. Bearden has also written a book, *The Painter's Mind,* with his friend and colleague, the late Carl Hulty. Mr. Bearden began exhibiting in 1945, following his Army service. His first show was with the Samuel Kootz Gallery, where many now-famous artists also began their careers.

Your work often depicts the daily life and cultural heritage of black people. But you've also tried in your paintings to explore the things common to all cultures. You said that you've tried to forge a cultural synthesis between the Harlem where you grew up and the Haarlem of the Dutch masters that contributed to your understanding of art. What do you mean when you talk about forging a synthesis?

RB: Well, art is a manner of processing. The art of the world belongs to everyone, and since I was doing so many of the things in interiors, I looked at the Dutch masters—like de Hooch and Vermeer—because they were really masters of that. And I was able to study their work and the rectangular way of presenting their subject matter, and I incorporated it in my own work.

BLDD: From what did your own interest in art stem?

RB: It is hard to say, because I first majored in mathematics, and then I went to medical school. Kind of like Gauguin—not that I equate myself with that great master, but I mention him only to say that I started art late—I gave up medicine to go into painting.

BLDD: How much time did you spend in medical school?

RB: I was in my second year, and when I came home my mother said, what are you doing home so early? And I said, I quit. She said, "Son, you

are throwing your life away." So that's given me courage to go on in painting, since I always thought my life was, in a way, behind me.

BLDD: Well, those were significant words, especially coming from a mother as influential as yours. Your mother was a very well-known social force and political activist in Harlem, a newspaper editor, and when she made a pronouncement I guess she knew what she was talking about. Was having a mother so prominent and so powerful a help or a hindrance in your career?

RB: Oh, she didn't bother me. I think she meant well because she thought that artists would be living in a garret and starving, and she was 90 percent right. I can't say she was a hindrance, no. She died when I was quite young, so she never lived to see me have an exhibit or anything like that. I think that would have pleased her.

BLDD: Other than your studying at the Art Students League, did you ever have any formal art training?

RB: No. After the war I got, as you mentioned, with the Samuel Kootz Gallery, and after a while I felt that I really needed to learn something more about painting. I had read the journals of Eugène Delacroix, and through all these journals he wrote he would go to the Louvre and copy the paintings of Rubens and Veronese and other baroque painters, and I said, here is this great artist, if he did this, it might help me. But I was too

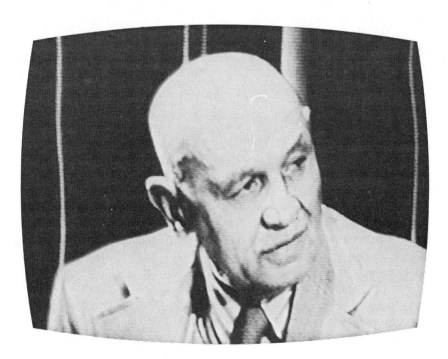

bashful to go to the Metropolitan or the other museums. I had a man enlarge some of the old masters' paintings for me, so I stopped exhibiting for about three or four years, and I got large sheets of brown paper, and then I began to copy.

BLDD: Then what would you do?

RB: I enlarged the paintings. They were black and white, so I had to imagine the colors. Now the only one that I really had difficulty with was a painting of Rembrandt called *Pilate Washing His Hands,* which is at the Metropolitan, because every time I thought I had it I would see something else in Rembrandt that I had missed, because he is the most mysterious of painters (his structure is hidden). To understand Rembrandt, you have to look at his drawings because his paintings have been cloaked, or clothed, with so much varnish. But I found that this was very helpful to me in learning how a painting was put together. It stopped my career in painting with the galleries, but I felt that I needed this kind of study.

BLDD: As a successful and self-taught artist, which artists other than Rembrandt have you looked to for inspiration and direction?

RB: When you say self-taught, I think all artists are self-taught, because even if you go to art school, after you get out you have to learn. Painting and sculpture are something that can't be taught, something that you either have to make your own or have a disposition toward.

BLDD: Are you suggesting that academic training is really not essential for a student of art?

RB: Well, I don't want to knock art schools, but what I said is, after you get out, your study of art just begins. The thing that I would say is wrong with some art schools now is that they teach success instead of the fundamentals of art from which a person can grow.

Remember when abstract expressionism was the phase of the time, they were teaching that in the schools; but when the students came out everybody was doing pop art. But Picasso, for instance, or Matisse, could do anything because they had the basic training. This is what I meant when I said that so much success is taught in the art schools.

BLDD: Your first exhibition in New York was at the Samuel Kootz Gallery. What memories do you have of that exhibition? How was that arranged?

RB: I had an exhibition in Washington with a lady named Caresse Crosby, who had opened a gallery there during the war. I think a biography of her husband recently came out—Harry Crosby, who was a kind of poet and banker living in Paris. Right after the war I had an exhibit at her gallery. Then I met her in New York. She went to see Samuel Kootz, who had just opened his gallery with a show of Alexander Calder, and was responsive to young artists at that time. (Peggy Guggenheim had

closed her gallery with such painters in it as William Baziotes, Jackson Pollock, Bob Motherwell, and they had come to Kootz.) Caresse Crosby told him, "I had a show of Romare's recently. Why don't you look at his work?" Kootz gave me an exhibit shortly thereafter.

That's how it happened. It was only that there were so few young American artists. It's different now. I wouldn't have the same luck at the present time. But Betty Parsons and Samuel Kootz were just about the only two galleries showing that kind of avant-garde art at the time. You see how things have expanded.

BLDD: It's difficult to be an artist, but I imagine even more difficult to be a black artist.

RB: Yes, it's true. I mean they have a great deal of difficulty, and for that reason I opened a gallery for young artists called the Cinque Gallery with two other artists. That was in 1967. We give shows to artists, and if they sell any work they get 100 percent of the money and we defray all of the expenses of the exhibition. It was not open just to black artists, it was open to minority artists: we have had Japanese, Chinese artists, a young lady from Israel.

BLDD: Who were the "we" who sponsored this gallery?

RB: Ernest Crichlow, Norman Lewis, and myself. Since last year, I am no longer with the gallery. We had to go around searching for artists and looking at the work; very interesting, but I don't have quite the time to do that at present.

BLDD: Your recent paintings are filled with very sophisticated imagery: Egyptian hieroglyphs, Japanese woodcuts, African carvings and northern European motifs. What caused you to choose to revitalize ancient history and myths in your work?

RB: Well, everyone should read the book called *A King and the Corpse,* by Heinrich Zimmer, who was a great art historian with a particular interest in Indian art—I don't mean American Indian, I mean East Indian art. I do try to deal with myth and rituals. For instance, a handshake is an extension of a ritual. There is a painting of mine of a young woman taking a bath in a cabin, and there is an older woman standing to her right, and a bird looking in the doorway. I called it *Susannah at the Bath,* and instead of the Elders looking at Susannah, as in the old masters' paintings, I had the bird, so that the painting doesn't relate to the particular place. It has a relevance to old masters' paintings, to the art of bathing as a ritual, as old as bathing as a ritual in the Euphrates. In my concept of myth and ritual I try to give extension to the work.

BLDD: In your earlier work, your work of the 1940s, you dwell on religious and Biblical themes. Are you a very religious person?

RB: Oh, I suppose so, but not in the sense of going to church or things like that. I used some of the religious themes because again it was deal-

ing with myth and ritual, although I hadn't thought too much about it at the time; it was just something that I did intuitively.

BLDD: Tell us about your trip to Paris in 1950.

RB: I had been in the Army for some time, and I had the GI Bill, and I had always wanted to go to Paris. I had a room, a studio, in a pension—three meals a day—for $37.50 a month. You can't match that in a day there now. But it was a wonderful place to be at that time. And Mr. Kootz gave me letters to Braque and Picasso and Brancusi, and others. I never could get down to do any painting, but I had a wonderful time. Paris, I feel, is a bad place to go to try to find yourself, because it's so seductive, especially at that time. We were always going someplace—to exhibits, to a party, something.

I used to smoke cigarettes while I was in Paris. I gave up smoking when I read it wasn't too good for you later on. And when I ran out of American cigarettes I smoked the French, the Gauloises. There was a woman I knew from here—she and her husband had a nightclub in Paris and I used to go by there frequently. In the Paris of that time everybody knew where Chez Inez was. I went there and was talking to a Chinese gentleman who, I found out later, was a great gambler. He suggested that I try one of his cigarettes. I didn't know it was hashish, because the Gauloises I'd been smoking were so bad that I didn't notice any difference. After a couple of these hashish cigarettes, I remembered that when I'd first come to Paris I had seen Notre Dame lit up at night—you know, *La Ville Lumière,* with the lights on the buildings—and how very impressive it had been. So after I smoked this hashish I said, "You know, I must go and see Notre Dame again." I left the club and the next thing I knew was that somehow I was on the bank of the Seine across from the cathedral. I thought I saw an angel all glowing walking across the Seine and thought, this is wonderful, I'll run and confess my sins and everything. But then the angel was gone. So I came back to the street level. It was about two o'clock at night, and the only person in the street was a lady of the evening, but I thought I had to talk to somebody; I told her, "You know, I saw the most wondrous thing. I was standing down there and an angel walked across the Seine." She said, "You men are all alike." I asked, "What do you mean?" And she said, "You see those angels holding up Notre Dame? Don't you think that they get tired and they want a little walk at night?" So I said, "You know, I was going to paint that angel, but you just wrecked a painting for me."

When you look at Notre Dame from down the quai and it is all lighted and there is a mist in the air, it seems to go endlessly into the sky. I think the Gothic symbolism was that the top spire was like the finger of God pointing to the heavens. When you look at the Empire State Building you don't usually look up because you're engulfed by it, just as one

would be in the Grand Canyon. But Notre Dame was made in exact proportions and scale to realize that great feeling of height from the quai. This was very important to me in understanding space and how to articulate a painting, to understand the adjustments of scale that are so important. I found that was one experience in Paris that I took home with me.

BLDD: Your career has certainly been varied. There was a period that you turned away from painting. Not only did you try to write songs, but you managed to write a hit song. Can you tell us about that period?

RB: When I came back to New York I wanted to go back to Paris, and in the studio was a piano, so I said, "I'll sit down and write a song."

BLDD: Is this the space you shared with the Apollo Theatre? And Louis Armstrong and Duke Ellington?

RB: Right. They were writing all those songs, and so I said, "I'll sit down and write, like Duke, Cole Porter, or Irving Berlin, and I'll be able to go back to Paris." If you don't think this way it's no use being an artist. I took four or five years of my life doing that.

The Seagram's whiskey company was promoting a drink called Sea Breeze, a gin drink mixed with tonic. Since the whiskey companies couldn't advertise, a salesman I met said, "You know, if you write a song mentioning gin and tonic we'll get Seagram's whiskey company to back it, and we'll buy a lot of the records." So I did, and Billy Eckstine recorded it, and I still get money from ASCAP on it.

But after that I gave it up. There was a lady that you may have known, named Hannah Arendt, and her husband called me and asked me to come see him. "Romare, if you continue the way you're going you'll never paint again, because you have no ability as a songwriter," he told me, and he was right.

Then I began to get nervous—I hadn't painted in a long time. One day I was walking down the street, on Lexington Avenue to be exact. I'd been going to the doctor; I thought everything was wrong with me, I knew just enough medicine to mess myself up. Anyhow, when I got to 103rd Street, I couldn't take another step. The next thing I knew I was in bed someplace and I asked the nurse, "Where is this place?" She said, "You are in Bellevue psychiatric ward." Jesus. Then finally a doctor came and I said, "What did I do? What's the matter?" He said, "You'll be all right, young man, you just blew a fuse."

BLDD: What happened?

RB: Well, all this, writing songs, not painting, had its effect on me. My father was living then, and I think I'll tell you that story because it offers a bit of explanation of what an artist has to do. When I was released my father came down and met me in a large auditorium at Bellevue. I thought, I've been here before, not as a nut. I knew I'd been there before.

I remembered, in the thirties, I had met a Mexican plasterer who had plastered frescoes for Sequieros, Diego Rivera, and other Mexican artists. Someone—one of the WPA artists, I think—had done a fresco in that auditorium and Miguel had been the plasterer. I pointed out to my father where the fresco was, or had been. I said, "It was over there, but they whitewashed it." You know, painted over it. When you do a fresco you paint in wet plaster, and you have to work that plastered section or else you have to trowel off what's left undone. The plasterer joins each day's work to the next section, and a good plasterer leaves just a little seam.

So I was going through this wall, looking for these seams, to see if this was indeed the place, where the fresco had been. A guard was standing nearby, and asked my father, "Is this your son?" My father said yes. "Well, I am afraid he is coming back here," said the guard.

So you see, I tell that story because art, especially the art of painting, really doesn't deal well with what is lachrymose. The artist has to take these things, the things that have happened to him, and out of this cauldron transform them in terms of art.

BLDD: The remarkable thing about your life and your art is that it is all attached to a story. It seems that your art is very anecdotal. Would you agree with that?

RB: Yes. I like to refer to things that are the fulcrum of my memory.

BLDD: Let's talk about the period when you turned away from painting and were working for the city. How did you come to do that?

RB: I worked in the city because I felt—and this again is where I am going to get myself into trouble—that the worst thing that an artist can do is to teach art. It is obvious that an artist is very lucky if he is able to live from his art. However, if that is not possible the simplest thing seems to teach. When you teach all day, psychologically you feel that you've done your work. But if you are digging ditches or something else, you are glad to get through with it, so you can come and do your work. So I was offered and took this job working with gypsies.

BLDD: Was that part of the Department of Social Welfare?

RB: Yes, and I did that for about fourteen years, until I felt in the mid-sixties that I wanted to paint. Then I told my wife to get a job to support me, for a while. It was about 1964.

BLDD: In 1963, in the midst of the Civil Rights Movement, you and a group of other painters formed the Spiral Group of Black Artists. What was it that you tried to accomplish? And how did the name evolve?

RB: They took it from the Archimedean spiral. Hale Woodruff suggested the title. That was the time, you remember, of the March on Washington. A number of artists I knew went down as a group, and wanted to continue together. They came to my studio, or Norman Lewis's, or others. Hale Woodruff, Charles Alston, Alvin Hollingsworth, Merton Simpson, Calvin Douglass. There were twelve to fifteen artists.

BLDD: Was the group concerned with social protest?

RB: No, it was just a coming together and talking about art. We didn't want a political forum.

BLDD: One of the ideas that the Spiral Group had in mind was to paint collaboratively. Was that a success?

RB: It came up one time—instead of one artist painting a picture, we said let's see if two or three of us could work on it. But the question was how to bell the cat. When I came home one evening I saw some of my wife's ladies' magazines, and I said, "Gee, if I cut some of these pictures out here, maybe Richard Mayhew, a landscape painter, could do the trees and things, and others of us could put in figures, and let's see imaginatively what might evolve."

I told the other artists about this and everybody was enthusiastic, so we were to meet one Saturday and no one came but Reggie Gammon and I. So I began to put these things together, and that's how I got into doing the collages.

BLDD: What happened from that point on? Did you find collage an ideal medium for you?

RB: It was an ideal medium for me at that time. We are so much conditioned now by television and by the size of the television screen

and the immediacy of it, and also, as Paul Valéry says, man's patience has been killed by the machine; so if you put all the great artists together you couldn't paint any more with the realism of Van Eyck, Dürer, and the great Gothic tapestry designers. Even with magic realists, you feel the works come from the photograph. No one now has the patience to sit down and work like the old masters. So at first I cut out pictures and made collages.

Yes, that's how I first did it. And then I said, "You know, cutting out pictures of real people—they might sue me for doing this." And then I had to think of other ways of doing it, so that it wouldn't be actual people. Now a lot of people say, "You must have a lot of photographs and things." No, I don't. The things I do when I cut paper I just make up. Really, the way I do my collages is like drawing, or painting. That's how my work has evolved up to the present time. No face that you see, for instance, is actual. They are all cut out and put together, you might say, like a mosaic.

BLDD: Certain images recur in your art work: trains and birds, and that famous Conjur woman. What is their symbolism?

RB: Yes. I am working on a ballet I will present to Alvin Ailey. If the money can be raised, this will be the first time that Alvin will do a three-act ballet. But this project is about a year or two off. It'll have a Conjur woman in it as one of the principals.

BLDD: Perhaps you might describe who the Conjur woman is, and what she symbolizes.

RB: She is gone now. She was a woman who knew herbs and to whom people went for advice on family matters, love matters. To lay a spell on a person they disliked. A lot of people, like myself, were frightened of them as little children. The word comes from the word "conjuration" or magic.

BLDD: What do the trains, the birds symbolize in your paintings?

RB: Well, they can bring you to a place and also take you away. That was the image of one particular culture and the image of another.

BLDD: Is that part of your North Carolina to Pittsburgh to Paris to New York odyssey?

RB: I suppose so, yes. I always wanted to be an engineer, just as I imagine a young boy today would want to pilot an airplane. Things change so fast. Bertrand Russell said that changes which in the last century took one hundred years to encompass, in the twentieth century come to pass in a decade. I remember well one day in North Carolina—we sometimes left Charlotte for the country—and my grandmother was always after a young man who delivered food. He drove a red delivery truck, and it was the first truck that had come to this part of the country, because the roads were made for horses and wagons. And you could

hear his delivery truck coming half a mile away, the two cylinders moaning, the horses neighing, the chickens clucking. And when he stopped my grandmother would always lecture him on how fast he was going, and tell him to be more careful. He was going about fifteen miles an hour.

I had seen pictures of an airplane, but I had never actually seen one. One day I was standing on the porch and I saw this red airplane. I was just beside myself. I started jumping up and down on the porch, and I shouted to my grandmother. She thought that something had happened to me and came running outside. I yelled, "Grandma, look, look!" She said, "Oh, my God, I told that boy to be careful! The way he drove! Now God knows how he is going to get down."

I knew better than to tell her that that wasn't the truck up there, because I knew I'd get a whipping. But you see how quickly things have changed.

BLDD: What do you mean when you say that you prefer to create images that are not too specific?

RB: The best kind of painting or sculpture is when the viewer has to finish it, you know, when he is allowed some entrance into your work, as if you invite somebody into your house and make them welcome so they can find their own proper place. In Chinese painting of the classical eras, there is always an open corner where you can enter, and this is why I try not to make things too specific, because I want the viewers to enter the work on their terms.

BLDD: Your work has a direct relationship to the black experience. Is there something that can legitimately be described as a black aesthetic in the visual arts in this country?

RB: I guess I hadn't thought about that very much. But look at my work, or at Jacob Lawrence and a few others. I don't want to go any further, I might miss somebody.

BLDD: Let's go back for a moment to the Spiral Group. The group never participated directly in the civil rights movement. Did you all ever convey your opposition to the existing laws, to the continuing discrimination and social injustice?

RB: Yes. They had a show just in black and white, and some artists did. I remember Norman Lewis had a very moving painting, even though it was quite abstract and not representational. Some did, and some didn't. You know, you live in a democracy and people make their own choices.

BLDD: Talking about a black aesthetic, one thinks of jazz instinctively. You grew up surrounded by the music of Duke Ellington and Louis Armstrong and Fats Waller and Billie Holiday. Is there a common meeting ground between jazz music and your own art work? How influential were they on your work?

RB: It's very interesting. I was looking at one of the art magazines, and there was an article on Jackson Pollock and jazz. Many of the abstract expressionists painted to jazz music, and the aesthetic of abstract expressionism, the dissonance, the action, the so-called action painting, the rhythms, certain colorations, have a lot to do with jazz. It only could have been done in this country. It was the first time American artists had developed a kind of style of their own. It is rooted in the American experience.

So, for instance, James Joyce's style is very much in the rhythms of black conversation. On the other hand, James Baldwin's style is very limpid and owes very much to the Bible and to the great masters of English prose. So these things don't run ethnically. Anyone who becomes an American becomes four things. He becomes part Indian, he becomes part black, he becomes part Anglo-Saxon, and he becomes part frontiersman, because these are the roots out of which the American experience grows.

So that's why I say we mustn't be too confining. You confine, and you find yourself in some place so that you can't expand.

BLDD: When you were a student at the Art Students League in the late 1930s, your teacher was the German emigré George Grosz. Did his rationalistic art work that depicted German society prompt you to depict the American Negro as a subject? Was he a great influence on you artistically?

RB: Perhaps. Before that I was trying to do cartoons. Grosz used to tell me, "You don't have the same problems as the other art students, who are very tight in their drawing. But you just don't observe anything, you just sort of glance all over. Why don't you draw a hand or a nose or something as big as a piece of paper, and really look at something."

He was a great teacher. But you don't have people like that now, like Grosz and the others.

BLDD: To the works of what other artists do you most respond?

RB: I just like any artist who can help me in my own work at the time, so whoever you need for help that's who you like.

BLDD: And whom do you like?

RB: Well, Matisse. I had met Matisse—someone, maybe Mr. Kootz, had given me a letter to him. I went to see him shortly after the war. The first interview wasn't so good. After that I saw him two or three times. The last time I saw him I was sitting, I believe, in the Dôme—a café in Paris—and it was twilight. The French, especially in the small farming areas, always refer to *le temps entre le chien et le loup,* the time between the dog and the wolf—twilight—and it was that time, which is always a quiet, placid time, and someone said, "The Master is passing by." I didn't know whether God had come back or what, but there was Ma-

tisse. He was very elderly, and a young man was holding one of his arms. There were two young ladies walking behind him—I guess they were models—and all the waiters, about ten waiters, went to the front of the café and began to applaud, and everyone there stood up and began to applaud, and it made me, as a young artist, feel so good, because it wasn't Maurice Chevalier or Brigitte Bardot, but a man who had changed the way people saw life. Matisse was oblivious to what was going on until the young man called his attention to it, and then he went and shook hands with all the waiters. That was a very touching scene. It was the last time I saw him; he died shortly thereafter. But that certainly was a big lift to me, to go ahead!

BLDD: Paris seemed to enlarge your palette . . .

RB: Yes, and my palate as well.

BLDD: I was thinking of your use of color. In a recent magazine interview a number of artists were asked what they would do to redesign New York, and I wonder how would *you* do it?

RB: I would take New York in its various sections and then paint them different colors. When you flew over it it would be orange and blue, and it would be a nice pastel effect. You might take Yorkville and paint it blue, or another section and paint it orange. You might paint it like Seurat, just dots, or whatever, if you felt that way.

BLDD: Do you think that your audience sensationalizes, in a sense, the fact that you were a Harlem painter?

RB: I don't know, I must ask some of the people who buy it. I assume they buy it because they see some artistic value in it. The main thing is that they keep buying. If they buy it for that reason, maybe in time they'll see something else.

BLDD: Do you have any suggestions for young painters starting out today?

RB: No, because everyone must find their own particular way. What can you say? Each young artist is going to do his or her thing in his own way, so there is no common denominator. The time of the Academy, with its rules and conventions, is long past.

BLDD: If you had it to do over again, is there anything you might do otherwise?

RB: I probably would have gone on and finished medical school. I mean that.

BLDD: Did you ever expect your life to unfold the way it has?

RB: No, life is a matter of discovery. If you are a hunter you cannot say, "I am going out to shoot a deer or a partridge or a sparrow,"—you have to take what you find, and this is what life is: you take what you find and you do the best you can with it.

Isabel Bishop

(Painter. Born Cincinnati, Ohio, 1902)

BLDD: With her traditional approach to figurative painting, Isabel Bishop, a New York painter for over fifty years, captures the mood and movement of the bustling city. Her work continued without recess even during the years when other figurative painters of her generation all but vanished before the tide of American abstraction.

Plans were recently announced to give Union Square a fresh image, something you have been doing for about forty-five years now. Can you give us some idea of the nature of your relationship with that very special location, Union Square?

IB: Well, Union Square has meant my work home since the very beginning of my efforts to be an artist. I lived in my studio at 9 West 14th for eight years, and that region became nourishment to me, partly the bustle of the street, partly my closeness to it—that studio was on the second floor, with big store windows looking out. Union Square seemed to me to be characterized by multitudes of people.

The people had a certain character also. The square itself was occupied by professional hobos, mostly. At noon hour there were the shop girls and the stenographers and so on who lived, I am sure, in The Bronx. There was a legion of people coming and going, not residents, and that had a meaning to me too, that they were people who came there from somewhere to have their work life and possibly romances too. And all of that engaged my imagination for these many, many years.

BLDD: Why did you choose to restrict yourself to one location?

IB: Perhaps it was an instinct to stay with something that happened to nourish me. You can't tell what will nourish you. I like other parts of the city too. Sometimes I go to 57th Street and Fifth Avenue just to see an entirely different world, and to feel the beauty of high style clothes and a certain beauty of persons, tall, thin girls, spectacular costumes. They seem outward, they are not inward to me. But I love them. It has seemed to me all these years that the high style—at least that's my word for it—in

that part of the city is perhaps only equalled in a peculiar sense by the bums in Union Square, because their clothes have been worn so long that there is a counterplay—counterpoint—between the clothes and the person. It's comparable to the beautifully designed clothes which in another kind of way do the same thing on Fifth Avenue and 57th Street.

BLDD: Has the scene changed much in the forty-odd years since you first set up your studio and started to observe that traffic there?

IB: It has changed so little that you'd be surprised. Just now a good many buildings are boarded up, but until very recently it had changed almost not at all. It always was very shabby, just very shabby. But the denizens of the park have changed—they are younger and they are hostile, they are taking something that makes them behave in a certain way. No one sketches in the park any more. I used to spend part of every day out there.

BLDD: When you say *every* day you mean that. You have such a keen commitment to your work that you literally have spent every day of your life working. Isn't that true?

IB: Well, I do come down from where I live, which is far away, in Riverdale.

BLDD: And you commute seven days a week.

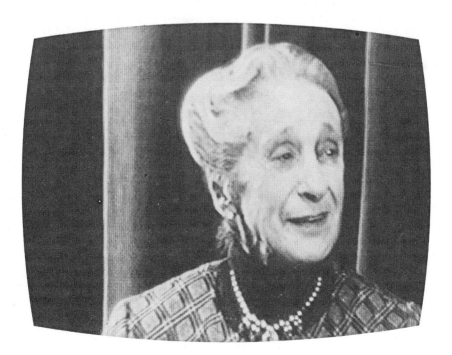

IB: Yes. My husband has been dead for seventeen years and my son is grown up. Until then, of course, I didn't come down on Sundays, but I did on Saturdays. Now I come down Sunday, also.

BLDD: Did you ever have a studio at home?

IB: No, I never set up a studio there.

BLDD: You had the same studio in Union Square for forty-three years, until a little more than a year ago. Why did you decide after all that time to change your view?

IB: I didn't decide. People came from California and they were looking for a building on Union Square, and they fancied this little building four stories high. I was on the top floor and had a wonderful skylight and a wonderful view of the square where people walked all day long. That's what they bought the building for. They left the other tenants alone, and they simply told me that they would terminate my lease, which was almost up, and that was it, because they wanted to make an apartment there and live in it. Anyhow, I had to find a new place, and I was so afraid of being homeless that the first thing that was offered I took. It's on the square, just half a block away from my old place.

BLDD: A different view, though?

IB: It's entirely different—it's on the eleventh floor, and I don't see the people. It may be very stimulating. I hope so.

BLDD: Do you ever work from photographs?

IB: No. Years and years ago I had a Brownie and I photographed like mad. I come across these pictures once in a while, and they are really interesting to me now. Mostly men standing on the street. Men's clothes are very hard to draw, and it's fascinating, again in this counterplay, because a man's suit is like armor, and then his movements change that. But since that time long ago—probably thirty-five years—I haven't photographed because since then I've been interested in movement. At that time I was interested in the genre point of view. I had these bums come up and pose for me in my studio, and they'd send each other.

BLDD: How did you get them to come to your studio?

IB: The first time I was very frightened. I had been drawing people on benches in Green Park in Antwerp—and it was the first time I had drawn outdoors, which was the beginning of my art life, and I got so fascinated with the people. Then when I came back I began to draw in Union Square, and that fascinated me. It was different, the pattern was different. There was a bum who was usually asleep, so I observed him and drew him. When he sat up one day, and I got my courage together—he looked very foreign, he looked like an Egyptian or something—I said very slowly, thinking he wouldn't understand, that I had a studio and I

wanted to draw him one of these days, and he said, "Do you want me to take my clothes off?"

This loft building I was in was being vacated gradually, and there was really nobody in the building but me, and so I fixed my easel at the farthest point from the door; when he came in he was more scared than I was, and he crept along that wall, you know. But he posed for me for years.

BLDD: Did you originally come to New York to study commercial illustration?

IB: I came from high school. I didn't go to college. I came from high school in Detroit, Michigan, to New York to study commercial art with the idea of being an illustrator.

But then something happened to me. I heard about the modern French movement, which I had not heard about before. You see, I came to New York in 1918. The war was just over, in fact we students went out in our smocks and marched on Fifth Avenue. So I know what the day was. The Armory show had been in 1913, at which time I was eleven and not in New York. There seemed to have been so much focus on the war that when it was over there was a strong resurgence in the challenge of the Armory show. The old controversies excited people again—was Duchamp's *Nude* art or violently nonart?

So this opened a world for me. In Detroit I thought of art as something in the museums, as something that you learned how to make, and then you learned what was beautiful to paint and you painted that. That didn't seem interesting to me.

All this ferment over modern art excited me. Then art became a problem of discovery, of intellectual pursuit of possible new dimensions and original thought. So after two years I went to the Art Students League, where things were seething. I mean I went to study with Max Weber, who was in his cubist period. Well! And what I did he thought was perfectly awful.

BLDD: What did you think of what he did?

IB: I couldn't tell distinguished works from undistinguished works, you know, but his work was very exciting. It didn't look at all like nature.

BLDD: Was there a particular teacher to whose work you responded at that point or who especially influenced you?

IB: I'm not really sure. I couldn't get on with Weber at all. He thought my work was awful, which was a little hard. He had a way of having his students lay out their work on Monday, and then he would talk about each painting before the whole class. He pointed to mine and he said, "I come to this first as a fireman goes to the worst part of the fire first."

Then another teacher I had was Kenneth Hayes Miller, who had been in the Armory show.

BLDD: Was his work considered radical at that time?

IB: He was classical, but not in an academic sense. He was a non-academic person, and he was exploring in his own way, which was different. And I found him intellectually stimulating, a fascinating person who presented all sorts of new possibilities and points of view. And I stayed with him. I studied with other people. I studied with Guy Pène du Bois and I became a friend of his and was always influenced spiritually by him, and to my great surprise I found that Raphael Soyer had been influenced by him too. I found that out in reading Raphael's book. We were influenced by his point of view, I think, more than by his painting, which is very beautiful but is underrated today.

BLDD: At that same time one student became a very close friend of yours, Reginald Marsh.

IB: He was in and out of the League. He was four years older than I, and had graduated from Yale, where he was everything on the *Yale Record.* And when he came out of Yale he got a job on the *Daily News* reviewing burlesque. He rated the shows so many stars, and made an excellent living.

But he was around the League, and became an admirer of Kenneth Miller. Although he wasn't formally his student he visited in his studio, and said, "To the end of his life I showed Miller everything I did." I became very fond of Reg.

BLDD: What was the nature of your professional association with Reginald Marsh? Did you share work and criticize each other's work as well?

IB: He was so beyond me as an artist. Good gracious! But we always were friends, and he was kind enough to look at my work, and I always looked at his. I went to Coney Island with him, too.

BLDD: You also went to the burlesque with him?

IB: I went to the burlesque with him. He took me backstage at Minsky's. Minsky's grandson wrote to me recently and said, "My grandfather was a great admirer of Marsh and owns some paintings by Marsh." I thought it was nice to be backstage at Minsky's, but I couldn't do anything with it as a draftsman.

BLDD: You had your first exhibition in New York in 1932, at the same gallery [Midtown] where you still show. How did that first exhibition come about? How did one go about engaging a young painter, let alone a young woman painter, in 1932?

IB: Well, this young man who founded the gallery, Alan Gruskin, had just got out of Harvard, he had no money, and it was the time when

solidly established galleries were closing in the depths of the Depression. He started a gallery on a shoestring in a dreadful place. It was on Fifth Avenue, but it was a railroad flat with dusty red carpets from one end to the other.

I don't know how, but he got together about fifteen or so young people, girls and boys, and charged us five dollars a month to hang something there in a group show, and then after time went by and he thought that you were ready he would give you a show in the front room—there was a small front room, also with a red dusty carpet. It was on the seventh floor, and when I finally did have a show the elevator broke down, and it was a very hot May.

BLDD: The critics treated your work very kindly, and early on you were awarded many prizes.

IB: Well, I don't remember it that way, but they were relatively kind, except that one very influential critic of the *New York Times* said, "I've heard that some people like this person's work, but I can't see it." He said "It's so gray, I stand off and I squint at it, I come nearer, and I still cannot see it."

And he referred to a picture that now hangs in the Metropolitan Museum and is occasionally liked today.

BLDD: You have reworked the same theme in many ways—in prints, in etchings, in drawings, in oil. How do you know when you have finished a work of art?

IB: I don't think I ever consider them finished, because I am not even willing, let alone able, to carry them to a point of physical finish, but I have to concede that they are done when they what I call read right, that is, when they read a statement back to me.

BLDD: When does an artist know—or when does the public know—when an artist has succeeded in a work?

IB: That I don't know.

BLDD: Once you said that the artist succeeds when the viewer looks at a work and the work governs the questions that the onlooker asks of it.

IB: If the artist has succeeded he does govern the questions, doesn't he? Not that you *can't* ask the wrong questions, but you *don't feel* like asking the wrong questions. That is, you wouldn't ask a figure by Raphael or Mantegna to move; it would be a totally wrong question and you wouldn't ask it.

I was impressed by this one time when I was struck by the immense power of a Poussin at the Metropolitan Museum—*The Rape of the Sabines,* in which a battle is going on over the Sabines. It was convincing, it wasn't just a description. In your nervous system something happened through opposition of lines, something was going on. But then you can

ask the wrong question—can that soldier move that arm? He can't, it would break off. I mean this is all empirical, and I could only convince you by photographs and slides. You have to experience it. But in experiencing it you do find something quite interesting.

I think critics will find that some artists, as for instance in the Victorian period, who were "great" artists in their own day, did not have the concept of governing the questions.

BLDD: Then what do you think of their results?

IB: They are inconsistent, they are unsatisfying. Of course the critics say these things are coming back, and I think they are coming back, as camp. But I say they'll never come back on the level at which they went out of style, which was at the top. I mean they were considered equal to Rembrandt, to Titian, Veronese.

It seems to me, to put it very simply, that there are really two forms of painting. In the one case you see the world as disparate, as separate ordered forms, and in the other only as a continuity. Both have their terrific powers, and both have their terrific limits, and to combine them results in something that is fallacious. Nineteenth-century painters such as Bouguereau combine them, they want everything, both the power of having that arm able to move, and the power of the kind of design in which this would not be possible.

You can't have them both.

BLDD: There is a notion that you have found useful during all this long time that keeps on running through your mind, and I wonder if you might share it with us.

IB: I'll try. The aphorism is, "Strict with the thought, unfearful of the form, so shall you find the way, and hold it fast."

If you think of it, it seems odd that it shouldn't be equally valid the other way around. It sounds just as good if you say, "Strict with the form, unfearful of the thought," but it doesn't work. It only works "strict with the thought" because the form always must be the outward shape of the content.

BLDD: Is that a view that you shared with Ben Shahn?

IB: Yes. Ben Shahn wrote a series of lectures for Harvard, which he called *The Shape of Content*. The form was the shape of the meaning. The meaning is the thing, and it has to have some shape, and the shape that it has is the form. But it only has the correct form if the form does express the meaning.

Ben made his lectures at Harvard into a book and it was translated into Japanese, and the Japanese called the book *The Outside of the Inside*. I thought that was perfect.

BLDD: On a subjective level there is another test that you apply: "Is it so?" What does that mean?

IB: That is the most severe test. It means is it psychologically so, subjectively so, because it could be naturalistic, but inside of yourself you know it isn't so. It's something made up, and it's not so. Think of Rembrandt, who's been adored for so many centuries; think of the number of people who've modeled themselves on Rembrandt in etchings and paintings—and yet they are not so.

BLDD: Style in the most fundamental and aesthetic sense is a recurring theme in the content of your work and your ideas. Perhaps you might tell us a little more about your ideas about style and continuity.

IB: The continuous form is our form in this period. It's even shown in objects. Remember the old, old, old automobiles which emphasized separate parts—they had a nose sticking out here, mud guards out here, and then gradually over time there was a slow change toward unified design.

I think it's true in clothes, too, it's true in decorative art, in jewelry, it's true in belt buckles. We seem to feel the world in this way. I believe we feel the world as a continuity.

I had a feeling of enlightenment when I thought about cubism, because cubism, which looks edgy, cut up, is really an example of a continuous style. The breaking up of the objects in cubism breaks up the distinction between an object and the world, so that they are not distinguishable—they are broken up and put together. The cubist form was very short-lived, really, in a purely didactic form, and I think part of the reason is it was so hard and so demanding. It was extremely austere.

BLDD: Do you think of cubism as a baroque style?

IB: I think it connects. If you look at Fragonard (and who is more different from a Braque or a Picasso) or at a Delacroix or a Rubens, you find this continuity. If I could then oppose this with the other styles, the discontinuous, the disparate ones, where these disparate elements are ordered (and that would be Raphael, Bellini, Piero), this point would be emphasized.

BLDD: Are there any artists at present using those techniques?

IB: Very, very few. The only ones that come to my mind are George Tooker, or Richard Estes, who is a photorealist but who usually orders his images strictly.

BLDD: How do you respond to the work of the photorealists?

IB: I don't at all, except for Estes. I really think that they have not ordered the images, that they have taken the camera image as the validity. You can use a camera all you want—no objection to that—but the validity has to be in the artist's idea, to my mind.

BLDD: Why did you give up using the camera?

IB: I couldn't use it any more because I was interested in motion. It doesn't help me with motion. It only helped me with details when I was essentially involved with still figures.

BLDD: Since the 1960s some of the groups of strolling people that you have focused on are very young people, students. Is it the vitality and the dynamism of their motions that especially engages you?

IB: Oh yes. Also, you work from what you can get, and I found that at a point I could get young people who were graduate students to pose for me. They were engaged in something at irregular hours, many of them were dance or film students, and could give me a couple of hours.

BLDD: Is a young person a particularly challenging subject?

IB: I think so now. I didn't earlier. I think so now, especially because I am interested in walking, and they walk and walk for me.

BLDD: Lately your paintings represent an approach to abstraction that is more marked than in any of your earlier works.

IB: It's not with any aim at abstraction. It's only my effort to find a way—I certainly haven't found it—of expressing walking without declaring the environment exactly, without saying anything about the place where they are walking. And it seems practically impossible.

BLDD: The work appears to be more abstract to me. It seems that the brush strokes are more simplified and spontaneous. Do you attribute that to your interest in more modernist innovations?

IB: No, I never thought of it that way, and I am sorry they look that way; if they do it's no part of my intention.

BLDD: Some consider you a social realist painter. How would you describe your work?

IB: Well, certainly not in those terms. Somebody lately said of me, "She is a romantic realist." Well, that's all right, but certainly not a social realist, because I have had no interest in social causes, even in the depths of the Depression.

BLDD: You were painting working men and women. Did you not think of that work as a political statement, as well?

IB: They were there, they were serendipitous, really.

BLDD: Do you think that "romantic realist" would be an accurate description of your work?

IB: I guess I do.

BLDD: What is a romantic realist?

IB: I take romantic in a formal sense. I don't know how the person meant it, but to me the romantic form is a continuous form, is the baroque form. It means to me a kind of form.

BLDD: Is there any advice that you would give to a young person who is starting out today as a painter? Something about the nature of the work and the commitment to the work?

IB: I feel that the pursuit is very important. Now look, we can say so-and-so looks like an eighteenth-century man, or he looks like a Roman man. But we don't know what an American man in 1979 looks like, we don't have an image. Suppose the next wave of students took the idea that with all their splendid discipline many of them now have in the designing of a picture plane, if they took that discipline and went after image, they'd have to make one, find one by trying here and there and everywhere. They'd have to find one.

Now de Kooning, to my mind—and I am an admirer of de Kooning—his most moving work is that series of women, which are frightening, but they are searching for image. He would paint over these things, over and over and over for years, the same pictures, I think searching to get it out from the inside image, and I think that's where it would have to come from, by infinite trials and trying—from the inside.

BLDD: Getting back to your old studio, did the view from there provide you with all the subject matter you needed?

IB: Yes, but not literally. It was for the moving figures that I valued my view. You see, where my old studio was it had windows on the

square, only four stories up, and I had a skylight in another part of the room, with a sort of partition between, so I didn't paint actually looking out of that window, but I would put my picture where I could see it from the part where I could look out, and I could verify it subjectively. I mean I'd know subjectively by looking out, no, that's not good, that doesn't say the right thing. That was a way of verifying always, and it was like eating, like nourishment, to see those people, because in that part of the square people don't just cross the street, they go in many directions, so the feeling is always very ornate.

BLDD: For many years you were married to a distinguished neurologist. You lived in Riverdale, you had a husband, a son, a house, you painted every day. How do you compare your life and your work to other women artists? Did you ever identify as a woman artist?

IB: I knew women artists who managed it this way. Do you know who Yasuo Kuniyoshi was? I knew Kuniyoshi's first wife when she was very young, when they were just married. They lived in Brooklyn Heights, and she did everything. She was a meticulous housekeeper. She worked in the Art Students League lunchroom, painted some of the best pictures of her life, took her husband's work around to dealers, really, she did all that, and she was a very distinguished artist. She just died recently.

BLDD: Did you ever feel that you were at a disadvantage because you were a woman?

IB: No, I was lucky because if I had been a man perhaps this relative who subsidized my whole studenthood and after, my father's first cousin, James B. Ford—I don't know that he would have sponsored me if I had been a man. He was interested in a young woman who would want to put that much time and effort into anything. He would have expected a boy to do that, and he probably wouldn't have subsidized him.

BLDD: Did you ever expect to earn a living as an artist?

IB: I painted portraits for a while, just to make some money, and I never was good at it, it took me forever, so economically it wasn't profitable, but anyhow finally I paid an income tax. I remember, I was in my mid-thirties, and I paid the income tax and I was so proud! It was the first year I could.

BLDD: Throughout your career we've seen these figures in motion. What about motion? Is it a metaphor for something else, to you?

IB: Yes. It is a metaphor for me, because of something that seems to me characteristic of American life. Renoir lived in a particular layer of French society, and he painted this layer, and I am thinking of this as a touchstone. He painted a young woman—it's called *The Cup of Chocolate*—and you see something in the environment and in subtle ways you

know exactly just who she is: the little napkin contributes everything. You know that her mother would be represented in the same way, her grandmother would be represented in the same way, her children also—not her grandchildren I guess, on account of today's changes. But this continuity is *not* characteristic of America. We are always moving, that's characteristic of us.

Now these girls that I got interested in doing who worked in the neighborhood of my studio in Union Square, and who came from The Bronx usually, they struck me as being mobile in life, and I was interested in expressing mobility in a physical sense. I desperately wanted mobility, not thinking of the social aspect, but I wanted mobility. Then, wanting mobility, I began to feel this in these people, in these girls, that they not only could cross the street, but they could cross the railroad tracks, and some of them did, as I know since some of them kept in touch with me for years. It seemed to me to be true of America.

BLDD: In the 1950s, in that tidal wave of abstract expressionism, how did you sustain yourself?

IB: Well, this is interesting because the critics really went overboard. There was no discussion by any critical journal of anything but abstract expressionism. It took the whole scene. I didn't happen to know Raphael Soyer—I don't know why I didn't, but I didn't. I had a card from him—this was about 1950—that said, "Tomorrow some artists are going to meet at this restaurant, called Del Pezzo, and would you like to come?"

Well, I came, and there was Ben Shahn, Raphael Soyer, Reginald Marsh, Yasuo Kuniyoshi, well, a number of them.

BLDD: Any other women artists?

IB: I don't think there was any woman at that point.

BLDD: And you didn't know most of these people? Soyer just wrote a postcard to you?

IB: And Raphael didn't know them, he really didn't know them either, but he wrote this card because he thought it was a time when figurative painters should come together and talk. We adored it, loved it, and Del Pezzo put us out because we didn't drink enough.

But Ben Shahn, who was then enormously famous, had just been through the country lecturing at universities, and he was shocked because he found that in the universities' art departments, which were teeming with students, the students didn't know anything, I mean they had no knowledge, they were ignorant, they had no library of slides, they weren't taught any art history, they were just being disciplined in one mode—abstract expressionism—and they became very good at it, a great many of them. But at the same time they were ignorant—in other words

they had no leverage on any change of style. They were just given this one way, and they had no leverage for any changes. It was a bad situation. So we spoke about that with a great deal of feeling.

Then after quite a lot of meetings, at one point Kuniyoshi said—and you know he was a man of very few words; I have spent whole evenings in his apartment and he would never say anything at all, just smoke his pipe, but he did take his pipe out and he said, "Couldn't we just talk about art?" And we had been talking about things like education and troubles about the critics. "Couldn't we just talk about art?" I thought that was lovely, and everybody really stopped in their tracks.

BLDD: And did they start talking about art?

IB: Yes. We thought of what to do, and we thought we would like to at least express ourselves, so we got together a little paper. One of the instigators of this wanted it called *Reality,* and I was totally opposed to it. but no one listened to me.

Jack Levine. who was one of the group. wanted it to be called *From the Horse's Mouth,* which was right. Well, it was called *Reality.* We got articles from Kokoschka, from Berenson, from a good many distinguished people abroad and a good many distinguished people here, and made quite a stir. In four years we issued four copies—four copies in four years—and these weren't sold, we sent them to universities and libraries and so on. Art magazines became absolutely furious. They wrote long diatribes about this horrible idea.

After four issues there was no use going on—we had all said what we had to say. But it is remembered now as a sort of collector's item.

BLDD: What do you think of the level of art criticism today?

IB: I think the art is better than the art criticism, frankly.

BLDD: What role does criticism have?

IB: I think it could be very useful. That's the reason I feel rather badly about it.

BLDD: Do you feel that criticism can also be dangerous, and misleading to artists?

IB: It can be very misleading, and it had a great deal of power.

BLDD: Are there any artists to whose work you respond currently?

IB: I'll answer that generally. When one looks at the work of the past one has a feeling of emulation. I don't think one looks at the work of the present with this attitude. I mean not because it isn't worth emulating, but because that isn't one's relation to it.

BLDD: How important is printing and etching to your work?

IB: It is important to me. In order to come to an image that I could then work on in painting, I have to come at it, and maybe I have been coming at it in complicated ways. You have a drawing, and a way of

finding out if there's any what I call idea in the drawing—by idea, I mean a visual idea—is to make an etching, because an etching is a more austere medium.

Then in recent years putting aquatint tone on that plate in order to arrive with a certain freedom at a tone that will be serendipitous. There is a lot of chance in aquatint. Your hand does something that maybe you wouldn't think of. Your hand does something, and something can come out of that which results in an image, and I can really go after it in painting. It won't be the same thing, because it will be quite different in painting from what it was in black and white.

BLDD: For a long time you said that figurative work was not only not seen, it was invisible.

IB: It really was invisible. But that's not true now, thank heaven. It really isn't true now.

BLDD: There's a phrase on your studio wall, "We work in the dark and we do what we can." Do you still feel that way about your work?

IB: Oh, yes. We work in the dark. It's Henry James.

BLDD: How does the passage go?

IB: "We work in the dark, we do what we can, we give what we have, our doubt is our passion, and our passion our task. The rest is the madness of art."

J. Carter Brown

(Museum Director. Born Providence, Rhode Island, 1934)

BLDD: One of the most celebrated and highly regarded figures in the international art world is J. Carter Brown, the director of the National Gallery of Art in Washington. Can we start by your telling us: what is the central philosophy of the National Gallery and just how national is the National Gallery?

JCB: I suppose if we were to sum up the philosophy in one word it would be excellence. It's easy to talk about, but hard to achieve. The national aspect is a much more complicated question. We are national in the very real sense that we get federal appropriations, which means that we are kept alive by income tax returns. That makes us national automatically. We try to be national in another sense, in the sense that this is our national heritage. This is our national best foot being put forward. When Andrew Mellon was secretary of the treasury in the thirties, the foreign heads of state used to come and say, could you please take us, Mr. Secretary, to your National Gallery? And he would have to say that the United States doesn't really have a national gallery—they may someday, but they don't now, but if you would like to come to my apartment I can show you some pictures. The fact is that his apartment had twenty-one paintings that he bought from the Hermitage in Leningrad and some other goodies which became the nucleus of the collection of the National Gallery.

BLDD: How much of the National Gallery support does come from the federal government?

JCB: Most, for operations. The deal that Andrew Mellon worked out with the Congress and President Franklin D. Roosevelt was that the full faith and credit of the United States would be pledged to the Gallery's maintenance and upkeep. It happened that he had quite a bit of leverage, since he was giving the largest gift that any individual has given to any government, and he gave us the building and his collection and a small endowment which basically covers the salaries of the top six execu-

tive officers. The other six or seven hundred employees are paid out of federal appropriations—they come under civil service—which has put us in a very nice way.

BLDD: Are curators civil servants who work at the National Gallery?

JCB: Yes, they are indeed, and this means that they get all kinds of delightful fringe benefits in terms of health care, retirement, and so forth. Also, so far, we have had a cost of living adjustment automatically to keep up with inflation, which makes for a very nice rock-solid base. We go to a collector and say what he has is worthy of being taken care of by the nation, and give him some hope that it's like buying government bonds.

BLDD: What is the size of the annual budget and what percent is absorbed by the federal government?

JCB: The federal budget next year will be just over $19 million and there really isn't a private budget of more than $500,000 or $600,000 or around that. So it's largely federal. That of course does not cover any acquisitions, and the federal government has never given any money for acquisitions of works of art except indirectly. That means we have to go out and try to find donors just like any other museum. It puts us at a competitive disadvantage with our European colleagues because these

big state-supported museums in Europe sit back with enormous govern-
ment grants to buy art. Just the Tate Gallery alone in London has some
$2 million a year to spend to buy art. That goes a long way because they
are buying very recent art. The Louvre gets all its gate receipts free and
clear to buy art with, and that's over $2 million. Now that the dollar is
not as strong as it once was we find very stiff competition abroad in ac-
quisitions.

BLDD: How does the National Gallery differ from other museums?

JCB: Taking this national mandate seriously, we feel that we owe a lot
to the rest of the country, and for this reason we have an extension
service that goes out over the entire country. All fifty states were served
last year, over four thousand communities, and this reaches an enormous
audience. It's hard to count, because some of the programs go out on
video and you never know how many see it, but many millions of Amer-
icans are served by the variety of audio-visual and educational material.

We serve another audience which is largely national, but really quite
international, which comes to Washington as a sort of pilgrimage site.
We took a kind of straw poll last year. We didn't have any particular
temporary exhibition like Tut on at the moment, just the visitors that
came in one week in August. It was rather a small sample, just the people
who came up to the information desk to ask a question, and we asked
them a question: Where are you from? Out of that universe, about six-
teen hundred people, we had representatives from all fifty states and
fifty-three foreign countries.

BLDD: You played a major role in bringing the Tutankhamen exhibit
to the United States. How do you feel about what you helped create—
Tutamania?

JCB: I had an inkling that this would happen. As a matter of fact, it's
amusing to recall sitting in the office of the head of antiquities in Cairo, the
only air-conditioned office in the entire cultural establishment over there,
and trying to make a pitch that if these objects were loaned to the United
States, an entire wave of fashion would be initiated. People would begin to
imitate Egyptian styles and we would see it in the merchandise lines and so
forth. It's been amusing to watch all this prophecy come true.

BLDD: But is it art? What about the reaction on the part of the
public?

JCB: We took a survey when it was in Washington and asked rather
detailed questions of the people as to what they got out of it and why
they came. Even allowing for all the bias of people telling you what they
think you might want to hear, still it was overwhelming—some 86 percent
said that the top reason they came was because of the beauty of the
objects. I think that's true. I think that things are not that great a success

in America unless they have a lot going for them and there is a lot going for Tut: the notoriety, the sort of treasure-trove aspect, a spooky quality, a type of voyeurism that comes from peeking into a tomb that was never meant to be opened. But there is also the beauty of the objects. These are staggeringly beautiful objects. They come at a point in Egyptian art history where you have a crossing of two streams, all the naturalism that was learned just before this period and the old very hieratic signs.

BLDD: In addition to being so instrumental in bringing the Tut exhibition to the United States, you have brought master paintings from the Hermitage, Goya paintings that had never left Spain. How has the National Gallery managed to be first in so many of these important circulating exhibitions?

JCB: It really isn't as difficult as it sounds. I think people abroad like the idea of their country being represented here. The next building down from us is the Capitol of the United States and the avenue our new building fronts on is Pennsylvania Avenue, which many people call Main Street, USA. You have the White House at one end and you have Congress and the Supreme Court at the other and all of these 535 congressmen who are apt to drive to and from work right past it see it twice a day. Foreign governments watch news that comes from America and a lot of that news has a Washington dateline. They feel that that's the place where they would like to make their gesture; they feel also that symbolically their entire country is represented, and that this is a way of starting off with a bang.

BLDD: Many think of New York as a national city and see it as the art center of the world. Nonetheless, we see an increasing number of shows originating in Washington.

JCB: I don't think anybody should get too uptight about where a show opens up. For years Washington has had its share of great national shows and I expect that to continue. It is not by any stretch of the imagination the art center that New York is, certainly in terms of the creation of art or the buying and selling of art. But in terms of a repository for art and related museum objects, it is remarkable. Attendance on the Mall last year was 27 million visitors—the combination of the Smithsonian museums and the National Gallery. The Space Museum, which is right across the Mall from us, has been drawing more visitors than any building, not to mention any museum. A million a month. It's just a staggering attendance and people come to Washington in a pilgrimage mood. They come in an open mood, saying, "Who are we as a nation?"

BLDD: There are very few museum directors who have had such an extensive preparation for their role as you. More museums are turning to executives rather than art historians to run their museum. You have

almost unique training in that regard: a master's degree in business administration from Harvard and a master's in art history from New York University's Institute of Fine Arts. Whatever gave you the idea to take both degrees in the first place? It was not usual when you did that.

JCB: It was a little whacky. They accepted me at the Harvard Business School on the basis that I wanted to make museum work a career, and I think they scratched their heads a little bit. And they did it because they didn't have too many applications like that. But they teach administration, and even not-for-profit institutions need to be administered. Since then it's really been quite a trend. There is a whole club at the Harvard Business School of people who are interested in not-for-profit organizations and others who are interested in the arts; I have gone up to talk to them over the years and have watched this whole thing develop. They now have quite a little hunk of their student body who are doing this. It only stands to reason that large organizations need administrative attention and it is quite interesting to see what is happening to my colleagues at the moment. We have had through the Donner Foundation a very good survey on the training of museum directors and what might be done to beef up their exposure to administrative concerns. There are programs in museum administration, summer programs, mainly in five or six universities, and we are just beginning to get some of my colleagues excited about what is going on. I think it's a wave of the future. If possible an art institution should be run by an art specialist. Administrative help can be hired under that person to backstop the administrative and financial aspects. In the same way, great universities should have a president who comes out of an academic background.

BLDD: Do you think the Metropolitan Museum experiment is the desirable wave of the future?

JCB: I am not really in a position to judge an institution that is *sui generis.* It is too large—seventeen different institutions in one, with all the things they collect. The National Gallery is much simpler. We specialize in paintings, sculpture, and graphic art, but in the limited time from the Middle Ages on, and just in Western Europe and America. That's different from trying to be an encyclopedic museum, collecting in all fields, and being so big. It's hard to prescribe for others. But I personally would regret deeply seeing a trend, on a monkey-see-monkey-do basis, of all American museums being handed over to professional administrators, with the curatorial types being told to run and play.

BLDD: In addition to Cambridge and New York, you studied in Paris, in the Netherlands, and in Italy as well. Can you tell us something about that time in your life?

JCB: I went to see, as a pilgrimage, a great hero of mine, the director of the Metropolitan for many of its great years of growth, Francis Henry Taylor. He was certainly one of the most brilliant museum directors of our century and he retired from the Metropolitan because he "got tired of ordering toilet paper." I think it was a way of saying that the administration got to him. I went out from Harvard to consult with him about education and what one should do to prepare oneself for a museum career. His advice was very strong. He said, do not major in fine arts as an undergraduate. I was rather taken aback at that. Then he explained that I'd be spending the rest of my life specializing in art history and it's terribly important to get a broad cultural basis on which to build a foundation. So I majored in history and literature at Harvard and took some art history courses, but basically studied cultural history in its broadest sense. That meant that after I got through with business school, I had a lot to learn in order to get anything as rigorous as a New York University degree, which is a three-year course with a thesis and a joint program with training at the Metropolitan Museum of Art. So I took a year after I got out of the business school to try to catch up on all the art courses I had not studied as an undergraduate. The closest thing was the Louvre school, which is a prerequisite for everyone going into museum training in France. That's a three-year course that goes over all art history. So I stayed in Paris. No such study was offered in England, or in Germany, or in Italy and so I spent some time in each of those places basically looking at objects. I was working with Bernard Berenson, who had one great piece of advice: "You must look, and look, and look, until you are blind with looking, and out of blindness comes illumination."

BLDD: You are the last of the long, distinguished line of critics and art historians who stayed with Bernard Berenson at I Tatti. What was the greatest influence he had on your own emerging, developing sensibility?

JCB: It's extraordinary to have an opportunity to be with someone whose intellectual equipment was so formidable and yet someone who was also very interested in younger people coming into the field. I often feel that grandparents and grandchildren get along better sometimes than children and their parents do. Certainly in a professional field, when people are too close in age, there is a hidden competitiveness that sometimes blocks communication. He, at the end of a long and illustrious career, and I, a nothing student, were able to be relaxed with each other in a way that perhaps was not the case, notoriously not the case, with a lot of people who came to I Tatti and got lit into by a tongue that was quite famous for its acerbic wit. We were able to communicate with each other better than probably either one of us would have been able to

communicate with someone in the middle. He was enormously helpful.

BLDD: Why do the collections of the National Gallery start with the Middle Ages?

JCB: The concept of the funding of the National Gallery was based very much on Andrew Mellon's experience. Having lived in London and having fallen head over heels in love with the National Gallery in Trafalgar Square, he used to sneak off to that gallery from the embassy whenever he could and spend hours looking. He felt that the capital of the United States of America should have a national gallery too, and he was going to do something about bringing that about. That concept of a gallery rather than a museum is a very special one. It grows historically out of the great Roman idea of a country villa where a very enlightened Roman collector would assemble a few objects, and it was different from the Germanic idea of a museum. Like a lot of other European institutions, we really focus in on the history of Western painting. There wasn't much Western painting before the Middle Ages. There were some frescoes, which are hard to collect, and some miniatures, which are hard to show, and so we really begin with easel painting. We have some thirteenth-century Byzantine icons and then we start in with the great awakening, in the fourteenth century in Italy, of the consciousness of painting an object as a work of art, and then take it right on through.

BLDD: Your board members include the Secretary of the Treasury and the Secretary of State. How does that affect both the philosophy, the acquisition policy, and the general policy of the National Gallery? Not only internally but externally?

JCB: It was set up to be helpful. Andrew Mellon, being Secretary of the Treasury, thought that he would be a good chairman of our finance committee and the Secretary of State was obviously put on there to help in international representation and that certainly has worked out. The Chief Justice is the highest ranking official in the United States who is not elected and that gave us the maximum potential prestige with the minimum chance of political interference. This was a subject that was very alive in Andrew Mellon's mind in the era when government was very rapidly moving into American life in a big way. The arts community was worried, after the wonderful success of the WPA, about what would happen in the following period in terms of political interference in the arts. It's a worry that persisted but now has begun, I think, to dissipate. The endowment is set up in such a way that we have been insulated a lot from political interference. But in the thirties, when all this got going, Andrew Mellon was worried that aesthetic decisions would be made by the power of a person or by leverage exerted by congressmen who owed favors to important constituents who might have a son or daughter who

painted and would like a one-person show. The legislation set up the board of trustees in such a way that there are nine people, with a majority from the private sector, even though the majority of the funding comes from the public sector. He was not dumb, Andrew Mellon, and he understood the necessity of having independence from political interference.

BLDD: Let's dwell for a moment on some of the board members who have been at the National Gallery since 1961. During that period have there been any secretaries of the treasury or of state who have been particularly activist or influential in international or domestic arrangements?

JCB: I wouldn't say so. Some have taken more interest than others. I remember particularly one calling me up saying that he had a free lunch and could he come down to the Gallery and find out what was going on.

BLDD: I am specifically thinking of the Secretary of State with a special interest in the Middle East. In terms of the Tut negotiations, did he have anything to do with that?

JCB: Not directly. This was back in the Nixon administration, as you know, and I was in Cairo just when Henry Kissinger was there, beginning the shuttle diplomacy. He took a great interest in antiquity and he and I were on fairly good terms and he knew of our interest in the Tut show. But all the original arrangements were made before the government got into it. When I was over there first discussing this with the head of antiquities, he took it up to a cabinet decision of the Egyptian government just a few weeks after that and it was approved by the Egyptian cabinet long before there was any kind of intergovernmental agreement. But they wanted an intergovernmental agreement and about a year later that took place as a government-to-government document. Then the circulation of the show was handed over to a consortium and by that time the Metropolitan Museum had asked if they could manage the consortium and we said fine by us. We realized that somebody had to do it and agreed that they take it over.

BLDD: In the mid-sixties, when you were assistant to the then director of the National Gallery, John Walker, one of your responsibilities included shepherding the construction of the I. M. Pei-designed East Building of the National Gallery that opened in June of 1978. Why did the National Gallery so early on think that it needed a new building?

JCB: Certain aspects of our operation were bursting at the seams and we knew that the site next door had been reserved, again by the foresight of Andrew Mellon, who put it in as a condition of the gift. And we had these magnificent donors in Paul Mellon and his sister Ailsa Mellon Bruce, and later on, the Andrew W. Mellon Foundation.

BLDD: You might explain that there were certain givens in the construction and design of that building. Why the site and shape of the building was chosen, and so on.

JCB: The site was always there. The original donor foresaw that there might be a need for it some day. He probably thought that would be one hundred years down the pike. Here we had a building larger than the National Gallery in London and, starting off with a nucleus collection of about 135 paintings, he had 136 galleries to fill even in the West Building. Now they hadn't much idea in those days that museums needed many people to operate them, and the architect's original plans of the National Gallery showed five offices. Also the executors of the Andrew Mellon estate—he died before the building was realized—were very worried about the pennies, and thought they might run out of money; they decided not to excavate under the building, so two-thirds of that original building was never excavated. This meant that all the air-conditioning equipment erupted up into the potential work space, and there was very little room for all the ongoing scholarly, educational aspects of the gallery. We needed space.

BLDD: But not for exhibitions?

JCB: Not right away for permanent exhibition.

BLDD: Certainly no space was provided for modern art.

JCB: A lot of people get the wrong impression that, since we built this new building with a contemporary architect expressing a very contemporary style, it somehow immediately was coming in on the half-shell as a museum of contemporary art. This is very far from the truth. The building was first of all for our Center for Advanced Study in the Visual Arts, an outgrowth of our scholarly program. It provides a bigger library, a new auditorium, and space for temporary exhibitions, which had not been thought of adequately in the original building. It was always the idea for us to be basically a retrospective collection and that is what we are. Space in the new building will be given over to permanent holdings in the twentieth century field eventually. We still do not buy strictly contemporary art, but do accept gifts in the contemporary field if it looks like they may eventually become of commensurate quality.

BLDD: Is there any written or unwritten law about showing the works of an artist who is still alive?

JCB: There was originally. There was a working policy set by the trustees that they did not accept any works of art for the permanent collection by an artist who had not been dead for at least twenty years. That was like the concept of the Louvre, but there they do it more intelligently. They say that the artist has to be born one hundred years ago; you can't do it by death dates, since some artists die very young and some live forever. It's got to be very hard to explain why we felt that the great Picassos Chester Dale had and wanted to leave to us might not be appropriate. But the artist was still alive. So that rule was changed and when Chester Dale died *all* of his collection came to the gallery. Now we are very welcoming to gifts in the contemporary field. But we feel that for our own limited purchase funds we have to zero in on our major demonstrable gaps, which are usually in an earlier period.

BLDD: You have been quoted as saying that what makes a museum great is smallness and that forty-five minutes of full attention is just about all one can be expected to muster. Has your idea of the small museum been realized in the East Building?

JCB: You can help the visitor, and the East Building is really quite a departure in that way. We wouldn't have built it the way we did if it were our only building. Luckily we have the great anthological building of 1941 vintage which is spread out. Rather than build a lot of acreage of gallery which might give you psychological fatigue right away, even before it gives you physical fatigue, the East Building was modeled more on the delight of a house museum like the Frick in New York City, the Phillips collection in Washington, or the Poldi-Pezzoli in Milan.

BLDD: You and I. M. Pei went on a pilgrimage to visit small mu-

seums throughout the world. Mr. Pei credits you with originating the idea that the small museum within a museum be included in his design. Was there any particular museum in your travels abroad that inspired you?

JCB: I don't think there is one specifically. The Poldi-Pezzoli has a beautiful staircase that is in a hectagon, so when I. M. saw that he immediately ignited and said, that's a marvelous staircase, and we will have the opportunity to build a wonderful staircase. I was delighted to see his sensitivity too. You needed a certain amount of monumentality on the outside and I was scared to death that that would then translate inside into something that would be antiart. So I came to him with this house museum concept of trying to break up the inside into something that was more to the human scale, and that's what he did.

BLDD: Who decided the design of the interior and exhibition space? Was there curatorial conflict there?

JCB: Yes. We decided that we would have the great central court that would get the visitor onto an aesthetic high in anticipation of the visit. Then when we got into where the art is it was architect hands-off, because we didn't know and still don't what eventually will go into any of those galleries. What we needed was flexibility to tune those spaces to the individual works of art.

BLDD: Are you saying that this custom-made gallery heralds a change in exhibition strategy, that the neutral all-purpose rectangular gallery is obsolete?

JCB: No. We have a lot of those in the other building. They are very hard to hang. My predecessor used to say it's like a sonnet form, it is very difficult to make it work but when it does work it gains strength from that. Certain kinds of art exist very well in rectangular spaces.

BLDD: The West Building is the original John Russell Pope neoclassical temple. You have said that that is one of the most successful museum buildings in the world.

JCB: Yes, I think it is for what it does. If you go into the building you have a marvelous rotunda and pantheon going like mad, and all this marble. But I don't think it works for twentieth-century art at all.

BLDD: So you do not plan to show any of the twentieth-century art in the West Building.

JCB: No.

BLDD: For the East Building you commissioned works by Calder, Miró. Henry Moore, Noguchi, Anthony Caro, Rosati, and Dubuffet. Why did you do that?

JCB: To complete the building. I don't think that the National Gallery should be out there forever onwards commissioning works of art. It's a

big gamble and the artist himself usually doesn't know, if it's for a client, how it will turn out. From the beginning, it was I. M.'s idea to commission just a limited number of works of art for certain specific spots.

BLDD: Not only were the works commissioned but they were commissioned to be of a specific size, like the Moore and the Miró.

JCB: The Moore is possibly the one exception. We told Henry that it might not stay there forever, that there is no one work of art that we want to enshrine as the permanent entrance to the building.

BLDD: Is yours the largest Calder that exists?

JCB: I think so, depending on how you measure it. It's about seventy feet across the middle and three stories high. But it is universally accepted as one of those magical moments when the right work of art is in the right place. We were a little fearful that a Calder mobile was sort of a cliché and didn't want it to look like just another airport. But he had a specific space to design it for. I. M. knew Calder's sensitivity to scale from working with him on the Calder stabile outside the M.I.T. building years ago.

BLDD: Do you consider the Calder the most successful work that you commissioned?

JCB: It depends on who you ask. We had the two critics from the two Washington papers review our commissions and each one liked about half the works, the half the other one didn't.

BLDD: What was the process by which I. M. Pei was chosen as the architect of the East Building?

JCB: We hired Pietro Belluschi, a grand old man of contemporary architecture, as a consultant to help draw up a slate of about a dozen names. When I saw the slate I relaxed because I figured any one of the twelve could have done a beautiful building that would have been in an uncompromisingly contemporary style. Then we started narrowing down and we got down to two and then down to one.

BLDD: For how long did the planning go on?

JCB: We started programming in 1968 and broke ground in 1971. In what's known as "fast tracking" we were breaking ground before the final designs were in. We still have a few questions that have not yet been resolved regarding the building. What a great building needs is to marinate, it needs the architect to get deeper and deeper into the problem, it needs a give and take between the architect and the client. It's a give and take evolution and this process went on at a very intense level for almost a decade.

BLDD: If you could choose three to five objects, regardless of price or availability, what would they be?

JCB: You mean that we would add? Wow! I had an uncle who used to

say about women, I love them all but adore the one I am with. I find that about works of art—that my enthusiasm changes according to what I am in contact with. But I have some pets. Vermeer is one—luckily the gallery already has a marvelous collection of Vermeers. Another pet is Domenico Veneziano, who is one of the rarest Italian Renaissance artists. There are only about a dozen in the world and about two-thirds of them are in the National Gallery, and there is a little John the Baptist that we have that I would love to slip out under my coat someday.

BLDD: Perhaps you might tell us some of the details that surround one of your celebrated recent acquisitions. I am referring to Jackson Pollock's *Lavender Mist.*

JCB: That was a last-chance gulch. This was the last great Pollock in private hands. Pollock was interested in having his major works represented in major institutions while he was alive and saw to it that the beautiful *Autumn Rhythm* went to the Metropolitan and so forth. But he probably never imagined one of his pictures could go to the National Gallery in those days—nobody there was interested. So we knew of this picture and hoped that some day it might be left to us and we talked about price and never could get very close together and then, darn it all, the Australians went and paid $2 million for the big *Blue Poles,* which we felt was a later and less important Pollock; this ruined the market but it also did get the owner in the mood to sell. And this was a very difficult time for us. We were building and we didn't know what inflation was going to do to that, and we didn't know whether we would ever be able to get the money together. But on a time payment basis we were able to work it out and we now have one of the great masterpieces of American art. It comes from the 1950 period, which in my view was the absolute apogee of Pollock's output. It's the most complex, the richest, the most subtle and, I think, the most moving of all his paintings. So we are glad it's there.

BLDD: Let's return to that earlier question—if you had the opportunity, what paintings or objects would you like to acquire now both for the East Building and West Building of the National Gallery?

JCB: The Museum of Modern Art has a marvelous Matisse collection but we don't have anything from that early period when he went to Morocco and got the kind of inspiration that really changed the course of art history.

BLDD: Are there any other great glaring omissions in the collection?

JCB: It's like trimming on a Christmas tree—there is always going to be a gap. The collection has certain amazing strengths. It is easily the greatest collection of old masters of German art in this country, and by far the greatest collection of Italian art. When all is said and done it will

be the greatest French impressionist collection in this hemisphere. But then we get into the twentieth century. We had a late start and we have a long way to go, and there are many, many trends and works that are lacking. What we want to do is collect slowly and on the basis of quality. We got a Kandinsky last spring, a blockbuster of a painting, and I was delighted today to see a New York dealer, whose judgment I respect, being absolutely overwhelmed by the quality of this picture.

Chuck Close

(Painter. Born Monroe, Washington, 1940)

BLDD: Chuck Close is one of the leading figures in the school of art that has come to be known as photorealism.

Mr. Close, who was born in Seattle, Washington, rejected the open road of modern abstract painting and chose instead the path of human imagery, so precise that at first glance you might think you were looking at a photograph.

How would you describe photorealism? What is it, and what is it trying to do?

CC: Actually, photorealism is a bag that I am not comfortable to be in in the first place, and I am not sure why I am in it with other people. There are certain common denominators which I don't feel I share with other people's work.

BLDD: Would you feel better with the term superrealism?

CC: Photorealism actually makes more sense than superrealism, I suppose, because I do work from photographs. Basically, photorealism has come to mean anything that has a reasonable amount of likeness to a photographic source, and it encompasses a lot of very disparate people, people on the West Coast for instance, who I think have a completely different type of sensibility than I do, and maybe Richard Estes and other people who work on the East Coast. There are people interested in the sort of banal American image, like hamburger stands and pickup trucks, and I think that what I am doing, just by the nature of the subject matter, probably differs from that.

But the word realist gives me problems too, because in a way I am not really trying to make something real. You can't make a nose. If I went to the studio and said, "I want to make a nose today," all the willing for that to happen isn't going to make any difference. The only way that I can accomplish what I want is to understand not the reality of what I am dealing with, but the artificiality of what it is. So perhaps I would feel more comfortable with "new artificialist" than with "new realist." I am

not making a nose—I am distributing pigment on a flat surface. If there is some consistent attitude toward what those marks mean and some notion of syntax that a particular kind of marking system will generate a certain kind of image, then it's that kind of concern with artificiality that really interests me.

BLDD: Let's begin at the beginning. You started with big, loose, open abstract paintings with lots and lots of paint. Now it's been said that you get the best pictorial mileage ever—most of your paintings are seven by nine feet, sixty-three square feet—out of an eight by ten photo and about two tablespoons of black acrylic paint.

How did you go from those big abstractions to what I have just described, in terms that are too simple?

CC: My tax man is trying to figure out how I can only take off sixty cents a year for paint. To back up and explain how it happened, I think sometimes the way a movement takes place in an artist's career—I won't use the word progress because that implies moving up, and I just mean movement—is a mystifying process for people. If I can explain what happened to me, I was a superstudent; I could make any kind of art marks you wanted.

BLDD: Where did this take place?

CC: On the West Coast, the University of Washington; then I went to graduate school at Yale and studied in Europe for a while. I was very good, I got rewarded, I got scholarships, I was told I had a good sense of color, I was told I had good hands.

What that meant was that I knew that certain colors, certain color combinations were interesting. I knew what art looked like. Once you know what art looks like it's not hard to make some of it. But if you are going to make something that looks a lot like art, by its nature it must look like someone else's art or it wouldn't look like art. And the dilemma that I found myself in after having gotten out of graduate school is enjoying making art but not liking what I made, not liking the product, and I found myself in real trouble not knowing what the hell I wanted to do. For lack of any heavy art idea—really, there was no profundity at all, I was just desperate—since I didn't have anything, any art ideas, anything I wanted to do, I simply tried to make sure that I couldn't keep making the same old paintings that I'd been making.

So I tried to impose half a dozen severe limitations on myself which would guarantee that I could no longer make those old paintings.

BLDD: But that is also a rejection of a painterly tradition, to make art that looked like other art. How did you come to do that?

CC: I rejected what I had been doing. Had the computer put me in Painting Class 101 instead of 102, and had I started making paintings with masking tape then, very thin, perhaps I would have ended up making thick, loose, open paintings. I don't know. But I didn't want to keep making what I was making.

BLDD: You started to say that you'd imposed several limitations, self-imposed limitations. What were they?

CC: The paintings had been about no image. They were about paint and about marks—art marks—therefore I wanted a very specific image so that it would be as different as possible. I started using photographs and decided that no matter how beautiful a shape, if it weren't the shape in the photograph, it was wrong. I craved, after winging it on my good taste and guts for many years, I wanted rights and wrongs desperately. It was totally capricious and arbitrary which system I chose to use, but I desperately wanted something that was right or wrong.

So the photograph gave me shapes. Now the interesting thing is that when I had every shape in the world open to me—I had no limitations—I made the same seven dumb shapes over and over. The minute I decided to accept the limitation of the shapes that occur in the photograph, I found myself making shapes that I had never seen before and had never made before, so I found that liberating.

Secondly, I had always tried to pull off paintings with my good sense of color, which was crap. Anyway, I decided that if I depended so heavily on color I would get color out of there completely and would make black-and-white paintings.

Thirdly, I could never make a decision, and I would paint in and paint out and scrape it off onto the floor and put it all back on. I wanted to have every mark that I put on the canvas to still be there and still be contributing to the image by the time I was through. And the only way to do that was to work as thinly as possible and not allow myself to paint in and out. So I got involved with the notion of the least amount necessary to do something. And the least amount of paint necessary to make a black-and-white painting is black on a white canvas. So I worked with this very thin medium of just almost black water and it turns out that it only takes about a tablespoon of paint to make a painting. This isn't something that I impose, that I am only going to make a painting with one tablespoon and if I get one foot to the bottom and run out of paint I would quit or something.

BLDD: What's the medium that you use, and what are your tools? And how did you arrive at a seven-by-nine-foot canvas?

CC: The medium is either acrylic or watercolor or some variety of paint. Also, one of the other limitations that I chose was, I had tools that were old friends: a brush that had pulled off a painting five paintings ago that was now endowed with some incredible divine mystic power.

BLDD: Your lucky brush.

CC: In a clutch situation I would grab that brush. I was trying to break habits. So since all my habits were connected with the tools, I had to throw the tools out. I got new tools, I got an air brush. Other tools which I got were tools that have no finesse, with no degree of facility.

The seven by nine feet—that's as high as my ceiling was. Had my ceiling been higher it probably would have been bigger.

BLDD: But nobody else's ceiling would have been higher. Wasn't that a practical consideration?

CC: Oh, I've never been terribly practical. I always build a boat in my basement and have to figure out how to get it out. Seven by nine is essentially the same proportion as a four by five photograph or an eight by ten photograph. Also, to be quite honest—and I don't mean it flippantly at all—the bigger they are the longer they take to walk by. I make no bones about it, I wanted a high impact, a high image, and I wanted to knock people dead when they walked by, I wanted to pull 'em in. I want something that can be seen from a hundred yards and then hopefully orchestrate an experience for them, so that not only does it have impact

from a distance, but if they get up close enough, it all dissolves into the kind of orchestrated visual experience independent from the image marks on the surface of the canvas.

BLDD: Could I assume that what you are saying is that your realistic images are really primarily vehicles for conveying new kinds of visual information?

CC: Yes, and one of the reasons why I chose heads rather than rocks or trees or pickup trucks is that people know and care a lot about heads.

First you have to understand that I am an incredibly lazy person. There are two things you can do if you are lazy. You can either say, "That's the way I am! I am lazy!" Or you figure out something that demands that you get up every morning to go to the studio.

BLDD: Do you go to your studio every day? How come one painting takes fourteen months?

CC: It's because I am self-destructive. It keeps me out of the art bars, you see. If I had any kind of work that I could work a couple of hours on and leave I would be in very big trouble, because I love to gossip and I love all those things that make me paranoid and crazy. So I stay in the studio. You see, if I were dealing with an image that people didn't know a lot about, I could say, "Well, it doesn't look like *that* rock, but it looks like *a* rock, it's close enough." But with heads, since we've all logged so much time looking in the mirror and looking at other people's faces, if there is anything slightly wrong it begins to look surreal. If the color is a little too green the person looks ill; if the texture is a little too rough it looks like they have terminal acne or something.

BLDD: How do you choose a subject for your portraits? They are not only identifiable, they are people very close to you.

CC: I decided a long time ago that I wasn't going to do any commissioned portraits because I assumed that anybody with an ego large enough to want to have a seven-by-nine-foot painting of themselves hanging around the house probably would want the nose straightened and the teeth capped and a lot of crap that I wouldn't want to get into.

I was struck with the dilemma of who to get, who to rob images from, in a sense. And I didn't want to go to totally anonymous people. I also didn't want the paintings to be identified with famous persons, you know, paintings of Richard Nixon, for instance. I wanted the people to be relatively anonymous, but very specific. I feel very fortunate that my friends have loaned me their image.

It's a very difficult thing to deal with a nine-foot-high image of yourself, and I have painted myself several times. Anything that is wrong with your face—like your nose is bent a quarter of an inch—when it's

nine feet high it's bent four inches, and you can't kid yourself anymore. You can't say, my nose isn't bent, because there it is.

BLDD: How do your subjects react to this? Are they still your friends?

CC: Yes, they've been very good about it, but they almost always immediately change the way they look. If their hair was long they cut it short, if it was short they grow it long, people with mustaches shave them off.

BLDD: The paintings you've made of yourself were always from old photographs, weren't they?

CC: Yes. I had some photographs of myself. I've had a beard since 1958, and only for about six months did I not have a beard, and I had a few photographs of myself from which I have been painting, so I dealt with an image which was not the way I look—I always refer to it as "him" anyhow.

Only one person ever understood what I was doing.

BLDD: I think you are referring to the Joe Zucker portrait.

CC: Yes. Joe Zucker is an interesting guy. Joe has curly blond hair. When I photographed him I didn't even recognize him: he had gotten a haircut, he'd bought a jar of vaseline, greased his hair down, he borrowed a white shirt and tie because he didn't own one, and borrowed someone else's glasses, and he looked like a Midwestern used car salesman, for a hundredth of a second.

Then he went home and washed his hair.

What he realized was that all he was going to do was provide me with evidence that somebody like that existed. It need not be an image that he had to relate to or deal with.

BLDD: Well, there are two central issues that you raised. One, that both you and Joe Zucker required distance between yourself, your real self, and your photo self that was reproduced in a portrait, and you both established that up front. Would you agree with that?

CC: I don't think I understood it, but he did.

BLDD: Perhaps we should describe the process that you used. You said that someone like a Midwestern used car salesman existed for a hundredth of a second. I think we should talk for a moment about who takes your photographs, what process you use to work. Do you use mechanical projection? Do you work from a photograph or are there sittings?

CC: I hate photography. I mean, I like other people's photographs, but I hate the process and I hate owning equipment. I have the opposite of the Midas touch: anything I touch turns to shit. If I owned a camera it would jam or something would go wrong with it, and I always forget

something or other. I am very nervous, I am always on the edge of hysteria while I am photographing. So I find it very good to have a photographer there who owns the equipment and who will remind me that I forgot to close down the lens or that I didn't pull the slide on the film.

BLDD: Let's talk about your black-and-white period, where you painted directly on the canvas. How long does a seven by nine portrait take?

CC: A seven by nine black-and-white takes about four months. In color, a year.

BLDD: That's three times as long. Let's talk first for a moment about black-and-white. There was a period of about three or four years when you really used only a few tablespoonfuls of black acrylic paint. How did you achieve shading?

CC: I'll have to answer that in a circuitous way. I always hated a palette. You make a decision on the palette, and you hope that when you put it in the painting it's going to be right, but you are making the decision out of context. Say I am going to make a green. I want a particular green. If I mix the green on the palette and I put it in and it's not the right green, well, at least it's green, so there is a temptation to leave it.

I didn't want to make decisions out of context, so I did away with the palette. I wanted everything to happen on the canvas, all the paint to mix on the canvas. With black-and-white paintings, to get the modeling or the shading or whatever you want to call it, it's just a question of applying more and more pigment, and the more dense it got the darker it got. But since I did not use any white paint I had to paint the whites by not painting them, by going around them. It's a kind of economy.

It may take longer to make a painting, but in another way it's economical in that the least amount of pigment is necessary to build an image.

BLDD: When did you decide to give up black-and-white for color pictures, and how did you arrive at a palette without a palette?

CC: I worked for several years in black-and-white and I got to the point where there were no surprises in the studio anymore, so I wanted to change something. I looked around for a variable. The first thing that occurred to me was to change the subject matter. What I was bored with was not the painting or the image, but what I was doing in the studio. So I looked for a variable that I could alter that would drastically change what I did in the studio. Of all the variables, going to color was going to change things the most. Now I wanted the same kind of economy in the color paintings that I had in the black-and-white, so I said, "What's the least number of colors necessary to make a full-color image?" And I thought four was in the regular printing process, but it turns out to be three: red, yellow and blue. So if I am going to make a painting without a palette, all the color has to be mixed on the canvas, which means I have to know how much red, how much yellow, and how much blue.

BLDD: Directly on the canvas?

CC: Directly on the canvas.

BLDD: One at a time?

CC: One at a time. So I paint three one-color paintings on top of each other.

BLDD: Where do you start, by the way?

CC: I start from the top and work down because I am a slob and I splatter.

The process itself forces me to think differently of different kinds of processes, to move at a different rate of speed. Images are generated much more slowly. It forces another kind of introspection, perhaps.

BLDD: You describe a kind of codified existence that is almost a defense against your own harshly critical view of yourself. Is that accurate or is it a reinvention, as you've often said?

CC: Well, I don't know because, as I said, I've rewritten my own history so many times to make more sense that I am not quite sure what

happened, but I think that I spent the first twenty-five years of my life, or twenty years of my life, giving in to what I thought I was. I am a slob, I am a nervous wreck.

BLDD: Tell us about your pleasure/pain theory of education.

CC: The first-generation abstract expressionists suffered and after that it was a system. We painted out of a system. We didn't have tortured, anguished, alcoholic people. We were art students, for Christ's sakes.

Anyhow, the thing I remember is the suggestion that you were on the right track if you were having a good time and just had a lot of fun. And I had a lot of fun in the studio. But at a certain point I said to myself that I didn't want to make those paintings any more. I made a trade-off.

You see, I used to have a lot of fun, but I didn't like what I made. Now I don't particularly like going to the studio every day—it's boring, and I hate it a lot, it makes me crazy—but I care very much about the things that I make, and I think that is a very reasonable trade-off. Who says you have to have a good time all the time? I think it's a sense of professionalism. I'm absolutely willing to do whatever's necessary to make something that I care about. In the same sense that a writer might not like his or her backache sitting at the typewriter all day long, but it's necessary to do it. You have to do it.

BLDD: Are you as pragmatic as you sound?

CC: If you have a year to make a painting you have lots of time to sit around and think about all this. You've ordered your life. And no one wants to feel the fool.

I don't think that a painting is more valuable just because it takes a year to make. Some of my favorite paintings in history took a day to make.

BLDD: Is the head an interesting form to work with?

CC: If I painted motorcycles I don't think that I would know the difference between one Harley-Davidson and another. But one of the really incredible things about people is that a head is like a bigger fingerprint, in a sense. Even though they take me a year I think there are as many paintings as there are people. And every time I approach another image, to me, it poses a totally new set of issues.

People have sometimes said—and I can understand their saying it—that my work hasn't changed because I stay with the same kind of iconography. I think it changes a great deal, because first of all the images that I deal with change. The coloration changes. And also the process that I use, whether it's a black acrylic on canvas, or a black watercolor on paper or a three-color acrylic on canvas, or the dot pieces that I've been doing, where I simply spray stupid dots.

BLDD: Can you picture making a drastic change in what you do?

CC: I've always made drastic changes in the past. I always thought that if somebody doesn't change every once in a while, they don't have any guts. Always I've felt that. I don't like Poons's new paintings but it took a lot of guts to stop doing the lozenges and start doing these other things.

I said to myself, if I have any integrity I don't want to have such a vested interest in heads that that's all I can do the rest of my life, and if I have any guts, after a few years of doing this I'll do something different, and I haven't done that.

So while I am sitting around making paintings and I have nothing else to think about I think about that, and the conclusion I came to is that the reason I haven't changed is that I am successful at it, and I don't mean just financially—though that's terrific too. I think I used to change so much—the way students change so often—not necessarily just because I had more integrity than anybody else, but because I was not getting a certain amount of feedback. And when you get the work out, published, and you get a feedback, it's much more difficult to make changes because you have much less impetus, much less reason to make drastic changes. All of a sudden the subtle, fine tuning becomes very important.

I don't know. Maybe I totally lack integrity, maybe I just lost my guts.

BLDD: Does any image spring to mind that might interest you?

CC: Well, the only thing I can think of is something very different.

BLDD: Are you interested in sculpture?

CC: I am very interested in other people's sculpture but not in making it myself.

BLDD: What are you working on now?

CC: I am just making drawings that are about making the color paintings. A red drawing, a blue drawing, and a red and blue together, a yellow drawing and a full-color drawing which suggests how the paintings are made.

BLDD: What did you have in mind when you used the dot system?

CC: I don't know, but I must have been crazy. I thought when I got the white canvas, you know, I put fifteen coats of web-sanded gesso on a canvas; and said if I were Bob Ryman I'd be done already. Then I put the pencil grid on and I said, if I was Agnes Martin I'd be done already. Then I realized that I have another fourteen months of sitting there spraying these stupid dots, and I really do wonder what I was thinking.

Essentially what happened was that I've always held to the notion that one of the things that I wanted was to make every square inch of the painting as important as every other square inch. But physically that was not possible. If you are making a black-and-white painting, those that are white you don't do anything to, and those areas that are black you do

something to, so you can't make every square inch the same physically, because of the difference in activity. So it's an intellectual or attitudinal situation.

But the activity of making a stroke which equals a hair is very different from spraying a piece of cheek. So again the way that my hand moved, the articulation of the marks across the surface was different for each area.

So, I wanted to make pieces in which every square inch was physically exactly the same, and also I wanted to get away from virtuoso art marks (my good hand again, how beautiful the stroke was). I wanted a stupid, inarticulate, uninteresting mark, that in and of itself could not be more interesting than the last mark or more beautiful than the next. And so I decided I would simply spray. I would divide a canvas—in the case of the large ones, into 106-odd thousand squares, and I would spray a dot, and each dot would be hit an average of ten times.

BLDD: With what do you spray?

CC: With an air brush. So it's about 1,006,000 dots when you come down to it, and fourteen months of my life, and my eyes went; I was a mess. But here is a system in which there is no difference in the way you make hair. It's all dots, and a dot doesn't equal hair, or a dot doesn't equal skin or background. So the way the image was generated was in the way these dots came together, and in some notion of syntax and in what way these marks relate to each other. There was no virtuoso brushmanship or finesse at all.

BLDD: You used the word syntax several times. What do you mean when you say that?

CC: We are tagged onto a long end of a series of conventions which everybody has agreed upon mean something. For instance, perspective isn't real, but perspective is a convention, and we agree that these lines converge, railroad tracks going back or whatever.

Now in the twentieth century, marks themselves have become content. Obviously if Roy Lichtenstein can make a painting about a brush stroke, the brush stroke itself is essentially content. Okay. Now every time you have a mark-making system or any codified system where you assign a value or a meaning to any kind of mark, then you get involved in the physicality of what you are doing, plus what it stacks up to mean on another level. And that's what I mean by syntax.

BLDD: How do you deal with the human quality?

CC: I try to get it in the photograph in the first place, and I try and maintain a consistent attitude toward what I am doing, so that, in the translation, whatever aspect of that is in the photograph ultimately ends up in the final product.

But I don't think you ever get it by simply desiring it. You have to sit down and do it.

BLDD: What are you telling us in your visual imagery about the human condition? Or are you?

CC: I think I am, but I am trying not to editorialize. I am trying not to crank it up for any given effect or to make sure that it's seen one way. What I am trying to do is put it out in relatively objective terms, without editorializing, footnoting or otherwise pointing to things. I try to deal with the human condition as directly as possible.

I'll tell you what I try not to say. I am trying not to talk about man's inhumanity to man or other humanist issues, like why somebody is not a nice person or whatever. But I think that people's faces are roadmaps of their life to some extent: somebody who has a lot of laugh lines—I noticed that people stand in front of a painting in which there are laugh lines and a little curl at the corner and they stand there and they smile at the painting.

BLDD: Why is it always a formal frontal pose?

CC: For two reasons. First of all, it gives you the most information. It's why the police have a mug shot. They also give you a profile, but essentially when you want to know what somebody looks like, you look at the frontal mug shot. And I wanted the most information per square inch that I could possibly deal with.

BLDD: You made the largest mezzotint ever. What was that all about?

CC: Some other insanity, I suppose.

Part of the whole material thing of the sixties, where sculptors were running down to Canal Street and buying latex, rubber, and other junk, was that they were trying to get hold of the materials which had not been already pushed through the art process, so that there was no built-in art way to use the materials, and hoped that if they kept shoving the shit around long enough they could make something more personal.

Well, I suppose I wanted to do that too. Nobody has made a mezzotint in a couple of hundred years, and nobody knew how to do it.

BLDD: What *is* a mezzotint?

CC: It's a process of etching in which the plate is made to print black. In my case it was done mechanically. They used to do it with a rocker but anyway the plate holds the ink, and then you scrape and burnish, scrape and burnish for three months.

BLDD: How are your works different from a photographer's and how do you see them in the context of the history of painting?

CC: Well, I hope they make sense as paintings. I am not interested in photography. Photography is a means to an end and it's a very important tool that I use like drawing. Perhaps in another time when you were

doing a landscape painting and you wanted to do it in the studio you'd
go out and make a drawing of the landscape and then you'd go back to
the studio and make a painting from the drawing. In a sense photo-
graphs have become my sketches and my studies for whatever—the
things I make the paintings from. Either the paintings are different from
the photographs or I am the world's biggest fool, because if I am stand-
ing there for a year I must think that it's going to be different from a
blown-up photograph. I hope they stack up against other paintings, and
I hope that in some small way I may have altered the way some people
see, otherwise I wouldn't want to be in the racket.

Christo (Javacheff)

(Sculptor. Born Gabrovo, Bulgaria, 1935. Came to U. S. 1964)

and Jeanne-Claude

(Business Manager. Born Casablanca, Morocco, 1935.
Came to U. S. 1964)

BLDD: Two persons who produced some of the most monumental pieces of art in recent times, in scale as well as in importance, are Christo and Jeanne-Claude, his dealer, his manager, and his wife.

Christo is your given name. You were born Christo Javacheff, a native of Bulgaria, and you left there twenty years ago. Can you tell us when and why you chose to leave that country?

C: I was born in Bulgaria but I am also Czech. I lived in both countries—in Bulgaria and Czechoslovakia—until late 1956.

The last time I was in Czechoslovakia was in 1956, and I crossed the border in January 1957 to Austria and to Vienna. Why I left Bulgaria and the East? For many reasons, and of course I was very young, I was twenty-one, and this type of decision was most easily done. I studied at the Art Academy in Sofia in the mid-fifties, and was involved with architecture, movies, and propaganda art during the Cold War. During that time I learned about Russian-Soviet art of the twenties through some movie directors.

BLDD: Tell us your views about propaganda art.

C: That was during the Cold War, and all the students were obliged to give their Saturday or Sunday to the Party or to the proletarian revolution, and there was a lot of activity, basically activity in cooperative farms and factories. During that time the only Western people passing through Bulgaria were on the Orient Express going from Paris to Constantinople, and the Party was very eager that all the landscape and all the view for 400 kilometers along the Orient Express line, from the Serbian border to the Turkish border, should be proper-looking, dynamic,

prosperous and full of work. The art students were sent to give advice to factory workers, ranchers, farmers, on how to stack their machinery, how to put things around the railroad tracks, so that they would not look disorderly and clumsy.

Perhaps that was a very significant part, because during those weekends I developed a taste for working with different people outside of the academic world of scholars, people who were not doing art but who were managing space in a different way.

But early in 1956, during the Khrushchev era of the Party, it was really through the de-Stalinization in that period that I started to learn about the underground.

There was the Hungarian revolution during that time. It started in late September. The Soviet army was on the border, but there was a way of crossing the frontier.

BLDD: What was your way?

C: Well, that's a long story. I crossed the border with sixteen people, mostly a Czechoslovakian family, and on January 10, 1957 at four o'clock in the afternoon, I found myself in Vienna.

When I arrived in Paris in 1958, one of the first people I met was the French writer and critic Pierre Restany. I spent both the summer of 1958

and the summer of 1959 in Germany, and I met John Cage at that time, and Mary Baumeister and Karlheinz Stockhausen.

BLDD: What about the new realist group?

C: I was not part of the new realist group. An important concept in that group was that they would do work with objects or with space but with extremely low interference of the artist. The artist's interference with the objects and the situation would be minimal.

My interest (especially the packages I was doing at that time), was not considered pure enough by Pierre Restany for me to be in the group. This is why I was not one of its founders. I showed with them twice, in 1962 and in 1963.

BLDD: You started as a painter of portraiture. Whatever happened to that work and how did it evolve to wrapping those first small objects?

C: I really did not start in portraiture, no. It's just the same if you ask if Jasper Johns was doing show windows.

BLDD: He was.

C: Yes, he was doing show windows but he was not a show window artist. I was doing portraits, and all my portraits were signed with my family name, in the way Kandinsky was doing flower paintings in Paris and here, you know. And I was doing portrait and landscape and I was also washing dishes in restaurants and doing garage work, anything available and fast to produce enough money to do my work, and this is why the portrait is something I have no predilection for.

BLDD: When did you first begin to wrap objects?

C: The first wrapped group, in 1958, was called *Inventory*. Inventory was like you were moving from your house, and you have chairs, and you have cases all covered with cloth and fabric, and there was a group freely put together, and there were cans and bottles and all sorts of materials, sometimes very small—about twenty—sometimes large—about forty, fifty pieces—and they were all home objects, you know, objects you can manipulate yourself alone, some large—perhaps the chair and table were large—and some small ones.

BLDD: What was the first object? A bottle?

C: I don't know exactly. There was a group of objects, not one object. There were a number of elements in my studio: certainly chairs and bottles.

BLDD: Well, you have always known the effectiveness of size. Obviously that was one of the things you learned early on from your propaganda art. But what of the scale of your initial work?

C: It was small because you know, I was in France, I was speaking French very poorly, I had no means, I was living in a very small place, and I had a seventh floor studio, a little room in a Paris house, and of

course the only material that was around me was very humble, small things I could manipulate at that time, or use for my work. But that was a very short time. I should tell you that in 1961, at my first show in Cologne, I did a project inside the gallery, but I did a very large one outside, a dockside project on the Rhine, in the harbor in Cologne.

BLDD: Was that the first large-scale project, the oil drums in the Cologne harbor?

C: There was a huge amount of material on the dock, like paper, rolls of industrial paper, eighteen to twenty feet high. Now the gallery was just in front of the harbor, so it was very easy to do a piece inside the gallery and, outside, do pieces using the harbor sights and some ruins from the war.

BLDD: The two of you represent one of the more successful art mergers in history. When did you first become interested in Christo's art, Jeanne-Claude?

JCC: The moment I fell in love with him. I've known Christo since 1958.

C: In 1961, I was doing the exhibition in Cologne, and at that moment they built a wall in Berlin, and there was a very tense moment in Germany and in Europe. It was almost the outbreak of a world war. I came back to Paris. During that time Paris was in an incredible political uproar because of the end of the Algerian conflict. It was very exciting.

I proposed, in September 1961, to build a Wall of Oil Drums, an iron curtain, in a small street on the Left Bank in the Quartier Latin, Rue Visconti. I did the photomontage, I did some drawings, and I started to ask for the permits from the prefect and the government in Paris. That process was very long, almost a year; I had to go to court and to the police and never got the permission. But I did the project anyway, in June of 1962.

BLDD: Jeanne-Claude, you are almost uniquely known for your managerial skills, and it certainly is, if I may use the word, a unique collaboration that the two of you have. When did you first become so deeply involved in Christo's projects?

JCC: Ask Christo. It's for him to say when I started to be useful.

C: I think already in 1961 or 1962.

BLDD: All your projects have not only been monumental in scale, but with costs to match. How did you go about raising the funds for something like Valley Curtain?

JCC: The Valley Curtain cost $850,000, and we never use the word raise because that is not the word that artists use when they sell their drawings and works of art. They never say they are raising money, they call it a sale, and this is what Christo does: through me he sells his works

of art, which are either recent—a recent project—or future projects, or old projects or early packages, and he sells them through me, through the corporation of which I am president. The works of art are sold to museums, to art dealers and to private collectors, and the money is used to build the projects.

BLDD: There are so many concerns—economic, technological, political, social. How much do these matters impinge on the making of your projects? I am thinking of some of the projects that you tried to do, Christo, that met with opposition: wrapping the trees on the Champs-Elysées, wrapping the Reichstag and other monumental projects. How do you deal with that?

C: I hope you understand that the final object is the end of the work of art. The work of art is the dynamic stage of several months or years. The lifetime of the work is the work, and the physical object is the end of the work, and of course that is the essence of that project. They are conceived subversively and they are never commissioned, you know, and they involve unpredictable futures. They have a basic suicidal character. And of course that is a very important part of these projects, because the projects are larger than my imagination, than the imagination of anybody, and they build their own identity in a complex life or world where this has happened. In the case of the Running Fence, it involved directly half a million people, and in the case of the Reichstag it involves complex national and international relations.

A project grows like a child and is like a giant monster. We hire a lot of specialists who give us advice, but there is no way to know where the project is going because nobody did a Running Fence before and nobody did Valley Curtain. And I will never do another fence or another Valley Curtain. This is the basic importance of this project. It is like experience which is lived and after that cannot be repeated, and there is no routine, no precedent. And of course that is the challenge of the work. There is no reference in the courts to building permits, no reference when you go to the public hearings and trials in the different courts, and that of course really makes the project build itself and be its own invention.

BLDD: Your work remains such a personal gesture on the one hand, and on the other, involves a vast army of people that collaborate, or at least have roles assigned to them. Why do you object to the choice of the term, collaboration? How does the final expression, after three or four years of work, becomes a seamless, personal expression of Christo's work?

JCC: When you talk of collaboration with half a million people, I will not correct it—that is absolutely right. But very often in the case of

Christo and me it is used as if they think it's a 50-50 collaboration, and that is wrong. It's 99-1.

BLDD: How do you communicate your philosophy, the idea behind your projects for your volunteer "army"?

C: It's very important to be simple because that is the way the projects become understandable. Often the idea for a project is very simple, almost stupid, often very stupid. The Valley Curtain is a curtain in a valley—I mean it looks like a curtain in a valley—the Running Fence is a fence that's running, and it's very basically like a fence. They are not titles with dubious meanings. They are very descriptive. A very complex reality.

BLDD: Perhaps you might tell us how you select first the geography, and then the specific site for a particular project. Why California?

C: I think I'd like to talk about a specific project. For a long time I was interested in doing a project in California. For me California was a huge fascination. Perhaps this is the most American state in the way of living. You know, the people live horizontally, in a very complex relation between urban, suburban, and rural life, and of course through all that sort of living they have a huge, acute notion about the land, the use of the land, driving to the land. And now they have the most highly advanced laws restricting land use and working on the land, and this is why—the project should be rooted in a community with a fantastically acute and very nervous relation to the land.

BLDD: Do you like that edge of anxiety?

C: This is why the project was horizontal, and the 24.5 miles are dealing with these urban, suburban and rural situations. The axis is basically east-west. The fence is related from a very rural situation around the coast going inland to suburbia and a small-town situation around Freeway 101. The fence crossed a very typical element of California life, the freeway, that very busy eight-lane highway.

Now there were many, many considerations why we chose California, just as there were when I was doing the Valley Curtain in Colorado. I felt these projects should be done in a society or community where the people have very strong relations with their street, or their houses, or their mountains. Colorado people are most strongly attached to their mountains. They refused to have the Olympic games there, the winter Olympics, because they like to keep their mountains clean, and the mountains are used in a very complex way between farming and ranching and sports.

Well, all this answers the question why I was doing the project in California and not near Capetown in South Africa.

And when I chose to do a project in Berlin in the city, I was not

choosing just a type of city, like Tokyo or London or New York. I was very interested in doing a project in a city extremely affected by our twentieth-century life. There is no other city in the world like Berlin, a metropolis of five million people who are divided physically by the Wall, living closely, completely together, within a few hundred yards of each other. This is why we did the Reichstag.

BLDD: You selected the very symbol of German unification.

C: This is the only strip in Berlin which is in the jurisdiction of the Soviets and the Western powers.

And of course, to do that project we needed permission from the Soviets, and from the British, the Americans, the French, and the German Bundestag. From there evolved a huge relationship between the East and the West, and we put together the Soviet generals and the British and the German Bundestag to let us do it.

BLDD: So then the political and social contexts are as significant or perhaps more significant than the topographical context.

C: They are all bound together. We cannot avoid it. In California I chose exactly a typical specific situation. Same thing in Berlin—the Reichstag.

But we cannot qualify one part as more important and another less

important. The most important part is really the driving energy for the physical object. If the physical object is not the ultimate end, we never arrive at this fantastic power of the project.

JCC: You mean if you did not really intend to build it.

C: Yes. You know, it's very easy for the conceptual artist in the conventional way. The conceptual artist can stop his projects after a few weeks, saying that he has gathered enough political material.

BLDD: Then you reject the association with the now-traditional conceptual artist?

JCC: He rejects it.

C: Absolutely. I don't think I am a conceptual artist. Because the final object is the ultimate end of the work. It's like the goal set, and that is the energy. The work created a fantastic energy for and against the project, the true energy, and that is energy that I have only because I pledge and I swear that in the end I will go through with the work.

Of course the buildup, the antagonism, the forces, the committee to stop the Running Fence, the opposition of some Christian Democrats in Germany—that created a fantastic rolling machine against each of the projects. But that is the force of the project, because they know that if the project is not arrived at the final object will be a failure, and I have many failures. And of course the failures are very important because the failures are like a cold shower, and very good for my ego, and also very refreshing. They make you see and consider and revise things, and it is very important, I think.

BLDD: Does it lend an existential aspect to the work?

C: Perhaps.

JCC: Yes, but it keeps a true, real suspense constantly, not a fake suspense.

BLDD: There are some people who would describe your work, and admiringly, as a theatrical experience. There is an art critic who says, "We call it art because we do not have an alternate word to describe it." You just said, "I do not think of myself as an artist." How *would* you describe yourself and your work?

C: No, no, no, I think of myself as an artist 100 percent.

JCC: He meant conceptually.

C: There are really two questions to answer. It's very important to understand that all those projects have not one single element of make-believe.

BLDD: Not one?

C: Not one. It is the contrary to any theater, including very advanced theater. All these projects are outside of the art system. This is very important. Actually all the art activity, including avant-garde activity, is

manipulated by an art system at all levels, through the gallery, councils of the arts—the New York State Council of the Arts—public grounds reserved for art activity, pledged to art activity.... All that makes art into a make-believe reality. What is important with the Running Fence or the Reichstag or the Valley Curtain—they are outside of that art system, and they are thrown directly into the everyday life of the country, of the community, of politicians, of the army, of circulation on streets and highways. And of course that is like teasing the system, you know, and the system responds very seriously, and that became the humor of the project, because when the system responds very seriously, we go to court and have these three judges discussing the fence in court. Before the fence was built.

BLDD: You were still negotiating permissions because of some of the opposition to the project?

JCC: Three serious judges are discussing something that doesn't exist yet.

C: Yes. In the same way the system is teased and the government of California, Governor Jerry Brown, all the county, different departments, will all hold public hearings open to radio and television and newspapers, and the people attend, the people talk against, the people talk for. Now that is how this work is done. And of course that is the reality. The project draws energy from that reality.

BLDD: Is that dynamic energy a component of the project?

C: Yes, but that is the true reality. It is not orchestrated by me or invited by the gallery or things like that. Not at all. We would be glad to have less problems. But it is like an enormous machine—that's the exciting thing.

Now when we work on the Reichstag project, the project is much beyond any possible control, so that I could not do anything. If Mr. Springer is against the project, or *Pravda* writes editorials against it . . .

BLDD: The publisher Axel Springer?

C: Yes. And *Pravda* just wrote editorials against the project. Now this is a story that is beyond any valid situation in the art criteria system.

JCC: And has nothing to do with theater.

C: And that's why it perhaps looks like a political campaign. When people were building the fence it looked very much like they were installing electricity poles. Anyway, many of our workers on the fence were specialists in television and high-wire installations.

But the ultimate goal—and that is extremely important—is the irrational purpose of the project.

BLDD: Irrational?

C: *Ir*rational, totally irrational, totally. Now this huge amount of en-

ergy, hundreds of people coming to the hearings—court trials—the only purpose of the Running Fence—it's not a windbreaker, it's not an agricultural fence, it's a work of art for a few days, and of course the logic to be injected in the mind of these people, this half a million people . . . this is a slow process. It does not happen right away. It's an extremely slow melting process, welding process, it's almost like a generative thing, and that is why the politicans and others were very upset. They cannot understand how two hundred and fifty ranchers, who are such pragmatic people, can be involved with a project completely without purpose. But of course that is the magnetic power of this project, because they have this incredible swinging around, and it is electrifying.

The point is, that energy can, by simple momentum, create forces for and against the project.

BLDD: Do you think of the fence as a real fence, or as a barrier, or as a work of art? What do you want from the people involved in a project, the people who live there? Do you want them involved in every aspect of the process? What do you really want them to do? You say you are 100 percent an artist. I assume there is something about their perception and something about their vision that you care about.

C: I start from a very simple story and I try to elaborate my language, but I never try to tell what the fence really means. But there was a Swiss journalist in the home of one of our ranchers, long before the fence was up, a typical California rancher, not very poor, not very rich, he had a plastic home with plastic furniture and carpets, and on the wall a reproduction of an oil painting of the sunset in plastic, mass reproduction. And through his window he was seeing the fence and we later got the fence through for almost one mile. Now that rancher, who later became one of the greatest supporters of the project, was trying to explain the fence, what it meant to him, to the Swiss journalist.

BLDD: And how did he describe it?

C: He looked at the landscape in the reproduction and he said, "You see, the sunset in the landscape is make-believe art. The fence is the real art, not make-believe."

There was an enormous build-up of imagination in these three and a half years, because the ultimate object was the fence, and throughout these hearings and the court trials the only things I could show was some sketches, some drawings and some photomontage, to really try to visualize the fence. But the ranchers and the people who supported the project, and the people who were against the project also, built some high-level imagery of how the project would look—that really was a dynamic situation because the fence did not exist. And because so many people were fighting against it and so many for it, they started to build a vision of

how the fence would look on the hill. And of course that was one of the most important facts of this project, this type of perception of art, the enormous anticipation. No graph can develop this kind of dynamic understanding of art, you know, when the people of an entire community have that type of communion, when there is something that will become the ultimate work of art.

I remember when the fence was going up—the process was slow—and over twenty-four miles it was impossible to take care of the huge number of friends and people and some of the media, so we simply asked the ranchers to become our PR people, and the ranchers invited TV people and journalists to their homes and were holding press conferences—they were telling what the fence is and how they were fighting for it. For them, the fence became their own project. They were doing that for three and a half years.

BLDD: What was the opposition about? Please describe the process of going to each of the sixty ranchers who were involved, and how you turned opinion around.

JCC: We knew, we thought the most difficult would be to convince the ranchers to rent us the land.

BLDD: Was this in Petaluma, in northern California?

JCC: Yes, fifty miles north of San Francisco. I told Christo that there shouldn't be any problems at all with the permits, but the ranchers would not sign, so we thought we must concentrate on getting the permission from the ranchers because it is all private land—except for the last parcel; because it is the frontier of the United States, being the coast and the ocean and navigable waters et cetera, this belongs to the state and to the military.

And we thought, we are only two, with a few helpers; we cannot start talking to everybody, and the most important persons are the land owners. So we devoted most of our time to them, which afterwards made us realize that maybe we should also have devoted some time to some other people, but this you always learn afterwards.

At first I thought I would nicely and gently explain to the ranchers' wives how interesting Christo's work is and to please tell their husband to let us do it. After a few weeks—three or four visits to sixty ranches—I understood that this was not at all the right approach, because those people had no reason at all to be interested in Christo if we were not interested in them.

So we started learning about them. I know everything now about making butter and milk and artificial insemination, everything. And we were genuinely interested, because they would have felt the make-believe and it wouldn't work—they are very genuine people. We became friends, and once you are friends then it's easy because from a friend you can ask anything, even to put up a Running Fence on his land.

Of course there were details. It's a five-page contract of agreement, written by lawyers, which means it's in Chinese, and we had to talk with their lawyers and our lawyers, but those were details—once we were friends everything was all right.

Now it took almost one year to convince sixty families. It was not a few weeks' work, and we learned very much about them. Unfortunately now in retrospect we understand that politically we were naive in not taking care of some supervisors or some congressional persons.

We were keeping a very low profile, trying not to let the press know that we were doing the project, because we didn't want to upset the ranchers by having it become public before they agreed entirely on the land. But by September or October 1974, when all the ranchers had signed, even if you have rights of private owners in the United States—at least in California—you cannot do anything without a fantastic battery of governmental permits. There were about fifteen governmental agencies to go through for that project, from county level to a very complex federal investigation. We were thinking that that could be done in a few

months. Actually the governmental permits took us more than a year and a half. We started in late 1974.

Meanwhile, coming inland to the east, which becomes more and more suburban and urban, the fence was going through several subdivisions, behind kitchen windows and all kinds of gates. Some of the subdivision people—about a quarter of a mile of the fence—were opposed to the project, and they started to write letters to the counties. We really were not aware how powerful the opposition was.

In the first public hearing we lost, but not entirely because of the opposition. We lost because the supervisor was not quite sure that he should let us do the project. And on January 29, 1975 we understood that we were facing a terrible amount of very complex opinions.

BLDD: Did you think at that point the project would not be realized?

C: I never thought that, but there were some very low periods in that time of exhaustion. You know, some of these public hearings took seven or eight hours.

BLDD: The Running Fence was up for two weeks. What happened to it after that?

C: When I was renting the land there were all kinds of agreements. The agreement on the project was that the fence would remain in full view for two weeks maximum, and after that it would be removed entirely before the rainy season started. This is why all the real physical work on the project was done in the entirely dry season of California. We must remove everything—that was the condition of the government agency—the holes would be filled with earth and seeded so that the grass would grow, and the cable, the fabric and the poles were given to the ranchers. That was our payment to the ranchers as friends—that each rancher have the material, and they use the material for gates, for fences, for barns, for covering the tractors and other machinery during the rainy season, and things like that. I know some of the ranchers were selling the fabric for wedding dresses and things like that.

BLDD: What do you think your work has done to the credibility and the status of monumental works, traditional, conventional ones?

C: Our perception of art is basically Victorian. The object, the commodity as a work of art is a completely recent perception, and of course this became more and more evident—perhaps I now talk like a Marxist— with the advance of capitalist society and industrial society, when you have the family, the molecule of husband, wife and children, an apartment, and have the commodity, transportation, goods that you can move out fast with yourself.

And of course relating the value of art in terms of a commodity object

is an extremely recent perception. It's very sad to see, but in the postindustrial epoch we are still living with objects that are physical elements and we venerate them like the Christians venerate the shirt of St. Peter in Rome.

Before, art was a much more fluid communion—I always think that art in the tenth century was much more democratic than it is today. In that time nobody was involved with owning art because the people owned the kings and the gods, and there was a complete link, like for them the kings and gods were the same thing, and they were the direct link with art that was real, existing.

But when art became a commodity and we started to own it and to have it only for ourselves, that is when our monumentality started to be broken into small pieces. We cannot have monumentality when we are involved with a commodity, with transportation of goods and all these things, and it's very sad to see that we are claiming that we are doing public art when actually we do only garden objects and things of that kind around the city. I don't know how long it'll take until our society understands that it's capable of mobilizing energy, if you call it that, or wealth or money or power, so that that power can be used for irrational purposes. That's very important.

BLDD: Did you originally start to wrap objects to protect them from people, from pollution? What is the idea? Is it symbolic?

C: You touch on another important question, the fabric. The fabric is a very important part of my work. Friedrich Engels said that fabric made man different from primitive man. The process of weaving is the oldest and one of the most important processes of the evolution of man. In the same way fabric is almost like an extension of our skin, and you see that very well in the nomads, and in the tribes in the Sahara and Tibet, where they can build large structures of fabric in a very short time, pitch their tents, move them away, and nothing remains. But also fabric can be used in large dimensions. This is why using it in the late fifties and early sixties to wrap objects with was the most simple way to do something, and these objects were always compared: there was a wrapped bottle with an unwrapped bottle, a wrapped chair with an unwrapped chair. There was always this comparison.

BLDD: The fabric becomes less and less opaque as your work evolves. Is that significant as well?

C: In the early sixties I used plastic because of the "passing through" activity. Actually all these projects were about passing through. It's a dynamic situation when the light passes through. Often what is in the package is not important. But actually that activity of passing through should be very, very acute. You cannot have that passing through if

there is obstruction, if it's steel or wood or concrete and it never can go through.

But the fabric is extremely fragile, and the fragility is essential for the project. It can break and it breaks, it can tear and it tears. Of course the fabric is dialectically the only material that can be used in temporary projects. It would be completely idiotic to build a fence with some kind of incredible steel material when the fence is intended to last for fourteen days.

All these projects are thought of as temporary. This is why it is so completely funny and extremely ironical to see all these great artists doing huge steel structures for a short time and move them away, and it's stupid. There is no logic in it. It's like some people dropping things for an imperial power because they have the right to drop them and then they drop something very big.

All these projects, from the bottom to the end, they work in a completely dialectical relation. In the way a thing is done, in the way a life is lived, in the way people live their life, in the way people fight for their life in their streets, in their neighborhoods, in the way the wind affects and everything—those very, very simple things.

BLDD: What is the status of the Reichstag project?

C: Very, very ambiguous. I am now involved up to here with international and national problems. I have never before been involved with a project which involves millions and millions of people—including the President in Washington. And of course I don't know how to do that. With the ranchers in California there was a one-to-one relation—finally we could go to the ranchers, to the congressmen, and talk. But when you involve a large number of politicians and generals in different states and nations, then it's very difficult to know who is really the decision-maker of that project. And we tried to enlist advice of many people, and we tried to explain the project to many people. Last July I was in Berlin and we had a long talk with the new mayor of Berlin—and he advised that we give the project more international attention to make it more flexible.

BLDD: And what did you do about this?

C: The Reichstag is a very critical thing. Anyway, we tried to explain the project to the politicians in London, in France, in the United States, and to the media.

I'll tell you, if that project happens it will only be because some friend or professor or art historian tried to help me. I cannot do it alone. And of course that will be the first work of art that can be experienced and lived and seen from both sides, east and west, simultaneously. But of course a good number of East German people and Poles and some Russians think the project is going to happen.

BLDD: Jeanne-Claude, how do *you* plan to pursue the Reichstag project?

JCC: The same way as other projects. It's always different people, different countries, different customs, different levels of society, and each time we don't know anything, and we have to learn. Now that we are specialists about ranching, we have to learn about international politics, but we can learn, it's all right.

BLDD: Christo, you may talk like a Marxist, but you don't think like a Marxist. That Running Fence cost an almost unbelievable $2 million.

JCC: Three.

C: But you know, if I succeeded in that it's because I used the system fully. I learned that from my studies in my country.

When I was in Washington at a meeting for the National Endowment to make some possible efforts to better relations between artists and business people and the big corporations, in the end I was so furious that I told them, why should we not talk in decent terms? The business community and the government always try to see artists as the orphans and the blind, on a charity level. Why not talk on the ego level? Artists have a great ego and you, the company, have a great ego. There is nothing wrong with that. In the great period of the Renaissance, in the great period of Christianity, the pope or the king recognized their identity.

JCC: During the Renaissance the business community knew that helping the arts is good business, while today helping the arts is charity.

Jim Dine

(Painter. Born Cincinnati, Ohio, 1935)

BLDD: Jim Dine is an artist who has made heroes of everyday objects, an artist who until recently addressed himself to expressions about human life without ever using the human image. Jim Dine emerged on the scene along about 1959, as a creator of happenings and of painting assemblages. It was in that year that, together with Claes Oldenburg, he shared his first one-man show at the Judson Gallery. What did you exhibit then?

JD: I exhibited objects based on expressionism—large heads, suits of clothes that were really my suits, as though there were humans in them but there weren't. At that time I was very influenced by primitive art. I don't mean art of the primitive cultures, but art of the insane, a Dubuffet kind of art, children's art.

Oldenburg was interested in it too. We'd pick up stuff on the street that children had dropped. We found that sort of thing inspiring—because we were trying to walk around abstract expressionism, this thing made by our fathers, and because there is that pressure in America to constantly be making something new. We used to respond to that by neglecting the lessons one was taught and hoping that you would make some discovery by this other method rather than going the natural way through your history, through one's history.

Oldenburg and I both showed things that had to do with the iconography of the street and graffiti. We were particularly in love with the Lower East Side and the dirt, not absurdly so, in the sense that we really felt a great romance with the way soot lay on snow, or the way one would see bums dead in a snowstorm in the Bowery. And we were fortunate to be able to exhibit at the Judson Church, which was a swell place.

BLDD: And you expressed this with these antiart objects?

JD: We didn't think they were antiart. Everybody else did, but I knew I was an artist so therefore there was nothing to be anti about.

BLDD: Can you tell us about the early happenings?

JD: It's Allan Kaprow's word, which had to do with something quite different than what I was doing or Oldenburg or Red Grooms. We were doing a kind of expressionist theater without words mainly. But it was close to psychodrama—the art of the insane at times. It was influenced by early films. Grooms was certainly influenced by things like *The Cabinet of Dr. Caligari.* I was influenced by my bad dreams. I wasn't influenced by Allan Kaprow particularly. I was under his command, in this rebel army. He was an older man and he was the most famous artist we all knew.

BLDD: How old were you at the time?

JD: I was twenty-two or twenty-three. But he was famous. He had been studying with John Cage and much of his work was based on Cage and the laws of chance, all of which I didn't understand, and it didn't interest me anyway. But what interested me was that there was this group of people that one could relate to, and it was exciting.

BLDD: Whatever happened to happenings?

JD: I stopped making them because I was put here to be a painter and I could not take my time from it any more, and happenings were just one more thing than I could deal with. At the time there was a small public that fed off this so-called avant-garde, this downtown scene, and it was

quite a romantic scene, I guess, for many, and those people kept pushing and said, "You sold out. You made such great things. Why don't you make these happenings? The car crash was so great." Well, I just wanted to paint, and it wasn't any of their business.

BLDD: Do the happenings relate in any way to today's performance art?

JD: I don't think performance art could exist without the happenings and I think they were far more interesting. They had beginnings and ends, and they were something of a literary event. I can't stand the idea that performance art is called this. It should be a theater form or something. It's not about painting, and that's really what I consider myself—an artist and a painter, a draftsman. I don't feel any relation to the people that show those things, you know, like Lorenzo de Medici in a gallery somewhere, a nude.

That's their business. But I wish they wouldn't show it in galleries. It's rather narrow of me, but that's the way I feel.

BLDD: Jim Dine doesn't own a bathrobe. He says he doesn't ever even wear one. Yet for fifteen years you have been obsessively painting uninhabited, larger-than-life, invisible-man wraps. Can you give us some clues to these mysterious emblems and what they mean to you?

JD: Well, they are only mysterious—I hope they are mysterious—after I've painted them. It's not a mysterious idea. I was a young person in New York under the pressure of first reacting against abstract expressionism, but also living in a climate of abstraction, and much less strong-willed than I am now. And I wanted to make a self-portrait badly, since that seemed to be the thing I was most interested in. That is, my interior self as a landscape or as a subject matter for everything. And I did see in the *New York Times* this bathrobe that looked like I was in it. And I just thought I would start that way, and in the beginning I hung things on it. It was a support for objects that I was charging with these metaphors.

But recently when I've drawn it or painted it, it's anonymous, and I don't consider it a self-portrait. I think it's a rather prime object, and therefore I keep using it and won't discard it now. It would be silly to.

BLDD: Is it a neutral image that is a vehicle for a technique, a scaffolding?

JD: Well, nothing is a vehicle for technique for me, because I don't think that matters. It's a way for me to make a painting that I hope is very beautiful, and something that I am familiar with so I can concentrate on the painting itself.

BLDD: I wonder if you could make some comparison between your use of the robe with Willem de Kooning's use of the woman.

JD: I think he was much more direct than I about figurative art, and

certainly much surer. Of course he comes from a much more enviably well-trained position than I do. That is, he comes from an academy, trained as a draftsman, as sure as hell that the best thing to draw in the world is the human figure, never questioning it, able as a mature human being to abstract from it, and from landscape, and so therefore I don't think there is a comparison. I think mine is quirky and eccentric compared to his.

BLDD: During the eighteen years that you have been painting now, you have held over sixty exhibits. What do you think about the tradition of retrospective exhibits? Yours was at the Whitney in 1970, when you were thirty-five years old. Did you think it a good, or an appropriate thing to happen to you then?

JD: Well, I didn't say no. But I don't think it was particularly appropriate in that what looked like a well-formed career in talent was actually just a lot of training getting ready for some big action. I think it's quite nice that they gave me an exhibition, but I wish they'd waited a few years, although I don't think it was detrimental. I just think it could have been better, because just after that I got a lot of ammo going.

BLDD: Your early works often have objects hanging from them. They often have tools—tools as psychological, sexual presences, heroes; sometimes tragic, sometimes objects of affection. What is the genesis of the use of these tools, and what is their significance?

JD: I grew up with them all my life in my family's hardware store. I found them exciting as objects, and it seemed a natural thing to do, as natural as using oil paint. To use a hammer to me was as real as picking up a brush and putting on a piece of red paint. The red paint was no different to me than the hammer. The hammer of course had a lot of connotations. I didn't choose to paint it very much. But I haven't used an object on anything in about three years, and I certainly don't miss it. It was a support mechanism. It wasn't necessary, I don't believe, and I was selling myself short. I can't say it enough about myself, I am just now beginning to understand what it is to be a painter, a draftsman, and I am not interested in short-cutting it by using the real thing. I don't think that's a particularly brave move, nor is it a radical one. At the time it was the only way I could speak, that's all.

BLDD: Have you turned your back on all that hardware now?

JD: I don't turn my back on it, I don't refute it. It's just that I've gone beyond that, I hope.

BLDD: The iconography of your work seems obviously autobiographical. In fact sometimes the spectator almost feels like a snoop. If you are under the bathrobe, for example, who is that ubiquitous heart?

JD: That's another thing too I found was a kind of universal sign. It's

not just a heart. It's a way once again to make a painting. Skirting this issue of figurative art, you see, that's what it stood for. It's nobody in particular. It's not my Valentine. But then of course one likes a Valentine, and that's what I mean—it is a very universal, nice form.

BLDD: Not just a playful invention?

JD: I don't think I am particularly playful, that way.

BLDD: Your private allegiance to poetry and to literature repeatedly surfaces in your art, especially in your choice of subject matter and the number of collaborative projects with writers and poets. Can you describe any of those efforts?

JD: It gets lonesome being an artist in a studio, so it's nice to share with other people—people you respect and get some feedback from. So it's a social act as much as anything. Sometimes you are out of ideas, and it gives you something to do. Also, it makes me read harder the people I collaborate with, and then I learn more.

BLDD: You have made a series based on Rimbaud.

JD: I had been very moved by Rimbaud and by his life. His life almost more than the poetry. I think his life is really interesting—the prodigious nature of the early years and the peculiar mercantile nature of the end—and I used his face like one would use still life.

BLDD: Somewhere you said that "literature has meant more to me than anything except for music. The fact is that both music and literature really mean more to me than painting." Is that quote accurate?

JD: It's a little simplified. Obviously painting is the most inspiring thing for me, and it's the reason I am here. But for a day-to-day muse I find music and literature more sustaining, mainly because I can't get off too much on reproductions and I am not always running to museums, although it's a nice thing to do.

BLDD: You say that going to museums is a nice thing to do. Not many artists that have come here have talked about their interest in viewing the works of other artists.

JD: That's all I do. I spend a lot of time in museums. In the late fifties and early sixties it was an ugly word, this French painting, and what was really going on was that these great men—Pollock, de Kooning and Rothko—had turned their backs on France. We had an art of our own now, an art of power, and it was a very bad thing for a young man to be caught looking at a French painting. I went to Paris quite a few times before I went to the Louvre. I was afraid to go. But then once I went it was obvious that they were full of shit. I mean I am absolutely gaga for French painting.

BLDD: To the work of what artist do you most respond?

JD: To a lot. I love Monet and Cézanne and Fantin-Latour. I like

everything at the Jeu de Paume—well, not everything. You are not selling out and it's not some nationalistic thing that's going on.

BLDD: To the works of what contemporary painters do you most respond?

JD: I have a good friend, R.B. Kitaj, the Anglo-American painter who lives in London. I don't necessarily respond to everything he does. I respond to him because he is my friend, and for what he has to say. He has a lot of cranky, terrific stuff to say, that helps me clarify my thinking. And I like his work quite well. I know it's peculiar, a little kinky art, but that isn't what interests me. It's that singlemindedness of commitment to the figure and the way he manipulates it. I am very moved by it.

I like the French painter Jean Hélion, his figurative things, because I think he's been a brave man to sometimes make such ugly paintings, sticking to this thing.

I am always devoted to and owe much to de Kooning as a draftsman. I think he needn't be so obscure sometimes. Like the sculpture—I kept trying to see what it was. It was just too obscure, like Francis Bacon, who I also think is a grand artist on a grand scale, but lousy finally. Both those guys know how to paint and everything, but everybody doesn't have to look like Quasimodo just to be modern, you know. It's a kind of failure of modernism that that happened.

There are other peculiar artists whom I like. I particularly like a painter called Lucien Freund. And in America I love Edward Hopper and Eakins, but I cannot relate to them totally. Their art is a Yankee-WASP art and I am none of those things, and I can't relate to them particularly. I mean I wouldn't know what to take from them. I love Giorgio Morandi.

BLDD: Is there a teacher or a relative who has especially influenced you in your work?

JD: No, nobody that I could say really was this great influence that changed things for me. I was always going to be an artist. It's the only thing I could do, and I only had one trick, so there was no reason to influence me because that was just what I was going to be, always.

BLDD: You had a lot of early experience with paint, working in a store and mixing it. Did that influence your palette later on?

JD: Nothing influences the way I use color because I don't understand that. I just throw in my nerve. I do what has to be done for the moment. I am so naive about painting and so puerile in what I know, I am just trying to feel my way about it. I don't know enough about painting. I have given most of my time to drawing because for one thing I find it easier to do and more enjoyable, but also because it's a simpler process, and I've tried to learn how to do that first. I am painting now, but it's

awful painful and I am not very sure of myself, not necessarily of the outcome, but as it goes along. As I make a painting it's a very unpleasant experience, not like it used to be, a joyful one, a kind of cathartic way to get a lot of material going. Now it's a very painful experience for me, and tedious, until I get to the final part, where I can pull it together. Most of it is just technique.

BLDD: Was the European experience significant?

JD: I'd rather live in Europe than here. I live here because I am an American and to be a full-time expatriate is less than satisfying. You are caught in between. It's a horrible longing because you are enjoying yourself so much there, but you want to go back here and you know it's not as nice, and it's a terrible dilemma. I will always go back to Europe. It's the place I feel comfortable in. I was raised by Europeans, and I see people in Europe and they act like my grandma and grandpa. I know what they are talking about.

BLDD: Your first trip to London was in 1967. During the period you lived there you did not paint for about three years. What did you do during that time?

JD: I didn't paint because my dealer at the time said I owed him a lot of money, and I didn't have a lawyer because I was stupid. I just took his

word for it that I owed him all this money and I'll be damned if I was going to give him any more paintings. So I just became extremely stubborn and didn't do anything. Those four or five years I wrote a lot and I drew a lot and I made a lot of prints. It turned out I didn't owe him the money, which was nice. I learned. And I got a lawyer and it all worked out fine.

I got involved in the theater. I designed *A Midsummer Night's Dream* in 1965 for the Actor's Workshop in San Francisco. And then in London I designed *The Portrait of Dorian Gray*—which was never produced—for a commercial company; the Museum of Modern Art owns the drawings. And I went out a lot, had a terrific social life. I got into living, you know, it wasn't on the barricades, like living in New York was in those days. I got to look at architecture for the first time. I became aware of the weather and things like that.

BLDD: You mentioned your conflict with your dealer. How important is a dealer to the career of an artist?

JD: It depends on the artist. I don't want to be a businessman and I don't want to sell my paintings, so he is very important to me, and I happen to be, right now, in a very good situation with the dealer, and it's productive for both of us. I am delighted to be able to make enough money to take care of my overhead and to have the freedom to paint, although if I didn't and had to do other things, I'd still paint.

BLDD: You returned to this country seven or eight years ago. What mobilized you?

JD: I had to get back. It just is my landscape in a way. I had to see what was happening, and I wanted another situation too. I went to live in the country and I had never done that before, so for seven or eight years I learned a lot, living in the country, and learned a lot about nature and about plants.

BLDD: Several guests have talked about the importance of New York to the career of an artist. From your remote perch in Vermont, how important is it for you to have a link with New York?

JD: Not at all, except commercially. My links were by mail and through my memories.

When I came here in 1958 or 1959 it was important. It was the only place to come, and I still think it is, just because for a young person it is where things could happen to you, and it is electric, and it exists not like Paris or London because it's beautiful—they are beautiful—but it exists in this idea of people making things and making creative things. I have two teenage sons who really need it for their artistic endeavors, because it is the most exciting place to be, but it certainly is not important to me. I am here now because I miss going to the ballet and concerts and things, and

I just don't want to miss that any more for a while. And I've had it up to here with snow.

BLDD: Given your early avant-garde reputation, your largest drawings of nudes and figures seem a dramatic, even unexpected change. Are you moving more toward a human presence, and are surrogates for the human presence interesting you less and less?

JD: I am not able to paint figures yet, not well enough. I am painting still lifes because they hold still and I don't have to talk to them and I can spend more time concerning myself with making a picture. But I do draw from the figure all the time and I am getting ready to do it, because it seems to me a much more interesting way to spend one's time than pushing paint around, than high-class decoration.

BLDD: How did this change to representational pictures evolve?

JD: Through my prints. In prints I seemed to have the nerve to start making pictures of humans because there was something once removed, that is, the printer. I didn't have to account for it so much. There was a lot expected of me, and I am someone who is not unaware of the pressures around; I felt I had a certain image to live up to, and this was what was expected, et cetera, et cetera. But in print making for some reason I was able to be freer, and in 1970 I made about nine dry prints of myself. It went from there, but it also went because I was spending a lot of time printing in Europe, particularly in England, and spending time with Kitaj at his house, and we had a lot of talks about it, and he said some very, very seductive things, things that made sense to me. He said there is a hierarchy of subject matter, that the painting of a face *is* more interesting than the painting of an apple. An abstract sculptor I know—Bill Tucker in England—told me that Rothko said to him he'd much rather see a painting of a bullfight any day than a painting of apples. It is just true. We are not talking about so-called heroic issues of world art or American art or what we fought for and have gotten to in this avant-garde. I am talking about the need that somebody who is an artist has to speak through his hands and eyes to represent the human visage, because it is the most interesting thing he can do. I can't get enough of it. I mean I paint still lifes too, but as I say I am training. I am just training now.

BLDD: Would you say that applies to Cézanne too, that his paintings of apples and people are markedly different?

JD: I would. I don't think one is better than the other. I think you get more of a charge from a painting of Madame Cézanne than you do from four or five apples and an eggplant. I am presuming that he had more to say about his wife than he did about his apples.

BLDD: You have this wonderful reputation that you have to respond

to—about your beautifully executed linear style. How did you come to choose that style?

JD: I didn't choose it. It came to me.

BLDD: Is there a grand design to your work?

JD: No grand design. I just want to keep on working.

BLDD: Now you are working in ceramic as well.

JD: I love ceramics, and I am very inspired by them. I have a collection of them. And I like to work in clay, but I am no good and I have no patience for it. This whole last year I worked with a friend who is a potter in England. I sent her drawings of pots and she threw them, and then I wanted to make not decorations on them but full-blown drawings, which I think succeeded. And that's the extent of my interest. I've made other pots that I just keep on destroying myself.

BLDD: I have seen some of those pots. and many of them have still-lifes on them.

JD: They are plants. I am interested in plants and botanical illustration. I really am very interested in it.

BLDD: You mentioned that you have a collection of pots?

JD: I collect eighteenth-century Staffordshire pottery called Wilden-ware. I discovered it in England. It's based on T'ang pottery, but it's very English, and I like the painting on the plates particularly. Jolly, Jolly-ware.

BLDD: Regardless of price or availability, what objects would you most like to possess?

JD: All the Degas drawings.

BLDD: How do you tell a good artist? What does that mean?

JD: As far as I am concerned it means that he can draw and paint, and can somehow relate to the past. You don't see too many of those people around.

BLDD: You've said of two of your friends that they act like artists, and that you admire that quality. What does *that* mean?

JD: It means that you behave on the canvas as an artist is expected to, with the tradition of it. I mean one doesn't come from nowhere. If you want to act like a bulldozer operator it's okay, it's your business, but please don't call yourself an artist, that's all.

BLDD: You are known as a gifted draftsman. Did all that graphic endeavor lead you to the paintings that you are doing now?

JD: Yes. It just gave me more confidence in my hand.

BLDD: Can you tell us a little about the recent evolution of the figurative in your work?

JD: I really did run out of gas. I could no longer face getting up in the morning and putting another object on a beautifully painted abstract

ground and calling it by some terrific title. I could no longer face that. I mean, I could just as well take these objects and put them on other people's abstract paintings too. That's really what it came to. And also the evolution took place because of looking at older art and realizing that I don't come from nothing, and that there is a history, and that one learns from the history. And every day I am checking myself out against these people in books. That seems to me the most natural thing to do. After all, baseball players compare batting averages. I don't understand why artists have to wrench themselves out of the culture to make something new so that they become famous, which is the way it has been done in the last twenty years. It's destructive, and there has been a tremendous dropping along the wayside of a lot of people, and they sure aren't having any fun, I'll tell you.

BLDD: One of the things I'd like to talk to you about is the state of art criticism and art reporting. What is your assessment of it currently?

JD: Of art criticism? Well, it hurts my feelings if they don't like what I do. Otherwise I don't have anything to say about it, because I've never learned anything from art criticism in the *New York Times*—let's just take that. If they like my work I'm delighted. If they don't I can't wait till Sunday is over, because it gets thrown away.

I don't think it's a particularly constructive force, although if you get a good review it does seem to sell paintings, so I guess that is constructive.

BLDD: Did you ever consider yourself a pop artist?

JD: No, no. They all did, I know. It was a very confusing situation. But I never did think I was a pop artist. It's just that it was easier for magazines and people to lump everybody into that. No one looked hard anyway, and that's what I mean—no one looks at anything.

BLDD: How did you decide to use the written word in your work? I am thinking in particular of an enormous painting that I guess lists the name of every person you knew in Cincinnati, your original home. How did that happen?

JD: I used the written word for two different reasons. I had no confidence that people would understand what they were looking at that I painted. So I would paint a hammer and write hammer underneath it. And it seemed terribly brave, and people got very excited about it, but in fact it was just like another object, this word. It came out of the tradition of people doing that. After all, cubist paintings are based on a lot of that. But the painting called *The Name Painting* I did because it was the first indication I had that I was running out of these avant-garde ideas. I was sitting in London and I hadn't made a painting in a while, so I thought this was a terrific idea, it would just be something no one had ever done, so I just wrote out the names of everybody I ever knew in my life, and I

think I remembered everyone. I left a few people out because I hated them. And it looked very nice, like a little landscape. It's okay, but it's an eccentric work.

BLDD: What do you think of contemporary painting.?

JD: I don't think much of the younger famous painters. I think it's art that's confused. It's not Matisse, it's not Morandi. It's an extremely narrow-minded, mindless procedure that feeds on a public that has been conditioned to look at that sort of thing, which is finally nothing. I am not unaware of the beauty of a wall, and I am not unaware of how dirt looks and how pretty it can be, but to elevate it to that other level, it takes a lot of nerve.

I talked to George Segal. I've known him for years, and he said his daughter was a painter. I asked, "What are her paintings like?" And he answered, "They are very personal." And I said, "Well, what are other people doing?" "Everybody else is making either very minimalist art or photorealism," he told me. And that's pathetic. That's all that's done in the art schools. It's all about the art students thinking that's how they'll make money. And there are still going to be just a few people who are talented, and the others are not going to make it. It's a pathetic thing, and it's the teachers' fault. The teachers don't say anything.

I saw the Seurat drawings at the Metropolitan the other day and there was a drawing that he made in the Academy where he had to sit all day, without an eraser, for probably six weeks at the same pose, and he built this male figure. Now there isn't a monochromatic painting in this world that can move you like the way this young man built this male figure. And it would take the same kind of effort. I am not questioning the motives of the young people who paint this way. I just think they are misled, and they are misled by a lot of things.

BLDD: What do you think of contemporary realistic painting?

JD: I think there are some very neglected people in America, really neglected. There are some wonderful artists. There is an artist called Leland Bell who I think is one of the greatest artists in America, completely neglected. Gandy Brodie died neglected, a wonderful, great artist. But they took no stand on the barricades of avant-gardism. They just knew what they were here for, and that was to paint. I am inspired by them, by what they do, I look at what they do. But now there is no one to look at for me. I still would rather look at a Giacometti drawing than at most things I see. I'd much rather look at a Derain than at most things I see. But that's probably my revisionism, you know. ;

BLDD: You made a less than admiring reference to photorealism. You sometimes use photographs in your own works, but in a whole other fashion.

JD: I did. I wouldn't now. I used things from magazines and things like that, torn out, just to get that immediate look, that look of modernism, of the modern movement, just to get that thing that was related, that really comes from cubism and Dadaism, which is what I come from. It's my cross, that and expressionism. This modern cross of collage is there. I should have taken my time and drawn it, that's all. I am very devoted to photography, I have a collection of it, and I have been moved by it through the years, and have a lot of friends who are photographers. But it's not the same thing, you know.

From audience: If you were starting all over again as a young student in art school, would you have the guts to say what you really loved and believed in rather than making it in New York because of the fads?

JD: I wouldn't have done it any differently. I didn't know any better. I only know now because I am forty-two.

From audience: What do you feel about the California artists' rights law, the one that says that artists should get a commission whenever one of their paintings is sold?

JD: I have a very unpopular pose about this. In 1960 I was teaching school for 4,000 bucks a year, and Martha Jackson said, "I'll give you $25 a drawing and $100 a painting. I'll equal $4,000 a year, you don't have to teach school." That meant she got a lot of paintings and drawings, and what she did with them is her business. She freed me from something I couldn't stand doing and got me to do something that I really wanted to do. So if someone bought one of those paintings from her for $200 and can sell it now for $2,000, I think that's terrific. I mean that's their business. When a painting leaves my studio I don't think an artist has the right to get that money back. He shouldn't have sold it in the first place if he was so goddamn attached to it.

Brendan Gill

(Writer. Born Hartford, Connecticut, 1914)

BLDD: Brendan Gill is the author of books, short stories, plays, film and Broadway theater criticism for the *New Yorker* magazine. He is also the ultimate urban activist. He is, or has been, the chairman of the board and guiding spirit of the Institute for Art and Urban Resources, the New York Landmarks Conservancy, and the Municipal Art Society. He is a member of the New York City Cultural Affairs Commission, and has had long-term involvement with the Morgan Library, the Victorian Society, the Film Society of Lincoln Center, among others.

You have had many voluntary commitments, but only one job during your entire career. How does a curious and restless fellow like yourself come to stay in one place for so long a time?

BG: Well, it happened that I never had to ask for a job because when I got out of college I began selling short stories to the *New Yorker,* and then the editors asked me to come and join the staff. From that moment on, that was the only place I wanted to be, and it isn't quite as confined a career as it sounds, because on the *New Yorker* it's possible to do a great many different jobs. In effect, my life has been broken up over a period of forty-two years into many different jobs, all of them agreeable. In extreme old age, I hope they'll find me something new to do. Nobody should go on being a drama critic indefinitely. At my age, it's a scandal.

BLDD: You were a film critic.

BG: I'm still a film critic. It's scandalous to be a film critic at my age, too.

BLDD: Why do you say that?

BG: Young playwrights shouldn't be judged by old men. It's a terrible thing. One of my colleagues within the last couple of years reached the point where he not only could no longer find his seat in the theater, he couldn't find the aisle, and just before he retired he couldn't even find the theater. This man was passing judgment on young playwrights in their thirties and forties. He was also passing judgment on black play-

wrights and he didn't like them. You know the prejudices and bigotries of age are indefatigable and therefore worse by far than the prejudices of youth. It's a historic fact that most drama critics have done their best work in their early thirties.

BLDD: But you didn't even become a drama critic until you were past fifty.

BG: Fifty. It shows how perverse the *New Yorker* can be.

BLDD: What jobs have you held at the *New Yorker* in addition to being a film and drama critic?

BG: I've written short stories and poems and many, many hundreds of "Talk of the Town" stories, and many, many scores of "Profiles" and "Reporters at Large." Scores and scores of book reviews. They're all different kinds of occupations and they're all pleasurable. The only thing I could never bear to be, and I tried that, too, is to be an editor, because that is selfless and I am far from selfless. I couldn't stand not sharing the credit for a piece of work that was sufficiently good to reach print.

There are other kinds of people—they're saintly to my eyes—who don't want to share credit, who just like to help other people do their best work. That is wonderful. So unlike me.

BLDD: Is that true? You said most of your activities were very plea-

surable. Do you feel there are some of them that are also memorable?

BG: A curious thing: I wrote a book about the *New Yorker* a few years ago and in it I said that I had no history because I had had such a happy time and had done so little work. Then I went on for 400 pages.

BLDD: You're referring to *Here at the New Yorker.* You probably are the fastest pen in the east; the work pours forth with uninterrupted regularity. Last year, you also wrote *Summer Places,* a beautiful volume of text and photographs.

BG: *Summer Places* is largely the handiwork of a Canadian photographer named Dudley Whitney, who did a celebrated book on barns a few years ago. To everybody's astonishment, it sold over 100,000 copies. Nobody knew that all over America and Canada people were mad for barns. Dudley and I share a common sympathetic interest in nineteenth-century architecture and we had a marvelous time going around visiting houses all over the United States and Canada. It was so agreeable that we thought afterwards we should have told the publishers that the book was impossible to complete in one year—that it would take us five years at the very least.

BLDD: In *Summer Places,* the opening lines are quite lyrical. You say, "Summer places: to me the words are among the most haunting in the language. The sound of their mingled syllables seems to hint that something exceptionally pleasurable is just about to happen."

BG: I think there is a mysterious connection between summer and childhood. Anybody that I ever asked about this connection seems, like me, to have far more memories of summer than of all the other seasons put together. The awakening of summer and the awakening of self-awareness in childhood are somehow linked. I have hundreds and hundreds of separate memories of the first five years of my life in summer. But I don't have an equivalent number of memories of winter, which because of school and other things ought to have been an equally important time to me. Perhaps our bodies become more alive simply by our going about so nearly naked in summer. One of my chief memories of winter is that of having mittens with strings passing through the sleeves of my coat. A strangulation of prison garb.

BLDD: How does a resort become popular?

BG: The first summer resorts grew up around mineral springs. Soon it wasn't enough for our ancestors to take the vile-tasting waters or to bathe in them. Gambling casinos sprang up nearby, along with big hotels, racetracks, and the like. Saratoga, for example, began with health and ended with racing and gambling; similar developments occurred in Warm Springs, Hot Springs, and all the other springs.

BLDD: What are the most enduring summer places?

BG: Oh, Newport by far. Very early in the nineteenth century, it became a summer resort for southerners. People from Charleston used to come up by boat—often enough in their own boats—to spend the summer in Newport, far from the danger of malaria and yellow fever, and far away, too, from the terrible southern heat. Later in the nineteenth century, it became fashionable for New Yorkers. In the twentieth century, contrary to what most people think, it remains fashionable. There's more money than ever in Newport. Big houses are still run with dozens of servants; you might find a footman behind every place at a sitdown dinner for twenty-four. The rich become richer and richer, though they're more discreet about showing it than they used to be. In the nineteenth century, there was no point in being rich unless you could be conspicuous; in the twentieth century, after the Depression, people got to feeling differently about conspicuous display. While the disparity between rich and poor increases in our calculated system of social injustice from one generation to the next, the rich take care to lie low in every resort I know of except Newport.

BLDD: And where are the rich most modest? In Maine?

BG: It doesn't take much money to be rich in Maine. There are people building houses now in East Hampton, for example, which cost over a million dollars, and they look like such simple little houses. In Maine one can still buy a big old shingled summer place for a fairly reasonable price.

BLDD: What's your own special favorite place?

BG: Where I spend the summer, in Norfolk, Connecticut. It's my wife's old family place. I had always lived by the sea in summer as a little boy and this was one of those decisions made in the course of marriage, whether the wife goes to where the husband has always gone or whether the husband goes to where the wife has always gone. And this particular property that my wife had inherited had fallen into disuse. It challenged my ingenuity to bring it back and so I did.

BLDD: In discussing summer places, you make the very interesting point that in a mere handful of generations men went from fearing solitude to seeking it. That obviously is intricately intertwined with larger issues. Could you talk to that point for a moment?

BG: What was eagerly championed in the nineteenth century, especially after Emerson and the transcendental movement, was a conviction that Emerson had borrowed from Rousseau and others, to the effect that there was something in nature that was immanently good. Man, if he was fortunate, sought out in nature that immanent good, which was certainly not to be discovered in cities; corrupt and corrupting, cities brought out the worst in man. Very early on, Emerson was camping out in the forest

of the Adirondacks, and his disciple Whitman was striking out on the open road. Whitman seemed to find everywhere that goodness in nature which I, for one, would argue doesn't exist at all.

BLDD: Somehow one doesn't think of you as an outdoor person.

BG: I'm very much a city person. As Lewis Mumford said in his book, *The City in History,* all civilization is in and of the city. There's no way to sustain life, intellectually or emotionally, except in the cities, and even people who live in the country and suppose themselves to be independent need the contribution of people in the cities who from earliest times made the very apprehension of the natural possible through words. For centuries people labored over the Alps and not one single person ever wrote about the Alps as being beautiful until city-bred Petrarch came along. The Alps weren't beautiful to the Romans—they were just a damnable nuisance. And yet by the end of the eighteenth century, the thickest clod of a young English milord catching his first view of Mont Blanc would burst into tears. That's what you can achieve by culture.

BLDD: How did your interest in the total urban environment, in terms of architecture and design, ever come about? What prompted such a deep interest in preservation and conservation?

BG: Architecture is my first interest. When I was five or six years old, I was already making blueprints in my bathtub at home, and I continued to be fascinated by architecture throughout childhood and youth. I'm now doing a book on Stanford White, who was familiar to me when I was seven or eight. My father used to point out a certain house in Hartford that he said had been designed by Stanford White. It turned out not to be by Stanford White at all, but I had that name fixed well in my memory. If you're interested in architecture, you tend to become increasingly catholic in taste, and so you become increasingly eager to preserve as many specimens of as many styles and periods as you can. That leads one straight to preservation.

BLDD: If you were so interested in architecture, why didn't you become an architect?

BG: I didn't like the courses you had to take in order to get to architectural school. I hated mathematics, for example. Now I like it. Once, taking my college boards, I got the lowest grade in geometry of anybody in the United States.

BLDD: Why didn't you become early on a critic of architecture?

BG: I suppose I was otherwise occupied. My first novel was called *The Trouble with One House,* and all my metaphors and all my images and all my figures of speech tend to be linked with houses and rooms and corridors, and gradually over the years I've acquired enough knowledge

to become a good architectural critic. I will be practicing that art in the Stanford White book.

BLDD: And do you envision in the evolution of your own career doing more and more of that for the *New Yorker?*

BG: No, I would like to do about two more factual books and then I would like to write fiction. Because you tend to lose your wits in regard to fiction very early; few writers have been able to write fiction in age. This increasing difficulty happens in all the arts, but it happens most painfully with writers.

BLDD: When can we expect the Stanford White book?

BG: Surely by next year, which is what I say every year. It's going to be a social history as well as a biography. White is interesting in part because he lived when the rich in America were still under the domination of the work ethic. They didn't have a particularly good time; they had money, but nothing to do with it. White paganized them, or tried to. He got them to enjoy themselves. He staged wonderful parties for them, filling their houses with greenery and roses.

BLDD: I can recall your once telling me that the most recurring and absorbing figure in your own work and life and imagination was Stanford White. Is that so?

BG: I identify very strongly with him. He's my ideal of what a human being should be. I would like to imitate him in everything except his death. I wouldn't much care to be murdered.

BLDD: What is the standard to which you aspire?

BG: By far the most pleasing thing that was ever said about me was said in a letter that Marianne Moore wrote to me once. She wrote that I engendered in others an insatiable appetite for life. That's what I would like to have cut on my gravestone, though I fear that gravestones have gone out of fashion.

BLDD: You have written and published poetry over an extended period of time. Do you still do that?

BG: Oh yes. My greatest ambition is always to get a poem in the *New Yorker.* That happens once every few years.

BLDD: I was thinking about your special book on Cole Porter. Did you know Cole Porter?

BG: No, he was of a different generation from mine. He was halfway between my father's time and my time, and I perhaps wouldn't have known him anyway, although I know a score of people who did. I was always interested in him. When I was an undergraduate in New Haven, *Red, Hot and Blue* came to town. Porter was very much a part of my Yale life, and when the publishers asked if I would write a book about him with Robert Kimball, I was delighted to do so.

BLDD: Did you ever know Tallulah Bankhead, the subject of another book of yours?

BG: I met her only in passing. That book grew out of the fact that, having done a successful book on Cole, my editor and I thought, "Well, who else in the United States is also known by one name?" and of course that was Tallulah.

BLDD: You could have ended up with Hildegarde.

BG: I always have the first sentence of a book ready long before I have anything else in the book, and I said to our youngest son, "Charles, I already have the first sentence for 'Tallulah.' " Charles looked up at me with his big blue eyes and asked, "What is that?" I said, " 'She was a strange one, and no mistake.' " And Charles said, "Are you sure that's good English?"

BLDD: You said you'd like to do two more factual books. I assume one of them is the Stanford White book.

BG: I plan to do a book of essays, to be called *Thirties People,* which will embrace some of the people I've already written about, like Philip Barry, but will also be about Frank Lloyd Wright and other people whom I knew in the thirties and who are now long dead. I would like it to be a high-quality paperback, mostly for use in colleges.

BLDD: Who were some of the other persons?

BG: I want to write about both the Roosevelts, Eleanor and Franklin. He was the first person I ever voted for as president, and I encountered him a little bit, and I encountered her more, and I'd like to set down my thoughts on them. There will be probably about twenty essays altogether, and I hope they'll be of some documentary value.

BLDD: Why don't we take an inventory of a rather hefty slice of New York City's cultural life, by just reviewing some of your involvements? Can you describe for us the purpose, the program, the nature, the motivation of some of the groups and your involvement with them. Why don't we start with . . .

BG: With the Municipal Art Society. New York a hundred years ago was a city devoted to money-grubbing and much less beautiful than any other city in the United States. Some people thought it ought to be comparable to Philadelphia, Baltimore, Washington—all proud cities—and so they founded the Society to that end. In the course of time, the Society has become a kind of watchdog of urban amenity in New York City. Most of the victories we have won leave no trace, because they are negative; that is, we have prevented some horror from taking place.

BLDD: The demolition of Grand Central?

BG: The Committee to Save Grand Central was spun off from the Municipal Art Society. The Landmarks Conservancy, which I have the honor to be chairman of, was spun off from the Society in order to do a particular job in regard to landmarks, which are in daily jeopardy in New York.

BLDD: There's a whole other area. For example, you're the vice-president of the Film Society of Lincoln Center. What is your involvement with that group?

BG: It started with my having been a film critic, or, rather, a film reviewer.

BLDD: How do you distinguish between film reviewer and film critic?

BG: I always make the distinction that the reviewer is doing a journalistic task and the chief function of that task is to give the reader some sense of what a given movie or play or book is like. If the reader is familiar with the reviewer and can therefore take his biases into consideration, the reader will say, I'd like to see that play, that movie, or read that book. A critic addresses himself to the work, whether the work is pleasing or hateful; he addresses himself also to the maker of the work, and if the maker of the work happens to be alive, this may prove to be a useful function. Criticism is largely that which appears in quarterlies and annuals or in books; reviewing is and should be very ephemeral, and I think that a great many things in the *New Yorker* tend to increase in

complexity of attitude to the point of becoming criticism and to turn aside from reviewing. When we gave up having an ordinary arts reviewer, telling us what was in the galleries, we put in his place Harold Rosenberg, who didn't want to have a mere reportorial assignment. He wanted to issue wonderful pronunciamentos on the nature of art in our time, and we had reason to be grateful for that, but that was no longer what I call reviewing. Pauline Kael has tended now to do the same thing.

BLDD: What do you think of the state of criticism and reviewing of the arts in this country, at this point in time?

BG: The people I suppose I admire the most are the film reviewers, since they are livelier, more alert, and more interesting than my legitimate theater colleagues. There are an awful lot of time servers in the world of play reviewing.

BLDD: More and more people seem to be interested in and respond to "electronic" criticism, except there is very little room for critics within that medium.

BG: Our airwaves don't belong to us, they belong to two or three contentedly piratical corporations, which are perfectly satisfied to pretend that they're doing good by giving some nonentity two minutes on the air to talk about a play or a book. If they get a good man who attempts to do a worthwhile job, they throw him off the air. The record of the networks is disgusting.

BLDD: Do you see any major difference between the public broadcasting stations and the commercial ones?

BG: Of course there's a difference, but the public stations bungle their opportunities as well. New York is surely the greatest city on earth, and what does Channel 13 do about reporting on the arts here? Almost nothing. Nobody would ever guess in the year 2000, if the records available at that time were only cassettes of TV programs, public or private, that we had ever had any cultural life in New York City in the twentieth century. That we were the leaders of the world in various areas of art—no record of this will exist.

BLDD: Let's talk about the Victorian Society.

BG: It was formed to do something about preserving the best of nineteenth-century architecture and the decorative arts. We began with a very small group of half a dozen people and now we have 6,000 members from coast to coast and will soon have 20,000 members—it is truly an idea whose time has come. The nineteenth century was the greatest architectural period we ever had, much greater than the eighteenth century, of course, and greater so far than the twentieth, and the twentieth is, as you may have noticed, nearly over. It is also the period in the

greatest jeopardy. Every day, somewhere in this country we lose some wonderful Victorian building, nearly always out of ignorance. People are willing to learn; it is a question of getting information to them.

BLDD: Why have preservation and restoration and conservation become so popular?

BG: I think it's partly the fact that we are becoming more and more preoccupied with history. We were famous in the past for such fatuities as Henry Ford's saying that history is bunk. People didn't like to look back; now we are eager to do so. I think it's a healthy preoccupation because, as Santayana said, whoever forgets the past is doomed to repeat it.

BLDD: What do you see as the future direction of preservation?

BG: In New York City, I suspect that we won't go on knocking it down every thirty years and then building it up again. From now on, thanks partly to the energy crisis, we'll prefer to reweave the present fabric, mingling the new with the old. Eventually, it will be a much stronger fabric than it was and therefore a much richer and more nourishing city to live in than it's ever been. It's a thrilling challenge to young architects.

BLDD: Are they being reeducated to that vocabulary and that challenge?

BG: Philip Johnson, the architect, who loves building new things, was talking last year and said, "You know, I've never remodeled a building in my life," and somebody in the audience shouted, "What about Avery Fisher Hall?" Philip said, "My God, I'd forgotten all about it."

BLDD: Last year you articulated a theory about the nature of buildings and their life cycle. Can you recount that for us here?

BG: It's a thing that I really believe in, though it seems but a kind of toy of an idea. A remarkable man named Douglas Gordon, who loves architecture and has done much to help save old Baltimore, hit upon something he calls the Gordon Curve, which posits that a building is at its maximum moment of approbation when it's brand-new; that it then goes steadily downhill, and at seventy reaches its nadir. If you can get a building past that sticky moment, then the curve begins to go up again very rapidly until at a hundred it's back where it was in the year one.

You can test the Gordon Curve in New York City or any town you happen to live in. Again and again, you'll find that a hundred-year-old building is much more likely to be saved than a seventy-year-old one.

BLDD: As chairman of the New York Landmarks Conservancy, you prepared an essay for a catalogue on the U.S. Custom House. One of the things that you comment on is the group of four enormous Daniel Chester French sculptures mounted on this extraordinary building. You

raised the question that went something like this: does anyone know what Henry James—as an architectural critic, I assume—thought of statues that sit instead of stand? What is your reply to that question?

BG: Henry James said that, everything else being equal, a building that sits is more pleasing than a building that stands. Once you hear that remark, you spend the rest of your life looking at buildings and judging them in those terms. This building sits, that building stands. The Morgan Library sits, obviously the Chrysler Building stands.

BLDD: Except the Villard houses, and the Palace Hotel, which will both sit and stand.

BG: Well, yes, if you put the two together that way. The Gothic cathedral leaps and the Greek basilica sits. Nowadays we can have a house that not only sits but lies down, because we have the technology to do it. About Henry James, I posed the question in fun because I don't know that Henry James ever did decide *any*thing about statuary, whether sitting or standing.

BLDD: When you talk about houses that sit rather than stand, it brings to mind your early involvement with Frank Lloyd Wright. I can recall your once having said that during your own Frank Lloyd Wright period, you redesigned your Norfolk, Connecticut, house. What was your involvement with Frank Lloyd Wright, and do you really think of yourself as a designing man?

BG: Oh yes. I was recently elected an honorary architect by the local chapter of the American Institute of Architects. That doesn't give me the right to design even as much as a doghouse, but I accepted the honor with joy. I came to know Frank Lloyd Wright when he was coming to town, many years ago now, in connection with the first drawings and plans of the Guggenheim Museum. James Johnson Sweeney was the director of the Guggenheim and it was he who commissioned Wright to build it. Sweeney introduced me to Wright, and Wright and I became fast friends. Whenever he came to town he would call me at the *New Yorker* and say, "Hello, Brendan, this is Frank." I was young and he was old and I felt no more ready in my heart to say "Hello, Frank" than if George Washington had telephoned me and I would have been expected to say "Hello, George." But I stayed with Wright out in Taliesin, in Wisconsin, one of the most delightful houses in America. We always had great fun together.

Wright designed very little in his sixties; he had a hard time earning a living throughout much of his life. There was a certain measure of the charlatan in Wright, as there was in FDR and Picasso and Hemingway. I think that'll be something I'll be dealing with in my essays on Thirties

people: the fact that even as early as that decade the media were turning our heroes into charlatans. . . .

BLDD: A charlatan, or a public pose?

BG: A mountebank, a clown. In the media, you have to be vivid in order not to be ignored. For Frank Wright, charlatanism was one of the means by which he attempted to keep afloat financially. But then there is always *some* excuse for any mode of conduct.

BLDD: Are there any architects at work currently whose contribution will be marked with the significance that you give to the nineteenth century?

BG: Hardy, Holzman, and Pfeiffer have a good chance of leaving some work behind that will stand up—work that isn't an act of personal arrogance. They're among the brilliant young people who are prepared to take an old building and treat it with respect, which is what they did with the Carnegie mansion in the course of turning it into the Cooper-Hewitt Museum. They respect the past, they work with the past, and they produce serious works of architecture.

BLDD: I assume one numbers the work of Mr. Johnson and Mr. Pei very high on any list. How do you respond to their work?

BG: I think I. M. Pei's East Building of the National Gallery of Art is an authentic masterpiece. It is a folly, I can only call it a folly, but what a splendid folly!

BLDD: Why a folly? Because of its scale?

BG: Yes, it's absurdly large for what it does. It didn't *need* to do any of the wonderful things that it does; oddly enough, that's often a sign of great architecture. I think it is a fine thing that Paul Mellon, a true devotee of architecture, would let my friend Pei build a building that costs $120 million . . .

BLDD: $93.5 million, that was quite enough. And the work of Mr. Johnson?

BG: Also a close friend. I've always admired the fact that he has been experimental. He's been very uneven. One of the first times I encountered him was when he designed some dormitories for Sarah Lawrence. I saw the blueprints in the office of Harold Taylor, then president of the college. I told Harold that the buildings struck me as ugly and unworkable. Harold picked up the phone, rang up Philip Johnson, and said to him, "Philip . . ."

BLDD: "Brendan says . . ."

BG: ". . . that your dormitories are among the ugliest things he's ever seen. I want you to show him models and everything else," and Philip said, "Send him along," So we ended by having a debate about indus-

trial architecture of the nineteenth century, to which I compared his dormitories. Philip said, "Yes, aren't those buildings wonderful? Don't you love those windows?" On and on like that, impish and adroit. Now I think Philip might agree with me about the dormitories. He was going through a phase, approaching the shaped windowness of windows instead of the importunate glassiness of glass walls. It was a first attempt at something that he developed afterwards in a different way.

BLDD: Was the building ever built in terms of the original design?

BG: Just the way he designed it, unfortunately. Philip is a spellbinder. All the great architects I know of have been spellbinders: Davis, Hunt, Richardson, White, and the rest—they could talk birds out of trees!

BLDD: Perhaps architecture is ultimately a fantasy profession.

BG: Frank Lloyd Wright was beyond anything in his skill at getting clients excited about building something that, in fact, he had designed for another client in another place.

BLDD: What buildings were they?

BG: Many; one was the famous Price Tower in Bartlesville, Oklahoma. Mr. Price was an immigrant who had invented a way of threading lengths of gasline pipes together. He made a fortune. His office was in a little two-story red brick building in Bartlesville and he needed another little red brick building, but his children were proud of his success and they said, "Daddy, you ought to get a great architect to design you a proper building." Price called Wright, who answered at once. He had next to no work on the boards, and he headed lickety-split for Bartlesville. He told Price, "I want to build you a tower, I want it to be like a needle in the desert, and he went on and on in that fashion and Mr. Price said, "Yes, by all means, build it!" He didn't know for years that his needle in the desert was a design that Wright had made for St. Mark's in the Bowery, here on Second Avenue. The Crash had come and the project had to be scrapped. There the building stands in the least likely place on earth, Bartlesville, Oklahoma. Mr. Price couldn't rent any of the upper stories of the building for fifteen years, but he took great pride in it. He was an admirable client. I salute him as fervently as I salute Wright.

BLDD: You've written on so many diverse subjects on a weekly basis, in journals, in magazines, in books, poetry, short stories, a prize-winning novel, you've been everywhere, you've met everyone . . .

BG: I've never been *any*where, except in this country. That's the only drawback in my life. I've never been to Greece, I've never been to Israel, I've never been to Egypt. Shocking.

BLDD: Well, you've been everywhere on this continent. If you ever want to know what is happening any place, ask Brendan, he was there.

BG: Yes, I keep criss-crossing the country. I love seeing all the different cities of America, that really is one of the happiest aspects of my life.

BLDD: When do you have time to write? Really, how do you do that?

BG: Usually I go to parties every night, even sometimes to two or three parties a night. We're told when we're young that we'll need less sleep as we grow older. I can live on three or four hours of sleep, and I always get up at six o'clock in the morning no matter how strenuous the night before has been, and I leap to my desk.

BLDD: Do you have any plans for an autobiography?

BG: Not at the moment. But you know how things are with writers. If a publisher were to ask me to write my memoirs and if the price were right . . . and if it wasn't, I wouldn't. A. J. Liebling used to protest to our editor, Shawn, that he wasn't being paid enough. Shawn said gently: "Liebling wants to live like a stockbroker, but he doesn't want to *be* a stockbroker." That's how I am, too: I want to live like a stockbroker, but I don't want to *be* a stockbroker.

BLDD: If you had it to do all over again, would you do things differently?

BG: Of course I wouldn't be who I am now, if I were to do even the most trifling thing differently; so the answer has to be no.

BLDD: Why do you do all of these good works?

BG: Well, obviously for personal satisfaction. One likes a certain view of oneself. I believe in everybody's having a powerful incentive, and one's ego is certainly that.

BLDD: Could the motive ever be for the larger good? Is there no altruism in your vocabulary?

BG: Why should there be? And if there were some strain of altruism in my nature, how could I possibly recognize it? I can bear witness to my deeds, but not to my nature.

BLDD: Couldn't the incentive or the motive be the larger good?

BG: You do things because you want people to form a high opinion of you. You want to form and hold a high opinion of yourself. I think the only word of advice that I would ever offer a child would be not to take more out of the world than you put into it.

BLDD: That is a noble concept.

BG: Not necessarily. Again a matter of one's image of oneself. I want to have lived a life of some value, but in the course of living that life I delight myself. Success is a very seductive process. Things that I do that I fail at obviously don't give me much pleasure.

BLDD: Well, they never come to public view. I wonder what they are.

BG: You start novels and you fail and you write short stories and

they're rejected. Fame is said to be the last infirmity of a noble mind. I think otherwise. I think to be famous would be very nourishing.

BLDD: Don't you think you're famous now?

BG: I mean fame like that of Old Blue Eyes or the Groaner.

BLDD: Did you ever think of being a performer?

BG: I *am* a performer. I perform in front of my family. I recite "The Face on the Barroom Floor" to amuse my grandchildren. I put everything I have into it and they're filled with wonder. They say: "Who on earth is this very strange old man? And why is he lying apparently dead on the floor?"

BLDD: Brendan, are these the best years of your life?

BG: All my years feel as if they were as I experience them. One of my daughters made a remark recently—a very daughterly remark. She said, "Oh Pop, aren't you glad you're peaking so late?" There's no way to answer such a question except with a resounding, joyous "Yes."

Milton Glaser

(Designer, Illustrator. Born New York, New York, 1929)

BLDD: Professionally Milton Glaser is known as an outstanding art director. He is in addition a humanist, a philosopher, a gourmet, and a graphic artist, whose combined talent has changed the face of what we read and see in American publications. In your varied work, is there some guiding artistic principle or standard?

MG: Yes. The guiding principle is clarity.

BLDD: How do you take a piece of information or some original reference point and translate it visually?

MG: You're talking about the heart of a designer's work, which is the transfer of this information from one point to another. You do it somewhat differently in every case. At its center, the profession of design is responsive to external requirements. The difference between being a designer and being an artist is that the obligation of our profession is problem-solving, or taking a piece of information from one point to another. How you do that depends on the peculiarities of the situation that you're in. For instance: if you're doing a poster for a musical event that's aimed at an audience of people from forty to sixty, you wouldn't use the same language as if you were doing a poster for a rock concert. The form of address itself has to change as an accommodation to the audience you expect to be talking to. Design is a language, and you have to understand what's vernacular in order to speak the language that is known. One of the difficulties about communication is precisely the issue of what is already known by the audience you're talking to, which in turn raises the terrible question of being innovative, or being fresh, or being original, or, in fact, being creative. A much-abused word. You see, the real problem is what is "creative"—in my mind, there are always quotes around that word. What is creative is invariably what has not already been experienced, and therefore, by definition, cannot be understood. So you see why the idea of being creative and the idea of being a person involved with transferring information are, at some points, in opposition

to one another. If creative, in fact, deals with what is not already known, the real question becomes, how can you make what is not known, known.

BLDD: Did you have a philosophical mentor?

MG: I don't think so.

BLDD: An aesthetic one?

MG: Yes. I realize now that my real mentor was Picasso, in a peculiar way. The thing I liked about Picasso is, he showed that you could discard your own history and keep moving. The one thing that Picasso demonstrated by virtue of his performance over his lifetime was that you did not have to feel bound by a single stylistic convention. As you know, the pattern of an artist, virtually, until Picasso, was always the same. Early confusion, apprenticeship, development of an early style, refinement of that style, success at that style, and then death. Now, what Picasso demonstrated was that you could be a cubist, a synthetic cubist, surrealist, romantic, and naturalistic, and maintain quality in all of these stylistic positions. I suppose that the most important thing to me was that you could embrace a number of styles in your lifetime that were entirely contradictory to one another.

BLDD: With whom did you study?

MG: I started studying in an official way when I was thirteen years old, with Moses Soyer, one of the three Soyer brothers, right on 15th Street and Fifth Avenue. And I remember, at the age of thirteen, going into my first life class and seeing a naked woman, which was absolutely terrifying. But I survived. That was the beginning of my formal study. Then I went to the High School of Music and Art, the Art Students League, and Cooper Union. I had a Fulbright, and I studied with Giorgio Morandi in Bologna.

BLDD: Was that a very influential period?

MG: I would say that, of my post-teenage life, it was the most significant, artistic, and perhaps philosophical period of my life. Morandi was a man I admired deeply. I was very influenced by him, mostly because of his refusal to accept the traditional role of the artist in society that many of his contemporaries played. He is essentially an artist who did still lifes of bottles and landscapes. Very few representations of people. He was a marvelous man, a fabulous etcher, and a marvelous painter, a painter of great tonal beauty. And at the time I was studying with him, I was twenty, twenty-one, and he was already one of the most famous artists in Italy. He never left Bologna, which is a small, somewhat provincial, northern Italian town. Actually, not provincial at all. It's a lively and politically active town. But it's relatively unknown by Americans, because it has no great tourist attractions.

Anyway, he was very happy never to move to Paris, never to move out of Bologna, never to charge more than $200 for a painting, even at a time when his dealers were getting $14,000 for his work. What you could do, you could order a painting from him, for which he charged $200, and what he would do, he would write your name on the back of the canvas, and he'd put it away. Then, during the course of the next five years, he'd do a painting, and after he'd finished the painting, he'd turn it over and see whom it belonged to. Then he'd send it to you. The point I wanted to make was that the total refusal to get involved in the mechanism of success, accomplishment, money, was something that I found enormously compelling.

BLDD: Do you think that inhibited or furthered his career?

MG: If you mean career in the sense of being as highly successful financially or as well-known as he might have been, I suppose there was some inhibition about that. On the other hand, as it turns out, in the curious way that life has in dealing with these issues, today he is probably one of the most expensive graphic artists to buy prints of.

BLDD: What is the difference between design and art?

MG: The real difference is the difference between internal and external needs. The way we seem to define it, it is the internal need that is the

most significant role that's acted out by the artist. Let's say that you have a vision, a vision that is either in some way obsessive or compelling. You want to manifest that as a primary thing in your life, and whether it is understood, or is responded to, is really quite secondary to the internal need to externalize it. The issue of success or reward also seems to be secondary to that basic need. Its principal psychic intention is to externalize an internal vision.

The reason for the confusion about the two forms is that the training for both is the same. You go to the same art school, you learn the same rules, and so on. But with design, there is also the external demand for transferred information. The graphic artist has to represent something that exists in the world and must be taken from one place to another, has to tell people what's going on, to convince people about a fact. So, design at its best—and it's not always this—represents a synthesis of external demand, which is to convey information, with the internal demand, which is visionary or personal, and somehow fit them together in some way. That, in a crude way, is what the difference between the two activities is.

BLDD: It is said that your work contains a lot of art history references. Tell us about some of them. Obviously, the one most widely referred to is the Dylan poster.

MG: I suppose what you mean by that is the fact that I wrote a little piece on the Dylan poster. Somebody asked me what the inspiration for it was, and I said that as far as I could trace it, one of the inspirations was a cut-out that Marcel Duchamp did as a self-portrait, a silhouette. I had that in the back of my mind as something that I found particularly interesting, and then I combined it with something—I'm very interested in Middle Eastern painting, the Islamic, Turkish kind of color range, those swirling forms, so I did that with the hair.

I always look at the history of painting as just more information, and, as you know, artists tend to learn more from art than they do from nature. For instance, in another poster, the landscape is taken right out of one of Piero della Francesca's paintings of northern Italy. So my feeling about art is that it is, more than anything else, a resource for additional information, and in some way, enriching surfaces, both from a literary point of view and from a formal, or plastic, point of view.

BLDD: Let's talk more about your references. What about American comics?

MG: Well, certainly that. I wouldn't be at all surprised that if you asked any artist in New York what their original source material was, it almost invariably would turn out to be the comics.

BLDD: Lots of writers, too.

MG: Sure. It seems to me that's the way we all got started. The first thing I ever wanted to be was a comic strip artist, and the first thing I ever did that I can remember, practically starting in kindergarten, was copying from the comics. Everything. The Katzenjammer Kids.

BLDD: Often I see the thin wavy lines of Matisse in your work.

MG: Yes, but I think what happens is that you eventually start losing consciousness to some extent of what your sources are. In fact, you can only begin to work when you begin to erode some of the consciousness around the sources, and when you don't say I'll take a little from here and a little from there.

But one of the dangers of an eclectic attitude, of a sense of piecemeal, of putting things together, is that they never come together. They remain undigested pieces of information, and one of the things you have to deal with as a designer is how you make these elements, in some ways, synthesize, so that they don't assert their own authority by reminding you that there's a piece of this and a piece of that. The experience of a good design, at its best, is seamless. You don't know where one thing begins and the other thing ends. You see, the energy and the conviction of the piece has to come through a single experience, rather than through an understanding of the ingredients. It's like cooking a great meal, where you don't really want to be conscious of the separate ingredients, but rather of the total experience that you get when it's properly combined. So, even though the sources of information may be random, the work cannot be successful if the viewer is conscious of their randomness. They have to be, in some way, digested. That's true of a painting as well as of a design.

BLDD: Why do you work in so many styles?

MG: I really can't tell you the real reason. Maybe it is the absence of belief. I really can't believe anything about art, you see, and I don't believe that art is a single mode. I don't believe in abstraction. I don't believe in reality. I don't believe in lyricism, and I don't believe in hard forms. I don't believe in romantic as opposed to classic. I mean, I can't seem to ever come down with a decision about what art really is. I have no convictions about art. I'm convinced it's illusion, and I'm convinced that any belief about art is essentially a way of limiting your perception.

BLDD: You said in the past that one of the things you wanted to avoid is typecasting of your own work. In an interview about a year ago, you said: "The whole trick in life is to disrupt expectations, rather than confirming them. The more specific you are, the more confined you are. It's good to be as fuzzy as you can." What did you mean?

MG: It seems to be a personality issue, and it has to do with your own boredom level. It's like whether you prefer to have steak and potatoes every night, or whether you like to have a change of experience every night. It's really more bound to the peculiarities in one's personality than to any aesthetic position.

BLDD: How much of your work is your personality profile?

MG: All of it, but none of it individually. The real issue of the work is that it represents me in its lack of centered belief, rather than anything else.

BLDD: In your work, what's Square One for you?

MG: Well, one reason I'm a designer is that Square One is always external demand. I mean, Square One is always somebody calling me on the telephone and saying, by next Wednesday I need a cover for something. That's Square One. And it's one of the reasons that I don't work unless I have something explicit to solve.

BLDD: One of your best-known pieces of work, perhaps because of its publishing success, is *New York* magazine. Would you tell us, as best you can, from start to finish, how do you lay out a magazine?

MG: A magazine, like many other things that you get involved with, is a collection of energy and information. The form of a magazine is bound, more than any other single thing, by the time involved in its preparation and the frequency of its appearance. Both those facts have some relationship to one another. Which is to say that a daily newspaper has a different demand, in its formal qualities, than a magazine that comes out every week, and a magazine that comes out biweekly is very different in structure than a magazine that comes out monthly, which has a very different appearance from a publication that comes out quarterly, et cetera.

So the first thing that really is a constraint in designing a magazine is its frequency and the time involved in designing it. To be more specific, in a product that comes out every day, like a newspaper, the reader is much more willing to tolerate mistakes, lack of refinement, crudity. There are many typos in the *New York Post,* but the fact that it's a daily newspaper makes it easy to accept that lack of refinement.

You make more demands on a weekly, particularly when it's a slick weekly. The change of surface in this case from newsprint to slick paper also begins to act upon the viewer as an element. Not only that, but the actual size of the page is one of the considerations of the language you use. It is one of the reasons that *Time* magazine has developed *Time*-eze, which is a kind of condensed language related to the frequency of turning the page. You don't have to condense language as much in a large

format. The way people read is something you have to know. Every time you jump a story, you generally lose 50 percent of your readership, which is to say, if you get a hundred people on page one, by the time you're on page seventeen, you get fifty. When it goes to page nineteen, it's twenty-five, and that's why nobody ever finished a story in the *Village Voice.* At the *Voice* we stopped jumping stories the way they used to. At any rate, those are the considerations that you begin to deal with when you're trying to find out the form for a magazine.

In the case of *New York* magazine, the way I put that together was to make the magazine comprehensible in ten minutes. The requirement is for a very easy reading experience. Here's what you use. You use a system that is very constant. You don't use fancy layouts in a magazine like *New York,* because the issue is not beauty of layout but clarity of information. In order to be clear, you keep all the clues constant. Same size heads. Same size and position of the subheads. The same kinds of captions. And a very austere and unobtrusive design system, so that you're never conscious of the fact that it was designed at all, but rather, that it was put together in the most accessible way. The reader will find that *New York* magazine is very easy to read—at least, I hope it is—that

you get through it very quickly. If you don't want to read it all, you can go through it reading headlines, subheads, getting fragments, and almost experience the magazine in ten or fifteen minutes.

BLDD: How influential is film on your work?

MG: You notice that the illustrations in *New York* tend very often to be a sequence of illustrations. We'll have a visual joke that goes over several pages and pays off at the end.

The thing that's always interested me about magazines is their relationship to motion and time. I remember the thing that always disturbed me most about the *Times* on Sunday was the sense of going through it and saying, "I'll get back to that thing. I'll get back to that thing. I'll get back to that thing." And then never getting back to it, because you just haven't got the time. I always felt terribly guilty as the paper sat on the shelf for the rest of the week, and then, of course, next week was upon me. I really wanted to avoid that experience in designing a magazine. The other model for me, curiously enough, of how not to do a magazine was the *New Yorker.* You never knew, when you're sitting down to read an article, if it's going to take you two hours or ten minutes. I just don't think that in this point in history, people are willing to lose control over their time that way. I felt that the *New Yorker* system, from my point of view, was a very attractive system for another period of time. I still wish we could get the literary quality of the *New Yorker.* But the thing I knew that didn't work for me was the fact that I didn't know how long it was going to take to read, and I didn't know who was writing it.

BLDD: *New York* magazine seems to be far more directed to a mass audience.

MG: No, it's pretty much the same audience in terms of education. And the *New Yorker* has more readers, but of course it's not a New York magazine. It's a national magazine. Nevertheless, the point I'm trying to make is that you begin to design a magazine with those kinds of considerations. Not so much considerations of the way things look on the surface, but more the way people experience their lives now, how much time they have, what they're willing to spend it on, what information they want first. In *New York* magazine, the form is really quite straightforward. Information, hopefully, is put out quickly, accessibly, and that's why it's almost simple-minded in the way the layouts are done. And then, what we try for is much drama and quality in the illustrations or the photographs to get some sense of excitement and interest.

BLDD: Do cover lines sell magazines? How significant is the color of a cover?

MG: Everybody's always looking for a formula that sells magazines, and after all these years of billions of magazine covers nobody knows

anything. There are certain things. I like to think that clear, effective presentation of information in a graphically interesting way works. When you get something that really is thematically right, and the cover line is clear and the image is strong, and the author is known, that combination works. A cover called "The Sexual Diamond" by Gail Sheehy, coming at the time it did, was an overwhelming success. There's a couple, a man and a woman, big type, "The Sexual Diamond," and Gail Sheehy's name—all those add up to a big box office smash. When you have that combination of elements, that's when something really takes off. Otherwise, it's all instinct. I've done over five hundred covers for *New York* magazine, right? I still don't know what kind of success or failure an individual cover might have. However, I do know a cover line that I'm absolutely certain will sell magazines.

BLDD: And what is that line?

MG: Good news about sex.

BLDD: What is the best design in an American periodical that you know?

MG: Well, the *Times* is now beginning to be pretty well designed in some of the new sections that they've been doing. I think the Entertainment Section, Home, Living, Weekend.

One of the curious things about design has been that the best-designed magazines were frequently the ones with the worst, or the least significant, content.

BLDD: What do you call bad design?

MG: Bad design does not communicate its essence clearly. You can have a magazine of very crummy literary material, presented in a very handsome and contemporary way. I've had trouble trying to figure out whether that was good design or bad design. Some things that are scruffy-looking are appropriately or well designed for the scruffy nature of their literary content.

BLDD: You've taught at the School of Visual Arts for sixteen years now. Why do you continue to do that?

MG: I love to teach, and I've always learned something in the process of doing that. And also, just externalizing some of your own obsessions and anxieties in a safe situation, which a classroom can become, is an enriching activity. I teach totally out of my own self-interest. I wouldn't do it if I weren't convinced of its rewards in a personal way. I always test the experience out by seeing if I have more energy when I leave the class than when I go into it. I mostly do, which shows me that something positive is coming out of it.

BLDD: You once did a poster for the School of Visual Art that was not only visually attractive, but was, I always thought, a projection of the

inner Glaser. The caption was, "Our Times Call for Multiple Careers," and the pictorial representation was a juggler, and you couldn't tell quite what he was juggling.

MG: That's very significant. You know, one of the problems in talking about visual stuff is that it doesn't yield to interpretation by discussion very easily. You can talk around the issue, but you can never describe the inner nature of the experience.

BLDD: Let me quote what was written in a catalogue for the show of your work that was held at the Museum of Modern Art: "I think it was something like by the very early seventies, Milton Glaser had become the nearest thing to a cultural hero that American graphic design has produced." What, in your mind, is your most significant contribution?

MG: I think my most significant contribution was in somewhat breaking down the compartments between certain kinds of visual activities that had become rather institutionalized, only breaking them down to a point where they were perhaps back to where they had been in other times. Say, for instance, that in this profession of designer, whatever that is, there are categories of activities, such as illustrator, letterer, art director, et cetera, et cetera. My particular appetite and interest sort of flopped over to many of those. I do art direction and I do illustration and I design letter forms, and I do exhibitions of three-dimensional stuff, and so on. To use the terminology of the sixties, I've become a generalist, a visual generalist, by working in a lot of areas at once, and perhaps demonstrating that the particular parochialism that occurs in the profession is not necessarily a fixed boundary for people, if they want to take the risk of spreading themselves thin or humiliating themselves by doing something badly.

BLDD: Have you had that experience?

MG: Many times. The worst of it was doing *New York*. The first two years, I had no idea what I was doing. I'd never done a magazine before, even though I'd designed elements of a magazine. I'd designed layouts and covers, but I'd never operated at the day-to-day level of producing a magazine. The only thing about that was that my mistakes were visible every week, for two years, and for a hundred issues of that magazine.

BLDD: What were the most glaring mistakes?

MG: A stupidly laid out magazine. Everything was out of proportion. The pictures were always in the wrong place on the page. The type looked lousy. Everything. It was a disaster. I mean, if anyone wanted to learn how to do a magazine badly, look at the first two years of *New York* magazine. Now, the thing about it was that everybody criticized— my friends used to see it every week, and they'd call me up, and they'd say, how could you do something like that? It was a terrible experience. In fact, the only thing I'm truly grateful for is that the magazine didn't

fold after two years, which would have ended my reputation as a maga-
zine designer. At the end of that period, I finally figured out how to do it,
more or less.

BLDD: Apparently. With how many other magazines do you now
consult, as their designer?

MG: The *Voice,* and *New York,* and *L'Express* in Paris.

BLDD: Your work seems more and more to be heading into the en-
vironmental direction. I'm thinking of the space at the World Trade
Center, the monumental mural for the federal building in Indianapolis.
Tell us something about this large-scale work.

MG: A lot of the work for the last years at the World Trade Center
involved big graphics programs, all the menus and the trademarks and
the advertising stuff, but also a lot of sculptural things. Now, have you
seen those big letters downstairs? They are sculptural letter forms, a
combination of graphics and three-dimensional stuff. And I did a six-
hundred-foot mural for the federal office building in Indianapolis.

BLDD: Six hundred feet? What did you do in six hundred feet?

MG: It is a band of some undulating colors that changes from side to
side, and it's lit with a rheostat at night that fades and glows, so from a
distance, what you see is a strange little orange-yellow-blue-green strip,
disappearing and appearing.

BLDD: In a humorous reference, you said that was a job that could
have been done on the telephone. It is a part of your view, and one of
your breakthroughs in design. Do you feel that assistants can color in the
work?

MG: Oh, yes.

BLDD: Can you explain those views, and how you get quality control
when you have a workshop?

MG: A lot of things I don't do myself. I really had to clear my head
about this, because I always felt attached to the issue of the hand-made
object. I finally said, I can get through that. I realized that I had to
increase my productivity, because I was working as hard as I could, and I
was only doing a third of the work that I had to do, and I tried to figure
out a method that would produce more work, maintain the quality, and
still have some kind of authenticity in the way it was done. What I did
was actually very simple. My notion was the same device that animation
uses, which is essentially to establish a skeleton or forms in a linear way,
defined by outline, and then assign somebody to physically fill them in.
In this case, we use a material that's a type of color film that can be cut
out and, with a wax backing, rubbed down.

BLDD: How do you control the quality of the work that someone else
has done for you?

MG: All you have to do is establish the color scheme. You say, use

Y3R here, PG2 here. It's all like that joke, where the people tell jokes that are numbered punch lines. If the guy doesn't laugh, you say, what's wrong? He says, you didn't tell it well. It's the same thing here.

BLDD: What happens if they don't draw it well?

MG: They don't draw it. I do the drawing, and all they do is cut the stuff and fit it. However, the drawing may have taken, let's say, twelve hours. The coloring may have taken thirty. The effect is exactly the same as if I had colored it. Once you get into a form of work where the methodology does not change the intended appearance, then the ideological issue of whether it belongs to you or not is not as critical.

BLDD: Can you satisfy a creative urge and maintain the standards of excellence that you do, and still meet the demands of a client or an advertising agency or a government agency? Are the two compatible? Is it possible to do something that is commercially viable and aesthetically outstanding?

MG: I hope so. If it were not occasionally possible, I think I'd go into another profession. It's only out of the belief that that is possible that I work. The fact of the matter is that design activity requires the foundation of that external demand as part of the central issue of work. One of the problems I have is that there are some clients with whom I am truly incompatible, where the two separate objectives may not line up. All you can do in that case is get out fast.

BLDD: Has any of your work ever been rejected?

MG: Oh, sure.

BLDD: On what basis?

MG: Because somebody didn't like it. Actually, by now, I have a pretty good track record. Mostly, it's because I don't get involved in situations that I can tell in advance are impossible.

BLDD: How did you ever become Mr. Underground Gourmet?

MG: Trick of fate. It happened with an idle street-corner conversation with Jerome Snyder. We were trying to one-up each other as to who knew the most cheap restaurants in New York.

BLDD: Good, cheap, restaurants?

MG: Good cheap restaurants. And with the sudden startling insight that happens only a few times in a lifetime, that everyone in New York wanted to know where the good cheap restaurants were, and nobody was writing about them. Once in a while perfectly obvious things become visible. Of course, art is discovering the obvious. So Jerome and I had this conversation, and at the end of it, I said, "You know, why don't we do a book about this?" And then we started to do it.

We did a book, *The Underground Gourmet,* twelve years ago. We started publishing in the old New York section of the *Herald Tribune,*

things like articles on Princess Pamela's Soulfood Kitchen. We wrote the first articles on Szechuan cooking.

BLDD: What's been the greatest satisfaction in your work?

MG: I guess the greatest satisfaction came from the sense of being useful.

BLDD: And the greatest disappointment or frustration?

MG: I can't think of any really great disappointment or frustration. I've actually accomplished much more than I ever dreamed I was going to. It surprises me.

Thomas Hess

*(Art Critic, Writer. Born Rye, New York, 1920.)**

BLDD: For thirty years, Tom Hess was a principal contributor and editor of *Art News,* and now is a critic for *New York* magazine. He is one of the critical fathers of the New York School of art, he helped to create an exciting, shattering, new visual rhetoric, abstract expressionism, and wrote the first book on that subject twenty-five years ago.

Why don't we begin by comparing the world of New York artists when you started to what it is like now. Was it better or worse?

TH: It was smaller. Of course, there was less money in it. It was a much stronger, local, regional, parochial school, the remnants of socialist realism and regional art. The dominant faces in the galleries—the masters who are now internationally famous, like Pollock or de Kooning— were not so much unknown as beleaguered. Known to the art world public, unknown to the wider public. Being unknown has its advantages.

BLDD: What are they?

TH: You don't have any taxes, and you have a lot of time to do those things that time permits you to do, to be more contemplative. The life of a free spirit is more easy.

BLDD: Your time at *Art News* coincided with what may have been one of the most exciting periods in American art history: when the confluence of circumstances created this new internationally prominent art, with both American and New York art at the forefront. Tell us about some of that, won't you? Perhaps you could be specific and tell us about the first shows of Pollock?

TH: It's difficult for me to see these things in terms of historical events, because they seem very recent. Pollock's first show was at Peggy Guggenheim's gallery on West 57th Street. It was called Art of This Century.

BLDD: How did that come about?

TH: Peggy Guggenheim was a collector and an ardent friend of the

* This interview took place in the Fall of 1977. Thomas Hess died in July, 1979.

surrealist artists. She had been based in Paris, and came here bringing in her train Max Ernst, André Breton, Yves Tanguy, and a number of other European surrealists.

BLDD: This was pre-World War II?

TH: The middle of World War II. I think she arrived in 1941. The permanent collection was the star attraction and included all the great surrealist artists, de Chirico, Paul Klee, Max Ernst and Dali and Marcel Duchamp.

Peggy Guggenheim felt a certain responsibility to America and American artists and wanted to show them also. She had as adviser a very far-seeing dealer named Putzell, who in turn was a friend of John Graham's, who in turn was connected with the downtown artists. She showed Jackson Pollock, also Clyfford Still, Baziotes, Robert DeNiro, his wife, Virginia Admiral, Hans Hofmann, and others.

BLDD: Was there any sense of the importance of what was happening at the time?

TH: Well, it all seemed terribly important. It probably seemed more important then than it does now, because now the importance seems historical, which I find trivial, or monetary, which is incomprehensible. It seems very important in terms of someone finally making it, or breaking

through the rather icy reserves which bound the art world. It's very difficult for an American artist to be shown at all, outside of the accepted idioms of a kind of romantic realism or socialist realism.

BLDD: The *Art News* review of the first Pollock show was rather critical but quite on target in identifying this new talent. At the time, it was the custom to quote prices. His upper limit was $150.

TH: I married my wife in 1944 and we bought a Pollock at that time. We bought it reasonably, I don't remember the exact price, but then it seemed like a lot of money.

BLDD: What part did criticism of the time play in developing that work?

TH: Criticism is a curious force. Dumb criticism has no impact. On-target criticism facilitates something that might happen anyway. Pollock was covered with invective by critics who were totally unprepared for his approach, who were still having a great deal of difficulty with the Matisse of the 1920s and with Picasso. Critics in the *New York Times*, the *Herald Tribune*, the *World*, the *Sun*, and *Time* Magazine.

BLDD: What about the early action painters attracted you?

TH: I object to the whole phrase, action painters, because I don't think it means anything.

BLDD: You helped disseminate it to the world.

TH: I never used it. I published a lot of things I don't. . . .

BLDD: Perhaps we should explain what we're referring to.

TH: It's a phrase coined by Harold Rosenberg in an article which was brought to my attention by Elaine de Kooning; it was a very well-written article which I was happy to publish, over the dead body of the then editor, I might say, who objected violently to it. But I never thought the phrase action painting meant a hell of a lot, because it referred to an idea of the painting in the process of being painted. It did not refer to the finished picture, and it could not account for the art.

In theory, the painter gets himself into a kind of creative state. He confronts his blank canvas. He is seized upon by certain spiritual, psychic forces, the painting comes out, and that's action painting. Then this thing happens again. Now the problem is, these paintings look exactly alike. It's funny that these creative forces and psychic energy should all be repeating themselves. I mean, there's something else at work. Quite obviously, there are styles at work, pictorial intelligence is at work, planning is at work. It's not at all a matter of Zen—just throwing darts. It's a matter of pictorial thought.

Writers often can't conceive of visual thinking. That is, I think, the problem. They think if a person doesn't verbalize in an *a* plus *b* plus *c* plus *d* formulation, there's no thought going on at all.

BLDD: What would have been a more apt term to describe that school?

TH: Abstract expressionism, for all its faults (it's an old term, formulated by Kandinsky to describe his works), is close enough. New York School is being used now. It has a funny sort of ring to it, like Ecole de Paris in translation. It was, I think, coined by a dealer on the West Coast named Frank Perls.

BLDD: You've not only written criticism and books and edited magazines, you've also developed the concept and arranged for exhibitions in various museums. Tell us about the very significant show currently in Albany titled New York, the State of Art. How do you define the New York experience? What does that show mean?

TH: Actually it's three shows. I'm only doing one. There's a show on folk art and there's a show on the Hudson River School, and there's a show called the New York School, which is painting and sculpture, which I'm doing. There are 40,000 square feet of raw space, totally empty space. It's the Empire State Museum, and it's just vast. I mean, it's Nelson Rockefeller's idea of what a museum should be. It's enormous. We have about a hundred works of art, several of them over a hundred feet in length. One is so long no one's been able to measure it. They keep losing bits of it, you know. It's this huge piece by Jim Rosenquist.

BLDD: Who is featured in this exhibition?

TH: We start with Gorky, a very beautiful picture called *The Diary of a Seducer,* and end with the generation of Richard Serra, Jennifer Bartlett, that group of people—young, under forty. There's been no attempt made to get into the very interesting, even younger group, like Mary Miss and people like that.

BLDD: What were the criteria for inclusion in this show?

TH: Well, there are no criteria. I really don't believe in criteria. I was looking to get a lot of big pictures together and see what it looks like. One of the characteristics of New York painting was scale. That's a very interesting problem, because there was statistical background and there were technical imperatives which we can go into. To oversimplify. In this kind of situation everything has to be oversimplified, and everything is slightly wrong, but you start throwing paint on the floor like Pollock, or you paint uninflected, even strokes like Newman, or you wash the colors on like Rothko, or you push enormous brush marks like Franz Kline. You are flattening what we call virtual space. Virtual space is the illusionary space the artist plays with on the flat canvas. Actual space is the real flat canvas.

Virtual space starts to approach an identity with actual space. In other words, the forms get flatter. Now when this happens, obviously, logically

the image should get bigger. And it did. It got bigger and bigger and bigger. The image at first was kept within certain limits by pure economic necessity. People couldn't afford the large studios. Later, there were technical problems. Canvas only came in certain widths.

Little by little, these various technical problems have been overcome until you finally get the painting moving outside a frame into hundreds of feet. But this is not a purely American situation. It is also deeply rooted in the European experience.

BLDD: With what examples?

TH: Ever since the Academy there was a thing called the Salon, where everybody showed their art, and in the Salon the big painting was the prize-winning, the most important picture. It was a thing called *the machine*. It was traditional in Europe: the large picture. the complicated scenario. with architectonic composition. many small parts cunningly fitted together. complicated subject matter. Picasso's *Les Demoiselles D'Avignon*, Matisse's *Le Lux*, the large paintings by Miró. Cézanne's *Bathers* are basically Salon machines. although they are antiacademic. A third very important influence is from the Mexican socialist realist movement. It had the idea of educating the workers. the revolutionary proletariat. through images on city walls.

All these complicated lines meet in the ambition of the New York painter to make a large painting. And I wanted to get as many of them as possible together and look at them to see what they had in common. how they compared to each other. what the cross-references would be. and also. given that scale as a denominator. casting that out. what's left? In other words. the mysterious issue of New York light. things like that. An interesting show. if you're interested in New York painting and sculpture. Lots of sculpture too: Alex Liberman. Oldenburg, Grosvenor. Serra. Morris. Mark di Suvero.

BLDD: Have the standards of judgment that we, or you, use now become different during the course of the last thirty years?

TH: It's a difficult question. As one gets to know more, one can bring to bear more facts and ideas upon an issue. Of course, the more one knows, the more one forgets. I think one becomes less and less sure, which may be a form of wisdom or just a form of cowardliness, I don't know.

BLDD: In your experience and in your opinion, does the writing report, reflect, or create—that is, help validate and certify—the art?

TH: Writing doesn't create art. No, art does itself. You can't give out any visas or passports. Writing about a work of art is like writing about anything, writing about a character in a book, a landscape, a view, a window in Africa, a fictional idea. Writing's just plain writing. If the

subject matter is art and the writing is accurate about the art, it will be convincing, just as a character in Tolstoy is more convincing than a character in a detective story.

BLDD: Who have been your principal critical ancestors?

TH: Well, when I was young, I liked, of course, the great people like Baudelaire, and some of the Germans, for instance Burckhardt, Riegl, Wölfflin. Just standard. Meyer Schapiro, Alfred Barr. I read the English, like Frye and Bell.

BLDD: Herbert Read?

TH: No, I liked him as a novelist and a poet. I didn't think he knew anything about art.

BLDD: I hear discussed more and more that there is a dearth of new critics, not only in the visual arts, but in the performing arts and literature as well. Do you agree with that?

TH: Oh, I think dearth is a perpetual condition of everything. There's a dearth of artists, a dearth of sculptors, a dearth of critics. People say when there's good art there's bad criticism and vice versa—I don't know. It's almost impossible to judge your immediate contemporaries. It's certainly impossible to judge yourself. I think there's a lot of good criticism today. There seem to be fewer artists writing about art today than there were.

BLDD: And how do you explain that?

TH: When I was hiring reviewers, I tried to hire artists. I think they're extremely good. They bring a sense of actuality, a sense of describing a work so that you can see it. A lot of them had bad experiences. They became tight as writers, and they had trouble making it as painters.

BLDD: Over the years you did engage a number of artists as critics: Robert Motherwell, Robert Goodnough, Fairfield Porter.

TH: I think you'd find a lot of them, if you'd talk to them, would say it did not help their careers.

BLDD: And what was the limitation? The ability to be so articulate?

TH: When you get down to selling pictures, you get down to the basic prejudice of the public. And it seems the public doesn't want smart-ass writers as painters. They want their painters to be dumb. This is an idea. I'm not sure it's true. Sam Kootz told me you just can't sell a painter who's a writer. To me that's a ridiculous idea. But there you are.

BLDD: John Kenneth Galbraith said in his *Galbraith Reader* that the public still wants the artist to be poor, that we want him always as the supplicant. Do you think that still holds true?

TH: I notice writers who would like the artists to be poor. Writers, especially of the *Partisan Review* sort, intellectual writers, think it's outrageous that these noodniks are making a fortune.

BLDD: Since *Partisan Review* pays a penny and a half a word, one can understand why.

TH: And I think the public has a love-hate relationship to rich people anyway. I don't think they care about artists any more or less than movie stars or automobile racers.

BLDD: Do you think they're considered that glamorous by the larger public?

TH: I just don't know. I don't know. Have they heard of Calder? Picasso? They've all heard of Picasso.

BLDD: Picasso and Dali. Were you ever an artist?

TH: Yes, I did some painting, when I was at the university.

BLDD: Who principally formed your vision then?

TH: Picasso. And Klee. I liked painting very much. Applying paint to canvas. Our history teachers at Yale urged us to paint. I would urge anybody who wants to be an art critic to try all the mediums. he should know how to do oil painting, frescoes, watercolor.

BLDD: Why did you stop painting?

TH: I didn't have anything to say. I had no subject matter.

BLDD: By all accounts, the current period in art is one of diversity and eclecticism. How do you see it now and where do you see it going?

TH: A critic who prophesies the future is trying to snow you. That's a rule of thumb. Don't believe him. Because no one knows what will happen. It seems to me we have a very eclectic situation now, but I'm not sure that the present does not always seem eclectic. Things aren't sorted out.

BLDD: In more recent times, there seems to be a movement away from art as a precious activity, beginning, I guess, with the period of the action painters, and currently taken to the extremes of self-mutilation, in some cases. What observations do you have of any of these new art forms? I'm thinking of word art, performance art, the new importance of photography, or architectural drawings. Why don't we start with word art and performance art?

TH: They all seem valid. None of them seem terribly new. Anybody who's read *Alice in Wonderland* got a lot of word art. There's a whole English nineteenth-century tradition of nonsense word art. And Marcel Duchamp played with it. In other words, the Americans have a capacity for reinventing the wheel, so to speak. Picking up a European idea and doing it afresh, as if it had never been done before. There's a kind of joyful innocence to the American artist. So I think he could reinvent that. The word.

BLDD: What about performance art?

TH: Going back to the Greeks, theater is a visual pictorial thing, which has a dramatic space to it, which isn't the space of reality. It's a visual space. Visual artists tend to get mixed into the theater. They'll do scenery. They'll do the theater architecture, like Palladio. They may become actors, mimes. They may paint themselves, like Red Indians or certain religious sects, Africans, Eskimos. These things, I think, are just normal human creative behavior.

The one difference is, in the last two hundred years, there's no religion informing it any more. We live in a fragmented society, and the artist can't get a sanction from a priest or a king.

BLDD: What do you think of the new importance, not so new any more, of photography?

TH: Photography is, I think, just debased painting. We all love debased art, so we all love photography. No, photography is just a form of image making. It's square, because paintings are square. You know, the lens is round and the photograph should be round, but a square frame is put behind the lens, just as if the picture had a frame, which gives you a square or rectangular photograph. And then, they're usually composed like a painting, except that instead of going to all that dumb work, you click, and it's terrific. I've almost never seen a photograph I don't like. It's a very, very low level of art.

BLDD: How about architectural drawings, this season's phenomena?

TH: They can be very interesting. We were talking a moment ago about art as it approaches theater. These drawings are art as it approaches science, as it approaches math—geometry, engineering and, today, the more advanced technologies, like computerized researches on materials.

BLDD: What about that failed revolution of the sixties, that promised revolution of the influence of technology on art? Do you see that as having a second coming?

TH: Oh, it's wonderful. I hope it comes back. Because the technology never worked. All that techmatic art, it was all busted within two minutes. I mean, the art was great, but the motor stopped functioning. I liked that. It absolutely has a great future.

BLDD: Turning to the Museum of Modern Art, what do you see as its future direction?

TH: I think they should limit their collection to, say, 1870 to 1970, like the Musée Jeu de Paume, which is impressionism. And cut it off. Or sell the early stuff if they want to, but at least limit themselves.

BLDD: Are you saying they should be a museum of modern art rather than of contemporary art?

TH: They should have some limit. They can't be in an infinitely big collection. Then they should have an exhibition space outside, but not a tower, so that traveling shows can be held, by the Guggenheim, the Modern, and the Whitney together. These things are liable to solution.

BLDD: Do you see that, by the way, as the future direction, cooperative shows between the museums?

TH: Oh, sure. I think they'll have to get together. In small towns, universities and museums will get together, and in large towns the museums themselves will get together, like they already have in San Francisco. There's one museum directorship for three museums.

BLDD: Are you suggesting that the future of the museum is as an educational institution, or that it always was one?

TH: In small towns, I think it's a waste of money to have an art history department and a bunch of curators in a museum. Because of the socialist nature I foresee for museums, they will be funded by the various municipal, state, and federal entities. In order to justify their funds, they're going to have to show some social function. Now, they just can't take their Giottos and parade them around the streets of the town. They're going to have to go out to the classrooms and educate the people in the classrooms and bring them into the museum and with all that closed television stuff and videotapes, they'll have to do all that in order to show that they should get money.

BLDD: Is it the Department of Health, Education and Welfare, in its education arm, or the new Museum Services Institute that you see as a possible funder for these museums?

TH: I don't know enough about it. It works differently in different countries. In England it's under the Ministry of Education. In Italy, I think there's a minister of culture. In France, there's a complicated pyramid which goes to the cabinet level.

BLDD: How can we pay for all our cultural activity?

TH: We'll pay for our own museums by taxes. It's not very much money. Oh, it's such a banality. We'll build three less bombers. It's not very expensive. The problem is to run them, I think. In other words, the problem is these bureaucracies the government builds up, with incompetence at various levels. And that's where you get trouble. Although you can get very good people too. I'm talking about the European experience.

BLDD: Some museums are now considering the solution of a paid president and a paid director, one being the administrative director and the other an art/architectural historian. What do you think of that as a solution? Can the art historian make aesthetic judgments without the administrative director, who will ultimately be the fund raiser, either approving or vetoing the amounts of money for any show? How do you see that?

TH: Short range, I think they're going to do it. I don't think it's a very good idea. The big job is fund raising. The way to raise funds, I think, is to speak with conviction, and the only way to speak with conviction is to know what you're talking about. And they think that conviction comes not from knowledge but from a kind of eloquence, which I think is a mistake. I may be wrong.

In the long range, I think it makes very little difference. These things do work out.

BLDD: You are the acknowledged authority on the work of de Kooning. Not only did you write the first monograph about him in 1959, almost ten years later—I believe it was 1968—you directed the de Kooning international retrospective for the Museum of Modern Art. In your book on his drawings, one of your interesting insights was the analysis of what the woman really means in de Kooning's works. As I recall, you likened it to Albers's square.

TH: He talked to me about this, and his idea was that an abstract painter has to invent all these shapes out of himself. So he is really faced with a whole group of nonpictorial necessities. (Now we're talking about pure art.) He's faced with a lot of impurities whereas he, de Kooning, takes a woman who has a forehead, two eyes, a nose, a mouth, ears, and

so forth. That's his given, his hypothesis, and from there on, he can take it easy. Then he can paint, you see, and everything is pure painting. That was his distinction. Critics such as Clement Greenberg would say the introduction of a female head into a modern painting is anomalous and is an impure literary quality, and so on.

BLDD: Is it analogous to the Albers square?

TH: As it is a format, a given format, yes. Because a face is a format and a figure is a format.

BLDD: Can you give us some idea of your view of the influence of de Kooning on three generations of artists?

TH: It's difficult to consider that, you know. An artist influences other artists in many ways. Just by being there and doing something. He can influence an artist who is doing something entirely different just by his presence, if there's someone working who is getting through. In America there's always a great doubt about the very possibility of existence as an artist. Stuart Davis once said that when you go back to your hometown, they ask, what are you doing, and you say, well, I'm an artist, and they want to know, what you are *really* doing. Whereas in Europe, you say, I'm an artiste, and they answer, it's good, you can charge the groceries.

BLDD: Do you think those roles are reversed? Continentally, now?

TH: No. In New York, maybe. But New Yorkers are not very aware of what's going on outside of New York.

BLDD: Is New York still necessary?

TH: Well, capitals are essential in modern culture, yes. The cosmopolitan capital.

BLDD: Is it still necessary, for an artist to make it, to make it in New York?

TH: Making it is one of the more vulgar concepts we have. No, I don't think so. You mean financially making it? Making a lot of money? You can make a lot of money without ever coming to New York. There is an art world that we don't even know about.

BLDD: The rise of alternate spaces is obviously significant and worthwhile. They have made a dent in commercial gallery importance. Or have they?

TH: To go back to our idea of scale, where we were long ago: all modern artists long at some point to be united with society, to have the role they had in the Renaissance, when they could go to a church and paint a Virgin and Child. Well, one of the things the artist longs for is to get back to the common man, to get back with the workers, to get back on the street. So artists are apt to wear workers' clothes, drink in workers' bars, use workers' language, and it's a very conscious kind of nostalgia for what we all think was an Arcadian moment in history.

BLDD: Does that explain this rather *homey* movement?

TH: I think also the alternate space lets you get out of the sort of miserable asceticism of the art gallery. The whitewashed walls begin to hurt your eyes, and then everything seems so manicured. You really want another reality.

BLDD: With the limitations of space of a weekly column, the fact that there are so few of them, and in spite of the fact that you, Tom Hess, are continually looking at new work, how does an artist yet to command wider attention hope to gain your attention?

TH: Usually artists make themselves known through other artists. What mostly happens is that an artist comes around, starts to work, meets other artists, they talk, and then an artist becomes known among artists. And one of the artists has a gallery—it's really a system of mutual help. Then there's usually an exhibition of some sort, and it's got a lot to do with temperament and personality, so mistakes are made. A lot of people we all think are wonderful are just wonderful people and their work isn't so hot. But that's okay because maybe the work is hot after all. Things change, opinions change very quickly. In twenty or thirty years, one changes one's mind.

BLDD: The most recent minority expression in art is feminist perspectives. A while back, you edited, along with Linda Nochlin, a work that was called *Women as Sex Objects.* Certainly feminist perspectives have contributed substantially, to a new way of analyzing art. Do you find that there is a change in art making as a result?

TH: Yes, I think there was a change in art making. Whether you can will subject matter at all is problematical. Whether you can will any logical subject matter is even more problematical. I think the feminist movement made us aware of the very great difficulties under which the women artists worked in the past. The question was, why have there been no great women painters? And the answer was, why have there been no great Eskimo tennis champions? I think there weren't any great women painters. They really are not very good artists, and of course, as Linda Nochlin pointed out, they weren't allowed to study from the nude in a day when the historical painting was the best painting.

BLDD: So what they had to draw were cows.

TH: Or still lifes. Or portraits. Mostly portraits, or landscapes.

BLDD: Describing a show of women artists, you said much of it was third-class work. What do you consider first-class?

TH: You talk about the level of Titian, let's say. You look around and what have you got? You've got Velasquez, Rembrandt. And then at the next level, someone like Guardi. Guardi obviously is not as good as Titian. Right? So you look around and you find someone like Pissarro

maybe, along with Guardi. That would be second. Or Juan Gris. Then you go a little below that and you get other very excellent artists, very good artists.

BLDD: We are constantly bombarded by a whole range of visual imagery. What will the effect of this vast array have on painting in the future?

TH: It's a very good question and many people have talked about this—especially the effects of television and movies—they've talked about the lack of reading and the increase in visual material, the retinal bombardment. And everyone agrees it's bound to have some effect. Now, you could have a kind of nausea with the visual, or you could have a craving for the visual and turn to very stark realistic painting. Who knows?

Robert Indiana

(Painter, Sculptor. Born New Castle, Indiana, 1928)

BLDD: Robert Indiana, the man who invented *Love,* also created a mainstream in the river that was pop art. Words are central to the entire body of his work and the cornerstone of his highly personal and paradoxical work, work that vividly evokes the signs and the slogans of American life.

Of course, your most widely-known work is *Love.* Perhaps we should begin by your telling us how you happened to create *Love.* What's the evolution of that emblem that has been given, I guess, the widest public exposure of any work of art?

RI: It all started probably a long, long time ago, and it comes, of course, from a spiritual rather than an erotic beginning. When I was a child, I was exposed to and involved in the Christian Science Church, and all Christian Science churches are very prim and pure. Most of them have no decoration whatsoever, no stained glass windows, no carvings, no paintings, and in fact, only one thing appears in a Christian Science church, and that's a small, very tasteful inscription, in gold usually, over the platform where the readers conduct the service. And that inscription is God Is Love.

Well, a few years ago, in the mid-sixties, I suppose, a wealthy Seventh Avenue dress manufacturer who makes his home in Ridgefield, Connecticut, and who has long been a patron of the Museum of Modern Art—in fact, it was his fund which permitted the Museum of Modern Art to acquire its very first Indiana, what has now become *The First American Dream,* although it was at that time just *The American Dream—*

BLDD: You're talking of Larry Aldrich, I assume?

RI: Yes. And Larry had the inspiration to expose his rather large private collection to a broader public. There happened to be a building available for this in Ridgefield; it had been a grocery store back in the early nineteenth century, run by two Revolutionary War veterans. This grocery store, later on, some time in the 1920s, became a Christian Sci-

ence church. Then the Christian Scientists wanted better facilities, so they built themselves a new church next door.

I was at a party at Andy Warhol's old factory, and Aldrich was there. I didn't know him very well, but well enough to confront him. I was a little piqued because he had no Indiana, and I thought he should. I told him that an excellent opportunity was forthcoming for a special Indiana, because since he was making his museum in a former Christian Science church, I had an idea to do a very special painting just for him. And that was the reversal of the religious motto. My painting read Love Is God instead.

That was around 1964. Actually, I had done a small *Love* painting in 1962, but that was an incidental painting in a long stream of small canvases. Although the *Love Is God* canvas bears no relationship to what has now become a logo, it started me thinking about the subject of love. I had been at one time employed as a typist for the man who was to become the bishop of California—then Dean Pike, later Bishop Pike, and now in some area of sainthood, I suppose. He, of course, was greatly involved with the subject of love, particularly from an ecclesiastic standpoint.

All these things kind of came together. I like to work on a square

canvas, since the way I put the letters down, it is the most economical, the most dynamic way to put four letters on a square canvas.

That is how the *Love* came about.

BLDD: Did you ever expect the image to be received the way it was? Did its success surprise you? And does it please you?

RI: When I did the first *Love,* or the first *Loves,* no, I wasn't thinking at all about what would happen. However, just as I was tackling the subject, I was invited by the Museum of Modern Art—and I was already in their collection with a sculpture and a painting—to design a postcard to benefit the Junior Council and therefore the museum. And on my desk at that particular time, or on my painting table, were *Loves* that I was doing, and the thought occurred, what better subject for a Christmas card. Now, this actually preceded my 1966 *Love* show, and that Christmas card at the Museum of Modern Art became the best-selling Christmas card that they were ever to commission.

BLDD: In what color was that card?

RI: In what I consider the prime *Love* colors, red, blue, and green.

BLDD: Why did you choose red, blue and green? Your work is so personal, so idiosyncratic, that I assume it was not accidental?

RI: No, not at all. Most of my work is very autobiographical in one way or another. In the thirties, my father worked for Phillips 66, when all Phillips 66 gasoline stations were red and green: the pumps, the uniforms, the oil cans. Frank Phillips, who founded the company, just had a thing about red and green, and as soon as he died, the company changed everything. There was no longer any red and green.

But when I was a kid, my mother used to drive my father to work in Indianapolis, and I would see, practically every day of my young life, a huge Phillips 66 sign. So it is the red and green of that sign against the blue Hoosier sky. The blue in the *Love* is cerulean. Therefore my *Love* is a homage to my father.

BLDD: Why did you tilt the O in *Love?*

RI: That was a part of the most dynamic arrangement, I believe. I never paint with stencils, but I design with stencils, nineteenth-century brass stencils. And when I was playing with the stencils, this was certainly the most effective and most dynamic way to arrange them. You can't really play with the other letters. The O is playable. However, that was not an invention of mine. The tilted O is a very common typographic device, and though I've never been per se interested in typography, I do know a little bit about it.

BLDD: Do you think that your work is close to typography in its design?

RI: Well, certainly the *Love* looks like a typographic exercise, but in

most of my other paintings, I don't think that necessarily comes to mind, because in all of them except the *Love* there's more play of composition and forms and shapes. The words usually occupy a much less dominant position.

BLDD: It may be that *Love* was the best-selling Christmas card, but it was certainly the best-selling Valentine's Day stamp that the United States government ever had.

RI: Yes, the stamp became the best-selling commemorative stamp the government has ever issued, except for Christmas stamps. It finally got to a printing of 333 million since it was issued in 1973.

BLDD: Have you benefited by this mass commercialization of *Love?* What royalties have accrued to you?

RI: Well, most of the *Loves* that people see probably are ripoffs—hippies patches and wastepaper baskets and paperweights and what have you. Nothing of that ever comes to me. The postage stamp is obviously the biggest burden. Out of 333 million stamps, I collected a designer's fee of $1,000.

BLDD: Obviously, the work was not copyrighted. Is that correct?

RI: That was the initial problem. With the copyright laws, every single thing has to bear the copyright notice. Well, when I first did my *Loves,* the thought never occurred to me. Then, when I tried to protect myself by putting the notice on things, it was already too late, because if one is in circulation, it already becomes public domain. There is a way of protecting oneself against defamation. There's a rather well-known print, designed by a young man who was on the staff at the Museum of Modern Art, which said something other than Love, and it wasn't really such a nice word—

BLDD: Another four-letter word, that isn't free?

RI: Yes. And that could have been grounds for some kind of defamation, but I'm not a fighter and I don't like to go to court about anything, so I just let it go.

BLDD: Do I see on your recent works, though, a little copyright insignia?

RI: Now I know better.

BLDD: What does that little © do for you? How does it protect you and how does it work now?

RI: That's a sore point for me, because it's caused me so much damage and grief. And it continues to be a sore point because the copyright laws, as they exist in America, are primarily designed for people who write books and people who write music, and who cares, on a book, if there's a legend that says copyright or a C with a circle around it? When it appears on a book, it is not obnoxious. First of all, it can be in type so small that you can hardly see it. However, when one does a painting, when one

does even a print (and it's the prints that become the crucial aspect because they're in a sense duplications), then this legend, this copyright, or the C with the circle around it, with the date and the person's name, has to appear on every single piece of art, or else the art has entered into public domain. And that's the embarrassing aspect.

BLDD: How involved are you in the issue of artists' rights now, and what do you see as the future for the individual artist and his art?

RI: My last involvement was a panel at the New School for Social Research. I'm essentially neither a fighter nor an activist. I'm very much of a pacifist, and I like to spend most of my time in my studio. I think it's fine if crusaders want to get out and fight the battle. I'll endorse these things. I'll support these people. I'm not going to go out with a placard myself and picket and so forth. It's not my style, that's all.

BLDD: do you see any way to enact into law, rights that would accrue to an artist, for either the resale of his work or the reuse of his work by the purchaser, the collector, or the dealer?

RI: There are different means of doing that. First of all, California has enacted a law which attempts to cover some of this territory. Also, one of the other panelists at the New School mentioned that when she sells a painting, she makes the person who buys the painting sign a certificate that they will do this and they will not do that. I don't know how legally binding that sort of thing is, but obviously there needs to be some kind of national legislation. As with every potential legislation, there will be lobbyists pro and con. The first people who come to mind are the dealers. This makes a complication, which I'm sure most dealers are not too wild about, and then the really high-powered collector, he who does a lot of collection—a Mr. Hirshhorn, for instance—isn't going to be ecstatic about that law.

What amazed me at that panel at the New School was, when there was a vote of hands taken—and one-third of the people there purported to be artists—there was overwhelming opposition to the law. A lot of artists aren't too keen on the idea.

BLDD: Why?

RI: It depends on where one is on the professional ladder. If Robert Rauschenberg is asked, when one is bringing prices the size of his, it really makes a difference. Five percent of $100,000 is a sizable amount of money. For the beginning artist, who is struggling and having a hell of a time selling *a* painting, those kinds of things are like sand in the eyes. It only makes it, in their viewpoint, more difficult to get started. Now, obviously, if this were the law of the land, people would bend.

BLDD: Robert Indiana, how did you come to be named after a midwestern state?

RI: I took the name. I didn't start out in life as Robert Indiana, but at

an early, early point in my career in New York City, there were already a
number of recognizable artists who had my own rather common name,
and I just thought that was going to be an awkward embarrassment and
a disadvantage. I wasn't particularly fond of the name anyway. And
given the fact that it was an old Renaissance tradition, when people were
taking names in the first place, to borrow from one's immediate geogra-
phy, and since I did come from Indiana instead of Nebraska or some
place like that—presto: Robert Indiana.

BLDD: It's been twenty years, as I recall, that you've been Robert
Indiana. How do you compare your life as Robert Indiana to that of
Robert Clark?

RI: Well, Robert Clark didn't really exist artistically. It happened at a
psychological moment when, after struggling as a student, struggling for
my own artistic identification, not for the main identity itself, things were
just coming together. I could feel that something was going to be hap-
pening shortly, and I didn't want to have something nice happen with
the burden of a name I didn't like. And it was just like going through a
revolving door from night into day. The first thing that happened was
that the very first major painting I sold in New York was sold to the
Museum of Modern Art.

BLDD: Which picture was that?

RI: That's *The American Dream.* And that just doesn't happen to
everybody; it was an incredible stroke of luck. You know, there is a
magic, there's a definite magic to names. In fact, one of my most recent
canvases celebrates that fact.

BLDD: Do you want to tell us about that?

RI: It started out as a print, and that's not usually how I work. My
prints usually follow my paintings. But this was a commission from a
publisher in Germany, to celebrate Picasso's ninetieth birthday, and I
really don't feel honored very often, but this really did seem like a little
bit of a special thing to have happen, because the first person asked was
Miró, and all of Picasso's immediate close artistic friends. I think even-
tually something like sixty artists contributed to that portfolio. I did
mine—unfortunately, I'm a procrastinator, and I kind of drag my brush,
and it didn't get done until after his death, so his death date is worked
into the painting.

But in thrashing around for a theme—I mean, how do you deal with
the subject of Picasso? It's so big. I could have done a portfolio on
Picasso—what occurred to me was, Picasso was a name changer too,
having started out in life as Pablo Ruiz. Some of his early canvases were
signed Pablo Ruiz. I can't imagine that a man could have achieved what
Picasso achieved with an unpronounceable name, at least for the En-

glish, and the change certainly was magical for him. It also was extra magical because the PP, Pablo Picasso, back to back, is a mirror monogram. And, just by coincidence, he was born in 1881, which is one of those rare mirror dates that anyone can be born on, so I would say, somewhere up there the stars were fixed for him.

BLDD: When did you choose this particular form of expression, the use of the word, that is so incorporated in your work?

RI: In the late fifties—this was during abstract expressionism—everybody was dripping and dragging and doing something tortured to their canvases. And those canvases were getting bigger and bigger, and if you wanted to hold your head up in the artistic community, they really had to cover a wall.

I was working part-time in an art store, selling art supplies, and I didn't have money for large canvases or for all that paint, whether it would be Duco or what. So in my native urge to economize, I simply looked about, and there in front of my studio, down on the New York waterfront, were all these nineteenth-century buildings being demolished. Here was all this gorgeous debris. Beams, pieces of iron, stencils, all kinds of treasure, and since I am basically a keeper, I collected this stuff and, of course, once it was in my studio—well, after amassing a certain quantity, what do you do with it? The forms which were most beautiful were the beams from these old buildings. And they were beautiful because not only did they have a gorgeous patination—the rain dripping on them, the age, they were all well over a hundred years old—but they had this peculiar shape on the top called a haunched tenon, which is simply the key for fitting one beam into another beam. There would be the female piece, and there would be the male piece and the two would lock together thanks to some very skilled rudimentary carpentry provided by Scandinavians at that time. I set them upright, and they really did look like hermae, the classical marble sculptures which would be set at roadsides and so forth, as road markers to the next town. I'd studied Latin for four years in high school and was very interested in the classical period. I thought I was updating the herm, for in those days you had to really think hard, because everybody was doing something, and if you wanted to be original or contribute something fresh, you really had to scrape pretty hard.

BLDD: Those hermae, or wood constructions, did you consider them sculpture?

RI: Of course.

BLDD: And they incorporated the word as well?

RI: They were not only sculpture in themselves—there was this key at the top—but then the beam itself had the female indentations in it, into

which the other part would fit. And then I myself took a knife and I made extra carvings on these pieces. As I said, they were beautiful pieces of wood. I used only rusted iron. I put rusted wheels on them and various other elements. I grew a little weary of that because, as you can see, I do like color.

And so, around 1959, color started to appear on these early constructions. Somehow, polychrome sculpture is not, or at that time wasn't, too abundant. That was rather a different approach. And the word appeared. Now, exactly why the word appeared, I'm not sure, but after all I was basing them on hermae, and hermae were the road signs of antiquity; my hybrid accepted the cross-fertilization of our own contemporary American road signs. Since columns are about this wide, the word couldn't get much longer than Love, but most of them were really three-letter words: Eat and Die were two of my favorite words at that time.

BLDD: Why those particular words? They are among the recurring themes in your work.

RI: Well, Eat and Die became part and parcel of my *American Dream* series, which greatly preceded the *Love,* and which I consider my major involvement in my work. I'm up to the sixth *American Dream* now. Eat and Die, in particular, stem from the fact that "Eat" happened to be the very last word that my mother said to me before she died. That stuck very, very vividly in my mind, and I think that accounts for it. However, Eat-Die obviously has something to say about the consumers of America and maybe the destiny of all organisms.

BLDD: In 1957, when you were sculpting and working with these found materials, you were living at Coenties Slip, and at that very same time there were a group of artists living there together. Who were they, and did any of them influence your work, or vice versa?

RI: Oh, enormously. Coenties Slip is the first slip below Wall Street. It's three blocks north of South Ferry, where you catch the ferry for Staten Island. And at one time, there were about a dozen slips. Most of them have disappeared. In fact, Coenties Slip itself has practically disappeared in urban rejuvenation.

But let me digress just a little bit. When I was working in that art store on Fifty-seventh Street—it's disappeared now, it was called Frederick's, and it was down the street from the Art Students League—after three years, I was allowed to decorate the window. One of the postcards I put in the window was Matisse's *Still Life of Oysters*, and one day someone came in and asked for that particular card, and that someone happened to be Ellsworth Kelly. Ellsworth had been living, not on Coenties Slip but on Broad Street, for maybe a year or so. He'd had his first New York

show at Betty Parsons' gallery and, although I didn't know it, was an established member of the art community. I told him my problems, and he was sympathetic. I was being thrown out of my loft on Fourth Avenue, and I desperately needed a new place and he said that there were hundreds of empty lofts down where he lived. So he made contact with someone he knew, and there was a loft immediately facing the river. From the front window one could see the Brooklyn Bridge and hear all the tugs going by and the ships, and it was just about the most romantic setting one could imagine. I went to the landlord and he said you can have the place for $35 and I'll put in the three front windows. Or you can have the place for $30 and you put in the front windows. So I took it for $30 and put in my own front windows.

Ellsworth very shortly thereafter moved to the Slip himself, and he was followed by Jack Youngerman, for he had known Jack for about six years in Paris. And both Youngerman and Kelly had absorbed enormous influence in Paris. They were still of that generation to whom Paris meant something. To me, Paris meant absolutely nothing. When I was there I couldn't find an interesting exhibit.

So Jack came with his wife, Delphine Seyrig, a marvelous French

woman who was later to be the star of *Last Year at Marienbad.* And
Ellsworth was also responsible, probably, for Agnes Martin's being on
the Slip, through their joint relationships with Betty Parsons. Agnes was
my next-door neighbor for several years, and we were very, very close—it
was she who brought me into my greatest communion with Gertrude
Stein.

BLDD: I think we should get to your pop art career. Did you ever
expect the media to proclaim the adventures of that group that became
known as pop the way they did?

RI: Actually, we were not a collective, we were all different artists.
Some of us knew each other and some of us didn't. And for a while, in
the beginning, it was called new realism; that was particularly the Euro-
pean name for it. In other words, people who were obviously rebelling
against abstract expressionism. Here was the image again in art. This
time blatant and abrasive and to most people absolutely obnoxious. It
just made them sick when they saw it, it was so awful. One young critic,
Gene Swenson, who was my chief supporter, decided to call it "sign
painting." *I* fit that particularly. For someone like Lichtenstein, it wasn't
such a good appellation, however. With Warhol and all his labels and so
forth, it wasn't such a bad one.

Then, of course, up comes Lawrence Alloway, a British critic, who had
named the same movement that had actually preceded ours in England,
pop. And it stuck just simply because it was such an obnoxious designa-
tion. Everybody hated the art and everybody loathed the name. My own
dealer would feign a heart attack if I were called a pop artist. She just
absolutely hated it. But, you know, time takes its course. And in the same
year Eleanor Ward introduced Warhol and Marisol as well as me.

BLDD: Why don't we talk for a moment about the auto-portraiture
that characterizes a great deal of your work, particularly that sequence
known as the *American Dream.*

RI: In an exhibit in 1972, there were ten paintings being exhibited
called "Decade: Auto-portraits," and in a sense this series is an extension
of my *American Dream,* and my *American Dreams* are, after all, *my*
American dreams and how I relate to that whole business. The auto-
portraits stem from that, mainly from a form aspect. How the canvas is
devised is very close. The auto-portrait, the decade, is the ten years of the
1960s; probably for me, as for any person, a certain decade is the most
meaningful one in one's life. I don't think any other decade will mean
the same thing to me as the sixties did.

BLDD: In that particular series, there is an almost obsessive dovetail-
ing of references, cross-references, all sorts of sequential symbols.

RI: The first, of course, is the circle, and for some reason it goes back to the childhood experience with Christian Science. Everything begins with the circle.

BLDD: Is there a circle in every work?

RI: Almost every, including the *Love,* because of the O. The sculpture *Art* stands apart, divorced from the form. But anyway, as a child, I was hit over the head with this hammer which said that the circle is the symbolization of eternal life. So we start with eternal life, because we all just know it goes on and on forever, and of course, cast in the circle is a decagon, and I'm very fond of geometry. I hated arithmetic and algebra, but I loved geometry. The decagon says decade. Within the decagon, hitting every other point, is the five-pointed star, which, I assume, is the American symbol. If one is going to be an American and talk about things American, one has to have a star some place.

BLDD: Sometimes I think the star is *your* personal emblem too.

RI: It has kind of become that, except I'm stuck with it too. Then, cast on top of those is the number one. I am absolutely intrigued with numerals, this coming from the fact that when I was a kid, before I was seventeen years old I had lived in twenty-one different houses. I had a mother who was an absolute gypsy. She couldn't bear to live in a house for more than a year at a time. So that was House Number Five, and this was House Number Seventeen, and I just got this thing about numbers. Number one is there because after all it is a self-portrait, and that is what one is all about.

BLDD: Can we go through some of the sequences of that decade? Beginning in 1961?

RI: We begin with 1960. Whereas in my own numeral paintings I used the zero as the final digit instead of the first digit, with the auto-portraits, it has to come back to its accepted order, and it stands for the first year of a decade, which would be 1960.

And 1960, of course, begins—I was still on Coenties Slip at that time, so the word Slip might appear, the word Coenties might appear. When I moved to the Bowery in 1965, the Bowery appears. Sometimes Skid Row appears.

BLDD: Sometimes in Dutch?

RI: Yes, spelled also in the Dutch manner, Bouwerie. Then I just pick out things from each of those years.

BLDD: Tell us, briefly, the highlights of each of the years. What is 1961?

RI: Well, 1961 is when it all really started to happen. In my own mind there's a great kind of jumble and confusion. I can pick out highlights.

For instance, the world Die does appear frequently, and it appears in a year, say, like 1963, when there was a major assassination. It might also appear in another suite the year that my father died. My red, blue, and green 1966 goes back to the *Love*. My *Love* show was in 1966. My father was born in June, the sixth month, into a family of six children. He worked for Phillips 66 and left my mother and went to California via Highway 66, passing all those little signs that said, "Use 666," which was a cold remedy. I do get caught up with very commonplace, everyday visual things like that.

BLDD: Why is death such a recurring theme in your paintings?

RI: Remember, if you have any knowledge of Christian Science, that there is no death, and that made a rather odd impression on me, because I really couldn't quite buy that—it was difficult when all the members of my family were passing away like flies. So it was an irony which was on my mind, you see. If you weren't raised as a Christian Scientist, it might not be so strange.

BLDD: Some critics have said that you're a traditional painter, and some others have said that heraldry is the term that can be applied to your work. Would you accept either of those references for your pictorial symbolism? How would you describe yourself?

RI: It's difficult. Obviously, I'm not a traditional painter in the way of English landscape painting, for instance. I am a traditional painter, I suppose, now, because I use oil on canvas, which is pretty shocking to most young people. They hardly know how to cope with that situation. If that's traditional, yes.

BLDD: How do you paint, by the way?

RI: I paint flat. I have a painting table. I do not use an easel. And my paints are mixed, so that they're the consistency of rather heavy cream. And I paint without masking tape or any devices like that. I don't use the stencils for painting. Each stroke is put down by hand.

BLDD: Could you go on to describe what the pictorial symbolism in your work means to you, by usual labels and definitions?

RI: There's one thing for sure, and that is, both temperamentally and artistically, I'm hard-edge, with maybe some soft parts here and there, but hard-edge without any doubt describes my work. I'm a colorist. I'm not interested in gradations of tone. Color is what I consider my forte.

BLDD: Who are the artists to whose work you most respond?

RI: Obviously the artist who has been the greatest influence on me personally was that man who bought *the* postcard—Ellsworth Kelly.

BLDD: But his work, now, is one that has absence of color.

RI: Yes, he's gone into a gray-and-white phase. That's okay. I think

Ellsworth's most beautiful canvases are of the most vivid colors, and I don't think I've ever quite come up to his color impact, because he has the great asset of simplicity, his things are so distilled. In a sense it was because of Ellsworth's influence and my not wanting to be totally trapped into it that I evolved a kind of painting which was much more complicated than Ellsworth's. I greatly admire his simplicity, but I would feel ill at ease being like that myself.

BLDD: Well, there are some other and earlier antecedents to whose work yours is often likened. I'm thinking of Charles Demuth and Stuart Davis.

RI: Stuart Davis I always felt *not* influenced by, and mainly because I don't like impasto, and on all his canvases, the paint's about that thick. However, somewhere back there, yes, I suppose I was touched by Stuart Davis. All those words and all that jargon.

But Demuth is another matter altogether. There's a marvelous painting, *Homage to Gertrude Stein,* and I'm greatly caught up in the Gertrude Stein legend and myth. The numbers one, two, three appear in the painting. There is a mask, and of course he who changes his name is wearing a mask. And love appears. The word love. I had never seen that painting when I started painting my *Love* paintings. I saw it only afterwards. It's not a very exposed painting, but it was recently in New York and then went on to a big collection.

BLDD: Regardless of price or availability or the need to acquire, if you had your choice, what would you most like to possess?

RI: Well, just off the top, my heart was broken when I wasn't able to acquire that particular canvas that I was just talking about. I would probably have sawed off a left arm, it meant so much to me. Now, artistically, it doesn't. It's not an important painting.

BLDD: What is your most prized possession?

RI: My most prized possession is probably my studio in Maine. It's a marvelous old nineteenth-century Odd Fellows Hall, on an island in Penobscot Bay, and that happens to be the island—Vinalhaven—where the granite towers of the Brooklyn Bridge came from. And since for eight years I used to look out of my window every day and see the Brooklyn Bridge, it's nice now to have a studio in the home of the Brooklyn Bridge. And that's an old Odd Fellows Hall, which means three rings over the doorway, and the first ring is friendship and the third ring is truth and the middle ring is *love*. The man who introduced me to Vinalhaven—I didn't know Vinalhaven existed, and fortunately, most everybody else doesn't either—was Eliot Elisofon. When I graduated from the Art Institute in Chicago, I received a scholarship to the Skowhegan

School, a summer school in Maine. Now I'm on the board of governors there. I went to dinner one evening at Skowhegan; Elisofon was a guest, and he said, "As long as you're up in Maine, why don't you pop over and visit my island?" When he was a staff photographer for *Life* magazine, one of his assignments during the war was to photograph an island paradise, and it turned out to be Vinalhaven. He had never seen it either. He immediately fell in love with it, just as I did, and bought himself practically a whole cove and has a beautiful old farm house there.

So I was his guest overnight. In the morning, I went down to the ferry to come back to civilization, and I saw this old wreck of a building, and I asked Eliot what it was. He didn't know. But it turned out that in two weeks he had bought it for me so that I could use it as a studio. By ill chance, he's now no longer here, but I finally have a home away from home.

BLDD: You made earlier reference to Gertrude Stein, and if she is a long-term influence, so is Virgil Thomson. Because of your persistence and your interest, a collaboration resulted in one of the most outstanding bicentennial events in this country. Can you tell us about *The Mother of Us All?*

RI: It was an extraordinary event. I learned that it's the second most expensive opera in musical history. My involvement started with my 1964 show at the Stable Gallery—it was my second one-man show. I wanted to have a little bit more than a table with a few glasses of wine and cheese. I wanted to have a gala opening, and what I really wanted was a musical opening. That came to me because when I looked around at my work in the studio before it went to the gallery, I realized that by some peculiar chance, the theme of every painting for that 1964 show was a theme that Virgil Thomson had dealt with. Now I had known Virgil's music since my art school days in Chicago. So, in 1965, I started working on sets and costumes for *The Mother of Us All,* and I've done two productions, one at the Tyrone Guthrie in Minneapolis and finally the one in Santa Fe last summer. It was a bicentennial celebration, it was an absolute extravaganza, and my work reached its culmination there.

BLDD: What will happen to that material?

RI: That material will probably not be used again in opera form, but it's going to be set up in a tableau vivant manner in my retrospective at the University of Texas this fall.*

BLDD: Getting back to *Love,* how has it affected your life?

* Unfortunate footnote. Since this interview, it has been ascertained that the set pieces for *The Mother of Us All* were destroyed by the Santa Fe Opera Company. The costumes still exist.

RI: What has happened with the *Love* has been one of the tragedies of my life. It has caused me probably much more damage than it has done me good, and that is on the very top professional level.

In other words, if you can project yourself into the minds of other artists, people are human, they're envious, they're jealous. Everyone just assumed that I was an instant millionaire from *Love,* because everybody assumed that I was raking in incredible profits from all the dispersion of this image. That was not the case.

And on the top professional levels—now, that in America is really museum people, critics, professors in art schools—it's very understandable that their reaction to something like this would be very dim and not approving at all. And that's exactly what the case was. But before the *Love* took place, almost all my major work went directly into museums. Now, I don't know why I was so lucky, but that's what happened. After the *Love,* that whole pattern changed. I feel that, because of the degrading things that took place with the subject I was most involved with, my reputation as an artist suffered.

BLDD: How important is it to be a part of the art establishment?

RI: Enormously important, if you want to "make it." Everything in life seems to be who you know and when you know them and where you are, and to be in the right place at the right time with the right thing is about what pop amounted to. And it's certainly my case. That's putting it very grossly, but it's a matter of contacts. I mean, all of life is a matter of the web that one weaves between one's fellow human beings.

BLDD: When you talk about the art establishment, do you mean the critical press, art professionals, museum professionals? How important is that to the work of an artist? Do you feel you've gotten the kind of critical attention that your work deserves?

RI: I personally have not. I think for me, that just happens to be some kind of peculiar fluke. One of my disadvantages is that the very first person who took my work seriously, and he happened to be the first American critic who took pop seriously, had to go and get himself killed. I should have had other critics interested in my work. Part of the problem is simply—you touched upon it earlier—how important is it to make contact with the art community? I am not a gregarious person. I spend most of my time at home in my studio. In the days, for instance, when the Art Club existed, I think I went there once or twice. I found it absolutely offensive. It was the club where all the School of New York artists hung out. That kind of art scene I didn't find attractive at all. However, one had to find some kind of interlocking, professional human relationship just to get the cart moving, shall we say. One can fill up one's studio with X number of paintings, and then either they go some

place or you have to move. By a strange irony it worked just the reverse for Agnes Martin. She had her early shows at Betty Parsons. It meant absolutely nothing. Nothing happened at all. It took her near-insanity and her moving away from New York and making herself into a myth to get *her* wagon moving. One can arrive at these things in various ways. Pulling a Van Gogh is a hard one!

Philip Johnson

(Architect. Born Cleveland, Ohio, 1906)

BLDD: For nearly fifty years Philip Johnson has been a major force in architecture and aesthetics. He was a teacher before he was a student, a client before he was an architect. Paul Goldberger, the architecture critic of the *New York Times,* said it best—that Philip Johnson is an intensely urbane man who began by studying history and has ended up by making it.

Back in the summer of 1932, the three-year-old Museum of Modern Art announced the founding of a new department of architecture under the chairmanship of Philip Johnson. How did you manage to persuade MOMA that a museum was not just for pictures?

PJ: I didn't have to persuade them. Back in 1930 we had a very strong leader, Alfred Barr, the leading art connoisseur of our time, and he felt that this town needed a museum that would cover the other arts the way the Bauhaus did in Europe, and that there was no reason to confine ourselves just to painting and sculpture, but we should have architecture as well.

So we already laid our plots in 1929—it's fifty years ago—and I came aboard, and it was not hard to persuade them since I picked up all the bills. That helped a great deal.

BLDD: Six months before this new department opened, you organized a show that was called the International Exhibit of Modern Architecture.

PJ: The International Style came in about 1922, and it swept Europe pretty much, but there wasn't much modern architecture in this country, so naturally at the founding of a new department we were all convinced—Alfred Barr and I and Russell Hitchcock, who was with us and worked on the catalogue—that the International Style was what was coming in architecture in this country, and indeed it's exactly what happened. We didn't think of any particular kind of structure—it was the look that we were after, and it conquered only too well. And now what

you see so boringly around you in New York is all the result of our work in 1930.

BLDD: Who termed it the International Style?

PJ: We did, Hitchcock, Barr and myself. We named it that, and we wrote a book, *The International Style.*

BLDD: You were the first to establish the International Style. And now you are among the first, in a sense, to abandon it. You've become a prophet of postmodernism.

PJ: Oh, that's much too sweeping. I am not the first postmodernist. There isn't anybody to date who builds modern architecture as we knew it fifty years ago. I mean as pleasant as the Seagram Building. I think that's probably the best building in New York in the International Style, but it's still a flattop glass box that we got a little bit bored with. In the International Style, everything looked like a box. Every church looked like a box, not a church, a library didn't look like a library. So it failed. but it lasted, don't forget, almost fifty years, which is a long time for a style of architecture to last. The Renaissance style lasted less than that before mannerism took over, and then baroque succeeded it.

So we feel that the International Style was a healthy and normal and

marvelous historical period, that it's the source of most of the things you see around you now, good and bad.

BLDD: What was the first building you built, and what was its architectural influence?

PJ: My first building was my own house in 1943. Wasn't it?

BLDD: I believe it was 1942. That is when you returned to Harvard as a student.

PJ: When I went back to Harvard, and studied architecture in my old age, 34, I built myself a house then that was very Miesian because I've been mostly influenced all my life by Mies van der Rohe who was, as you know, the designer of the Seagram Building, and for many, many years the leading American architect. But since then all that influence has dried up, and we think Mies now is too boring to worry about.

BLDD: You originally studied Greek and philosophy, then came to New York to work at the Museum of Modern Art, and then went back to being a student, already well known as a critic and an art historian. What was happening in that period at Harvard?

PJ: International Style houses, wooden houses—we all designed wooden houses under Marcel Breuer, who was a great teacher. I just went backwards into my profession, that's all. Which is just as good as going forwards. You all come up at the same place. Life doesn't begin till you are seventy anyway, so it doesn't really make much difference whether you go to school first and then work, or work and then go to school. In fact school is not very important. Schools, if they stimulate your imagination—good for them; then it's the right kind of a school. But regular school work is so dull and so uninformative, and you can learn so much quicker by yourself. I never took a course in the history of architecture. It would be a waste of time. If I wanted to know about baroque I'd go to Rome and look at it. Your own eyes are better than what the teacher says, which is probably wrong anyhow. He has been reading the same books that you can go and read, unless you are lazy. And if you are lazy you shouldn't be in school. Cooking is the only important art. No, there is one other—gardening. If you can get your garden and grow your herbs and mix your herbs right and follow Julia carefully, you'll all end up much happier, ladies and gentlemen, and maybe you won't have to go to school and come and listen to boring lectures late in the afternoon, when you should be home with a martini.

BLDD: I guess it was Calvin Tompkins who has said that you have always been your own best client, because soon after the Cambridge house you built another house for yourself.

PJ: The glass house. I built that in 1948–49.

BLDD: Can you tell us about the now legendary glass house that Vincent Scully has called one of the most important twentieth-century forms?

PJ: Does he really? I didn't know that. It's an important building and I am giving it to the National Trust for Historic Preservation so everybody will get to see it. I had to close it because it got too popular with students and friends, but it was great, I had many years of fun and entertainment there.

Remember the day it snowed all day? It was the most beautiful day we ever had in the glass house, because you could sit there all night with a roaring fire, and all around you the sky would come down in these little droplets, so you felt as if you were in an elevator going up through tiny crystals. It was terrific.

BLDD: Where did you get the idea to set a glass box in a natural setting, surrounded by vegetation?

PJ: It seemed like the right thing to do at the time. Artists really can't talk about their own works. I can give you a learned lecture on the early Mies, or on Frank Lloyd Wright and his times, but I can't tell you about my own work because I don't know.

BLDD: In that glass house there is the so-called processional element in architecture, which recurs in a great deal of your work.

PJ: My main impulse in architecture is what I call the procession, the hierarchical arrangement of spaces.

The way you work toward a building, the way you are turned aside, the processional element as you get off the avenue here and climb over that snow, slipping, is a very important part of the architectural feeling whether I am going to enjoy this building. I do not enjoy this building. You see, the processional part is wrong. And then to come into an assembly hall this big through those particular entrances and doors . . . I mean that's why I built the State Theater the way I did. I wanted to be able to go in feeling, "I am going to have a good time in this building, because I have baroque stairs to go up, and then I've got the longest bar in New York, and we've got all those beads dangling, and there must be something going on here."

And then as you go up the stairs of the State Theater—that's the right way to do a theater, I think—you go up the stairs to your seat, and then come out and talk in the intermission, all that gives you a pause that refreshes. You don't get that in most New York theaters: you step out and trip over the box office and keel over people trying to get their cigarettes out. So we think it's nice just to have a little sense of procession.

Now my glass house is just the same. It's not a theater, but it's the

same idea. You approach it at an angle, you come in through the door into a vestibule—it isn't actually a vestibule, it's all one room, but all these memories occur to you as you pass through this space—and the living room is just a raft of white carpet. You step up onto the carpet, and you are now in the living room.

I believe a dog is the nearest test for a procession. When a dog wants to sit down, do you know what he does? He doesn't go and sit down. He comes round, round, and round, and he usually makes two or three circumambulations and then sits down in a curl. Well, everybody does that in their minds. You sort of think, where is the grandfather chair, where do I sit, how do I feel in this environment?

All these things are so subtle, and so absolutely important—how you do actually physically sit down, because the main part of architecture is more important than just sitting and looking at it.

Take a Gothic cathedral—you come through narrow streets and you open into a plaza that is too small from our modern point of view, but not from the point of view of the builders. They knew exactly what they were doing. And then of course you burst through the front door and into that enormous height.

The baroque sense of the procession was quite different. The piazza of St. Peter's in Rome is the grandest square in the world, but the church is not so important. It's the great arms that gather you; you must be in the most important place in the world. You sense it. But how different from the Greek way or the Gothic way.

Everybody has their own kind of procession. Look at the Egyptian kind, through a darker and darker and darker, thinner hole, and right to the holy of holies.

BLDD: You've often said that the drive for monumentality is as fundamental as the drive for food and sex.

PJ: Second, shall we say. The drive for monumentality is, I think, inborn.

Ladies wear shoes that aren't comfortable, but the ones they think are good-looking. You are all wrong to teeter on these heels that came down a few years ago, and now, for heaven's sake, are going up again. But it doesn't make any difference. If you think you are better looking that way, more monumental, more acceptable, more beautiful, that's what you do, and I think that is an inborn feeling. It expresses itself by your outward clothes, further by the decoration of your apartment, further up to the decoration of your cities and of your country. We are in a very low point right now in city building.

In New York there are two great periods in my mind, the 1890s and the 1920s. The 1890s are the post-Richardson, McKim, Mead, and White

period: Columbia University Library and things like that. In the 1920s we got the great buildings like the American Radiator Building and the Daily News Building, ending at Rockefeller Center. And then it got pretty bad after that, in the forties and fifties. Third Avenue, for instance—I think you'd have an awful time finding a good-looking building on Third Avenue, or Sixth Avenue. Oh, and another great period is the Cast Iron period—SoHo. The beauty of those columns and windows, it's just fantastic.

BLDD: There was a time, not so long ago, when surface ornamentation, or any kind of embellishment, was a dirty word.

PJ: We came in (in the thirties) on a wave of reaction against the art deco, against revivalism, against using Georgian details. We thought it was dishonest, and we were very honest in those days. We are not so honest anymore. We used to believe that the important thing was structure, expressing structure. The Seagram Building, for example, every column is evenly spaced, and those columns hold that building up.

BLDD: You are the architect for the new AT&T Building on Madison Avenue and 55th Street. Perhaps you might give us a little preview of what that building will be like.

PJ: That's in my new backward-looking, preservationist mood. It's the opposite of a glass box, it's all granite, it has nice small windows. At the bottom there is a sixty-foot-high hypostyle hall—that is a lot of columns that you wander among. The lobby is above that. So the whole thing is on massive, great columns, not these thin little columns, but five foot by five foot columns. In the middle there are enormous arches, a hundred feet high, arches like a cathedral. On the top, there's a broken pediment. You've seen them on grandfather clocks and Chippendale breakfronts.

There's ornamentation. There's molding. There's decorative shadowing that a few years ago we wouldn't have wanted to do. As I go down Fifth Avenue today my eyes are caught by every building before 1950; from then on, there are little thin straps and flat façades and no shadows and no details. You get bored before you start looking. It's just too bad, isn't it? So maybe we're coming into a nice new world where we can do anything we want.

BLDD: Why don't you tell us about your new preservationist mood, particularly the effort to save the City of Paris interior in San Francisco.

PJ: City of Paris is the name of a department store out there that burned in the fire and earthquake. Then it was rebuilt in 1910. They put a Beaux Arts domed room in there that's just so delicious. Every floor is different. Every railing is different. The roof is all of stained glass, with ships. It's a delight, that's all. And this was put in the middle of an older, uninteresting building. Now, the preservationists, including me, want to

do everything to save it. The building can't be saved because it doesn't comply with the new earthquake laws. So what we're doing is having that dome, piece by piece, the whole room, every detail, every colored, painted piece, put away and brought back and replaced in our new building. All we're doing, as architects, is making a setting like for a diamond for this beautiful old room. That would not have been possible a few years ago. But you see, so strong is public opinion in San Francisco that it forced Neiman-Marcus, not known for their philanthropy, to preserve the dome.

BLDD: Perhaps you might tell us about the 10,000-pane glass building that you are doing, the Crystal Cathedral near Anaheim, California.

PJ: It's a star-shaped building, longer, higher, and wider than Nôtre Dame in Paris.

BLDD: The world's first drive-in church?

PJ: Yes. A hundred-foot-high door opens very slowly on beautiful hinges; and the preacher talks to five or six hundred cars that are parked. There are no columns. It's all great space, thousands and thousands of little white pipes that connect it all up. Four hundred feet long, that's two New York blocks.

The nice part of architecture today is that there isn't any consistency. I remember when I was brought up, we thought it was terrible that the Revivalist architects of the mid-nineteenth century would do a Greek bank at the same time they did a Gothic church. Well, why not? From another point of view, it's dishonest. But how delightful. The church is much better in Gothic and the bank has to have columns, doesn't it? Obviously if you see a Doric column, you know it's a bank. Except that one on Fifth Avenue and I don't feel safe in that glass box. My money can't be safe. This is all mental, of course. But you see, it's got to look like a bank.

BLDD: Do you do your designing at home?

PJ: Yes, always. You can't design with a telephone. It's like designing in an automobile. The study where I work has just one little window. And the light comes down from a truncated cone, so there's perfect diffused light. The walls are all books plus an enormous fireplace, no telephone, and no toilet. A toilet is obstructive to architecture, and the study is near enough to my own house. And I can spend more money on sheer architectural nonsense this way and not on anything practical like plumbing.

BLDD: One of the ways you have indulged your taste is by amassing quite a collection of contemporary art. You hang some of that art, from what I understand, in panel arrangements. Would you explain that to us?

PJ: It's the only logical way to hang art. The idea is Japanese. They

would make rolls and hang them up one at a time in their houses. If you hang a lot of pictures jammed into each other in a room, you never see the pictures. I do that in my New York house and it's hard to remember where a picture hangs. You don't really stop and absorb it. So in the country, I built one gallery for the paintings in which all the walls are hung on a center column and they revolve around it like a postcard rack in a drugstore.

BLDD: Swinging panels?

PJ: Swinging panels that go around and around. So I show six paintings, two here, two here, and two here, all at the same time. And then if I want another six paintings, I turn it around. Then if I want to study the pictures, I walk in behind the panels and go through them quickly. It's a very, very good way. It's hard for public museums to do. Tom Hoving was thinking of trying it but the public gets lost in all those leaves. But for a private collection it's just great.

BLDD: There was something published about your building a red house.

PJ: That's a house I didn't build. You know, architects being like everybody else, I was foolish about costs. It's hard to believe, isn't it? I said to myself, I'll build a little $50,000 house—I had an idea in mind.

And I said, well, I know me, so it'll be $100,000.

So I set it up for bids and got ready to build it: $300,000 for a little house, one bedroom. So no house.

BLDD: You have been responsible for the design of a number of museums. The most recent is the Dade County cultural complex in Florida. Can you tell us about it?

PJ: What's great about the group in Miami is the plaza. You see, since Miami is now a great Latin American capital, a great international city— it's entirely different, it's like nothing else in this country. The type of festive occasion down there has already been infused with a little more light feeling than our Puritan ethic of the north.

BLDD: Yes, there is a distinctly Hispanic plaza style.

PJ: So I am creating a Spanish plaza with the roof tiles and coral stone and palm trees and things of that kind. The plaza is elevated, making it detached from the city, so that everybody can rejoice. In Miami; you see, you feel like getting out; the plaza life, I think, comes with the climate and the palm trees. So I am designing it accordingly. The clients are very, very surprised of course. They thought they'd hired a modern architect. And what it is, it's a series of arcades and great arches and round windows and tile roofs, tile roofs leaning on tile roofs, the whole bit. The main building—the palazzo—is the public library. But the public library should be a palazzo in a Spanish town. There is a great movement now

among librarians that you just rent space in an office building. Library design in this country has been falling off just like any other. Museums, for instance, are meant to be like the Museum of Modern Art now, which I think is a terrible thing.

BLDD: Why do you say that?

PJ: Well, it's just that you go to that terrible elevator, you go through all those columns that get in your way all the time, you don't know where you are, you just wander around groping. It's much too small, the ceilings are too low, and there is no sense of grandeur as there is at the Met. You go to the Met and you may get lost a bit but they'll tell you soon enough. This nice lady who explains things right in the middle of that big room. And the room itself . . . you're going into a place that is pleasing to go to. The Frick, of course, has another kind of charm, residential charm. I don't see any charm whatever in the Museum of Modern Art.

But I think what's nice at the Modern is the garden—which I did. I keep forgetting, you don't talk about yourself as being such a great architect, do you? But the cleverness of that design, (I didn't know it almost until it was done) is the canal, which forces you to go around and into patterns. If it were just a court, you couldn't have done that, but being

sliced that way, the sense of going up across the bridge changes space. You look down, your bifocals joggling, and it helps you change your pace as you walk in the different little squares. There are four or five different spaces in that little tiny garden, which makes it bigger. You go down steps below the level of the sidewalk, the lobby entrance and that increases the size enormously. What happens is amazing: all of a sudden it's twice as big. Of course, that's what we wanted in New York, to create space where there had been just a small little outdoor room.

My main point is that museums should be designed for the delectation of people and for the prevention of fatigue. I get museum fatigue in five minutes. I go in and look at three pictures and flee. But you get much worse fatigue in a rabbit warren, where you can't get out, than you do in the Met, where you walk further, but have much more pleasure.

BLDD: You have often designed against what is considered the conventional grain; I'm thinking of those trapezoidal buildings in Houston: Pennzoil Place.

PJ: Pennzoil Place—two buildings that hover over each other. It's now the symbol of the city. Strange how it caught on. What we did was to make sculpture at an architectural scale, large scale, for impressiveness, and it works.

BLDD: Some twenty years ago, Philip Johnson delivered a now-famous lecture called "The Seven Crutches of Architecture." It was a lampoon on Ruskin. Perhaps you'd like to update those crutches for us.

PJ: If you're not a very good architect, you have to have a crutch to get you through, and one of them is pleasing the client. If the client wants a Gothic door here, you give him a Gothic door in a modern building. So what? Aren't you supposed to serve the public through your client? Sure. So you get out of having to make a decision of whether that's a good design or not a good design.

The worst crutch is cheapness. Because you can say, "I had to build it that way because my client didn't want to spend the money." Well, I use that all the time. We all use these crutches. But that's a very bad one. You should be able to build even with modest sums.

The crutch of "models": we were all in favor of models in those days. The crutch of beautiful drawing. In my day, twenty or thirty years ago, if you made a beautiful drawing, it would seduce you into thinking the building was good. There's no meaning in making a drawing of a building. The building has to be good in three dimensions. You can't make it a drawing or a façade or a rendering.

BLDD: The only way to look at a building is to look at the building?

PJ: Yes, and the only way to build it is to build it. Too bad, because that makes it hard.

BLDD: Which buildings of the last twenty years do you think reflect the best in architecture as you see it?

PJ: In the last twenty years we haven't had much. I think that's where historians have the greatest difficulty. When Hitchcock or Pevsner write about the actual present, they get into terrible trouble, because your directions aren't clear. What is happening in architecture today? My work seems to prove that it's chaotic. Well, it won't be to the historians. I don't know how they'll treat this period.

Hitchcock once pointed out that in 1923 Le Corbusier designed a house with a balcony bedroom looking over the double-height room. That same year Frank Lloyd Wright built the Millard house in Pasadena, which is exactly the same plan. Now you see, they did not know each other, the two houses looked entirely different, they couldn't have come from the same source, and yet the plan feeling of the time was so strong that they came out with the same plan.

Now what's history going to say? For instance, right now there is a great feeling, I am glad to say, that the ceilings in our apartment houses are too low. But nobody thought they were twenty years ago. Why make them higher? When I made a house with a thirteen-foot ceiling, Mies van der Rohe, twenty years my senior, said "Why did you make the ceiling so high?"

I wanted a ten-foot ceiling in the Seagram Building when we were working on that, and he said, "What do you do with that extra space above you?" I still can't believe it. But Frank Lloyd Wright of course was the lowest of all. And Le Corbusier did six-foot-six-high rooms, which is even illegal, but he didn't see any sense in wasting all that space over your head.

BLDD: Recently a developer asked you to design the façade of a controversial building on Fifth Avenue opposite the Metropolitan Museum of Art. The Landmarks Preservation Commission, the Municipal Art Society, a group of citizen activists especially, banded together to redesign that building. It might have been too little, too late in some ways, but at the eleventh hour they called upon you to design a façade that was compatible with the Metropolitan context. I assume that the developer was somewhat surprised when you presented your design to him.

PJ: He certainly was. It was difficult because the building is much too tall for the site. It's right next to a McKim, Mead, and White apartment house of eleven stories and this is twenty-three stories. A very thin, tall façade, which had been designed with all glass; of course, we had to have glass on the park.

BLDD: That's what you taught in 1932.

PJ: I know. But I had to tell them that glass facing west is just lethal. Anyhow, I couldn't really make a great new building out of it, the structure was up. But for the façade I used stone, the same stone as the McKim, Mead, and White building next door. And then I had a problem with the top. Most New York apartment houses leave no room for topping of any kind, you know. What I finally did was put a flat mansard up in front, a fake front.

BLDD: Have you ever done that before?

PJ: Nobody ever will again. It's like a western town, you know, you put up these big high things and brace them up with two-by-fours. But I am very pleased with the results, and it gave me a chance to work with moldings that I never had. This was a brand new world, a very exciting world. Stone, for instance—how do you cut stone? How thick is the stone? How do you go around the corner with a piece of stone? What is the effect of a ten-inch round molding? Is the sun out or isn't it? What kind of a shadow does it make when there isn't any sun out? It still has great power.

You see, that's the result of the change in sensibility, the change in the minds of the consumers. I am just following along with popular demand, of course. Artists are only froth at the top; after abstract expressionism you get Jasper Johns. Not so much that Johns invented anything, or Robert Rauschenberg either, but they expressed what was seething underneath abstract expressionism all that time. De Kooning is not the less a painter because he never fooled around doing Johnsian images. He still may be the greatest American painter, but at the same moment we go through the whole Warhol thing over here and the Johns thing over there. And look at the neorealists, for goodness sake, their prices are higher than the abstract people now.

So it's great. The marketplace is a very good gauge in a strange way.

BLDD: Do you look to contemporary art for your inspiration?

PJ: I suppose so. The artist who is closest to me is Frank Stella. That's no accident. Of course he would like to be an architect, and he is getting almost that way with his recent planes that come out and hit you. Of course I love them. There may be greater painters from the point of view of history, I don't know. But from the point of view of an architect a man who can take those rigid shapes and create something that jumps from the wall and hits is closest to my own reactions.

That, and Paul Klee. He is not a modern painter perhaps, but Paul Klee is exactly the opposite for me.

BLDD: Do you ever regret that you introduced the International Style?

PJ: Not at all. It was absolutely necessary at the time. Now our whole

sensibility is changing dramatically. The word romantic wasn't so popular twenty years ago. It was "clarity," "honesty," "economical," and all those words. We want fantasy now. The higher the heels on your shoes the better.

That a number of us should be on the same wave length is unheard of, because the people that wanted to go back to McKim, Mead, and White were the enemy in my day. You see, you had to be progressive. But do we have to be progressive? It sounds funny just to say that now. None of us believes in progress any more. That got put on the shelf along with lots of other ideas we thought were sacred: it is getting better and better—or is it? Well, I think it changed all right, but it didn't get better and better.

Now we have this impulse to preserve what we've got. Why do we just mindlessly take down a building instead of seeing what we could do with it? Already hundreds, I guess thousands of buildings have been saved. Maybe too many, but that's a natural reaction.

BLDD: That is the next question. There is indeed the possibility of saving too many. How do you preserve the past without jeopardizing either the present or the future? I think there are ways other than individual designations . . . historic districts, special design districts, training architects to build in constraining ways vis-à-vis old buildings, and to add to old buildings in ways that are sympathetic to them.

PJ: There was that great period, from 1450 to 1550, when Brunelleschi built his chapel with the bambini in the spandrels. A hundred years later they copied that right down the line, so strong was the sense that Brunelleschi had created a beautiful plaza. That couldn't be possible even yet today. Now maybe with the idea of preservation districts something like that can come about.

But I don't think the architects are as advanced as people are on this front yet.

BLDD: For a long while you've been known as a bit of a gadfly and a maverick to the profession.

PJ: Peck's bad boy.

BLDD: However, Peck's bad boy is about to be awarded the Gold Medal of the American Institute of Architects.

PJ: Imagine. I wish you'd tell me what to tell them. I've insulted the profession and everybody in it for fifty years. I can't very well say I didn't mean it. I am certainly grateful that they have found me worthy of the Gold Medal. I can't say thank you, but I can't say you damn fools. I can't say what Frank Lloyd Wright said when he got the Gold Medal. He said, "It's about time." A very simple answer. I am not that arrogant.

BLDD: But here you are in the most austere company: both

Saarinens, Louis Sullivan, Frank Lloyd Wright, even though you called him the best architect of the nineteenth century.

PJ: That's all right, he forgave me.

BLDD: You say that this is a period of eclecticism and pluralism. You've also said that you think that it is important to record historically, but also to push ahead in new directions. Where do you see us going now?

PJ: I can't see. We are very bad as prophets. Historians and architects both make bad prophets. Naturally we would foresee it in our own image. Frank Lloyd Wright thought he was the last architect in the world. No point bothering with the future—what do you mean? We are there. Michelangelo and Wright. Well, we can't be that arrogant. In his day you could be a little more arrogant. But I can't see out of the present chaos.

BLDD: Are we through with ugly?

PJ: We are through with the International Style.

BLDD: I don't think of that as ugly.

PJ: I see. No, we'll never be through with ugly. I am afraid that's forever.

What I wish would happen is that there'd be a little more art in architecture and less commercialism, less business, less build-up for the smallest buck.

For instance, housing is our greatest need in this country. We could build easily three or four times as much as we are, and housing would mean new cities, and new cities would make a chance to create new plazas and new congeries of housing units. It only takes the will. We have the labor, but labor is not used in this country to anywhere near its fullest extent. We don't have the will. We have the will to make millions of dollars' worth of bombers and spread them around the world for peace, I understand, but we don't have the will to do anything about our cities and our housing. I really don't quite understand why not, because I've always had it and I think everybody should join me.

How about applying to the federal government for an equal amount for the Department of Defense and the Department of Housing? That would give us what, $100 billion this year? Oh, what I couldn't do with $100 billion!

BLDD: You have spent a lot of your time designing houses and museums and smaller-scale things. Now you are taking on larger and larger commercial commissions. Does that imply that you feel cities and their commercial needs rather than individual buildings are really the problem that we have to address ourselves to?

PJ: I don't think there is any question. I don't think it can be solved on an individual level. Whether it can be solved on a commercial level or not I don't know. I build commercial buildings because that's what people ask me to build. I am as close to the oldest profession in the world as you can get. If you hire me to build a small building I'll build a small building, if you hire me to build a big building, I'll build a big building. But I just wish that my client would be the federal government. *L'architecte du roi* is what I've always wanted to be, I mean some future democratic Louis who would want to build cities, you see. It isn't that we lack anything to do it with either. We have the architects, and they are very good architects, especially the young ones, but we don't have the clients.

BLDD: Are Las Vegas and the suburban shopping strip the legitimate architectural models of our times?

PJ: Las Vegas is not very pretty, not very charming. The spaces of those shopping centers are mean, and you can't have architecture without space. You can see in history the monuments that have come to us as city plans. St. Mark's Square—you could mention quite a lot if you wanted to. The greatest architect in the world was the architect of Sakkara, Imhotep.

But there are many places—you could make a list of the hundred great congeries of buildings that make the world a happier place for existing. In this continent it was the civilizations before the Spaniards ever got here that made the Mexican scene so beautiful. But in our day you'd have a terrible time. You could go to Taliesin West—Frank Lloyd Wright's home in Arizona—maybe. That's a great grouping of buildings. It's related to us and it is really, really of top quality. It's just magic. He knew all about processionalism, and how you turn a corner.

BLDD: Are we approaching a pharaonic tendency in American life? In major buildings, is there a kind of monumentality to architectural expression?

PJ: I don't think so. It always has been true in the commercial world that you want your building taller than your neighbor's. I've got two now coming in—forty-nine stories.

I said, "If you build forty stories in this little town,"—which shall be nameless right now—"it will in the first place look absurd, in the second place you will all be so full of elevators that there won't be any room on the outside for the offices." "Yes, but we've got to do this, because someone else was thinking of building one, and we've got to get one up first."

So it isn't commercialism—it's pride, individualistic pride that raises very many ethical points, and I don't know what the answer is. I don't

see what we are going to do. Being realistic means that I have to do what clients want, and being realistic means I like to build buildings. Le Corbusier built lots of cities in his dreams.

BLDD: Is he the architect who was most your mentor ideologically?

PJ: No, Mies van der Rohe.

BLDD: But before Mies? Did you think of Le Corbusier as the greatest of them all, at any time?

PJ: I think he was a greater architect than Mies, possibly, but I never liked him personally. We never got along. No, my mentor was Mies, because he had more vision, more passion, more gentleness, more sense of the historical process than any of the rest. So I felt that he was the greatest architect in the world.

BLDD: What do you see as the greatest achievement of architecture historically?

PJ: I don't think there is any *one*. Each civilization that might be called great has one. For instance, the Gardens of Kyoto is probably the purest emotion in the world. And there are Sakkara, the Parthenon, Chartres Cathedral.

Ivan Karp

(Art Dealer, Lecturer. Born Brooklyn, New York, 1926)

BLDD: Ivan Karp is as much a myth as some of the artists he has represented. He is a novelist, a lecturer in art history, and an adventurous tastemaker. Always in the vanguard, he was a high school dropout before it became a bourgeois pursuit. It's a pleasure to welcome Ivan Karp, the director of the O.K. Harris Gallery in SoHo.

How did you end up being a vanguard dealer whose personal collections embrace everything from Americana to nineteenth-century paintings, to software, to American tools, to memorabilia?

IK: Well, there are no qualifying exams for being an art dealer, so anybody who has a notion to open up a clean white space with a couple of plants and a chair is an art dealer. If you feel you have perceptions and taste you can open a gallery. But there is really no purpose in embarking on it unless you have the funds available, or you find a friendly backer. My involvement with the arts goes back to my early years, when my father took me, out of his sound instinct, to the Brooklyn Museum to listen to a band concert every Sunday afternoon. Even when I was four or five years old we went every Sunday afternoon, punctually at three, into this large marbleized chamber. At one session, I wandered about the place during the interval and saw objects that had nothing to do with the concert. Finally I discovered that it was a museum of fine arts in which concerts were being held and not a concert hall. From then on I got more elaborately involved with visual experience. I also discovered that I was distracted by sights, scenes, and spectacles and by objects and official works of art more than my friends were. I began to feel alienated, strange, eccentric. So I sought out others like myself and I found people in New York who shared my sensory passions. I traveled about in Europe after I came out of the army, looking at paintings and sculpture, and there were always reproductions around my house. After that period I wandered aimlessly for about ten years, until somebody said, "Listen, you have a very agile mind, Karp. You probably have some writing

skills. Why don't you write for this little newspaper that's just coming out? They are looking for an art critic and if they don't pay you anything, you may have to pay them to get your name in print. But they might be able to use your services." So I wrote art criticism and in 1955 I was the first art critic of the *Village Voice.* But I also had to cover films, dance, theater, and other events. But my greatest passion was for visual arts and I stumbled about in the various galleries I was assigned to by the editor, who knew nothing about the art world. I went around to these obscure galleries and met a charming young man who said, "I read your review about our gallery and it was most incisive." That was Richard Bellamy. He invited me to share with him the time he gave to this space. It was a new gallery.

BLDD: Was it a cooperative gallery?

IK: Yes. It was the Hansa Gallery on Central Park South. I joined it and we worked three days a week each. The compensation was twelve dollars each, plus 10 percent commission if you sold anything. We showed very peculiar things in those days. People like Richard Stankiewicz and George Segal, Jan Mueller and other artists who came to some measure of fame—people like Lucas Samaras. John Chamberlain didn't want to join the co-op because the artists' dues were more than he could

afford, so we showed him in an invitational. But we didn't gain anything in the way of fame or prosperity, and after two years the gallery developed a condition known as "excess of democracy." That's what happens in a co-op when the artists all have a very strong voice in the management of the gallery and the selection of talent. So after a great deal of internal turmoil the gallery decided I was too vibrant and strong and aggressive a personality to suit such a democratic institution and I was issued forth again into the wretched world.

BLDD: And you wended your way east?

IK: Just before that a sly dapper young man, not so young, came to see me and said, "Hey, Karp, you talk about pictures like you really get involved in them. There is a gallery uptown, a ritzy East Side gallery that would really like to use your services." And that was the Martha Jackson Gallery.

BLDD: During the time you were at the Martha Jackson Gallery, did the new media exhibition take place that was then considered a breakthrough?

IK: The exhibition took place just after I left her. I offered Mrs. Jackson Richard Bellamy, who had worked with me at the Hansa Gallery—it finally went bankrupt and Mr. Bellamy was out of work. Shortly before I left the Martha Jackson Gallery (I was there only for a nine-month period) Richard Bellamy and I instigated some of the more adventuresome shows that she had, like Oldenburg and Dine and some other marvelous artists.

BLDD: Where was the "store" where Oldenburg first showed?

IK: The store was on a side street on the Lower East Side. Oldenburg rented a little space and showed his wonderful plaster objects; he put prices on them as if they were fruits and vegetables, prices like $29.35 or $17.36. He was very careful to actually get the amounts made out to those particular prices; he wouldn't give discounts or add anything. I think the show sold four or five pieces out of fifty.

BLDD: You have led us very quickly to about 1959. After that very brief period at the Hansa Gallery and the Martha Jackson Gallery, did you go to work for Leo Castelli?

IK: Martha Jackson and I didn't see each other very often when I worked there. I worked on one floor and she worked on another floor. She had asked me if I wanted to bring one artist with me when I first joined her and my choice was John Chamberlain. She found that very disconcerting because when they shifted pieces of metal, paint flakes would fall on her elegant floor, so I had to show his works in the basement of the gallery and I had works of John Chamberlain for a while at very low prices.

Things were very amiable between Martha Jackson and me and she showed some very good talent. She showed Sam Francis at that time, and Antonio Tàpies, whose work was a grand inspiration to me. I remember I was so overwhelmed by the power of his work that my lecturing instincts welled up in me. I gave a spontaneous lecture to a group of people who came in and who hadn't anticipated somebody lecturing to them. "I just thought I would tell you about this artist's work—it's difficult, it's cryptic, it's elusive. . . ." And that is how my lecturing career began.

BLDD: Do you show his art now?

IK: No. I wish we could acquire his work, but he apparently has dealerships all around the world.

BLDD: After Martha Jackson's, did you wend your way to another gallery?

IK: Yes. A little man, a delicate, fragile man (he weighed eighty-four pounds) came to see me and said, "Mr. Karp, I heard you give that lecture on Tàpies, and you spoke with such conviction and overwhelming passion—I have never seen anybody get so involved with anything. We could use you in a new gallery uptown." I asked what was his name and he introduced himself as Michael Sonnabend. He said his friend Leo Castelli had just gone into business a year before and Jasper Johns and Robert Rauschenberg were in his first show. All of us in the art world were very responsive to that show and we honored this new dealer who was brave enough to show the work of these two artists. Leo and his wife invited me to lunch at the first haute cuisine restaurant I had ever been to. It was a terrible lunch but a lovely restaurant, at the Carlyle Hotel, at Madison Avenue and 77th Street. I managed to glance at the price of lunch and knew my salary was going to be larger than it had been up to that point. I went and bought a suit at Brooks Brothers in the ready-to-wear shop for a hundred dollars. I still have that suit from 1959 and it hangs at home in faded splendor as a memorial. Leo and Ileana invited me to join the Leo Castelli gallery, which I promptly did.

BLDD: During the time you were there, a number of artists were discovered and developed and promoted to international prominence. That period not only set a whole new aesthetic standard but new boundaries for art. I wonder if you would reminisce about the decade that you were there, from 1959 to 1969. Why don't I start by asking you a specific question? Leo's version of how Roy Lichtenstein first came to the Castelli Gallery differs from yours. And now we would like to hear your story.

IK: No question about my version—it is the accurate one. Leo was notoriously absent-minded and notoriously absent from the gallery at

times. A friend told me of a young man who was doing strange, peculiar, impossible pictures and asked would I look at his work. I said of course. I was teaching then in a place, now defunct, called Finch College. I taught there once a week, a course on disruptive elements in the art world. Actually, it was the students who were disruptive. Anyhow, I brought the young women to the Castelli Gallery, and the artist Lichtenstein was standing at the top of the stairs with four pictures which he could hardly stop from falling down the stairs. The artist was looking a little distraught at the surge of womankind coming up the stairs and I said to them would they not look at the exhibit while I talked to the artist. I said, "My God, why did you bring all these giant pictures here?" He said, "I don't have slides and I brought the paintings themselves." I said, "It's not the usual practice. Castelli gets upset even if the floor creaks when you walk in. He's going to be terribly depressed when he sees these four pictures walking in unsolicited." I told him to sneak them into this hallway, and we took them down the stairs, and I saw four enormous, aggressive, ferocious, brilliant cartoons. In my own vivid reaction, I said, "I really don't know if you're allowed to make pictures like this," and told him that these pictures were peculiar, strange, and downright dangerous. I said, "You leave one here in the racks, that one picture of a man sitting in a rocketship saying something, and I will sneak it out when Castelli comes back from one of his three-hour lunches and show it to him." That is how it began. Castelli was consistently responsive to it but he said to me, "I'm not sure he's allowed to do that." It was a brash painting; it was brutal; it was a cartoon. That is the accurate account of the arrival of Lichtenstein at the Castelli Gallery.

At that particular juncture the gallery was not extensively known. Rauschenberg was doing vicious works, rough textures with odd materials, his most brilliantly organized, exquisite compositions. But at that time they seemed rather unsettled and bohemian and so there really was no general buying public for his art. But Johns sold out his first show at prices, I am sorry to say, between $75 and $250 for major works. I heard the other day that a painting by Johns was sold for $780,000, and this was a painting from his first show.

Nobody has given more dedication and emotion to artists and collectors than Castelli himself. The man has such good nature and such compassion that he is frequently trampled upon. His reputation as a ferocious character is of course false. The process at his gallery was that we looked at everything. That was my own instinct, and Castelli had the same open attitude. But he didn't have quite the strength to receive all of the applicants, so I would sort them out; we saw at that time anywhere between eight and fifteen artists a day and their slides. I kept the slides of

those who looked interesting to me, and at the end of the week, usually on Saturday morning, we would go down to various neighborhoods where artists' lofts were. If we both felt that the artist was of merit, we would organize an exhibition, or put him in a group show, or keep some works in the back room. With the gallery at that point were already Paul Brach, Marisol, Salvatore Scarpitta, Norman Bluhm and several others.

BLDD: Was Twombly there yet?

IK: No, and it was our fondest wish to acquire Cy Twombly, who was hardly known then. In fact, Twombly at that time had a show at the Stable gallery, which was located in an old stable, and it was his image that entered my soul, more than Johns and Rauschenberg. He was the artist I most wanted to acquire for the gallery and it took a certain amount of diplomacy to do that.

BLDD: And Warhol?

IK: Warhol came into the gallery in 1961 with two friends and looked at drawings by Jasper Johns. He wanted to buy a drawing. Warhol then said he was doing a few illustrations. I said to him, "Do you want to see another peculiar artist, more peculiar than Jasper Johns?" And I took out the one painting by Roy Lichtenstein that we had there, of a man sitting in a rocket ship issuing a classical cartoon phrase. This very strange-looking man with gray hair and very odd complexion reacted vividly, saying that he was doing works of the very same kind at his studio. I asked "Do you mean you draw pictures of cartoon style?" and he said, exactly, cartoon type with bright, vivid colors and would I not come visit his studio. I went to his studio, on 89th Street and Lexington Avenue, which is still his residence. When I came in he was wearing a theatrical mask and there was very, very loud music playing, a rock and roll song. I was very powerfully affected by the rock and roll movement during this phase, one of its ripe, beautiful years, and he played this record as loudly as possible continuously during all the time I was there.

BLDD: Was this an early explanation of his later films?

IK: Of his films and everything else: a repetition you can't understand until you are bludgeoned by it. Anyway, it was a beautiful Victorian apartment with fabulous trappings of furniture, lamps, and all kinds of art objects. In the corner there were fifteen paintings, in two categories: one had cartoons with drips and one had cartoons without drips, and since I already had the Roy Lichtenstein painting at the gallery I was a leading authority on this school of painting. So I said, "You did these fine fresh bold brutal cartoons, but why do you put drips in them?" And he answered that the prevailing tendency of the artist is to be spontaneous and abstract expressionism is also about dripping and that nobody will accept his art unless it drips. I said let's try a frontal approach

and show the pictures that don't drip. He said, "You do anything you want, you are the guide to my career." Well, I found the work brash and raw and beautiful. I had Castelli down and he said if we show this man Lichtenstein, we can't show this one also because he's going to be competition. So we have to find another place for him. During that interval I invited other art dealers to Warhol's and they found the studio, the apartment, the furniture, and the paintings obnoxious. So for two years Warhol could not get an exhibition.

BLDD: Was he reticent and somewhat withdrawn then?

IK: He has always remained very shy and he is no good for talk shows. We tried to get him a gallery and in the interval, I invited collectors—so-called pioneer collectors, there are eight to ten of them—to his studio and they purchased his works, between $250 and $350 for large works and $65 for those little "soup can" pictures he did by hand. He sold a number of works that way until finally the Stable Gallery gave him his first show, the boxes of Brillo and so forth, and by that time his name was circulating very rapidly in the fashion press.

BLDD: What about James Rosenquist?

IK: I met Rosenquist in a fish restaurant downtown and he got me to visit his studio. He had very good pictures. He was still doing sign painting for a living, but he had his first painting there, an enormous painting.

BLDD: What was the scale?

IK: In the case of Lichtenstein and Warhol, scale at that point was not larger than Pollock's large paintings, but Rosenquist's works were larger. They were mural scale, and that was unsettling for any art dealer with a twenty-five by twenty-five-foot room. Anyway, I believed that Castelli would not be interested because again he was part of the same ideology of common images. So I invited Dick Bellamy, who had been fired from the Martha Jackson Gallery and who I had gotten to a man named Robert Scull as director of the Green gallery. Bellamy was looking for works and came to Rosenquist's studio and affiliated with him at once for the Green Gallery. Three artists were shown just about the same time in New York, James Rosenquist, Roy Lichtenstein and Tom Wesselmann, who showed at another gallery at that time—1960–1961. The antagonism to this was ferocious, from all of the artists at the Castelli Gallery, all the artists around town, all the established critics, the dealers. Hostility to this development went on for many years. All during those years, the Castelli Gallery didn't achieve any real commercial momentum, not until 1966–1967.

BLDD: What happened then?

IK: We already had Johns, Rauschenberg, Lichtenstein, Warhol, and Frank Stella. There was an irresistible tide and we were identified with it,

at first by the European audience. The Germans and the Italians were the first to respond to the pop-art movement and that was in 1965 or 1966, and the gallery financially achieved a measure of solvency. Up to that point there had been a collection of Pollocks, Klines, de Koonings, and Dubuffets in the Castelli family, and the gallery's solvency was dependent on the resale of those pictures and other works the gallery had on consignment.

BLDD: There is hardly an artist who came here during the course of these sessions who has not commented on Leo's generosity. Did he really find artists and underwrite them for extended periods of time?

IK: He has always done that. Since 1966, each of the artists in the gallery was considered a regular exhibitor and received a monthly stipend. He did this without foreknowledge of the future of their careers. That was definite faith in the artists' capacity. In many instances it didn't work out and he continued to support those artists whose careers did not flower and develop into anything llustrious; I know that during the time I was there, three-fourths of the artists who were not selling were still on full stipend, and that meant anywhere between $750 and $2500 per month. In order to sustain that, a lot of work had to be turned over. Fortunately Lichtenstein and Stella were selling a lot of work. Johns sold also, but very few works came to the gallery.

BLDD: That may be your own model. We are about to talk about the O.K. Harris Gallery. From what I understand, 75 to 80 percent of the works you show are not ultimately sold. Perhaps you will tell us why you chose to leave the Castelli Gallery and soon thereafter moved to SoHo and opened the O.K. Harris Gallery. Can you tell us what gave you the impudence to do that?

IK: Castelli Gallery had achieved by 1968 a large measure of international fame, and the gallery was actually beginning to flourish. Some of the artists who were showing on a regular basis were also very strong personalities—Donald Judd, Robert Morris, Stella, Lichtenstein, Warhol, Jasper Johns—though not all were selling very well. At that point, it did not seem possible to further inquire into the condition of new talent in America. The gallery had its regular exhibiting artists, and though I continued on a daily basis to look at new work, Castelli no longer had the strength, the energy, the capacity, or maybe even the will to go out with me on Saturday mornings to look at studios. Part of my own instinct for creative adventure in the arts was diminished and I felt I was not fulfilling my nature by being in that gallery, which had established its fame and credentials. So when another artist who had already achieved fame was going to be brought to the gallery, I didn't think this was a creative venture and announced my departure. That was in 1968. I had

no ambition to become a private dealer or to own a private art gallery as I was involved in writing fiction and thought that perhaps I would hide myself away and try to do something important in that area. But it was discovered very quickly, as it is in the art world, which is a very tiny and intimate community, that I was leaving the gallery. Three hours after my announcement eight people solicited my assistance in opening galleries. I was offered fabulous sums of money to open up a premise on 57th Street but each of the offers was for some involvement on the part of the backer and with my rather fierce sense of independence this did not seem attractive to me. The ninth offer, however, was very attractive to me. It came from a wonderful man who is well known within the art world and is a most generous benefactor. he said, "Ivan, you open a gallery anywhere you want and I will help you out the best I can and you pay me back when it is convenient for you."

BLDD: Can you tell us who he is?

IK: Sidney Lewis of Richmond, Virginia. He is a man who is very much involved still in collecting and contributing to the welfare of the art world. The flowering of my vision as a private dealer, as a gallery operator, came into being at that moment. I decided that it wouldn't somehow be feasible, with my nature and my personality, to do the same

thing everybody else did and I said I would open a gallery and it would be somewhat different from those I knew. I was already living in a loft in lower Manhattan and I had been visiting the SoHo district regularly, looking at artists' studios. The area was physically very attractive and had an architectural vitality, and the rents were very cheap.

The art that was being seen was becoming increasingly larger and heavier, so much so that in many instances we had to go through rigging operations to bring works into the Castelli Gallery. I thought if I opened a gallery it would be in this fresh new district, the SoHo district, which was not yet named, and found 7,000 square feet of space for which the rent was $900. I thought it was too large, but in an act of daring took the entire space. I had a fund of $50,000 to work with and the gallery cost me $46,000 to build. It had been a toy factory and was in a state of total decay; it was almost totally demolished. I had $4,000 in the bank on the day that I opened, in October 1969. I went down to SoHo not because anyone invited me. It was pure adventure and I had made some friends in the art world and knew that if I showed dangerous, threatening, re- markable art, somebody would come to look at it. But I remember walk- ing out on that Saturday morning in October 1969 and fortunately it was a sunny, shiny day and I went out with my broom because my father had said that one might have pride in sweeping one's own sidewalk.

BLDD: What was your first exhibition?

IK: We had five abstractionists and one realist. These were the artists whose slides I had accumulated in a little drawer at the Castelli Gallery over the years. In that drawer, fortunately, there were also slides by Duane Hanson, John de André, Ralph Goings. The artists that I showed in the beginning had never been shown before, except maybe in group showings or invitationals here and there, and of the six artists in my first show only one is still active. Maybe I failed them in some way.

BLDD: How would you describe the unique nature of your gallery?

IK: Its largeness is immediately evident. It goes through the entire block. My present gallery is my second gallery space in SoHo. The first one was 7,000 square feet, and when I got used to it, it was not nearly large enough. Also the rents seemed to progress; the building was owned by artists, a coop building, and artists as landlords are notoriously fero- cious characters. The rents went very quickly from $900 to $2,000 per month. In the beginning, during my early idealistic phase, I really didn't look at the contract they laid before me and discovered people in the neighborhood were buying such premises and paying much less. I found a place down the street which had 11,000 square feet, so I bought that space at 383 West Broadway.

BLDD: What does the name O.K. Harris signify?

IK: The name came about because Robert Scull decided that he wanted to open up an art gallery anonymously. He said he wanted a manager and wanted a name for it. I offered him Dick Bellamy, who was free since he had just been fired from the Martha Jackson Gallery for putting on the show of Oldenburg and Dine. Then I sat down with Dick Bellamy and we went through 3,000 names and they were all charming, exquisite names, but Scull rejected them. For myself, I decided a gallery should bear the name of a person, because then you can blame everything you do wrong on that person. "I'm only the caretaker, the manager, the director, but basically the final decisions are made by Mr. Harris." So I used the name because it had a kind of presence, a fast-talking, energetic, lively Mississippi gambler type of character. We have a portrait in my office of a bearded man and it says Oscar Klondike Harris, 1789–1969. We still blame things on him.

Bellamy, as an act of revenge, decided that he would name the gallery after a certain kind of oozing slime: the Green Gallery. Bob Scull accepted it as a dignified name for somebody.

BLDD: What makes a work of art qualify for your gallery?

IK: What you gain after looking at things with the kind of intensity and passion that I do is a conviction of your perception. That is, you see so much, you need to see so much, you have such an incredible appetite to look at things, that you learn *how* to look at things. You can test yourself as a collector, an artist, or a critic, but the most difficult is as a dealer, because the things you select as worthy of your contemplation you put out for other people to look at, so you are constantly challenged. That testing came about in the early years at the Hansa Gallery and then with Martha Jackson Gallery, where I had very few choices, and then certainly with the Castelli Gallery where, during the early years, I helped select the artists to be shown. One gains conviction that way. There is no other method or scientific device that one can employ to detect the vitality of art. The only method is when one is confident of one's visual perception.

BLDD: You saw the slides of twenty to thirty artists a week in your earlier period. Do you still have time to do that? How does a young artist get access to you now?

IK: We have seen upwards of one hundred artists each week in the last two years and this is increasing as the awareness of the importance of American art is increasing. The idea of the legitimacy of a person pursuing the arts has grown so that art schools have flourished and the number of applicants from all over the country has grown so overwhelmingly that it is almost impossible to receive them all. We look at every artist who applies to us. We don't solicit their visits, but they come in regularly

with their slides and photos and we see every applicant at the time of his or her arrival.

BLDD: That must be increasingly frustrating, both to you and to the applicant because, in spite of the fact that it is very generous to see so many artists, is there room to show more than a few each year at your gallery?

IK: Well, we have this enormous space and we are able to do four shows at once and our philosophical principle has been to exhibit the broadest possible spectrum of the most adventuresome art being offered. I don't have a narrow view as to what is put into art. Romanticism, realism, conceptualism, I enjoy photography and sculpture. So we show a very broad range of works. We have been accused of being a kind of supermarket of the arts because we are so broad-minded.

BLDD: Isn't that what you had in mind?

IK: No, I didn't have a supermarket principle in mind. I object to the term, but I like the idea of a museum spectrum that might be able to encompass the prevailing temperaments of our particular moment. It is exhausting and frustrating to see all the very good talent that I have to reject day after day. And we try not to give advice. Other dealers resent your sending artists to them for a visit.

BLDD: How many new artists can you show each year?

IK: We put on forty-four separate exhibits a season, which is more than any art institution in the country, and it is hard work and takes enormous expertise.

BLDD: How many of them are new artists?

IK: We took two out of five thousand applicants last year.

BLDD: To what extent has your own aesthetic judgment influenced the art of the artists that you have shown?

IK: The works that they do? I play an active role with my artists, those who exhibit with me regularly, thirty-four to forty artists who expect to exhibit on a regular basis. I am frequently with them and visit their studios. I help them sort out their works. I pronounce opinions and convictions. They don't have to listen to me, but I will only show the works that I like in the gallery. In other words, if an artist who is scheduled to show does not produce the kind of works that I want to dignify my gallery with, then I won't show them. We have no contractual arrangements with my artists. It's all on a mutual faith arrangement, basically a one-time arrangement, because each exhibition is based on the performance.

BLDD: To what artist's works do you most respond?

IK: Of my own group? Twombly is still my hero, you know, and John

Chamberlain has always remained my hero, and Lichtenstein. I think Roy is one of the four or five great creators of our time.

BLDD: And who are the others?

IK: Warhol, although Warhol's work now is diminishing in importance. It was good for three or four years, but is diminishing. Twombly, Chamberlain, a few others, and a couple of my own people. I have a young abstract painter named Jerry Horn, who does tough aggressive works. I don't want to mention any particular names here because I really have faith and strong convictions about all of the artists I exhibit.

BLDD: When you moved to SoHo you described it as an act of adventure, a bold daring gesture. Now the SoHo galleries are overcrowded, the loft buildings are prohibitively expensive, the ground floor levels are filled with boutiques. What happens to the experimental or the yet unrecognized artists in that kind of environment? How do you feel about the colonization of SoHo?

IK: I expected that on some level it was inevitable. Much of what it became was good. There are we don't know how many—six to eight thousand artists and residents in the SoHo district, fifty to sixty galleries, and thirty-five restaurants and new boutiques. The pioneering galleries are still there and we are very loyal to the neighborhood; we are trying to formulate an organization to protect the neighborhood against excesses. We do have the landmarks law to protect the particular zone, though enforcement is not very energetic.

BLDD: The staff is energetic and dedicated, but the law just doesn't have the kind of enforcement capability that would be desirable, nor is the staff large enough.

IK: Eventually there will be a commercial and civic society down there. We maintain the original posture of the community as at least half industrial because we like the casual look on a rainy afternoon in November. If you go down on a weekday it looks like what it used to look like: a little chaos, a little texture, a little blown rubbish in the wind. It's something we enjoy. Basically the neighborhood has the temper of the old New York and I like that very much. If we could keep it that way it would be very good.

BLDD: Do you see the possibility of yet another SoHo?

IK: There is a ripening area just below Canal Street called TriBeCa and in the last six months a number of loft buildings have been converted very rapidly into studio lofts. There are three or four galleries in TriBeCa but it seems difficult enough to find West Broadway and I think only 12 percent of the taxicab drivers in New York can take you there directly. We haven't really developed the potential of *this* neighborhood.

I think it's got to be the most vibrant art community in world history. It is a marvelous, wholesome, beautiful place to be.

BLDD: You mention eight thousand artists and residents in SoHo. There is another estimate that there are thirty thousand art makers in New York City alone. With all this quantity, how much quality do you see?

IK: In my gallery you see very even quality from month to month. For the most part professional artists. They come from all over the country but do not represent a particular regional style. Regional style seems to be finished. It's the American school. But I know it's fake west.

BLDD: Do you find the East Coast more knowing, perhaps, the Californian more experimental?

IK: No, not among the artists that come to see me. I see experimentation everywhere. We see up to one hundred artists each week, of which some 90 percent are totally professional; of these, half could be shown in some professional setting, and eight or ten of them are as good as the artists that I am showing in my gallery right now. It's painful and frustrating to have no place to send them.

BLDD: With the crowding of commercial galleries, some have turned to artist-run cooperatives. What do you think of this movement?

IK: My origins as an art dealer were in a cooperative gallery and it can be a functional and sensible alternative if there is strong management. The major problem is that in a coop the artists have to agree, and there must be a committee to determine who shows with the gallery and other policies of the gallery. I find that the collectors are generally democratic. They will look at any good show no matter what space it's in, even a coop. And it doesn't have to be run by an eloquent, dapper character who has a plush back room. We proved that with SoHo situations.

BLDD: How do you determine the market value of a work of art?

IK: Those who have been in the art community for as long as I have, over twenty years, have been seeking a meaningful conspiracy as to prices for that entire time and we simply cannot find one. You price the work of art based on your instinct about it. A work that is four feet by five feet, painted on canvas, is about $650 in the first show. If you take ten art dealers and you ask how much is a picture that size, that type, for the first show, he'll say $650 to $900; the second show is $1,200 to $1,500. It's progressive, but we don't raise the prices of an artist's work unless there are between five and ten collectors willing to pay that price. In Germany a number of my artists who were selling here at a particular time for $4,000 and $5,000 sold at auction for $15,000 to $20,000. We could have immediately priced the works at the gallery at that level but it

would have been futile and senseless because there was still no depth to the market. Pricing is an instinctual process.

BLDD: You have criticized the art critics for making artists into media heroes and inflating their importance. Is the role of the critic a necessary one? A useful one? Do standards exist?

IK: It's currently held that a group of critics or dealers can get together in a back room and agree that a certain artist might be major and support him or her and make a career. It isn't that simple. Collectors and museum officials and all the smart characters who come in and don't collect but only come to see—they are the final testing ground. The critic's role to me is significant: to try and sort out for us the meaningful creative ventures of our times, to identify those artists of consequence, and to deflate those artists who achieved major reputations for no proper reason. Unfortunately that is not frequently done. Critics are a special breed; they are not well paid and few of them are capable of writing with full conviction. They are concerned about their place in the art world. They are anxious not to hurt any fragile creative person. It's very hard to go into a first show of an artist and say this show should not have happened. Or that so-and-so, whose works are now between $20,000 and $40,000 per painting, should never have achieved such prices.

BLDD: I wonder if you would tell us your views of some twentieth-century artists? Start with Matisse.

IK: Matisse is not my artist. You can appreciate and enjoy and acclaim a kind of artistic achievement which is alien to your character and personality. But I don't happen to like Matisse, he's too French for me. Van Gogh appeals to me and Cézanne doesn't appeal to me and Picasso I like in part. I like him in the 1920s especially.

BLDD: Can we move on to the current evaluation of the work of Rothko?

IK: Rothko has achieved much of his recent fame because of the lawsuit about property. Both sides came to me and asked me to serve as a witness about the price value of Rothko's works. I was willing, for the prosecution, to announce that I thought that Rothko was an artist of great consequence and that he was worthy of a certain price structure and I was willing, for the defense, to agree that much of the work was not really up to par and was not worthy of the prices being put on it by the prosecution. A lot of people felt the same way on behalf of the defense, but the defense itself was so unattractive nobody wanted to testify for them. This is unfortunate, because some decent, honest people were very severely injured, particularly Theodoros Stamos, a painter who was one of the executors of the Rothko estate and who has been

bankrupted by this lawsuit. Rothko's prices were overstated. He was a fine painter at his best and produced a lot of work of no consequence whatsoever. Paintings by Rothko should be seen one at a time to gain the full measure of their power. That's how he conceived them, and that's how they breathe best. Somebody like Twombly is also at his best one picture at a time. In the case of certain artists—if the dealer is prosperous enough to advertise extensively, if the critic pronounces his or her work significant, that artist can gain a measure of fame that he or she doesn't deserve.

BLDD: Do you see any intimations of a new development in art?

IK: Once you see a new development you can declare how logical it is, but if you're in the midst of a new development you can't say what's going to come afterwards. People asked me in 1969, 1970, 1971, when hyperrealism just began to emerge triumphant, what would be next. It's entertaining to guess at. We have seen intimations of a new kind of illusionism in which materials shown represent other materials. The best example I could give would be the works of Marilyn Levine, who works with ceramics but the works look like leather. In the last sixteen months we have seen many instances of what I call material illusionism come in from all over the country. We're also seeing much pictorial and abstract illusionism outside of hyperrealism.

BLDD: How do you explain this movement?

IK: I have a fabulous explanation for it: a loss of faith with materiality.

BLDD: In that tortuous path from studio to museum, how important is a dealer to the work of an artist?

IK: In our time I think a great artist will be discovered no matter what. Nineteenth-century artists like Van Gogh went unnoticed. But with communications what they are now, with a number of people willing to look at art and give it a chance, no artist who reaches out a little bit and is worthy of attention is likely to go unnoticed.

Lee Krasner

(Painter. Born Brooklyn, New York, 1908)

BLDD: Lee Krasner is one of that group of New York artists who early on began to revolutionize American art. An artist for more than fifty years, her work has influenced younger generations and her peers.

From the very beginning of your art life, you have invested it with psychological content and emotion. Why don't we begin by your telling us about your early experiences, when you were a student of Hans Hofmann's.

LK: First I was on my own for quite a while. Then I decided that I wanted to work from a model. I couldn't afford my own model, and that's when I joined the Hofmann school, roughly in 1937.

BLDD: Although you were at his studio for more than three years, you've said that there was a lack of communication because of the language barrier. Can you tell us about that?

LK: Well, at least the first six months that I was there I understood not a word of what the man said. He critiqued work for a class of twenty-five to thirty-five students, working from still life and the model. I'd wait till he'd left and I'd call the monitor, George McNeil, over and ask him to tell me what he thought Hofmann had said to me.

BLDD: Nonetheless, you have said that you discovered cubism on your own.

LK: Well, I had certainly seen paintings of the cubist masters like Picasso, Mondrian, Matisse, before I became a Hoffmann student, but specifically what Hoffmann was teaching was the principles of cubism.

BLDD: What was his most enduring influence on your work?

LK: I am afraid I couldn't put my finger on that. Naturally, there was an excitement, enthusiasm, seriousness about painting, and my own direct contact with cubism.

BLDD: You mentioned Mondrian as one of your European heroes. How, when, and where did you first come to meet him?

LK: I can't remember the year, but there was a point at which Léger

and Mondrian were visiting here, and I was then a member of the American Abstract Artists, and we had an exhibition once a year, and on this occasion both Mr. Léger and Mr. Mondrian were invited to partake in our exhibition, and I think it was George L. K. Morris and Susie Frelinghuysen who were members of the American Abstract Artists, who did a party and invited Mr. Mondrian, and that's how I met him.

BLDD: You shared interests other than your art. Perhaps you could tell us about your West Broadway boogie-woogie.

LK: You mean the fact that he liked to dance and I did and we went dancing? Well, it has nothing to do with boogie-woogie. We discovered that we liked to listen to jazz and we used to go to Café Society Uptown or Café Society Downtown, I can't remember now, and dance.

I am a fairly good dancer, that is to say I can follow easily, but the complexity of Mondrian's rhythm was not simple in any sense. Uh! It wasn't easy for me to do it. And there was another dancing partner, Jackson Pollock, my husband, who was ghastly and stepped all over my feet. So those are my two dancing partners from the art world.

BLDD: On the scene at the very same time was an eccentric Russian émigré named John Graham. Who was he and in what ways did he influence you?

LK: He had an enormous influence on me. He wrote a book—I've forgotten the title of it, *Dialectics in Art*, I think it was—which I'd read long before I met him. When I met him and he came to the studio he invited me to partake in an exhibition—in 1941 or 1942—of French and American painting, and the unknown Americans were de Kooning, Pollock, and myself.

BLDD: It was considered a challenge to the French avant-garde at the time, to include these three Americans. As a result of that show you met Jackson Pollock for a second time. Earlier on you had met him at a loft party—an Artists Union loft party, I guess it was, years earlier.

LK: Yes, that's when he stepped all over my feet. We danced so terribly, and then there was this gap of three or four years before this show. In fact he didn't remember my name. I didn't remember his. So it was in the re-meeting that we really established our relationship.

BLDD: When you heard Pollock was going to be included in this exhibition, you had not yet met him or even heard of him?

LK: That's right. I looked him up. The idea was I thought I knew everyone who was painting abstractly—Gorky, de Kooning. Well, I had never heard the name Pollock, and the fact that he was in the area, painting abstractly, was more than I could take, so I made inquiries, got his address, went up and saw his works. I was on 9th Street between Broadway and University Place, and as it turned out he was on 8th Street between Broadway and University. Yes. I knew several artists, and at one opening—I think it was the Downtown Gallery—someone said. "You know, there is going to be this exhibition, and so-and-so is going to be in it," and that was the name Pollock, and I said, "Where does he live?" Then I went to see him. I got to the top floor of the building and someone was standing in the hall—Jackson's brother. He pointed to the door at one end of the hall, I knocked at the door and entered, introduced myself, and that was the beginning of our relationship.

BLDD: In 1942, which was just about that same time, you began to paint directly from the subconscious. It was long before you personally were involved in analysis; it was at a time when Pollock was involved in analysis. How did you react to his analysis and the fact that was then unusual?

LK: To begin with, my responses to his painting had nothing to do with analysis. I was responding to painting. I then learned that he was in analysis, which I was very shocked to learn, because I was very prejudiced, couldn't have been more against it, so that I had a conflict in response. That is, there was full response to the painting. Later I learned he was in analysis; I was very unsympathetic to that.

BLDD: At one point you brought Hans Hofmann to Pollock's studio.

Can you tell us how Hofmann reacted to Pollock's then radical paintings?

LK: It was a rough meeting. I thought, as a former Hofmann student, that he'd be one of the few people to bring up there to show the work to, and that he'd respond. That wasn't quite what happened. Hofmann in his teaching, independent of how abstractly you worked, stayed very closely with the image outside, whether it was the model or the still life—you had to adhere absolutely, you could reduce it to a vertical and horizontal arrangement of space, if you wanted to, he wouldn't object there, but you had to adhere to what was there in front of you.

Well, when he came up to Pollock's place his response was, you are very talented, you should join my class, you work by heart, this is no good, you will repeat yourself, you should work from nature.

BLDD: How did Pollock react?

LK: Pollock said, "I am nature. You see, Hofmann separates himself from nature, he puts nature out there, and he is the observer."

BLDD: And how did this affect your relationship with Hofmann?

LK: Well, let me put it this way. The transition I went through from the academy to cubism, I once more had to go through from cubism to Pollock after I responded to Pollock's painting. It was that much of a transition once more.

BLDD: You refer to some of these transitions in your life as swings of the pendulum. Was this one of the more significant ones?

LK: Yes, this was a mess. About three solid years of build-up of gray mass on the canvas, nothing coming through, so it wasn't an easy transition, but it was that violent a transition for myself. I went through that.

BLDD: What was Pollock working on during that period?

LK: I don't know. I had my own problems. I liked what he was doing, and those would have been some of his early shows. I had *enormous* admiration for him. But I was pretty preoccupied with the solid gray masses in my studio.

BLDD: For a long while your own work was eclipsed by Pollock's legend. Let's try to dispel some myths. There are many that felt that all the while you were nurturing him and his career you were not working. What *were* you doing during that period?

LK: I was working all the time. I doubt our relationship could have existed at all if I weren't working. As long as I was able to work I went about my business.

BLDD: In a pre-women's lib era, how were you treated by your fellow artists?

LK: Well, it was a curious combination. Remember, I start in high school and it's only women artists, all women. Then I'm at Cooper

Union, Woman's Art School, all women artists, and even when I am on WPA later on there is nothing unusual about being a woman and being an artist. It's considerably later that all this happened. Specifically when the scene moves from Paris, which was the center, and shifts into New York—first a group of surrealists who treated their women like well-groomed poodles, and then the abstract expressionists—where we now have galleries, price, money, attention. Up to then it's a pretty quiet scene. That's when I am first aware of being a woman artist and a situation is there.

BLDD: How would you describe the preformative years of abstract expressionism? What was going on in this city then?

LK: If I wanted to see Arshile Gorky's work, he didn't have a gallery. You went to his studio or you went to de Kooning's studio, or they came to your studio. You know what the scene is today: no matter what form of painting it is, you find it in some gallery or in some museum, and that's quite a transition.

BLDD: It was John Graham who first articulated the theory of psychological content and automatic technique. Do you think of him as the originator of the concept of action painting?

LK: I hate the term action painting. I don't think it's been defined aesthetically. That is to say, if we say cubism to each other we know what we're talking about. Abstract expressionism, now—but then it's been called many other things. So I don't think it has been defined aesthetically as yet.

BLDD: Did John Graham have a great impact on your work, in the long run?

LK: His responses, the fact that he responded to my work, had a great impact on my work, and he responded to Pollock enormously.

BLDD: And what did you learn from Pollock's work?

LK: I don't know. Let me put it this way. If we think of the Renaissance concept of space, where you are the artist, you are using perspective as your concept of space, and you are making whatever you are doing with it.

Now if we go from that into cubism, the artist still separates himself from nature. Only now the space is frontal.

In Pollock once more there is another transition. I can't define it for you, sorry.

BLDD: You said that to be a great artist doesn't come through the genes. Where *do* you think it comes from?

LK: I haven't the foggiest, and that's after many years of analysis and working with the subject.

BLDD: Well, here you are, a woman, the first American-born of a

family of Russian immigrants. Where did you ever get the idea or the courage to become an artist?

LK: The question of courage never came up. The idea? I haven't any notion, because it was nowhere around for me to put my finger on, and as I said, even in analysis, where I tried to pin it down, I came out nowhere, so I still have no answer to that one.

BLDD: There are certain secret messages, however, that you have been sending to us for many years, I'm referring to the recurring theme of hieroglyphics in your work. Do you relate them to any of your early training, to any significant influence?

LK: I think it was in my show at the Whitney that Marcia Tucker pointed something out to me I had been totally unaware of, and that is that I started my painting at the upper right hand at all times and swung across the other way, which she related to my early training in Hebrew writing. I had never made the connection. She pointed that out to me. I was doing it for many, many years without being conscious of it in any sense. And so at all times I was preoccupied with a kind of writing which I nor anyone else could read, and I wanted it that way. I don't know why.

BLDD: You talked earlier about those frozen gray masses that you were faced with, until there was another swing of the pendulum, and you produced a major series of works between 1946 and 1949, the *Little Images.* What were your contemporaries doing at that time, and what were you doing? What did the *Little Images* represent to you?

LK: For me, the *Little Images* was the breaking up of that three solid years of gray mass, and trying to make the transition. These were the first things that began to come through, so needless to say I accepted them.

At that particular time, Peggy Guggenheim has opened her gallery, we begin to see Clyfford Still, we begin to see Mark Rothko, not the square, you see, preformative stage.

BLDD: Do you think that the *Little Images* series has emerged as a key to the rest of your work?

LK: I wouldn't know. I know it's a part of it, a strong part of it, but I am in no position to really evaluate it and say it's key or not key.

BLDD: You've often said that you can't be trusted with your own work for any period of time—a less than whimsical reference to the fact that on two occasions you took earlier work, cut it up, destroyed it, and then remade it.

LK: Right.

BLDD: What made you decide to do something like that?

LK: It wasn't a decision. It happened, and then I observed what I did.

BLDD: Can you tell us about the first time—what did you do?

LK: On the first occasion, which takes it back to what became my 1955

collage show—so it started in 1953—I had the studio hung solidly with drawings, you know, floor to ceiling all around. Walked in one day, hated it all, took it down, tore everything and threw it on the floor, and when I went back—it was a couple of weeks before I opened that door again—it was seemingly a very destructive act. I don't know why I did it, except I certainly did it. When I opened the door and walked in, the floor was solidly covered with these torn drawings that I had left, and they began to interest me and I started collaging. Well, it started with drawings. Then I took my canvases and cut and began doing the same thing, and that ended in my collage show in 1955.

Now this current show, there is more than a twenty-year gap between my 1955 show and this show, so I don't collage all the time. I picked up the drawings I did at the Hofmann school, which dates them between 1937 and 1940. They've been stacked away in the attic and I haven't gotten to them. In fact it was a friend of mine, Bryan Robertson, who was in the studio—they'd be still in the portfolio unopened if he didn't have the kind of inquisitiveness he had; he opened the portfolio.

And once more I went through I don't know how many of these drawings, made decisions on what I wanted to keep and what I wanted to destroy, only I didn't get to destroying them until I felt the need to start

to work and the first stage was cleaning up the studio, and I thought, well, let me start by getting rid of those drawings that I have to get rid of, and again decided, no, I am going to use them. The 1955 collages were torn. These had to be incisively cut.

BLDD: And you used scissors?

LK: Yes, knife or scissors, but no tear, and that led to this show. Why I go back on my own work in that way I don't know. I like the results—that's good enough for me!

BLDD: Is Bryan Robertson the museum director who gave a retrospective of your work at the Whitechapel Gallery in London?

LK: That's right.

BLDD: That was a significant show for you, too. You've said that every artist should have the luxury of a retrospective every ten years.

LK: By the way, that's the only retrospective. I have not had one in this country yet. It was done in London and the British Arts Council traveled it. It seems to me that one of the functions of a museum would be to let the public—but more importantly than that, to let the artist—see what happened about every ten years. There is no other way to observe it except by its being spread out in that kind of space.

BLDD: You mentioned your life as a woman artist. Many of your early friends still remain your friends.

LK: They were all at the Hofmann school. Rae Eames was Rae Kaiser, I was Lee Krasner, Mercedes Matter was Mercedes Carles—this is before our marriages—there was Joan Little, there was Lillian Olinzy, who is now Mrs. Kiesler.

BLDD: You met Mercedes Matter again in a rather unusual place.

LK: She asked me to talk at the Studio School on 8th Street. We were walking up the stairs and she said, "Oh I have no introduction for you. I didn't prepare anything." By this time we'd entered the room, and she said, "Can I tell them where we first met?" And I said, "Sure. Where did we first meet?" And now she makes the announcement—in jail. I'd forgotten that.

BLDD: I thought I'd remind us all that you spent many a day in jail.

LK: Yes, many, because at the time of the WPA—the Depression, the WPA, and I was part of that—we used to be arrested quite regularly. It was an everyday affair. We had special outfits for when we were going to be arrested, because every time they threatened you were going to be fired, you could be cut off completely, or if you were sympathetic to some other cause and you went out and picketed, they rounded you up and put you in jail.

BLDD: You've described your work, as I said earlier, as a pendulum

swing. Much of it seems to reflect what happened in your life in different periods. Do you think of your work as autobiographical?

LK: I suppose everything is autobiographical in that sense, all experience is, but that doesn't mean it's a naturalistic reading, necessarily. I am sure that all events affect one—at least that's the way I feel about it—but I don't think it means using a camera and snapping events.

BLDD: There were a number of influences on your life, most notably Matisse. Can you describe how he informed your sensibility?

LK: No, except that I still respond enormously to Matisse. I went to Detroit to see the show—I missed it in Washington—and it's magnificent, and I respond that way to a magnificent artist.

BLDD: Do you consider him the most significant influence on your work?

LK: I don't like to do that. Right now the *Book of Kells* interests me enormously, so let's say if I respond I don't care to measure it.

BLDD: The *Book of Kells*, in what way did that influence you?

LK: I heard Meyer Schapiro do a whole series of lectures at the Morgan Library, slides and so forth, but it's very difficult for me to say in what way it does influence me. What's more, I don't think I care to tap that source. I am glad it is there, and I respond, and for me that's quite enough.

BLDD: Your work goes from periods with no color to intensely colored work. How do you explain that? A result of the Hofmann influence?

LK: I don't know. For me color is a very mysterious thing. Certain colors I can use easily, others I can't, without any logical explanation.

BLDD: Is there any color that has been more difficult for you than others?

LK: Yes, yellow was an extremely difficult color. I don't know why. I might decide I am going to do a yellow painting, so I get all my tubes of yellow. Now that would seem relatively simple, but somehow or other it turns into alizarin. And I insist on letting it go the way it's going to go rather than forcing it.

BLDD: There are some colors that are especially pleasing to you. I assume they're red and green?

LK: Well, I don't know if they're pleasing or not. I sure use them an awful lot, and often will say very definitely this is *not* going to be red and green—but it turns out to be red and green. So I let it go that way rather than willing it into whatever color I might decide to will it. I think that's part of the excitement of the thing.

BLDD: For a long while the titles of your paintings have interested me. In a recent interview you said that you did not give very much

thought to the titles of your paintings. Your housekeeper's five-year-old daughter walked past a painting and said, "It looks like a happy lady," and the painting is called, predictably, *Happy Lady.* Is it really that simple?

LK: That was an exception. This little girl, Frances, was about five or six years old. Her mother came to clean, she had no place to leave Frances—I had to deal with Frances and I was very irritated to have to deal with her until she started to discuss the painting. She didn't discuss it, she said, "That's a happy lady." I saw no lady, happy or sad or anything else, it's a pretty abstract thing she is looking at. So I say, "Why do you say she is happy?" And she pointed to a part of the painting and says, "This is a lady and she's happy," reading it as though it were an old red barn with a cow. Well, she titled something I had painted many years before, and it was and still is called *The Bull,* while when she looked at it, it was *The Happy Dragon.* And that really undid me, you know, because I said why, and she explained carefully, in great detail. And then one very large canvas, very complex canvas, I asked, "What about that?" And she said, "Oh, that's just another storm."

Okay. That fed me for the next ten years. That that five- or six-year-old could read with the kind of clarity, to me it was just fantastic.

BLDD: In about 1956 you completed a painting that you called *Prophecy.* It was just about that time that you decided to make your first trip to Europe. As I recall you wrote to Peggy Guggenheim and asked her to try to help make arrangements for space in Venice.

LK: No, no. It was my first trip abroad, and part of it was to visit Peggy Guggenheim, and I was in the South of France and the call was put through from there, and she wouldn't receive me.

BLDD: She was the first person who showed the work of Jackson Pollock. How did it happen that she did not want to receive you then?

LK: Oh, she is a complicated lady. I think she felt Pollock wasn't grateful enough, and I don't know—she disliked women intensely, and she just felt it was the wrong time of the year, and so on. I can't explain Peggy Guggenheim. Or why she behaved the way she did. But everyone thought that that's where I was at the time, because that was the way the trip was scheduled. It was the time Jackson was killed in the automobile accident, and they were trying to reach me, and I was supposed to be at Peggy Guggenheim's at that point.

BLDD: Let's talk about scale for a moment. You've said that too often there is a confusion about what scale means in painting. It surely doesn't mean footage to you.

LK: That's right.

BLDD: What does it mean?

LK: Scale is independent of size. You can have a very small thing which is monumental in scale and you can have an enormous well that's empty. I think we've all experienced that kind of thing. That's all I mean by it—that it's independent of size.

BLDD: You talked earlier about the difference between the art scene in the fifties and now. How do you compare the two periods?

LK: Well, the fifties were pretty active. A little earlier than that is the point I referred to, when in order to see another artist's work you went to their studio—we didn't have galleries, there were no such thing as sales, there were no exhibitions, except that the French painters were being shown. I am talking about the American scene at that point. Well, today the scene is, as we all know, very different.

BLDD: Would you characterize this as an age of collectors rather than creators?

LK: I hadn't thought of it. I think collectors are certainly a big part of any given art scene, and collecting becomes part acquisitiveness, becomes part of the scene.

BLDD: And where do you see it going from here?

LK: I don't have a crystal ball. I don't know where it will move to. And I don't believe it moves in that kind of logical sequence anyway. But I would just like to be able to recognize it when it occurs—wherever it occurs.

BLDD: What about the revolution of technology and its influence on art?

LK: I don't think technology will kill art, let's put it that way. I was just reading Susan Sontag's thing on photography, where I think she makes the point magnificently in her first chapter: that you don't photograph an experience—you *have* an experience. And they are two separate kinds of things. One does not become a substitute for the other. So in that sense, since art is as old as man, I am not apprehensive that technology is going to kill art.

BLDD: Do you work in Manhattan or in your house in Springs, Long Island?

LK: I am in both places, and find now that I work more comfortably here in New York, where you are not supposed to be able to work. I am more at ease. On my own I never would have moved to the country. While I was with Pollock it was one kind of thing and I loved it, but on my own I would not take myself off to the country, you know, so that now I am very comfortable working where I am now. I'd like a little more space.

I have what would be known as a regular East Side apartment with a dining room, a living room and so forth. I use the master bedroom as my

studio because the light is magnificent, and use the wall space around the rest of the place. Let us say I can only get a certain amount of things into the studio. Then, when I decide it's finished it goes into another room, where I can observe it on another wall. My storage, which is good storage, is one block away, so it's possible for me to work under those conditions.

BLDD: Let's talk about some of your early handmade objects—for example the mosaic table and wall. Early on, you took other objects and included them in your work: glass, keys, coins. What gave you the idea to do that?

LK: Very dreary! We didn't have enough heat, enough fuel to heat the whole house, so I had to work in the living room. I couldn't paint in the living room, it was open . . . you know, no privacy, you can't close the door, and so . . . I think it was Jackson who said, "Why don't you try a mosaic?" And that's how I tried a mosaic. I made two tables.

BLDD: Why did you choose to give one of them away?

LK: It wasn't my choice. A couple that we met there furnished our whole house magnificently. They couldn't bear the orange crates we were living with.

BLDD: This was in East Hampton?

LK: Right. And Jackson said they had admired this table of mine a great deal, and so Jackson said wouldn't it be nice if you gave it to them, and I said, why don't you give them *your* painting? And his response was, "Did you ever hear them admire it?"

I said no. And so I gave them my table.

BLDD: Did you ever expect your life to unfold the way it has?

LK: No. I did not.

BLDD: If you had it to do over again would you do anything otherwise?

LK: I doubt it. I am awfully stubborn. Somehow or other all along the line I think I would have made the same choices and decisions—I think.

Roy Lichtenstein

(Painter, Sculptor. Born New York, New York, 1923)

and Leo Castelli

(Art Dealer. Born Trieste, Italy, 1907. Came to U. S. 1941)

BLDD: Leo Castelli has helped define a whole aesthetic period and confirm new boundaries for art. It was he who introduced the first flag paintings by Jasper Johns, the first shaped canvases by Frank Stella, and the first cartoon paintings of Roy Lichtenstein. As critic David Bourdon once remarked, he may not have written it, but he has certainly lived and helped make the history of modern art, since he first opened his gallery nearly twenty years ago.

In 1962, when the art popping on the New York scene was labeled as neo-Dada, Roy Lichtenstein was known as the comic strip man, who used popular images and printing technology, Ben Day dots as a device for formal painting. His remarkable use of the commonplace challenged not only the way in which we live but our accepted ideas and ways of seeing art.

It's often been assumed that the source of Roy Lichtenstein's originality is in subject matter, the giant brush strokes, the landscapes, the comics. A first-rate curator and critic and a close friend of yours, Diane Waldman, says that is a misconception about your work. She says that yours is an art of reference and that you're willing to use anything that suits your needs from the art of your predecessors. Would you agree with that appraisal, and which painters would you say most affected your work? What I'm really asking is, how was your vision formed?

RL: Well, I think that what Diane Waldman said is true. "Reference" is an important part of the content of my work. "Reference" is a much better word for what I do than "parody" or "homage"; but I don't think I can know in any fundamental way how my vision was formed.

My early pop painting referred to comic strips and other commercial images, Picasso, Mondrian, art Deco, et cetera, but what really occupies me is what occupies most artists and that's constructing a painting—a work: putting together marks. There are certain characteristics common to all of my works and certain differences consistent with the particular subject I'm pursuing.

You asked who influenced me and that's difficult because there are so many influences: happenings and environments, Johns, Rauschenberg, and Rivers.

BLDD: Was this when you were at Rutgers?

RL: I was there from 1960 to 1963 and the most immediate influences on my work were Allan Kaprow, who was teaching there, and associates of his in happenings. Obviously, comic strips themselves were an influence, but the license to refer to them so directly came from work being done then by Kaprow, Oldenburg, Dine, Whitman, Rauschenberg and company.

BLDD: What about their predecessors, some of the instances in your work of homage to Léger and Picasso.

RL: These were more remote influences. I think my biggest aesthetic influence might be Picasso. I have only grown to like Léger recently. You

might think because of his preoccupation with industrial forms and the bluntness and "dumbness" of his style, that he would have been important to me, but I never understood him.

BLDD: I suspect all of these people had an influence on you.

RL: I agree.

BLDD: The work you were doing at that time was referred to as neo-Dada. You had a long friendship with Duchamp, who then lived in New York. What did he think of that new movement, and how widespread was his influence on the work of that school of painting?

LC: Well, curiously enough, the first of the painters that were influenced by Duchamp did not know him or his work at all. They knew about him, but they hadn't noticed him particularly. Actually, they got to know Duchamp through John Cage, who had known Duchamp before they did. So, I should say that Rauschenberg and Johns discovered, in quotes, Duchamp. Rauschenberg knew him a little earlier, but it was Johns who was closest to Duchamp.

BLDD: Then he rediscovered Duchamp.

LC: After Johns had painted the flag, the targets, the letters, the figures. But then, he got to know Duchamp, and Rauschenberg a bit too, and they became fast friends before the pop artists appeared upon the scene. He used to come to the gallery, and I showed him Lichtenstein's work, at one point, when it appeared, and he was very, very interested. He liked it very much and thought it was a marvelous development that was occurring in a direction that he had done so much to promote.

BLDD: In 1957, the first two artists that you signed up exclusively were Johns and Rauschenberg?

LC: Yes. That's true.

BLDD: Well, how did that come about? What is it that made the Castelli Gallery different from other galleries?

LC: Well, I wouldn't want to boast about what makes it different. I would tentatively say that I always had a historical viewpoint, that I was interesting in continuing the great tradition that the Museum of Modern Art had begun of really analyzing painters and movements, a thing that had not been done in France, where all these painters came from.

BLDD: Who were the painters that were represented in the gallery?

LC: Well, I was conscious after coming to this country in 1941—and I first went to the Museum of Modern Art—that something was happening there that had never happened in Europe. I saw that Alfred Barr, who was chiefly responsible for the choices and the structure of the museums, had assembled the artists—Picasso, Matisse, Arp, and Brancusi—who had really invented something that was new. So, for instance, for the first time in my life I saw Mondrian, and even more surprising, Klee, who

wasn't at all represented in Europe. They didn't know about him in France, strangely, whereas they knew Kandinsky, but only his last period. This was the first time I found out what modern art was about, and having found out, I thought I would continue the work of the museum and try to find out where art was going from this point. We all knew abstract expressionists and I was involved with all the artists of that group, de Kooning, Rothko, Kline, and so on, but this was a movement that I could not really deal with because they were all at the Janis Gallery, and Sidney took care of them. So I wanted to continue from there. Well, what was going to come after abstract expressionism? There were lots of followers and they were all just repeating, mechanically almost, the gestures that really had meaning in the others. And when I opened my gallery I had to put together a stable, and that is by no means easy. An accident helped a great deal there, and that accident in my career was the appearance of Rauschenberg and Johns.

BLDD: And after Rauschenberg and Johns, who were the artists in the gallery?

LC: Well, after Rauschenberg and Johns—at the same time as Rauschenberg and Johns—I did find a close friend of theirs, Cy Twombly. But he very soon went to Europe, disappeared, and although I had been giving him shows all along, he missed part of what was going on here in New York. He was a little bit of an outsider. But, of course, a great painter, as you all know. After that, the next ones who appeared upon the scene were Stella, especially, and also a woman, Lee Bontecou, who did, at that time, most amazing work. It's really a great shame that after a few years of glorious work she disappeared from the scene. Of course, Stella was to be much more important than Lee Bontecou.

BLDD: When did Roy appear on the scene?

LC: Actually, Lichtenstein appeared in 1961, and he appeared with a certain number of paintings under his arm. There were some that I liked very much and some that I didn't find as interesting.

BLDD: These were cartoon paintings?

LC: They were cartoon paintings of bathroom interiors. I found out pretty rapidly that in one of the canvases that was terribly interesting he was blowing small things up, you know—a cup, for example, much larger than nature. It was one of the things that was absolutely required to make them work. There were others that didn't do that, and I found them less interesting. Now, later on, of course, that element is not necessary any longer. His brush strokes were gigantic too.

BLDD: Roy, I've read that it was a Bazooka bubble gum wrapper that originally inspired you, and Leo once told me that it was cartoons for your children's room. What is the genesis of the work?

RL: I hate to be a great mediator, but I think I drew some cartoons for my children from Bazooka bubble gum wrappers. I hope history records this carefully.

LC: Just to finish a moment, about his appearance with his paintings: I liked them very much, and of course, I decided immediately that he would be somebody that we wanted to handle and show.

This whole group—Rauschenberg, Lichtenstein, and Johns—in the beginning, before the word pop art came out, was called neo-Dada. This was because it proceeded from the Dadaist beginnings of Duchamp, who actually wasn't a real Dadaist either. At that time, I had decided that we would do a very special, curious show. It was a Rauschenberg show, but it began as a group show. At first only one Rauschenberg would appear, and then, every other day I would take out a painting of somebody else's and put in another Rauschenberg, so that in about ten days all the other paintings were evicted, and there was only Rauschenberg; and then the show finished in the same way; he was replaced little by little by other paintings.

BLDD: Was that the first process art?

LC: It was the first thing I did that seemed a little bizarre. It was in the style of happenings, I would say. But to come back to Lichtenstein, who plays a role here, I put one of Roy's paintings in that show at the beginning, and it was on that occasion that Rauschenberg saw a Lichtenstein painting for the first time. He was incredibly taken aback and didn't know what to do with it. He said, what is that, I really don't understand, and the next day he came up and said, I really thought about it and I think I understand it, and I do like it very much.

BLDD: How would you describe the pop art movement, Roy? And who made the movement? Did you ever expect the press to react to the artistic adventures of that group in the way that they did?

RL: No, I wouldn't have imagined anything like that. I was brought up in an era when very few serious American artists had any success with their art, and I was teaching and painting, and I expected to continue that way. So, I had no expectation that something like that would happen. In fact I thought nobody would like the work. The only gallery that I thought would look at the work at all was Leo's or possibly Green Gallery. Most galleries, advanced galleries, seemed committed to abstract expressionism. I also didn't realize that other artists were doing a similar kind of work.

BLDD: Who helped it coalesce into a movement?

RL: I think it began when Leo (there were also, of course, Ivan Karp, Ileana Sonnabend, and Dick Bellamy) saw within a three-week period three artists doing somewhat similar things. Leo's description of me

bringing my work to the gallery for the first time is about right. I left the paintings at the gallery and came back three weeks later and saw Warhol's work and heard about Rosenquist's. I think this was seen to be a movement by Leo, and there were other artists involved too: Oldenburg, Dine, Wesselman, and Segal, to name some.

BLDD: Do you think the kind of art we're talking about can still be called pop art?

RL: I think our work has changed since the early sixties to the point where pop is no longer a good description. At any rate, I don't love having all my efforts summed up as "pop." Words like that stop people from thinking. Of course I liked that in the beginning: Roy equals pop. The word means what you think it means.

BLDD: What does it mean to you?

RL: Well, I suppose it is art that refers to commercial images or that imitates techniques of commercial printing. There is usually an absurd edge to introducing the insensitive elements of commerce into art. I think most people realize all this. But I think these elements get changed when the work itself is unified. All this can be referred to as pop if you want. I'm sure we will never be able to change the name no matter what.

LC: Actually, abstract expressionism is extremely varied and it's all put into the same bag too. You compare Pollock to Rothko, and you see that the difference is immense.

RL: Nothing can be done about it. The names stick. I use them myself.

BLDD: Leo, you said recently that you felt that everything in painting and sculpture seems to have been done. I suspect you might have said the same thing in the late fifties as well. Do you really mean that? Do you see any new trends ahead?

LC: I did say that things seem that way, but as you point out quite correctly, it seemed that way in the fifties too, the late fifties, before the appearance of Rauschenberg and Johns and so-called pop art as we've used the term. So one can never foresee what's going to happen. One might almost say that what happens occasionally is a mutation really, because artists tend to go on exploring and basing their explorations on the previous artists, and then perhaps they see a new area there that they can explore. And the more intelligent ones, the geniuses, do find a way out of the dilemma of going on and repeating what their predecessors have been doing.

BLDD: Well, your own work has certainly evolved. Roy—from cartoons to architectural influences to futurism to Ben Day sunsets to the influence of Monet and Mondrian and Donald Duck. It reflected, of course, much of the sixties technology. In what direction is your work moving now?

RL: I don't know for sure. I've just finished a group of still-lifes which was based on industrial furniture, institutional furniture. It was taken mostly from ads of companies that sell steel tubular furniture to offices. It's an offshoot of other still-lifes I've done. Now I think I'm going to do something with surrealism; but since I haven't done it, there's no point in dwelling on it. I mean, I have some ideas, a few drawings.

BLDD: Leo, how do you decide what work is shown in your gallery, and how do you decide the market value of a work of art?

LC: Whenever a group of paintings, say by Lichtenstein, is ready—even before it's ready—we start thinking when, how, and where we are going to show. Generally speaking, when something new comes up, I like to show it in New York to begin with and then it can travel to other places. But we have done otherwise on some occasions.

BLDD: Let me amplify that question a bit, if I may, because there is much talk that prices are not arrived at necessarily as a result of market forces alone. There is talk, and I guess there has always been in the world of art, that sometimes the bidding up of prices occurs, that there's collusion, and the placing, rather than the selling, of works of art. How much price manipulation has gone on and still goes on?

LC: I would say, since you mention the term "market forces," that most definitely these forces, at least in my case, make up the prices. As far as I'm concerned, when a new group of work comes up, it has exactly the same price as the previous group. The market forces may now come about through the secondary market. Dealers do buy paintings, not only collectors. Little by little, they increase the prices—my prices. It's a slow process. But then, suddenly, a sale comes about at Parke-Bernet, and a painting that I sold, say, two or three years before, for $30,000, as in a recent instance, shoots up to $90,000.

BLDD: What painting was that?

LC: That was a painting of a studio interior of Roy's, and we expected it to go pretty high, but not to $90,000. Then that of course influences the prices of other paintings that I may have or other dealers may have. We look at a painting and we see that it's just as good or better than the one that went for $90,000.

BLDD: How does that square with an artist's point of view?

RL: I have no influence over the price of the work.

LC: The only influence you have is that always when a new series comes up, we discuss the price of each and every painting, and we usually pattern our prices on the previous show.

BLDD: More and more museum directors point with pride to their ability to merchandise their museum and its activities. More and more of their conversation seems to concern itself with box office rather than

scholarship. What do you see, in terms of showing contemporary works of art, as the differences in role and function between museums and galleries?

LC: Well, we are obviously infinitely more flexible than museums can be. They have to make a plan way ahead of time. They cannot show anything really important that appears on the scene. So we are actually the pioneers. And sometimes—I would say through practically the whole of the sixties—the museums really have been very remiss. They haven't picked up any of the new movements, and the few galleries that are involved in avant-garde art have done the whole job of promoting the new art.

BLDD: Roy, do you think the museums have been remiss as well?

RL: I think they've been very late. I think they were very late with abstract expressionism, and I think they were very late from then on. They've been very late with pop and everything that came after. I think Leo and some other galleries are really important in that role because they do show work that may have no chance of selling, but that ought to be seen. I think that's a very important role. You're also getting separate views from each gallery. And there are many more galleries than museums.

LC: One thing that's not really recognized is that about 95 percent of

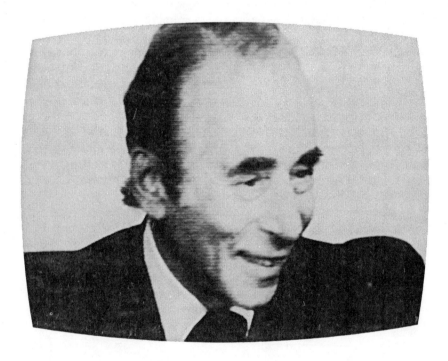

our activity—I don't speak of commercial galleries, but the galleries who take care of the avant-garde, the new things—I'd say 95 percent of our activity is public service activity. We have to finance ourselves for public service activity. The museums get funds in other ways, and they're always crying for money. Well, we have a tough time too.

BLDD: Do you see the role of galleries taking on what were considered to be the functions of museums in the past—educational roles and in the public interest? How do you see your own role and function as an art dealer—as an impresario?

LC: Yes, well, the impresario part, of course, is a little bit of a joke, because I was always thinking that really I was not interested in buying and selling paintings at all, but doing the job, discovering and presenting to the public works that are new, that seemed to me important, that indicated historical development.

BLDD: In 1964, Robert Rauschenberg won the top prize at the Venice Biennale, amid a swirl of rumors, most of them also related to your activities. What is your version of these events?

LC: My version is simply that Ileana Sonnabend and I had absolute faith in his importance and worked very hard to make Rauschenberg a famous painter and that it was as the result of our prolonged efforts that he got to the Biennale, that he got the prize.

From the audience: What do you do to build up your artists?

LC: Build them up? Well, one thing is, first, complete and total belief in the artist. If you don't believe in him, you can't build him up. I had really a fanatical enthusiasm. You can't imagine how fanatical it was. Now everything has sort of taken its course and many years have gone by. But how fanatical I was about the artists, like Rauschenberg, like Johns, like Lichtenstein, the early times, and therefore I felt it was almost like a mission to promote them. I was very much assisted in that work, especially with Rauschenberg and Johns, by Alan Solomon, who did a splendid show of Rauschenberg first, and Johns afterwards, at the Jewish Museum. And that was an incredibly influential event. Perhaps it was not understood how important it was at that time, but certainly it contributed enormously to Rauschenberg's getting the prize at the Venice Biennale.

BLDD: Excluding Lichtenstein, who are your favorite artists?

LC: There are Johns, Rauschenberg, and probably the first ones that I had who went in a certain direction. Then there is Frank Stella. Now I have two new artists that are pretty abstract. They are Ellsworth Kelly and Kenneth Noland. Then there are Oldenburg, Andy Warhol, and Rosenquist. Then come the minimal artists like Bob Morris and Donald Judd. What comes next is a little obscure. But let's stop here and not make a longer list.

BLDD: Roy, excluding Leo, who is your favorite artist?

RL: Duccio.

LC: An Italian artist of the thirteenth century.

RL: Duccio di Buoninsegna of Siena.

BLDD: There has always been a classical influence on your work, an informed sensibility. What about the influence of architecture?

RL: Just pediments and things that I've seen around New York City. I started to do those in black and white. We're talking about those long paintings that have architectural motifs. I took some photographs of buildings in bright sunlight with the shadow coming down to show the architectural detail. I did those black-and-white paintings maybe four or five years before, and then I found a way of adding color and other texture to the work, and did my recent work in that area.

BLDD: Is shape more important to you than color?

RL: Yes. I think shape is more important than color. It's the fundamental thing about art. There is no such thing as color without shape. A color has to end somewhere. I've never seen a color organization that had no form.

BLDD: How would you characterize the use of words in your painting?

RL: The words are usually absurd statements. They form an area of gray pattern—black letters against white. The statements they make are usually too simple or too complicated or mildly funny in some way.

BLDD: Roy, how great is the influence of photography and film on your work?

RL: Photography had an influence, quite an influence on my cartoon things, and I think it had an influence on my work because photography had an influence on cartooning itself. Airplane battles and things like that are not something you see at eye level in the normal course of painting a still-life or portrait. So to see a man in an airplane is obviously the result of having seen a photograph somehow. Of course, I saw the cartoon, but I think those cinema-like shorts which are used a lot in cartoons themselves influenced the character of some early work of mine. I'm not particularly interested in photography—I mean, as an art form. The photographic thing plays some part in the printing process, the dots and all that kind of—something vaguely to do with photography. That's probably what you mean.

BLDD: Who was Ben Day? What's the origin of the term? *

* The printer credited with the shading effect through the use of dots was Benjamin Day, Jr., the son of the founder of the *New York Sun* (circa 1832), the first of the penny dreadfuls. Incidentally, he was also the father of Clarence Day, who wrote *Life With Father*.

RL: I have yet to find out. It would be the invention of having some way of instead of making the gray, making little black and white dots on a screen, and they could be indicated by the artist that this would be a 40 percent screen—

BLDD: You slip the Ben Day dot in.

RL: And the printer puts the Ben Day on it. What I've been imitating more than that is something like art type, which is a printed dot on a transparent paper of some sort that has a wax on it, and you burnish it down on your drawing, which some cartoonists use, I guess. But it's supposed to imitate printing, of course, that part of printing comes through photography in a way.

BLDD: How did you become a painter, Roy?

RL: I don't know, I just went to art school. Since the age of fifteen or so I thought I was going to be a painter.

BLDD: And you're also something of a collector.

RL: Well, I've collected things, probably artists you wouldn't know, all my life. But I do have certain things. Dorothy and I like drawings and we have some Warhols and Oldenburgs, a Rosenquist, a Rauschenberg.

BLDD: Some collectors become dealers. Here you are, Leo, a Trieste-born businessman. But in 1951, before you became a dealer, you put together what is now considered a celebrated show on 9th Street. Can you tell us about that?

LC: Well, just to go back a little bit, I had a gallery in Paris before I came to America. So when I got here, well, I got interested in what was going on here, and I knew quite a few people, like Julian Levy, for instance, who had a gallery at that time, and I knew quite a few artists who came over soon after the outbreak of the war, like Duchamp. So I was right in the midst of that environment, right from the beginning when I got here to America. After I got out of the army in 1946, I began to go around and got to know artists like de Kooning and so on. I was sort of a private dealer and did what I could with paintings that my associates in Paris, who still had the gallery going, were sending over here. That made my livelihood for me. At one time we had a club that was formed back in 1948, I believe, and all the artists of the group and other people used to come and discuss various matters. And then the idea came up of doing a show of all these people that the museums really didn't want to touch back then. You know. Pollock and David Smith. And we set up this 9th Street show in an empty store. It was in a house that was going to be demolished. We got it for very little. For a period of two months, I think we paid $150 for the whole thing. And then, with the help of the artists, we painted the walls. I was the only one who had a little money, and believe me, it wasn't much. I contributed something like $500 or $600 to the enterprise.

BLDD: Was this the counterpart of the Salon des Refusés?

LC: It was the counterpart as we saw it to the Salon des Refusés. It was really a great success. Unfortunately, Roy wasn't around yet, but Rauschenberg was part of it. There were, of course, all the major painters—Kline, Pollock, David Smith, de Kooning—they all had worked very hard to put that show together.

BLDD: I'd like each of you to tell us what, regardless of price or availability, your favorite painting, sculpture, or work of art is—any period, any location.

RL: Well, one I can think of is *Girl Before a Mirror,* the Picasso which the Museum of Modern Art has.

LC: I like some sculpture, and I would say, the minute somebody asks me which my favorite sculpture is, it's Brancusi's *Bird in Flight.*

BLDD: And painting?

LC: That's more difficult to answer.

BLDD: What is your most prized possession?

LC: My most prized possession. There are several. To speak about people present, namely Roy here, I think that his portrait of Washington is one of my very favorite paintings. I have Jasper Johns's flag, which I

like very much. Jasper Johns's target, with plaster of paris. And, of course, some of Rauschenberg's work. But I like other things just as much.

BLDD: Roy, did you ever expect your life to unfold the way it did?

RL: No. I can't elaborate on that. I just didn't.

LC: It's really quite incredible. Well, it depends, very much on the character of the painter, what he does with his work, how he handles it. Roy has been going on from one thing to the other, working constantly. Jasper Johns produces a group of works, and then for years sometimes he doesn't do much except for his prints and drawings. So he's very spotty. He has adopted the attitude that unless he feels that he can do something that's new, he just prefers not to do anything. That's a very Duchampian attitude too. Rauschenberg has invented an infinite variety of themes. Some are almost impossible to place in a private collection, especially because they are either huge or flimsy. So there are many, many problems. But Rauschenberg has been, like Roy, immensely productive. The difference is that in the case of Roy, his production has always been very much in demand, very, very easy to sell.

From audience: I was wondering if you could tell us, Mr. Castelli, to what extent your own aesthetic judgments have influenced the artists that you have shown.

LC: Hardly at all, I would say, except—well, in the choice that I make of a group of paintings. I really prefer, say, three or four, and say to Roy, for instance, that I like this one or that one particularly. That might influence him. By the next series he can sort of figure out what elements in the work I do prefer. Then I have to say something that may interest you. In the beginning, Lichtenstein did two types of paintings. Some in which form was an important element, and some which were more related to the comic strips, that were funny. Now, I liked the paintings just for their form and didn't particularly care about the content. I think that Ivan Karp was quite involved with the content too, and so Ivan would express his enthusiasm about that particular group and I about the other. Now, perhaps it's not true at all, but I think what I felt about that particular group had a certain influence on Roy, and he perhaps, little by little, or very soon, abandoned the funny content, in the paintings.

From audience: May I ask the same question of Roy Lichtenstein? Do you think that Mr. Castelli has influenced your work?

LC: Maybe I'm entirely wrong there.

RL: Yes. But while anything might have some subliminal influence, there are so many influences that the result is unpredictable. The artist's major direction is stronger than all of this. There might be strong pressure to remain the same if you are successful and at the same time there

is pressure to change. There is no way to know if you are responding to pressure or following your own course.

From audience: When you were speaking before of price, it brought to mind something that I had read; some of your peers were talking about setting a basic price for resales, for future sales. I was wondering how you personally feel about that—in fairness to the buyer as well as the artist.

BLDD: I think what's being asked here is a central question, regarding artist's rights. An artist sells a picture at X dollars, and the collector then resells it at 3-X dollars, or 100-X dollars. How much of that should belong to the artist, and what is your attitude about those new contracts that were entered into by some municipalities, the City of Seattle, for example.

RL: I don't know. I'm not terribly enthusiastic about it. I don't think it will work and I think it obscures far more important legislation. I think the artist should discourage rather than participate in the resale of his work. Selling an artwork is more like selling a house than selling sheet music. You don't send a percentage of the profit from selling a house back to the architect or builder. The bill also seems to benefit the artists who least need it. There are also transactions such as one sculpture being exchanged for three drawings and some cash. I think these things are too complicated to control.

BLDD: Well, let me cite a specific instance. There's a legendary story about a Johns painting that Leo Castelli owns. He bought it when no one else wanted it—that at least is the way I have been given to understand the story—for $1,200. About a year or so ago, that very same picture that he paid $1,200 for, since we are now talking about dollars and cents and not aesthetics, was evaluated at $400,000. Do you think that is an equitable distribution?

RL: Well, the artist, for one thing, can save some of his production from each period if he is so interested in its possible appreciation. What happens if his prices go down? Should he pay the seller?

BLDD: How do you feel about that?

LC: I would say it would be eminently fair if the artist, or, as Roy pointed out, the dealer, could take advantage of these enormous rises in prices. But I think it's just impossible, as he pointed out too, to administer things like that. There are swaps, there are exchanges. There would be just an immense number of loopholes that could be found to avoid this. Also, the only artists that would profit from that, would be the ones that need it least.

RL: Yes, if that money went to a general retirement fund for artists, or something like that, it would make sense.

LC: It would be entirely for that, even if administration were cumbersome. The artist who really sort of lives very well, as Lichtenstein or Jasper Johns does, these artists have a great number of their own paintings. And Jasper Johns and Rauschenberg took advantage of the rising prices. I don't think their situation really calls for it.

RL: There's something else, and that is that the artist in this case sort of condones the resale; and you really want a painting to be held by a collector, not to be bought in order to be sold. For the artist to participate in the appreciated value means that he sort of condones these resales, because he's going to make something out of it.

BLDD: And you really want it to have a loving home?

RL: That's right. But I understand that there are other ways of looking at it. There are lots of things I'd like to see done for artists, but that isn't one of them.

BLDD: What would you like to see done?

RL: I think some sort of fund for older artists and funds for the exhibiting of work by younger artists. One or the other. Or both.

LC: The two extremes.

RL: If it could come possibly from this resale of art, that would make some sense, I think.

LC: And anybody would be more enthusiastic about contributing to something like that, rather than putting another $10,000 in the price of Roy's or Jasper's picture.

Thomas M. Messer

(Museum Director, Art Historian. Born Bratislava, Czechoslovakia, 1920. Came to U. S. 1931)

BLDD: Thomas M. Messer was born in Czechoslovakia, went to college in Pennsylvania, returned to Europe under the auspices of the U. S. Army and worked briefly as a secretary to a Wall Street broker, before going on to museums in New Mexico and in Boston. For the last fifteen years, he has been director of the Guggenheim Museum.

Perhaps we should start by your telling us what the unique character of this museum is? What is its history, its purpose? What makes the Guggenheim different from other museums?

TMM: Well, the Guggenheim was created in 1937, only then it was called the Museum of Non-Objective Painting. Therein is really its history, because the original idea of my distant predecessor, a lady named Hilla Rebay, who came from Germany to the United States, was to explain to Mr. Guggenheim, and through the institution that she eventually formed to the public at large, the importance and the viability of this new kind of painting, which did not show any images, which was called abstract or nonobjective. Of course, this kind of painting was not new in 1937. It was new, at best, in 1913, or 1912, when Kandinsky and others first had the idea and audacity to create works of art, to create images that did not reflect, did not refer to the world of common experience. The first *Improvisations, Impressions,* and *Compositions* that Kandinsky created at that time importantly broke with the history of painting as an essentially descriptive art, and made it enter its musical phase. In other words, it presumed—and this was no small presumption at the time—to convey meanings through structures, forms, textures and colors alone, just as music does. This notion, of course, was revolutionary, to put it mildly. It was not taken for granted, as it is today.

Hilla Rebay wished to be introduced to a very rich American, and was introduced to Mr. Guggenheim. She painted his portrait, because she was a painter herself, a good academic painter at first, and eventually a fervent disciple of nonobjective art. It was she who really persuaded Mr.

Guggenheim—that was Solomon R. Guggenheim—to create the museum. In its first fifteen years or so, it existed modestly in an old converted brownstone house. After her time, at the time of my predecessor, James Johnson Sweeney, it moved into a building on Fifth Avenue that Frank Lloyd Wright had had on the boards for a good fourteen years. It was opened in 1959.

BLDD: How did you make the shift from being a secretary to a Wall Street broker to a museum director in New Mexico?

TMM: That "secretary to a Wall Street broker" shouldn't be exaggerated. I spent about five miserable months there. Everybody shouted at me continuously, because I have no sense for figures, and I have a terrible habit of transposing. If you tell me 364, I respond with 463, or something like that. I'm a little better on our own budgets, but it was almost tragic for Wall Street purposes, so I didn't last long. But to go back, I grew up surrounded by Bohemians in two senses, partly because that part of Czechoslovakia is referred to as Bohemia, but also because my uncle was a composer and my father was a professor of art history. So all of this was around me, except that every effort was made to steer me away from the arts and into more dependable and more lucrative areas. And so I studied chemistry for many, many years. But the only thing that

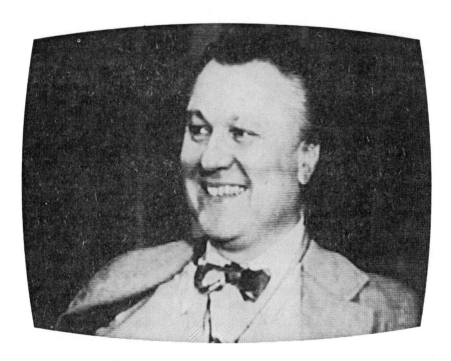

interested me was music in the first place and literature and art, secondarily. And so, gradually, as I worked my way out of this labyrinth, I ended up in another labyrinth, the Guggenheim Museum.

BLDD: Who determines what is exhibited in this museum? What makes a work of art qualify, and I don't mean procedurally, but actually?

TMM: Well, of course, any museum has the classic charge to show things that have exemplary importance. If you collect or I collect, we are free to buy and hang what we like; we can accept gifts from a friend or from our children; we are free agents in our personal rights. The museum exists, presumably, to show what, within a given context, is the best, the most meaningful that exists.

BLDD: Who establishes the standard? What forces conspire to determine what works are shown?

TMM: On the abstract, aesthetic level, a work of art has to bear evidence of some notion, a thought of sufficient weightiness, of sufficient uniqueness, of sufficient gravity, to come out other than commonplace. To say something that is analogous to a new thought, through which our awareness, our sensibility, our whole comprehension of life is somehow affected, is a qualifying consideration. What is acceptable in a public institution is nonetheless a complicated matter. I was on a panel a year or so ago, in which the audience was greatly agitated by the suspicion of collusion. Six of us, six museum directors from all parts of the world, were sitting there, accused prisoners as it were, and were asked how this "collusion" worked, and how we really get together with the critics, with the dealers, with other museum colleagues, with collectors, to contrive the acceptance of a work of art. The fact is that there is no dark intention that we deliberately, cunningly, or knowingly share and exchange. I don't mean to say that there are not, nevertheless, all sorts of pressures and forces upon all of us. None of us stands alone in this world. We are all part of a larger texture to which we are responsive. We do not always act in solitary splendor and we do, to some extent, base our judgment also upon what others think and say and do.

BLDD: What access does an artist have to your staff?

TMM: Any artist can ask that we look at least at slides of his work. Slides are coming in all the time, and members of the staff look at them. Once in a while, this leads to further interest, leads to the request to see an original, leads to a visit to a studio, and eventually, perhaps, in rare instances, this work, so brought to our attention, may find some place in the program of the museum. But it is rare. The entirely unknown artist who is extremely important is a myth. He doesn't really exist, typically.

BLDD: But how does a young artist make your grade?

TMM: Young artists, again characteristically, do not live in the desert. They live in the city, and they know other young artists, and they move frequently in packs while they are young, and in those groupings, leaders develop, so the young artists are the first ones who express respect or awareness toward the best among them. And those young artists again know young curators and know young critics, and they live and work together, and the younger ones bring it to the attention of the middle-aged ones. The middle-aged ones bring it to the attention of the old ones, and eventually some action is taken.

BLDD: Some see the museum's purpose to conserve, others to exhibit. What do you see as the role of museums in general, and the Guggenheim in particular?

TMM: All museums have the primary responsibility to care for works in their custody. If museums are understood as depositories of values, permanent values, then the first thing they have to do is to be sure that these things don't get lost, don't get alienated in a negligent way, don't get damaged, and don't disappear. If they do not fulfill that function, they have betrayed, it seems to me, their first charge. Beyond the conservation aspect, there is the obligation of most museums to build collections, to add to what they have, because very few museums come into being in a complete state. Most of them start with somebody's collection and gradually grow, enlarge, until they have a format that becomes recognizable. So I would say conservation and acquisition come first and then, of course, the use of it in exhibition form. Equally important is documentation, that is, the collection catalogues that tell the story about each work.

The modern museum, so-called, is something of an anomaly. Gertrude Stein told Alfred Barr, who went to visit her before he started the Museum of Modern Art, that what he's trying to do is very precarious, because, she said in effect, "you can be a museum or you can be modern, but you cannot be a modern museum." Her insight was correct, because the difficulty that modern museums—not only MOMA but the Whitney, the Guggenheim, many other museums of that type—the difficulty that these museums have is the cleavage between our responsibilities to the past, to culture, and to the present, to say nothing of the future. So the modern museum, of course, has less of a preserving and more of a utilitarian function. We have to look around. We have to find out what exists, what we think may become significant art. All of these are tricky aspects. The Guggenheim has, of course, a distinct function and its own history.

BLDD: Should a museum director be an art historian or an administrator?

TMM: A museum director should be an administering art historian. Most of those who today are halfway successful directors are both.

BLDD: You have described yourself as having retrograde tendencies when it comes to the question of museums and their numbers games. Could you clarify what you mean by that?

TMM: I have often been in a position to emphasize the fundamentally qualitative purpose of a museum, and to oppose current predilections for quantitative values. Not only in reference to museums, but also to universities and to churches and any area that does not deal primarily with numbers. I think it's perfectly fine for transportation, for industry, for many other respectable fields to measure their success in charts and in quantitative measurements, but the same is perfectly useless for a museum.

BLDD: Numbers are not of importance to you?

TMM: Yes, they are. It is difficult to be absolute about this argument, the argument that numbers are not decisive, because we do live in a large and populous nation. But the success of something like the Guggenheim rests primarily upon the distinction of its offerings, and, of course, one hopes that in a city like New York, such distinction can involve a great many spectators and participants. But if, for one reason or another, only a few come, yet the thing itself is defensible and valuable, I am content.

BLDD: It's a rare minority view, in that argument of box office versus scholarship.

TMM: Well, it is not only minority, but it is also difficult to sustain because we've got to live as an institution, and it is not entirely beside the point whether the public supports us or not.

BLDD: What is your annual attendance?

TMM: About three hundred thousand paid.

BLDD: Who is your public?

TMM: I don't know, at least not precisely. People walk in through the turnstiles, some of them obviously highly aware of what we are doing and well prepared to follow a particular exhibition or a collection, and others come as tourists. I think it is good in itself if people come to the museum and if they carry away as much as they can.

BLDD: What's been the most successful show that the Guggenheim has held, and by what standards?

TMM: When, many years ago, we borrowed from the nephew of Vincent Van Gogh his big collection of Van Goghs, it was predictable that people would stand in line to get into the museum. And this was nothing to be ashamed of. Van Gogh is a great painter, and those who took the time to look at his work, which the many thousands that came

did not necessarily do, could carry away a great deal of visual information that is valuable and contemporary.

The show that has given me more pleasure than anything else is titled The Solomon R. Guggenheim Collection, 1880-1945. It is, unlike the Van Gogh and a number of such presentations, not an exhibition that is assembled for the purpose and disassembled after we are through, but is based upon our holdings. In other words, every one of these two hundred paintings is ours, and they reflect almost forty years of collecting and sifting. To work with your own material, and then present something that in addition to everything else also has a theme, is very rewarding. The theme is simply painting in the first half of of the twentieth century. You can walk through those six ramps and get a notion—certainly not a complete one but an abbreviated notion—of what has happened since the time of Cézanne, and up to and beyond Jackson Pollock. So this, plus the quality of the works, the pleasure of having lived with them, makes me say that I derived greater reward from that show than from any other in my fifteen years with the Guggenheim.

BLDD: A number of people view the Guggenheim Museum as one of the finest pieces of modernist sculpture in this city. As a museum director, how you do view it as an exhibition space?

TMM: Very positively, and this is not a diplomatic answer, nor is it one that is shared by all of my colleagues. My predecessor, for instance, found himself greatly bothered by the building, and it is common knowledge that he and Frank Lloyd Wright engaged in something close to a fist fight. But I find the building marvelous in many, many ways. It is, of course, a great sculpture, but in being this, it sets a standard for any work of art that may accommodate itself within it. In other words, the building itself is a form so perfect that it almost demands the presence of works of high quality if these works are not to be demolished by comparison, by visual comparison.

BLDD: What is the most pleasurable part of your work as a museum director?

TMM: Installation. The contact with works of art, the weighing, the decision of what, within a given context, is important and valid, and its eventual presentation in a context which is, among others, also architectural.

BLDD: Other than money problems, what is the least pleasurable?

TMM: Oh, I don't know. In the end, of course, it is all one action, and it is not separable. I take it for granted that to answer the morning mail and to see any number of people whom I cannot help and who are merely wasting my time, or to go to cocktail parties—all of this is part

and parcel of a general function, in which these things fulfill a certain role and have a certain importance, and therefore cannot be eliminated.

BLDD: A number of museum directors have been talking more and more about the power struggles that go on within museums between the director and the voluntary heads, the presidents, and the boards. Are these conflicts as widespread as we hear?

TMM: I think you can say that conflicts between lay boards and professionals exist and have existed for a long time, and that they are inherent in our system. Unlike the European cultural system, which is basically one of state control and state guidance, our system is based, essentially, on a partnership between a philanthropic and public element in society on the one hand, and the professional museum person (or for that matter, symphony or whatever cultural institution or person), on the other. Unless we change the entire system, the entire system of society, there is simply no way to get away from this conflict. And occasionally the conflict gets out of hand, and the lay trustees, not knowing their place, begin to meddle with professionals, or the professionals, being incompetent, invite such meddling. The fault is not necessarily always on one side.

BLDD: At one point, the Guggenheim was thought of as almost a private and a family museum. I assume that has changed considerably?

TMM: Yes, of course, a number of board members are still either members of the family or closely linked to it. But first, as a legal matter, the nonfamily members on the board of our foundation are now in the majority. And secondly, which is more important, the funds which originally came entirely from the Solomon R. Guggenheim Foundation's endowment, are nowhere near sufficient to sustain us, so that at least one-half of our operational budget is secured from other than family sources. As a result, the balance between family and nonfamily has shifted very much in favor of the public aspect.

BLDD: From what I understand, your endowment is considerably better than that of most other museums of similar size in New York.

TMM: The endowment is less than $20 million, which isn't much. It's much less than the Frick has, for instance. The Whitney has less and MOMA has about the same, but then MOMA, of course, is a much larger institution, so it is correct to say that the ratio between endowment and size is a favorable one in our case. But not *that* favorable, because we have to strain very considerably every year to make up a large deficit created by the growing differential between income and cost.

BLDD: Who ultimately makes the decisions here? How much say do the nonprofessionals, that is, the trustees, have in the decisions of this museum?

TMM: Well, the trustees have the ultimate decision in everything. They have as much say as they wish to have. The trustees, as the word indicates, are your guarantee that this is a public place administered and run in the public interest. The trustees, for instance, can fire this director tomorrow, if they so wish. They then have to find themselves another boy, or girl. But though the trustees have ultimate power, in effect, they choose to delegate much of it to the director, and through him, to the staff.

BLDD: What is the difference between selling and deaccessioning pictures, other than perhaps euphemism?

TMM: It is a euphemism which I think is undignified. We have *sold* pictures and we shall continue to *sell* pictures, in order to buy other pictures and sculpture with the income from such sales. We have and will *sell* works which in the judgment of the appropriate committee are of insufficient permanent value to the permanent collection.

BLDD: What is the procedure that you use?

TMM: The procedure is much the same as is used for acquisition. In other words, with the involvement of those on the staff who are closest to

the subject, and within my own best judgment, I propose to the trustees that such and such work has not fulfilled any great usefulness in the past fifteen years, for instance, and that it would be better to put it up at auction with other such works and buy something that would do us a great deal of good.

BLDD: Approximately how many pictures have you sold during the fifteen years that you've been here?

TMM: Oh, maybe a hundred.

BLDD: Any regrets?

TMM: No. If we had the kind of endowment that would make this entirely unnecessary, I probably would have recommended fewer sales. I still would have sold quite a bit simply as a matter of housecleaning. There were things that were sold, for instance, which have absolutely no place in our collection. We are a museum of twentieth-century painting and sculpture. We had knick-knacks from Mexico and Oriental art and all sorts of things. Renaissance paintings got there in some way, don't ask me how. And these things simply took up space and money, so there was absolutely no question about selling them. The most dramatic sale, of course, was that of an important number of Kandinskys. There the reasoning was that we have to make up our minds whether we are going to be primarily a Kandinsky museum, in which case we should not sell one scrap and, on the contrary, buy more Kandinskys; or else, is it our function to be a museum largely of twentieth-century art, in which case the best Kandinskys would, of course, occupy an honored but exclusive place. And we decided in favor of the second.

BLDD: Perhaps you should explain the relationship between Kandinsky and Hilla Rebay?

TMM: The Museum of Non-Objective Painting was primarily interested in painters who did not paint recognizable subject matter, and Kandinsky was the first, or one of the first, so the museum bought him in great numbers, and I've reduced these numbers. We still have more than a hundred Kandinskys, with which we can stumble along, and we do not propose to reduce these any further, because it is right and just that Kandinsky should remain very prominent in the collection, which owes its existence to him more than to anyone else.

BLDD: What sort of pictures are you trying to acquire?

TMM: Primarily we are trying to increase and improve our American postwar collection of paintings. And the next exhibition that we are planning here is one which will make it very plain to everyone what we have and what we lack. We call it Acquisition Priorities. We'll present the most important things in our collection in these years, from 1945 to the present, and place them in juxtaposition with works that we would like

to acquire if we could. Now, those works will be borrowed from dealers or from private collectors, from sources, in other words, which at least theoretically would allow for the thought that they would be transferred, either as a gift or as a purchase. And so Acquisition Priorities will be a public self-critique of this museum, showing to everybody not only what we have, but what we need; not only our strengths, but our weaknesses.

BLDD: Is the Helen Frankenthaler painting, *The Canal,* a part of that show?

TMM: Yes. We did not have a Frankenthaler painting in our collection and have been looking for one. My staff and I have not only been to her studio, but have looked far and wide, until this particular work of 1963, *The Canal,* came to our attention and was bought.

BLDD: What is your favorite period?

TMM: In all art history? Well, "favorite" is a little difficult. I would hate to imply that there could be anything more favorite than Florentine painting of the fifteenth century or Greek art of the fifth century B.C. There are any number of marvelous periods. I'm personally most involved in what is now considered the historical modernism of the first half of the twentieth century.

BLDD: And who is your favorite artist?

TMM: I must give you at least a few. Again, without saying there are not others, it would be difficult to name a figure more moving and one that touches me personally more than Paul Klee. Even if I may admire a half dozen others, this admiration would not be in excess of Paul Klee, it would be of a different kind. There is no artist in the twentieth century, e.g., whose reach is greater than Picasso's and whose genius has greater explosive power than his. The twentieth century is literally unimaginable without Picasso, and I don't mean only the painting of the twentieth century or the sculpture, but life in our age would be different without him. Our visual sensibility, the appearance of the streets, of clothes, everything would be changed if Picasso had not lived—and, in a different sense, Mondrian. There would never be a certain kind of architecture, there would never be a certain kind of design, a certain courage in coloristic expression but for Mondrian. So all of this is something that cannot be exceeded, but if you think of Klee and the way in which he presented a world awareness, usually on very small surfaces, without any declamation, with the greatest modesty and economy of means, with an almost religious ethic about everything that he did, then it is impossible to say that one admires anyone *more* than Klee.

BLDD: What do you see as the next trend in art?

TMM: I'm not very trendy about art. First of all, trends are visible only in retrospect. They are not visible in the future, unless one is gifted

with prophecy, and I doubt that anyone is. Particularly not those who profess to be prophets. I'm equally skeptical about art historians and critics who give the impression that they know what is going to happen. So I think that we have our hands full coming to terms with those trends which are happening under our own eyes. For instance, the trend of conceptual art, the removal of objects from the marketplace, and the artistic tendency to go into the desert and do something far removed and something that has no resemblance to the *objet d'art* as generally perceived. That is a very interesting thought and an interesting trend, if you wish. But it's not a future trend. It is one that has already motivated very gifted artists and has created very interesting works. All you have to do is pick yourself up and go to the desert of Nevada and go beyond Las Vegas and take a plane or a car trip, usually of many, many hours. Then, if you are lucky, you might find a path which is cut in the prairies. If you are not lucky, you will do all of this and come back announcing that you haven't found it, which has happened. And then one must think about the meaning of a work of art created with such inartistic means and the effect that this kind of creation, left by human volition in a distinct part of the world, can have upon our artistic thinking.

BLDD: What is the relationship of the Guggenheim to other New York museums, to other museums in the country, and to museums internationally?

TMM: In New York, the fact is that we do pursue somewhat unique aims. Leaving out such obviously different institutions as the Metropolitan or the Brooklyn Museum, which are concerned with art encyclopedically, we have in common with the Museum of Modern Art and the Whitney the subject of modernism. The Whitney is a museum, by definition, of American art, and the Museum of Modern Art is much more broadly conceived than we are, with departments for architecture and design, painting and sculpture, all subdivided and separately administered. We really are a Museum for painting and sculpture of the twentieth century, so our scope is deliberately restricted, and thereby, perhaps, a little more concentrated. That is the situation as far as differences in New York are concerned.

In the nation, the Guggenheim is one of few sources for modern art exhibitions. Our shows travel from coast to coast. We share them as much as we can, and there is probably no other museum anywhere in the United States that comes very close to the Guggenheim in this respect. I am not saying that we are better, but the fact is that other modern museums have a different profile and are, therefore, not comparable with us.

Internationally, we have often been accused of a European bias, and it

has often been said that we have neglected American art in favor of European painting and sculpture. It is true that, given the distinction of functions here, we are a natural museum to pay attention to an area which is otherwise not as fully covered; and it is also true that the two directors that have preceded me here have had sympathy for European art, but not exclusively so, and I certainly would not want to say or think that we are not equally open to American expressions.

BLDD: If you had it to do over, what would you do differently?

TMM: The Guggenheim Museum? I would have asked Solomon Guggenheim to plunk down a large amount of money. Which he probably would have been happy to do. The strange thing is that when, in 1937, he gave $10 million, which has appreciated since, this was generous, but it would have been just as easy to tell him that we needed $20 or $30 million, and he probably would have said okay. The point is that at the time nobody could have imagined in his wildest dreams that even the $10 million could be used up, let alone more.

BLDD: What was your annual budget for the last fiscal year, and did you have a deficit?

TMM: Yes, we did have a deficit. The annual operational budget is approaching $2.5 million, and the deficits have increased from year to year, and the one that is threatening now is such that if I knew what is good for me, I would be somewhere raising money at this moment.

From audience: Will the deficit for this year and the last few years come out of the endowment?

TMM: If there is no other place where I can take it out, it will have to come out of the endowment, which is an inauspicious route. If it comes out of the endowment long enough and big enough, there won't be any endowment.

From audience: Do you expect some specific source of funding which will undo the harm you've done to the endowment during the past few years, or is there some other change that you see which will improve this situation?

TMM: It's a good question and a great one for the future. I don't even think yet about undoing the harm and replacing the deficits. I'll be content if we slow them down, or don't declare any further ones. But it is evident, and not only for the Guggenheim, but throughout the cultural scene, that the present formula doesn't work. It costs more to do the things which we feel we must do than we have income to balance it with, so something will have to give here. The history of recent years has been one of increasing participation of government on various levels, and we have been quite fortunate in having attracted sizable support from the New York State Council and from the National Endowment for the

Arts; without that effort, functioning would really be impossible. There are further efforts to increase government subsidies, and there is a new bill for the creation of a Museum Services Institute that would apply to certain areas not covered by the National Endowment. There is the large and difficult role of the corporations, and the great wealth that American business could set aside for the support of cultural institutions remains only partially tapped. Not for lack of interest on our part, I must say, but because it is difficult to raise this kind of money. So our plan is to pursue multiple giving. Use the endowment, of course; improve the yield of the endowment, if possible; enlist the support of a growing membership; play as hard for the government dollar as we can, and seek corporation support. Maybe I forgot something. If so, I'll be happy if you remind me.

Robert Motherwell

(Painter, Printmaker. Born Aberdeen, Washington, 1915)

BLDD: You've been very active as first a painter, and then as writer, teacher, lecturer and editor, have functioned as a spokesman for your own generation, and for modern art itself as well. Your art production ranges from tiny assemblages to major murals. How did it all begin? How does a philosophy major born in the state of Washington and reared in California become an artist founder of the New York School?

RM: I always wanted to paint, beginning in kindergarten. I even won an art fellowship when I was nine or ten. But my father was a powerful establishment figure, and my university studies were a stall and a compromise until I could find the world of painters, wherever it lurked.

BLDD: Your father was a banker?

RM: Yes. Since I was his only son, he didn't take to my desire very kindly, though he sensed it was real. I had never known an artistic milieu, but knew there must be one. My problem (apart from my personal isolation) was that it had to be a milieu of "modernism." I already knew the work of Cézanne, Matisse and Kandinsky and Klee. I had followed the usual route of prep school and then Stanford University, in short, the world of academe. Upon graduation Dad asked, "Is it to be law school or business administration or what?" My heart froze. I had never thought of the real world after graduation, except for the conviction that there was something else somewhere else. I stayed put, by going on to the Graduate School of Philosophy at Harvard. (Philosophy is the academic subject *par excellence;* moreover, university art schools before World War II were citadels of provincial painting.) The stand-off with my father was finally resolved by my rejecting the offer of a high-paying job (during the depths of the Depression), and accepting his alternative proposition, that in return for my getting a Ph.D. as an insurance policy, he would give me $50 a week indefinitely. On that amount I spent ten years in New York married during the entire 1940s (the $50, after my father's premature death during the war, being supplied until 1950 by an adventurous

dealer, in return for my entire output). In 1950 I had to augment my income and was given the task of wholly revising the graduate school at Hunter College, a period during which I had both a stepdaughter and two daughters of my own. My university clothes lasted well those twenty years, and California wine was less than a dollar a bottle. . . .

At Harvard I had specialized in aesthetics, more particularly, in *The Journals of Eugène Delacroix,* under D. W. Prall and Arthur O. Lovejoy. On their suggestion, I had spent fifteen months in France, on research ostensibly, but actually making painting. I had my stillborn, first show at Raymond Duncan's left bank gallery in Paris in May, 1939. Mainly, I think, on the grounds that I was a fellow Californian. . . .

In Paris I had met a young composer, Arthur Berger, who was studying with Nadia Boulanger. He suggested that I complete the Ph.D. at Columbia, instead of Harvard, with Meyer Schapiro, a most crucial external suggestion. Not so much because of Schapiro, who treated me as kindly as he could—but because otherwise it never would have occurred to me to settle in New York, let alone at precisely the right moment (with the emigration of modern European artists) for an aspiring young painter. I happened to take a room with French doors on the garden in

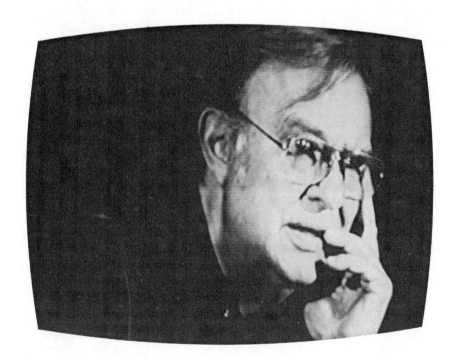

the old Rhinelander Garden apartments on West 11th Street, not far from where Schapiro lives. In my Far Western innocence, I had no idea of how busy celebrated New Yorkers are: on occasion in the night I would knock on Schapiro's door to show him a painting I was making. Finally his patience broke, and he suggested introducing me to other artists, I having made it clear that I wanted nothing to do with social protest painting or regional realism or naturalism in any form. Through him I also came to know and like the *Partisan Review* crowd, despite the obvious contradiction between socialism and individualistic modernism—their impossible reconciliation was perhaps the idealism of the late thirties and forties. Saul Bellow, exactly my age (as was Delmore Schwartz), gives a vivid account of the *Partisan* scene in *Humboldt's Gift* in chapter two.

BLDD: Was it Schapiro who introduced you to the circle of surrealists who had come to this country?

RM: Yes. Though he understood why I did not like most surrealist painting. He himself had attacked it earlier (which I did not then know), in favor of abstraction; but he knew that the surrealists were a highly cultivated, highly sophisticated international group interested in ideas, and headed by a major poet, André Breton, and though this latest embodiment of the Parisian tradition was an appropriate milieu for me, a painter, but more than a painter.

BLDD: And who were they?

RM: Besides Breton, there were Max Ernst, Marcel Duchamp, André Masson, Yves Tanguy, Matta, Kurt Seligmann, all of whom treated me most generously as a comrade, even as they began to suspect, as my painting began to evolve, that my eye was closer to their fellow exiles Fernand Léger and Piet Mondrian. I remember when I painted *The Little Spanish Prison* in 1941, Matta saying to me, "I don't know if Breton will go for a painting of a flag." (What neither of us knew was that we were looking at one of the earliest of what nowadays would be called color-field paintings.) Schapiro had arranged that I study with Seligmann twice a week, taking half my income; but Schapiro must have known that, more importantly, the surrealists were a closely-knit Parisian clan and that soon enough I would come to know them all—as it turned out, most particularly Matta, Max Ernst and Duchamp, who were encouraging and remarkably generous, much more so than my American comrades in art. The *Partisan* literary group was benign, if somewhat puzzled by the painter as literate.

BLDD: How affected was your work by surrealism? Is there any fundamental lesson that you acquired from it?

RM: Yes, most definitely. I had had a firm intuition as a stranger that the New York painting scene was filled with technical talent, but lacked an original creative principle, so that its work appeared one step removed in origin. For instance, the enormously gifted Arshile Gorky had gone through a Cézannesque period and was, for the 1940s, in a passé Picasso period, whereas much lesser European talents were more in their own "voice," so to speak, because they were closer to the living roots of international modernism (in fact, it was through the surrealists and, above all, personal contact with Matta that Gorky shortly after would take off like a rocket, before his early, anguishing suicide). In brief, as I saw it, the American problem was to find a creative principle that was *not a style*, not stylistic, not an imposed aesthetic. I found that principle, I believed, in the surrealists' own self-definition, "psychic automatism," by which they meant, in psychoanalytic jargon, free association. In the case of painting, psychic automatism usually begins as "doodling" or scribbling, just as small children begin, or as an adult does absent-mindedly while listening to the telephone or to an endless ceremony. *Doodling is not a style but a process*, a process in which *one's own being is revealed*, willingly or not, which is precisely originality, that burden of modernist individualism. The aesthetic comes afterward, according to one's sensibility, and one's gift for plastic transformation. For instance, Kafka or Picasso or Stravinsky were states of being that could be organized only by formidable artistry. And the dynamics of reaching the preconscious, though the same for everyone, differ for everyone, to the exact degree that each person differs from another. With such a creative principle, modernist *American artists could cease to be mannerists*. And what was American would také care of itself, as, in fact, it did soon enough, in the huge scale, the enormous energy, and the sheer daring of the lower depths of abstract expressionism. The theoretical procedure of the surrealists—Arp, Miró, Dalí, Masson, Ernst, Giacometti, Matta, and the others—is "psychic automatism." So is it the core of abstract expressionism—Rothko, Pollock, Baziotes, de Kooning, David Smith, Clyfford Still, myself and the others—but how different all these artists are from each other, and how different, in ultimate thrust, are each of these two movements!

BLDD: Obviously you and the surrealists both believed in the poetry of the unconscious, but did they not find your work perhaps a bit too abstract for them?

RM: Sure, that was the American difference, but "abstract" is not exactly the right word. From the surrealists' point of view, the question of "art" was secondary or unimportant. Matta and I fought over that.

For the surrealists, the surrealist "vision" and ideology took priority over painting; for us, certain surrealist methods were *means*, for arriving at painting as painting. (Americans value painting more highly than Europeans because we do not have enough of it; modern Europe is almost suffocated by millennia of it.) Still, we see now that abstract expressionism also went beyond art as art, in a way that no one has yet been able to articulate adequately in words, but certainly, as a vision of its own, profoundly different in weight, drive and frankness from the fantasy, dreaminess, satire, and black humor of the surrealists. Of the latter, it is certainly Miró, for all of his bright humor, who is closest in his working procedures and painting values to us Americans.

BLDD: You and about a dozen other painters formed what you have referred to as a "flying wedge," which made New York the center of the scene of the Western world. Can you tell us about some of those painters and some of those times?

RM: It's difficult to tell briefly. I have a contextual mind, and could only be intelligible if I spoke for an hour about what New York was like in the early forties: a strange mixture of Cole Porter and Stalinism, immigrants and emigrés, establishment and dispossessed, vital and chaotic, innocent and street-wise, in short, a metropolis clouded by the war. . . . Nearly all of my colleagues had spent years on the WPA. I think their take-home pay was $26.23 or so. Through the thirties in New York, social realism tended to dominate not only the art scene but the WPA, so that the modernist painters, according to my colleagues, were put in the worst studio corners, were rarely considered for the sugar plums, for doing big paintings, say, for post offices (ironically, since later we became known for doing big paintings). Gorky did do Newark Airport, highly intelligently, as Léger might have. There was a "beaten" quality of life. An independent man has to have a sense of dignity. A man who longs for independence is just a man who has a sense of his own dignity degraded. The New York art scene had done everything it could to beat it out of the young modernists, so that, given the poverty, the local anti-modernism, the prestige of Europe. . . . A depression scene in both senses of the word. . . . Unspeakable. . . . My Pacific Coast optimism was both shocked and perhaps useful, if irritating, in its hope for change. . . .

Yet, there was more great modern art on display in New York in 1940 than there was in the rest of the world put together. Any New Yorker could be much better briefed about the modern movements then than anybody living in London or Paris or Berlin or Milan or wherever. At the same time, for the galleries, for the collectors and the trustees of various art institutions, if one was an American *and* a modern artist—I exagger-

ate to make these points—one was ipso facto second-rate or third-rate and certainly derivative (as if Dufy or Kokoschka or Derain or Lipschitz were not), Calder, who had paid his dues to Paris, excepted.

BLDD: How and when did the term the New York School or the School of New York originate?

RM: I had to invent it. After my father died, my mother remarried several years later; her husband had a daughter who was married to a very well-known art dealer in California, Frank Perls. He became interested in what I and my friends were doing and decided to put on a show of it in his gallery in Beverly Hills, and asked me, who knew him only slightly, to write a preface for the show he had chosen. I called the essay "The School of New York." It was 1950, I think. He had chosen some artists who were not strictly abstract expressionists, so I had to find an umbrella phrase. A place served best.

BLDD: In 1948 you began a series that was later known as the *Elegy to the Spanish Republic* series. Why have you painted that now-familiar image more than a hundred times? It represents perhaps only 5 percent of your work, but is thought of as central to it, in the minds of many. Does the familiarity of the image increase its effectiveness? Perhaps you could tell us the genesis of the work.

RM: As a metaphor, some people think that, in that particular image, I hit (in the Jungian sense of the word) an archetypical image. There are quite a few people not liking abstract art who are moved by that particular image. Therefore the image by definition has something that is beyond or outside art; exactly what it is, I don't know. Some people think it's sexual, but I don't think so. Once I deliberately made one more overtly phallic, and it didn't change the felt response at all. Its specific feeling is not mainly dependent on sexuality—that I am sure of. The image is akin in feeling—a visual equivalent—to the feeling in Garcia Lorca's *Lament for Ignacio Sanchez Mejias,* and was meant to be. The force of Lorca's poem and its resonance are far beyond the death of a matador, but perhaps not beyond the death of Spain. I *meant* the word "elegy" in the title. I was twenty-one in 1936, when the Spanish Civil War began. And I love the "Spanish black" that Rafael Alberti writes of, and which some years later I illustrated in a *livre de peintre, A la Pintura,* to his poem. The Spanish Civil War was even more to my generation than Viet Nam was to be thirty years later to its generation, and should never be forgot, even though *la guerre est finie.* For years after the series began, I was often mistaken for a Stalinist, though I think the logical political extension (not that one need be logical: I hate dogma and rigidity) of extreme modernist individualism, as of *native* American radicalism, is a kind of anarchism, a kind of conscience. Witness Thoreau or

Whitman or Reinhardt. No bearable politics is not pluralistic. No en-durable existence is not in part private. That *Elegy* series was the first time somebody in this country used black massively as a color form rather than as absence of color. When I exhibited the first large one, *Granada,* in 1950, at the Kootz Gallery, which had a show called Black or White (for which I also wrote the preface to the catalog), Kootz had ransacked New York for black pictures, a great black Picasso, and de Kooning and Pollock and Gottlieb and Hofmann and Klee and I don't know who. One day, seeing Kootz about something—he was my dealer then—suddenly a small fellow came in, threw his arms around me, pointed at my picture and said, *"That is it."* I looked at him astonished, had never laid eyes on him before, and I asked, "What's your name?" He said, "Franz Kline."

There *is* something about the *Elegy* pictures, as there was to be in Kline, that is very different. Kline at his best is a superb painter, way beyond beautifully using black and white. An explosive energy, cropping and compactness, some kind of directness that is "beyond" painting, or to put it in another way, is something that painting can do, and very rarely does. My *Elegies,* though equally direct, are silent, monumental, more architectonic, a massing of black against white, those two sublime colors, *when used as color.*

BLDD: Do your colors—the black, the white, the ocher—carry sym-bolic references as well? Is there a vocabulary that goes with all of your colors, such as the blue of the Gauloises collages?

RM: In some ways all an artist's past years remain intact, but par-ticularly, as everybody knows, childhood impressions (and I would think also with a painter, the years of puberty and adolescent impressions) are crucial. No one except Dore Ashton, in a Mexican exhibition catalog—I had a big retrospective at the Museum of Modern Art in Mexico City several years ago, but unfortunately the catalog only appeared in Span-ish—I think she is the only one who has ever remarked how crucial was the fact that I grew up mainly in prewar California. My father had a vineyard in the Napa Valley. I grew up in a landscape not at all dissimi-lar from Provence, or from the central plateau of Spain, or from parts of Italy and the Mediterranean basin. In such landscapes, the colors are local, intense and clear, edges are sharp, shadows are black. The reverse of northern atmospheric light. A Rembrandt in Rome is inconceivable, just as a Piero della Francesca is inconceivable in Amsterdam. The hills of California are ocher half the year.

My so-called Francophilia or Mediterraneanphilia is not an acquired taste, but the acceptance of a certain kind of visuality that my childhood and adolescence were permeated with. A Cézanne or a Matisse painted

in Provence *looked more natural* to me than, say, a picture of a subway in New York. Cézanne and Matisse were my first two loves in modernism, not only because of their color and light, but also because, I daresay, their youths in nineteenth-century France were not dissimilar from mine in pre-World War II California: sunlit landscape, bourgeois placid life, inner torment, anxiety and artistic alienation. Painting was not only something to love. Its radiance was *everything*.

BLDD: How was your *Open* series inspired?

RM: Well, "inspired" is not exactly the word. I have had a continual problem in painting that has bothered me. All of you are familiar enough with collage technique. You realize that essentially the collagist takes a lot of disparate elements and assembles them. The problem is, given these disparate and conflicting elements, how ultimately to *unify* them. It's a painful and precarious way of making order. The separate elements tend to carry on guerrilla warfare with each other, a source of tension, true, but also possibly of chaos. Part of the public's difficulty in apprehending abstract expressionism is an inability to discriminate order that is on the edge of chaos, but still order; e.g., Pollock.

It used to cross my mind from time to time that it would be much more intelligent to go the other way—*to begin with unity* and then, within unity, create (through dividing) disparate elements. An idea floating around in my mind for maybe a decade. Now, one day I had a vertical canvas about seven by four feet; I had decided not to use its white ground, and had painted it flat yellow ocher. By studio chance, leaning against it was a smaller canvas with its backside showing—the wooden stretchers—and in looking at the wooden chassis of the smaller rectangle against the larger one, the two together struck me as having a beautiful proportion. I've always loved Spanish houses with those big, plain, stark façades, with a dark doorway cut out of the expanse, or say, two windows beautifully cut out of a maginificent whitewashed wall. So I picked up a piece of charcoal and just outlined the smaller canvas on the larger one. At the time, I had the notion of either putting imagery outside the smaller space or within it. One day it occurred to me that it really didn't need imagery, that it was a picture in itself, a lovely painted surface plane, beautifully, if minimally, *divided, which is what drawing is.* The image association was "an opening," and as I made more, the series came to be called the *Open* series, for eighty-two reasons; cf. the Random House unabridged dictionary.

BLDD: You've acknowledged that collage represents the more lyrical, the more joyful side of your work. How did you first become interested in collage? When did you first start to make them?

RM: In the most banal, practical way imaginable. My first dealer was Peggy Guggenheim, who really wasn't a dealer. She had a very small

museum of modern 'art—very small, I mean the size of a typical New York gallery—and she liked to put on small shows. She was very much influenced by the surrealists at the time, not aesthetically, but by their life attitudes.

Now the surrealist heroes were such people as Seurat and Rimbaud and Jarry and Lautréamont—people who had shown talent very early. Rimbaud was finished before he was twenty; Seurat was dead at thirty-one; Lautréamont in his early twenties; Jarry's *Ubu* was written as a schoolboy. The surrealists were always ransacking the cultural world for young talent. Peggy fell in with this. She was married to Max Ernst. She had met me and Baziotes and Pollock, and was going to give us young-sters one-man shows.

BLDD: Was this in the early forties?

RM: Yes. I think Pollock's show was in 1943. Baziotes's and mine were in 1944. I was in my twenties then, and you can imagine how I felt at being flanked on one side at her gallery by the abstract tradition—cubist works by Picasso and Braque, six Mondrians and God knows what else— and on the other surrealist side, by Miró and Masson and Arp and de Chirico and so on, at her Art of This Century Gallery, which was U-shaped in floor plan.

I should perhaps add that maybe ten people a day came to the gallery.

Nowadays one thinks that her gallery must have been some tremendous happening, like those at the Guggenheim Museum now. . . . In any event, there had never been a show in America of only collages. Peggy decided to have one. She told me one day, "Listen, I like you kids, and I am going to put on a show of Picasso and Braque and Schwitters and Max Ernst and Miró and Arp collages, and if you guys want to try the medium and what comes out is good, I'll show you all, too."

I conveyed this information to Baziotes and Pollock. Baziotes, who was a very private, profoundly, happily—and rightly so—married man, went back to his digs and did his collages. Baziotes, as I recall, made works that would be called more montage than collage.

Pollock and I both lived on 8th Street. I had only been painting a couple of years, painting in a bedroom, and he had a more professional studio. Both of us were filled with anxiety, and yet with desire, about this project. So he suggested to me to work together, in his studio. We both made our first collages together there. I can still remember watching him with a mounting tension, fearing I don't know what. But collage somehow became my joy, and has been ever since. . . . Also, it has another function: sometimes I get stuck in painting, as everybody does, and often, after shifting to collage for a time, I can resolve the painting problem when I return to it.

BLDD: What do you think of as your contribution to that medium?

RM: I think for a long time I was the only or almost the only American artist who was not solely a collage-maker who consistently took it very seriously. Collage had almost disappeared in the forties and early fifties; though in the last twenty years it has become ubiquitous. What shall I say, I helped keep it alive during the forties and fifties, and do some of my best work in it.

BLDD: You reviewed Jackson Pollock's first show at Peggy Guggenheim's, in, I believe, *Partisan Review*.

RM: Yes. You have to realize that when I wrote that most people, including highly knowledgeable people, didn't think what he was doing was painting at all. As I remember, I said that I thought he represented one of the few genuine chances of my generation to make a definitive art statement.

BLDD: How would you describe abstract art: does it have the same meaning for you now, today, as it did when you were fresh to it?

RM: No. The word "abstract" comes from two Latin words: it literally means "to take from," or "to select from." The only way one could represent completely without selecting would be to make a painted world identical with this world—which I think sometimes certain realist painters really want to do. Let's say your subject is the battle of Get-

tysburg: if you want to do it realistically, you have to put in every soldier, every cloud, every tree, every bullet, every drop of blood, smell, *every-thing.* Even artists who want to represent *have* to be highly selective in what they do. So, since the essential nature of abstraction is "to select from," obviously the purpose of selection—this I learned from Alfred North Whitehead—is *emphasis.* In this sense, there is no communication, no work of art that's not essentially "abstract" by definition, abstracted for the purposes of emphasis.

But there is a lot of art now that is abstracted to such a degree that it is difficult to know *what* is being emphasized. Not only that—there is some contemporary abstract work whose apparent basic premise is that all things are equal, so nothing is emphasized. I find it a kind of madness. Yet Mondrian is as passionate as Van Gogh. Not theoretically, but concretely and discretely, yes. (Here we have to rely on the eye, whose discriminations are far finer, subtler and more immediate than can be measured or described in words.) Intensity overcame decoration!

BLDD: You've said, "I feel pain for young artists today. The territory of modernism has largely been conquered, there is no longer much un-mapped territory, the ground has pretty much been covered." And then you said, "As modern painting completes its task, younger artists are reduced, by arriving so late historically, to adding paragraphs or foot-notes of great refinement, rather than whole chapters to the body of modernist art." What's a young painter to do? Give up paint and brush?

RM: Let me amplify a little bit what you say, because it sounds ar-rogant, or as though I am an old man, which I am, unsympathetic to the young, which I am not.

BLDD: Maybe I read it improperly.

RM: No, no, I said it, but I have a horror of boring people, and often say too briefly what I mean.

Obviously, the first generation in a virgin territory has the biggest area to conquer, in this case, modernism. The next generation still has lots, and the next generation after that still has lots, but there does come a moment when one reaches the Pacific, so to speak, where all begins to be pretty thoroughly inhabited. Then come refinements, or embellishments of specific things that have been already discovered, but maybe not thor-oughly developed. It's in that context that I made the statement. Histor-ical time is real. So, to answer your question, one can't *invent* a whole new continent. I mean it so happens that in 1863, or whatever year you like, say, 1803, there was a whole continent of modernism to discover. In my opinion, that continent, that dictionary, now is largely complete; the younger artists are, the more they have to deal with an established mod-ern language rather than inventing a new one. So there are perhaps two

possibilities for young people: one is to add historical footnotes, or further to refine an aspect of the dictionary; the other possibility is, as in Elizabethan times, or in medieval times with Dante, that somebody of extraordinary energy and breadth of vision takes an existing language and makes a Shakespearean or a Mozartian or Dantesque statement, shooting the whole works. This I think was very much in the back of Picasso's mind, for example. Though I don't think he was wholly successful. Perhaps Joyce was the most successful. . . . No novel after Joyce is worth as much, in these terms. They can be interesting from other points of view. But in the sense that poets too were involved in making the language of modernism, I could say that, next to Shakespeare, perhaps Joyce is the most magisterial writer in the English language. The modernist movement did produce, in Joyce's oeuvre, a supreme masterpiece. In my opinion, the closest in painting is the late work of Cézanne; and, as *the medium* of modernism, the collage technique, where in *Ulysses* or in Picasso and Braque's cubism or, for that matter, in TV commercials, which are technically better than the programs. . . .

BLDD: You've not only been interested in calligraphy for all of your life, but obviously the word as well. The works of many poets have either inspired on influenced some of your work.

RM: Poets, who after all were the word people, were able to formulate what was meant by modernism much better than, up to then in the forties (at least in what was available in English) the painters had been able to. Though perhaps the first manifesto of modernism is by an American, Edgar Allan Poe; and the next manifestoes are by the French poet who fell in love with Poe, namely Baudelaire. Poe had the fantastic luck to have his prose translated by Baudelaire, one of the great poets of the nineteenth century, and his poetry translated by Mallarmé, also one of the great poets of the nineteenth century, so that in French Poe seems and perhaps is—if words per se are crucial, I believe they are—greater than in English. It's difficult to judge, the French are so taken by the exotic. What could be more exotic than an early-nineteenth-century American genius?

BLDD: Early on you became an advocate and a theorist, a spokesman, an historian. Do we tend to be a little uneasy with an artist who is articulate? Has that been a help or a hindrance for you?

RM: It was a social responsibility, and a means toward our survival, but for me so much of a hindrance that for a long time I quit writing. . . . Alfred Barr suspected it, and was disappointed when I confirmed his guess. The Anglo-Saxon tradition, and even the French tradition, is that painters are high craftsmen, that there is something arrogant about a painter being literate; though I have never met a first-rate painter who

wasn't highly intelligent and extremely articulate, in his own manner. The Queen's English isn't the only form. It doesn't matter whether he writes a Coleridge essay, or wants to. He *is* able to communicate. Actually, painters are the most gregarious of all artists.

I remember one night years ago being at a poet's house (Stanley Kunitz). There were four Pulitzer Prize poets; I was the only painter, talking to the women present after dinner, while the four poets were in a passionate discussion—vehement—at the other end of the room, and finally I, rudely, male chauvinist pig, got up and said, "This sounds so interesting. I've *got* to listen to it," and went over to the poets. Robert Lowell was one of them. Allen Tate was another. And Meredith and Kunitz. They had all accepted that Robert Lowell was number one.

BLDD: But they were all arguing about number two?

RM: Exactly. Now painters have their own rivalries and jealousies, but basically painters are *voyeurs* and café and coffeehouse people, with a more live-and-let-live attitude. Or maybe I am naive. My wife—my European wife Renate—looks at me sometimes and says, "You know why I love you?" I say, "Why?" And she says, "Because you are so innocent."

BLDD: You are the spirit of several painters who haunt your canvases—Picasso and Matisse and Rothko and perhaps even Miró. If that is accurate, to the work of what artist do you most respond?

RM: Not Rothko as an influence. Otherwise yes, to an extent, but more than anybody, to Piero della Francesca. Secondly, Goya. And many others. I love painting! But there is something else that one has to explain. For example, I regard the Van Eycks as miraculous painters, I can only stand there in admiration. But it's impossible for a painter of my cast of mind to do anything with the kind of thing they do, or with Vermeer, or with Velasquez. I've always thought (with absolutely no factual foundation, though I have taught a lot and known some of the great artists of the century) that there may be, say, generically six basic families of painting-minds; and that, at any given historical moment, the art culture needs one family more than another, which therefore becomes historically more prominent. In this sense, though there are many artists I adore, I have to say that then I belong—I suppose to the degree that I can tell—to a family of "black" painters and earth-color painters in masses, which would include Manet and Goya and Matisse. Because Matisse is such a great colorist, don't forget that his greatest color is black. And other artists have this particular painting-mind. There are certain works of Picasso that belong to that family too; Miró certainly. It's an earthy, broad-minded, unsentimental painting family which, like all families, contains mediocrities, but more rarely than, say, the much larger family of representational, fool-the-eye painters. Though every-

body talks about Ad Reinhardt as a "black" painter, I don't think he is a black painter at all. He is a painter who uses dark *tones,* which is something very different from thinking of black as a black color—in the sense that one thinks of fire-engine red as red, not as a tone, if I make myself clear.

It also has to do with a sense of the surface of a painting. Very close up, six inches away, a Rembrandt is sensuous in a way in which emphasized representation, by, say, Vermeer, is not.

BLDD: You have a very carefully articulated attitude toward color, and I assume a strong aversion to some colors, too.

RM: I can't bear synthetic colors. You know, I like the earth colors and ultramarine blue, the cadmium reds, yellows, but the artificial aniline dyed colors and now psychedelic colors I find offensive. Peasant colors are faultless, contemporary consumer colors—industrial colors— are awful in themselves. Still, properly organized any single color can sing.

BLDD: You regard each single work as an element in a life's work. There are almost two hundred in the *Open* series, more than one hundred forty—in spite of the fact that you confess to occasionally erring in your numbering—in your *Elegy* series. What happens if there are more in the *Cave* series, and are there?

RM: Oh, I'm sure there will be. The principal dilemma is what Kierkegaard calls the despair of the aesthetic. If there are a thousand beautiful ideas, how do you choose one instead of another? All I hope (if I ever give up smoking) is to live long enough to develop some of these images much further. The reason I've made so many works (out of whatever I've made) that could be called series—I detest so-called "serial painting"—is simply because I feel that I've never fully resolved any of them. They remain an endless challenge. The day I can make an *Elegy* that really satisfies me, perhaps then I'll stop that search. But—if I may cite a mighty name—Cézanne wasn't interested in a mountain: it was to get down *Mont Ste. Victoire* exactly as he meant it. He attacked it again and again, till his heart gave out, and it's in that sense that I've attacked an image again and again, not to turn out yard-goods. The mysteries of black are inexhaustible, as are even more those of the human spirit, of which painting is a visual trace.

BLDD: One last question, and that is, how did you manage to select one image for the monumental mural that you were commissioned to do for the new East Building of the National Gallery in Washington, D.C.?

RM: I made many sketches, of many kinds of images, but finally settled on an elegy, but an elegy that is different from any of the others, less tragic in feeling, called *The Reconciliation Elegy.* The painting is to

be thirty-one feet wide, so that it is really quite an enormous painting. What I am trying to do is what I think abstract expressionism in part was always trying to do, to make a work, huge as it is, as a spontaneous gesture of the spirit, that one did it in a single moment of passion, so to speak. The technical and energy et cetera problems involved in large-scale spontaneity are unbelievable. But if I succeed. . . . Or, the other way around, what else should I do but try, given such a monumental location and such a size, try as best I can—and maybe fall flat on my face—to make my own ultimate statement of what my generation, each in his own way, was driving at, as I understand it?

Alice Neel

(Painter. Born Merion Square, Pennsylvania, 1900)

BLDD: Alice Neel is a celebrated painter of what she prefers to call "pictures of people." She is widely celebrated as well, for her work other than portraits, still lifes, landscapes and seascapes. She is perhaps best known for her soul-baring exposés, and she has said that her greatest strength as a painter is in her psychological acumen. What do you mean when you say that, Alice Neel?

AN: If I had been a psychiatrist I would be wealthy. In the process of painting someone, I reveal not only what shows but what doesn't show, what is also characteristic.

BLDD: In 1977 a number of curators were asked who they would consider the most underrated American painter and Anne Sutherland Harris, a distinguished educator and art historian, named Alice Neel. She felt that people are afraid of your bold images of humanity. Was that fair and accurate?

AN: What she actually said was that I was the best portrait painter of the twentieth century, which may not be untrue because actually portraits are where more crimes are committed than in any other form of art. I mean, witness the college professors that hang on walls in petrified form. I think they are frightful. Or go to the Harvard Club for dinner and you will see a lot of stuffed creatures. They are not Duane Hansons, they are portraits of so-called distinguished people; but I break those rules. My portraits are considered bold by timid people; they are not really bold, they are just the truth. And actually my work was not really understood until the late fifties; before, it was too tough for everybody.

BLDD: Why don't we go back a ways. You were born in 1900 in Pennsylvania, a granddaughter of a Civil War veteran.

AN: On both sides.

BLDD: You are also a descendant of a signer of the Declaration of Independence. How did Alice Neel from that proper bourgeois beginning become such a maverick?

AN: I don't know, I just always wanted to be an artist. My father's family had been opera singers, and that's connected with the arts. But he was, in fact, antibohemian. Anyway, in art the only thing bohemianism does is it takes that awful stiff coat off of things; at its worst bohemianism is bad because you die in the gutter, or something of that sort. At its best bohemianism is good because it is liberating. I don't know if there is any left today.

BLDD: But why did you choose to study at the Philadelphia College of Art?

AN: Philadelphia School of Design for Women; that was not bohemian.

BLDD: Not at all, that's really my question: why did you choose such a cloistered kind of education?

AN: For one thing, unfortunately, I was not lesbian—although if you're for women's lib today it is very fashionable to be lesbian. I am almost ashamed of not being lesbian—but I don't think my sons would like it. I was just up in Milwaukee and a poet read from her work there. She has three sons. I asked were they homosexuals? She said she didn't care if her sons were or wanted to be homosexuals—she was a lesbian, and since she took the right to be lesbian she gave them the right to be

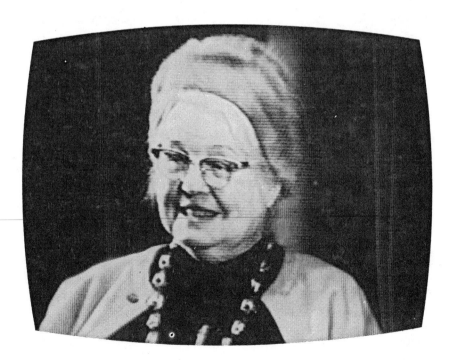

homosexuals. But I told her I just never wanted my sons, either of them, to belong to a little group in society, because I think it's harder to live like that.

BLDD: Perhaps it would be of interest to know just how much of a rebellious youth you really did have.

AN: I didn't. I was not ever rebellious at home. The Philadelphia School of Design was once a school for poor working girls, but by the time I got there it was like a school where rich girls went before they got married. I did it to learn about art. They taught a perfectly conventional art course (which I am not even against today), where you first drew from plaster casts—and they had a wonderful collection of plaster casts; they had those wonderful bas reliefs from the Parthenon—what they did with them I don't know. After you first studied that, you went to the life class and I worked hard there for four years. In the last summer I was there I met a Cuban who was also an artist. When I left the school I married him and went to Cuba.

BLDD: Was that where your first exhibition took place?

AN: Yes. When I give a slide lecture, I have several slides that I did in Havana in 1926. The road that I pursued, and the road that I think keeps you an artist, is that no matter what happens to you you still keep on painting. You know, women get pregnant and they give up painting for three or four years. They never go back to it and it's finished. You should keep on painting no matter how difficult it is, because this is all part of experience and the more experience you can have the better it is, unless it kills you, and then you know you have gone too far.

BLDD: The themes of your first marriage seem to have evolved through the fifty years of your career since then.

AN: They had nothing to do with that marriage. They were *my* themes. I did a mother and child, then I did a couple of beggars in Havana; it is one of the reasons for Castro in Cuba. When I lived there in 1926 there were people who were hugely wealthy and the bitterly poor were much poorer that I had ever seen.

BLDD: What are some of the forces and events that influenced your vision?

AN: Nothing except living and growing up, thinking and seeing the world. After I left Havana I came to New York and I was on the WPA project. And then I did innumerable street scenes and I have done some street scenes lately.

BLDD: From the time you returned to New York and were part of the WPA project you had a colorful existence.

AN: Very colorful, but nothing like today. I just came back from Milwaukee, where I met a very nice young couple. I asked them, "Are you

married?" and they said, "Oh, no, we're roommates at the college." They were just living together at the college and that was considered perfectly all right. But not in my day—then it was shocking. I was married once and I found out all about marriage. It's very expensive, divorce, remarrying and all of that. Also it seemed to me that I didn't have time for that.

BLDD: Throughout your portraits there are a number of men—an intellectual sailor, the Harvard man, the Puerto Rican nightclub singer, the intellectual filmmaker.

AN: I had a terrible nervous breakdown after the Cuban life broke up and then I went to Stockton. There was a sailor out there I eventually lived with in New York City who was very jealous and possessive by nature. He was also an early drug addict. I can't say too much about him because the Irish have a saying that you can't speak evil about the dead, and he died last year. He also went to Spain in the Abraham Lincoln Brigade and I considered that sort of heroic. But he did cut up and burn all my work. He got jealous. You know how men are, they get jealous, they're possessive.

BLDD: What about the Harvard man?

AN: I'll tell you the truth—I really didn't care too much about either of them; I was still more or less in love with the Cuban.

BLDD: But your friendship with the Harvard man persisted for over forty or fifty years of your life.

AN: He pursued me all his life. It was very strange. He liked aspiration more than realization. He chased me madly all his life and then, when he finally moved into my apartment in 1970, the whole thing had become a friendship and I became very bored with it. I realized it was just the fun of the chase and he really became a nuisance to me. One of the fascinations of him in the thirties was that everybody was starving and he used to take me to Longchamps and the Harvard Club and they had very good meals, you know.

BLDD: How did you ever move to Spanish Harlem?

AN: I had another so-called lover who was Puerto Rican. I liked it very much there—I got a huge apartment. It was a very wide railroad apartment and it had about twelve windows and I decorated it myself and it was very interesting and the rent was low and I had plenty of space, because being a painter, one of the most important things is to have space, to have room to paint and room to store things. Also I was surrounded by the people of Harlem that I found very interesting. I loved Harlem because it was full of wonderful material. I was also very concerned with the life that the third world people in this country had, so I really *have* a whole body of work now about Harlem. One of those pictures was out at the Los Angeles County Museum in an exhibit of

"Four Hundred Years of Women's Art," and what amazed me was that all the women critics respect you if you paint your own pussy as a woman's libber, but they didn't have any respect for being able to see politically and appraise the third world. So nobody mentioned that I managed to even see beyond my pussy politically but I thought that was really a good thing. If they had a little more brains they should have given me credit for being able to see not the feminine world but my own world. As far as being feminine is concerned, when I was on the WPA project there was a chap—I don't know if he was Spanish or not—he said, "Alice Neel, the Woman that Paints like a Man." "No," I said, "I don't paint like a man; but I don't paint like they expect a woman to paint."

BLDD: Have you remained in the same part of New York City?

AN: No, I am not in Harlem now, I am on the West Side—where I still get held up in the elevator and my Sony televisions get stolen, but I am in a really beautiful apartment, about a hundred years old and also huge, on the corner of 107th Street and West End. I moved away from the Harlem apartment in 1962 but only because some aspiring landlords bought the building and charged double the rent and just had to get everyone out. I was the last one to go; they got me out by letting all the bums from the corner come in and they set fires in the building every night. I could see all my work and myself burning up, so I moved to the West Side.

BLDD: For years you lived surrounded by your own work. Is it because at an earlier point your paintings were not considered aesthetically as significant as they are now, or is it also because some of your sitters found it rather difficult to live with your perception of their existence?

AN: Well, if they are backward people, they don't like it. But one reason why I got the show at the Whitney was that I dared to be experimental in painting people. You see, all during the forties and fifties New York was nothing but abstract expressionist and nobody painted people or anything like that. It was just abstract expressionism and they wouldn't even let people painters get a foot in the door. But during that time I couldn't give up what I was interested in for what was the fashion, so I kept right on painting and I have this whole body of work. Since I wasn't very aggressive and I wasn't a very good salesperson I reached the conclusion that if I painted a good painting, that was sufficient. In a way the Whitney justified me because they took about fifteen pictures that have never been off a shelf and hung them in 1974. Also, for the 1976 Bicentennial, I had two paintings in Philadelphia, one that I did in 1970 of the Gruen family—a very sophisticated painting; it had hung in a biannual at the Whitney in 1972—and the other was a picture that I did in 1950 of a black Spanish family that had never been off the shelf.

BLDD: What sustained you during all those years, both professionally and economically?

AN: A belief in art. I love art, I love painting itself, and also I had something very definite to say.

BLDD: You have had a life-long interest in problems of race.

AN: Yes, yes.

BLDD: You've been quoted as saying that you like blacks better than you like whites.

AN: Well, no. When I lived in Harlem I came to see that these Puerto Rican faces were just wonderful. But I don't like blacks better than whites. What I don't think is right is to cross out a group of people or to put them forever on the defensive, as they were put. When I lived in Harlem there were no Spanish teachers in the schools; these children had to go to a school that knew nothing about their native culture or their native language or anything, and I never thought that was fair.

BLDD: One of your sitters, Dorothy Pearlstein, says that your paintings are a document of New York City, the lost souls of street people and what she still refers to as the bohemian existence. Do you see them as history as well?

AN: Yes. I think that is one of the functions of art, although now everything is so insecure and we live in—what do they call it—the throw-away society? I don't think things are nearly as secure as we once thought they were. In fact I just heard on the radio that Carter is now making a type of neutron bomb that doesn't destroy property but it destroys people. I don't think that things like that should be done. That makes us even more insecure.

BLDD: You say that you paint because you like to make people happy with your paintings. But during the course of these many years that you have been painting, you often painted the mad, the miserable, the neurotic, the isolated. Is that a description of the human condition as you see it?

AN: If you read the statistics about the number of mental institutions and the whole problem they have with hospitals and everything else, you'd realize that everything is not the beautiful people. Now you mustn't leave out the fact that after I moved to the West Side I did a lot of very sophisticated people; Andy Warhol is owned by the Whitney; I did a nude of John Perrault, who at the time I painted him was the art critic of the *Village Voice;* and the Soyer brothers, who are two very respectable painters. They came to pose for me.

BLDD: You said that you are interested in painting the Zeitgeist and the Angst. Can you tell us what you mean by that?

AN: Well, in German that means the spirit of the age and the Angst is

the anxiety. I think that we are a very anxious people. All you have to do is read about the many people that die quite young of heart attacks to realize that there is a terrible pressure on people and it gets worse, I think, all the time.

BLDD: It was in the 1960s, and in your sixties, that life apparently brightened for you.

AN: Yes, and in the seventies I made all the pictures that the Whitney owns, while the Museum of Modern Art has one that I did in the sixties.

BLDD: Well, not only did your career brighten in the sixties, it appears to me that so did your pallette. Have your colors become more vibrant?

AN: That happened even before I left Harlem—I don't even know why, it just happened in the course of events that my pallette brightened. I was delighted to read Voltaire's *Candide*—I wish I had read it much earlier, because he showed how you can be pessimistic without being dreary about it. But I approached pessimism in an innocent fashion and I thought if you were pessimistic you also had to be heavy and dreary. But *Candide* is anything but dreary and yet you can't find anything more pessimistic than that. Someone said it's because Voltaire had such a luxurious background. He was the one that said, "The rich and the poor both have the right to sleep under bridges."

BLDD: You've said that in order to sustain your life as an artist you have had to work like the devil.

AN: You have to be two things—you have to be hypersensitive and you have to have a will of iron because you have to decide never to let anything make you give it up. The fatal thing is to give it up. Because art, besides being a great pleasure and very stimulating, is also difficult. It's even hard physically, and once you give it up you fall into the lazy way of not doing it and you're finished.

BLDD: Do you think art is created out of some despair?

AN: No, I wouldn't damn it to that. I would say that I like Mendelssohn a lot, and I think he was fairly wealthy, although I don't like him as well as Schubert, who was poor. But I don't think that is the factor. I think you are creative or not creative, and I don't think any school makes you creative either.

BLDD: You refer to yourself as a "people painter." Why do you object to being called a portraitist and what does that mean to you?

AN: The only reason is because I am just like everybody else. I get conditioned and the portrait was considered such a low form of art for so long that I was tainted. They say if you watch television it conditions your mind, it just takes you over; maybe in a few years we will all be robots. Well, that's the same thing to me. Jack Baur, who was the director of the Whitney when I had the show in 1974, said something about

my portraits and I said I hate that word. He said "Don't worry, Alice, you're going to change all that." Because he thought my portraits struck a revolutionary note in portraiture.

BLDD: How do you feel about other portraitists who think they've struck a revolutionary note—the superrealists and the hyperrealists. What do you think of that work?

AN: The new realists? Well, in the new realists emotion may be coming back a bit now. But for maybe seven or eight years, emotion has been considered very bad taste. The new realists equated a chair and a person and a table and some fruit—they are all the same thing. You see, I like not only the way the person actually looks but also the sense and the feeling that the person gives off.

BLDD: You have taken some great pride in your own militant feminism.

AN: I believe in feminism. I was born believing in it. My mother used to say, I don't know what you expect to do in the world, you're only a girl. But if anything, that made me more anxious to do something.

BLDD: You do feel great commitment to certain ideals. On two occasions you picketed—once at the Whitney Museum and once at MOMA. Do you want to tell us about the first?

AN: I picketed the Whitney because they were being unfair to blacks. But the funny thing is that with all these handsome blacks on line, they made a photograph of me. The funny thing is the way it scared the Whitney, these pickets. I went in to use the ladies' room and they were terrified, you know they were absolutely terrified of the pickets, and what do pickets do? Nothing.

BLDD: Why did you picket the Museum of Modern Art?

AN: Why because I felt that Rockefeller had a great responsibility in those forty-seven deaths at Attica. You see, he did the same thing that his grandfather did in 1921. In 1921 was the Ludlow massacre, where they burned up all the tents on Easter morning. Goons out of jail put coal oil on the tents and burned up the striking workers' families. If Rockefeller had gone to Attica, those prisoners were about ready to give up. But he didn't go and as a result many guards were also killed. In fact the women's outfit that I belonged to didn't want to picket the same day of the big demonstration in Albany, but I said it was good to have all the demonstrations in one day. I had a poster, I think it said: "Rockefeller calls the shots at the Museum of Modern Art and at Attica," because I felt that if he had gone to Attica, forty-seven deaths would have been avoided. He was probably afraid to go. . .

BLDD: You have been quoted as saying you don't look at the work of other artists.

AN: No. When they asked me if I had influences I said I never copy

anybody. I never did, because I feel that the most important thing about art and in art—and I tell students this—is to find your own road. In the beginning, you might be influenced by this and that.

BLDD: It's often been said, and you have denied this, that you were influenced by the German expressionists.

AN: I may have been. Actually, when I was very young I never even saw the German expressionists but I do like them very much.

BLDD: To the work of which artists do you respond?

AN: There are a lot of artists, you know. I like Rembrandt, I like Goya, I like Kirschner, Kokoschka. There are so many artists you couldn't narrow it down like that. I think that the mood of today and the history of today have their own rhythm, and the people you see today you should paint the way they are now.

BLDD: Is geometry very important in your painting?

AN: More than just the portraits of people—the whole composition of people is very exciting. In fact one of the most exciting things I do is to divide up a canvas—still life, street scene, or person painting. So it's not just the image of a person but the whole canvas that participates in it.

BLDD: Do you identify with your subjects?

AN: Yes, completely. Sometimes I get so much empathy that when they leave I feel like I'm in an untenanted apartment.

BLDD: How often and how long do they sit for their portraits?

AN: I made a mistake by having people sit too long. They sit for four to five hours for me and that's too long, because of my back. Also you do the best work in the first two or three hours. Now I can have up to five or six poses, but the first pose is two and a half hours and after that they're two hours apiece. I work very hard and in a very concentrated way.

BLDD: Is it a good time to be an artist?

AN: Right now, for me, art is getting very fragmentary.

BLDD: How do you see it rearranging itself or reemerging?

AN: I can't predict. You see, I don't know if we are going to be destroyed by a neutron bomb. I think Carter is twisting Brezhnev's tail. I don't know if that would provoke an atomic war but that would be the most frightful thing that could happen. I am not all that pro-Russian. It's just that I don't want to see the world destroyed and I think every sensible person should be pro-détente.

BLDD: If you had to do it over again what would you do otherwise?

AN: Nothing.

BLDD: What is your most prized possession?

AN: Life itself—that is one's most prized possession. I'm getting close to the end, and sometimes I get afraid of dying—a bit.

Louise Nevelson

(Sculptor. Born Kiev, Russia, 1900. Came to the U. S. 1903)

BLDD: Louise Nevelson is the doyenne of American sculptors. She is also, to deal in accurate superlatives, America's leading everything-else-you-could-think-of: philosopher, glamour lady, pyrotechnician.

Louise is also one of the busiest artists in the world. Her work pours forth with uninterrupted regularity, and she has just finished one of her most complex assignments, the design of sculpture, architectural ornaments, and even the vestments for the new St. Peter's Church in midtown Manhattan. Perhaps you can tell us about that commission.

LN: I've already done quite a bit of work in synagogues, one in Great Neck, and also in Boston, so when this commission was offered I accepted it. It's no different from any other, but what was interesting to me is that people said, "How can you do things for a synagogue and then do things for a church?" Even the *New York Times* asked me that question, and I told them that I feel the place I am in, I am not caught in any one particular spot. If you believe in, well, another world, that's fine, and we don't have to pigeonhole it, I am just not going to get caught in one little corner. And I don't really see that difference. So for me it was very easy to accept.

BLDD: For someone who was raised as a Jew, did you have any trouble in dealing either with the congregation or with Christian imagery?

LN: No, not at all.

BLDD: How did they feel about a woman executing this major work?

LN: In a long life, and in a long artistic life, I never took commissions—didn't want commissions—because I knew that you would have to be involved with architects and all the other people, and I've always believed that a creative act should be by the artist from the beginning to the end. But by the time the commissions came to me I was so grounded that never did I have one word from anybody.

I gave a lecture last week when I opened a show in Columbus, Ohio, at

the museum, and this is what I said then and I am going to say again: I don't make things for anybody, not even sculptures or paintings. What I am doing is fulfilling my understanding of my own life. Not long ago a very celebrated painter in New York said he is so happy when he finds that some people that see his work rebel against it or accept it. Well, I am *not* concerned about that. I am concerned about claiming my life; no one told me to, but I want to fulfill it, because I feel responsible for my claim, I feel responsible for my fulfillment. And I am still searching and hoping that by the time I am ready not to be here, I will have fulfilled it as I understand it.

BLDD: You've spent a good part of your life interested in metaphysics and historic religions, and I can recall having heard you say that you have consciously worked toward a higher order in your own life and work. What do you mean when you say that?

LN: This is a physical world. It is probably a pretty good world, but through humanity we want—at least I do—a more harmonious world, where we are not hit every day by problems that we can avoid through—I was going to say doubting, but I don't want to use the word—our awareness. I was interested because it was a matter of survival. I didn't feel very comfortable in a three-dimensional world, and also I couldn't quite

accept the dogmas of things. I was, I guess, a little too independent, so I began searching, and in searching I went into comparative religions, and I found that the symbolisms in all religions, they can only have just so many, and they dovetail and they move around, so you have a choice.

BLDD: When you came to New York about fifty-five years ago—to claim your own life, to use your phrase—one of the things that you did was to study voice and drama as well as painting and drawing. What caused you to do that?

LN: I wasn't very comfortable in that three-dimensional world, and also I suppose that nature endows different people differently. I had a voice, and the teacher said if I studied she would prepare me for opera. I studied modern dance. They said, well, we'll make you a dancer. I studied dramatics, and they said, oh, you'll be a great actress. Now I didn't want these, but coming from the country, and being a littler taller growing up than most of my classmates, and having certain abilities—if you have all this, you are just out of tune with your environment. We put a frame around a picture, but we think of the frame to suit the picture. Well, if you have a frame around you that doesn't suit the picture, you'll break the frame. And so I didn't study because I am a student. I studied for survival.

BLDD: Maybe we should start from the beginning. As a very small child, you came from Russia to Rockland, Maine. This was soon after the turn of the century.

LN: Yes. There were 8,000 people there then, and today there are 8,000 people there, so one had to die for the other to be born. Well, what could I do with that?

I don't think we reason. I don't think I even know what the word means. There is a dimension that I don't understand. People call it instinct, or intuition. Now there are very beautiful words and they say something, but I feel we are born knowing our capacity. For instance, if you have great energy, which I claim—and I also claim we create our energy—then you can do things, and the things that come out of you are going to be different from another person's who doesn't have that kind of energy.

BLDD: When did you first realize that you were going to spend your life as an artist? Did you have encouragement very early on?

LN: From the day I went to school until I graduated we had teachers that came from Pratt. Now that was something. Almost all my art teachers came from Pratt, so I already knew that Pratt was a school where you could go and then teach for self-sustenance, and so I had made up my mind to come to Pratt. But all my art teachers, from wherever they came, always gave me 100 plus. Well, I didn't get 100 plus in other things, so I

went where I got 100 plus, and also was happy with it. Now I don't like cold weather, and I found the schools cold, so I selected art—you didn't have to take it even then—and I remember thinking that I liked that room because it was so warm. Well, of course I loved my teacher too, but I thought, this room is warm. And it was only years later that I accepted the fact that I generated heat because I was so happy in that room.

BLDD: Thank goodness the gym was cold, because you got 100 plus in basketball, too.

LN: That was something else. Well, that's exactly what I mean about the energy and the capacity. Years ago when I was growing up, people measured your intelligence by academic training, in what you could excel, how you read, how you did your three R's, so you could go through school thinking you were a dumbbell if you didn't get 100 plus.

But now we know there are other rules. As a matter of fact I think it's reversed: if you get 100 plus, forget it!

BLDD: Early on you used materials that you freed from their previous associations, and in that way made new creations that reflected your own affirmation of life. How did you get to wood as a medium?

LN: It was World War II, I think, and bronze was impossible, metals were impossible, and also you must remember that there is a revelation about things in your own self. There are several things you think about when there is a war, and I thought, well, now what shall we do? We can't have materials. . . .

But the creativity of life—I was still breathing, that didn't stop. Where you breathe, that's where you move, because that's where life is, and if you feel life, you are going to create, out of any material. In our times fortunately many people, artists all over the world, have used every kind of material.

BLDD: There was an earlier period when you used terra cotta and bronze and aluminum.

LN: In the Whitney Museum, at the big show I had, they had terra cotta. I never used what you call realism. The time wasn't the time to use realism, but I used forms similar to cubism because already these were simplified and gave you great volume, I still don't like realism and I don't care for modern realism either. I don't dismiss it. I have seen so many different schools of art—earth art, conceptual art—that doesn't mean that one dismisses it. On the contrary, I think it gives you another handle to what is possible.

BLDD: What helped you inform your vision in those earlier stages? Cubism, African imagery, Mayan art?

LN: They are all pretty similar. You see, before we knew about cubism, if you look at Mexican work or you see African sculpture, there isn't

that much difference. A different consciousness, but not a different form.

BLDD: Many critics see you as the originator and chief exponent of environmental art. Is that accurate?

LN: Well, I hope so. I was doing an exhibition of my work, and I attributed really a great deal to energy—the fact that there was energy and I was building in space, up, you see, instead of horizontally or vertically. I recall that I was doing this show and I wasn't satisfied with just having a show, so I wondered, maybe way deep down I would have liked to live in a palace. Well, I am not going to live in a palace. So this was my idea of having a whole unity where nothing fell out, and so in this environment there were two windows and things, and I recreated it by creating into the one window, to get away from the awareness of the room and the space, and created a new order, a new space within that same area, and then from there on, of course, I've been doing that.

BLDD: Your first show in New York took place at the then celebrated Karl Nierendorf Gallery in 1941. How did it happen?

LN: There used to be an independent society in New York—I think you paid something like three dollars to enter—and the first paintings I ever did I stuck in there. I got press notice right from the beginning, so that wasn't my problem. I sometimes think I own the *New York Times,* that's how precious and generous they've been to me. That did not mean that I was ever selling anything or surviving on it. It just meant that I had a good press—knock on wood.

BLDD: But, of course, on *wood . . . !*

LN: Now I was quite depressed in 1940, around there, not only Depressed, but depressed. From the boredom! And when you are in that state you have more courage than otherwise. So I thought, well, maybe an exhibition will cheer me up, and I went to Mr. Nierendorf. I knew that it was the best gallery in New York, and where do you go, you can tumble only from the top, so I went in, and he asked, "What can I do?" And I told him, "Well, I want a show here." And he said, "But I don't know your work." I answered, "You can come and see the work." And it happened that that evening he was going to visit Amédée Ozenfant on 21st Street and I wasn't far, because the school was on 20th, and so he said, "I'll stop and see the work." And he came and saw the work and told me, "You can have the show in a month."

So it took me a month to clean up the dust and so on, and I had the show. It was beautifully received, and I went on with him, until he passed away.

BLDD: Were there many sales, in addition to the critical response to that first show?

LN: No. America is a young country and if you put gold in front of

them, well, people will buy it, but I was trying to prove a point with my work—old work, if you wish, in old wood. America was not ready for old wood you pick up in the street, with old rusty nails and things. But I knew then that my aesthetics were right and it didn't worry me, because I wasn't going to change, so I went right on. The Rockefellers and people like that are the ones who bought most of my work, in time.

I think that was quite a job, really. It opened up a place where people had to think and recognize that it isn't material they are buying.

BLDD: What did Mr. Nierendorf advise you to do?

LN: He said, "Look, with your kind of thinking you must not live in America. America is primitive, it's a couple of hundred years old. You must go of course to a place like Paris."

I said, "You know, Mr. Nierendorf, this is my country. It is primitive if you wish and hasn't been exploited in this field, in the arts, but I feel this country is a pioneer country and that I would like to be part of this pioneering and bring to this country things that you say that I could get in Europe." And so I did. But I think one of the miracles of my life has been that there was World War II, and we had all these great mentalities and gifted people who came to our shores, all these wonderful giants, the Rothkos, the de Koonings and we can go on and on. Franz Kline is, I think, a great artist who isn't so pushed up front at this moment, but I am sure he will be, because he is a great artist. And I can name more and more and more. This was a miracle that happened in this country, and particularly in New York, and that is one of the reasons why I am so devoted to New York. I think that's a miracle.

BLDD: In your memoir, *Dawns and Dusks,* which was done with your assistant Diana Mackown, you have an especially poetic reference to your feelings about New York. What is it about this city that makes you sing?

LN: We talked a little bit about beyond the three dimensions. New York, everyone accepts it and says that it's teeming with energy. It's like sound. Sound isn't music—it takes an artist to make music out of it. This city is teeming with energy and almost everything else. I don't think anyone thinks of the great wealth—I don't mean dollars and cents, but I mean the wealth. When you walk anywhere and you see the skyline around New York and you see the buildings, and you see the millions of people, and each mind in itself is a creation, it's overwhelming, and that goes for everything on earth. I look out of my window and it's the Bowery, and I think it's the most beautiful view I've ever seen in my life, because of the old buildings and the colors that go together and the cubes and the whole thing. So what is this? What is it, that cliché? "Beauty is in the eyes of the beholder." So when people say, "Oh, I've

got to go there to see this and that," I think it's because they are running away and haven't confronted what is in front of them, and New York has it for me.

BLDD: A critic called you a romantic in the grand manner. Another says your work sustains the kind of magical presence we associate with primitive ritual and theatrical mystery. What *is* most important for people to know about your work?

LN: Well, you know, I have to contradict what I said in the first place. I said I do my work for myself, and I wouldn't presume to superimpose any concept. I think that it depends on the development of the person that is observing it, you see.

You know, we are not born alone. It takes two to tango, and all that. So I do think we are born knowing, we do walk on two feet, and the whole body—if we are normal, we all have the same organs and the same senses. It's a variation on that theme. Now that variation is the way different people see things. But I had every reason, and probably the equipment, to fulfill what I wanted and how I wanted to build my life and see it, and I've lived with it every minute, just the thought of it fulfills me.

I've had difficult times, because if you accept the world three-dimensionally it's a tough racket, because you get banged every second, every

pore of your body is banged and you are black and blue all over. But if you recognize that you are not in that stream and you remove yourself and plan and have the courage to claim your life and move in another place, then you have it the way you want it and you project it. It's a projection. It's like a camera that projects. Of course now we don't have time to go into that in depth, but I think if you really read Shakespeare— not too many of that caliber, but in that range—you find that we project the world, and we have a lot to do with how we project it. Then you claim it. When you begin to think like that and identify with everything on earth that's living, you don't have these bangs so much. You claim them.

BLDD: From the very beginning the critics have always admired your work, but for quite a time it seemed that the general public did not find your found objects, your wood sculptures, to be either aesthetically or monetarily valuable. How did you manage through all of those years to sustain yourself, just to survive that entire period, to work and work?

LN: I think that an artist like myself has blinders like a horse. You just don't look too much, you have one place to go. Now I don't claim it's easy, and I don't want you to think for a moment that I found it easy, and I wanted to cut my throat about it for forty years—if I didn't do it, it's a miracle—so it's not easy, but it didn't dawn on me that there was another way to live. I was a dumbbell.

BLDD: So it isn't how you live, but how you finish.

LN: I remember my mother telling me, "You know, art is a very difficult life, and why do you want to choose that? You won't live as well as you could otherwise." And I said, "It's not how I live, it is how I finish my life." And I did it.

BLDD: You mentioned in your biography that you had married into a family that had great regard for Beethoven, but God forbid you should be Beethoven. How did that influence your work?

LN: Families of great wealth don't want their children to struggle to be artists and creators and musicians. It's a small percentage that would. But they always go to concerts and they gobble up everything: they gobble up concerts and dance recitals and books and everything that's on earth. They are so busy that they don't have time. If you are a gentlelady and a gentleman that isn't what you do. You do other things, you play golf, or you have a theater—there are other ways to show that you are a gentleman or a lady.

BLDD: But you never took the safe way, finding it very limiting?

LN: No. I was going to know what this world was about. I won't accept all things that are attributed to me, but I do think I had curiosity and courage to delve into life at all costs, sink or swim.

BLDD: Do you think that most artists create out of despair?

LN: I think there is a great deal of despair, yes. I am sure a man like Einstein or anyone in any field that goes into depth . . . that's the only way you begin to have a feeling of what life is all about.

BLDD: You came to be known for your black sculpture, and then at a certain point the black sculpture became gold. How did that happen? Was it a metaphor for something else?

LN: During World War II—I have a son, Mike, who's a sculptor too, and he went into the Merchant Marine, and they would be sent to, say Russia or Egypt or anywhere, six months at a time, and you didn't hear from them. After he joined the Merchant Marine, I used to sit there hoping to get some glimmer of where he might be. I think the guilt of motherhood is a little bit complex, because you think, well, if you had done it this way or that way it might have not happened. So I withdrew and I never stopped working. That's when I went into black boxes and even had velvet in front so you'd have to move a bit to look into it. And at the time I did it I never thought that I'd ever get out of that state, never, never.

So I continued. And then the war was over, and you do get healed a little bit, and before I knew it I went into gold. I went into white, too. But then what happens is, all these things become your ingredients, and your attitude toward these things—you outgrow certain things, but the essence remains with you, you see. I mean now black doesn't have that meaning to me any more, or white hasn't that meaning, because I've lived through that, and now when I do a thing it's really more of an essence, you see.

BLDD: What *does* black mean to you?

LN: Even on a three-dimensional plane you take black, and it's always the end result, and it is the most beautiful color, it really is. You take for instance any material and when you convert it into black—I don't even mean wood or a sculpture, I mean in anything—for instance a house—it's so distinguished.

BLDD: You think it's the aristocratic color?

LN: You bet your sweet life. I was on a panel at MIT, and the architect there, José Luis Sert, forgot I was there and said, "What are they doing in New York, it's all black?" And then he saw me, oh God! Oh dear!

BLDD: Then you went into white, and startled the art world. In 1959, at a show that you had at the Museum of Modern Art, suddenly you had an all-white installation that was entitled *Dawn's Wedding Feast.* Can you give us the genesis of that?

LN: I had reached a point at that time when I thought I had exploited the black to its final point, and I wanted to see what could be done with white. There were other things involved, because I think there are always

emotional things involved in my life. But then I grew into another phase, and it's like you have an octave—you know, like Beethoven has an octave—and sometimes you play these few notes and these few notes and these few notes. I had white last year in my show, yet do feel that I am closer to black. White is beautiful, and it projects other things, but I personally feel closer to black.

BLDD: You said that you've always thought that two dimensions, the flat surface in painting, is far superior to sculpture, but that there was more myth and mystery to sculpture.

LN: I still think so. But we don't at any time have too many great painters or sculptors. Painting permits a great illusion, you know. You can, for instance, get a whole thing in painting, some kind of illusion, with just a brush stroke.

BLDD: If Michelangelo were alive today do you think he would think of your work as sculpture?

LN: I don't know. But I know that the people that have put me where I am have been people who came to our shore, like Jean Arp. That is the funniest thing: we have great people in America, and yet it took Europeans to really recognize me and reflect it back over the ocean. The other one was Dubuffet, a great friend of mine, and then before that there were others. So I am too far gone probably to say it, but there was anger that our critics and our museum people, who are supposed to be so knowing and so well educated and are being paid for their jobs, were neglecting us, and by neglecting us they really deprived art, and deprived us of materials and things. So I applaud the Europeans who began with me.

BLDD: For almost fifty years, you've known everyone—Céline, Rivera Eilshemius, Gorky, Dubuffet, Wildenstein—people who obviously had a great influence on your life and on your art. How would' you describe some of that influence?

LN: Well, I wouldn't say that they had great influence, not all of them. Some did. In 1932 Rivera was in New York doing murals. I had no problem, I became an assistant, and even then I felt what I had to say was different from what he had to say, so I was never overwhelmed. Some people get overwhelmed. I wasn't because I didn't want to be a Rivera, you see. But nevertheless I think that anyone you meet has an influence. And there were several others.

BLDD: What about Louis Michel Eilshemius?

LN: Eilshemius I think was a saint. He was a great painter. I still think that America is very unknowing because they'll accept surrealism from Europe and have been so influenced by the French and still are, and Eilshemius is one of our great painters and really the brush strokes and

the colors, and the man himself was what you call a born artist. Just a great man, probably a little offbeat according to other people's ways of thinking, but I think he is a great painter, and as I said, so is Franz Kline. I think these two will be rediscovered. It has to be.

BLDD: Céline?

LN: Yes, he was fascinating. We met on a ship going to Europe. But I couldn't quite connect too much because . . . well, he was so bitter, and I think really there was a lack of sanity. You see, he carried all this venom and poison, but nevertheless he was a fascinating man.

BLDD: Jean Dubuffet?

LN: Dubuffet I think is one of the great, not only in painting but as a human being, as a thinker, and there again—what did they call it at the Guggenheim a couple of years ago?

BLDD: *The Cuckoo Bazaar.*

LN: Yes. I think that's one of the great things of our times. And it's received, but not the way it should be.

BLDD: You mentioned that you were not only interested in texture, but said that everything that we wear not only influences but expresses what we are. You have become quite well-known for your Nevelson assemblage, a cross between a princess and a peasant. Can you tell us the philosophy of how you dress and who your designer is?

LN: I won't tell you who the designer is.

BLDD: I was assuming that you were going to say *you* were your designer.

LN: I don't want to take too much credit. But at a very early age I began to learn how to put things together—hats, even shoes, and clothes—and then I liked it too. Now I don't sew, but I just put things together. And that went along with me. I believe that people should project the best they can of themselves because they owe it to everyone who will look at them. Why should we be callous about projection? So I began putting things together and I've never stopped.

BLDD: I'd like to quote a few sentences from your memoir, *Dawns and Dusks*, and I wonder if you would comment on them:

"My total conscious search in life has been for a new seeing, a new image, a new insight. This search not only includes the object, but the in-between places, the dawns and the dusks."

LN: There is not a mind on earth at any time that is totally original, because if it were it would go insane. There must be some measure of communication—you follow? I'll illustrate.

When I came to New York, I knew that Greenwich Village was where the bohemians were, and you wore berets and you were free. I was pretty

young and I thought, well, if you have to wear a beret and you have to live in Greenwich Village and be bohemian, to be so enslaved, I wasn't going to have any part of it, you see. And by the same token I don't claim a totally original mind, it's not possible and I don't think we should push that point, but I do think that if you want to fulfill yourself—now, that's impossible too, because if we don't get things from other people we go to books, which is really the same, or we look at pictures. Whatever we do, we are searching for the same thing. All of this becomes part of you.

Anyway, I began creating my hats and my clothes, so that I would be independent of having to go to a store or being enslaved, and that is the tragedy—that so many people in this day, or any time, are slaves of a situation. They work a year to get a fur coat, or they'll do this or that. We know that life is life. These things are man-made, and you must get into your place of thinking and find a way for yourself.

BLDD: You never seem happier than when you are at work.

LN: That is true. I feel that I spend time socializing and all these other things, but they are always like a little ice cream after the meal, you know. The work is where there is a total awareness of living.

I had to go day before yesterday to sign some etchings because they are going to be in my new show, and I seldom say this, but they gladdened me. When I was signing I said, "You know, this is an experience that I must tell you, that I was gladdened when I did them, just seeing them again is like seeing a good friend."

BLDD: Order is very important to you, not only in your studio but in every aspect of your life. You don't even tear open an envelope. What is the importance of that?

LN: Well, it is important to me, because if I make a mistake I am very unhappy. Let's say I buy something and I don't like it and I have to go back. Then I have to buy a new one. So it isn't one mistake—you get these activities, you see, and they intrude into your life, take so much of your energy with anger because you made a mistake. Now people say, well, it's only human. Well, I don't know. It's only human to have the best.

BLDD: What advice would you give to young artists?

LN: I only know this—you can't give advice to an artist. Could I tell Caruso that he's got to sing or that he's got to take lessons? Caruso was born with a voice. Then of course he cultivated it. Or take Sarah Bernhardt, all these people—they were born with a certain equipment, like a musician with perfect pitch. Without equipment you can give advice until doomsday and it's no good. To the persons that feel—and they

have a right to fulfill that—that they want to give their life to what they are doing, I say, sure, go to work, just work, and the work will invite you to move.

If there was a yardstick it wouldn't be very interesting. Sometimes I think—and maybe I shouldn't say it—that we have at this point in the world too many colleges and too many art schools, and of course you can learn the rudiments—you know, primary colors, and a little bit more of this, a little bit more of that—and so it becomes a bit out of creation actually.

Look, I'd like to be a ball player. Well, it takes a different kind of equipment. Or a fighter. You can't dismiss what you are born with first, then overcome. But some people overcome things by sheer desire.

BLDD: If you had it to do over again, what would you do otherwise?

LN: It's very hard to say. I feel that I wanted to do what I've done. I wouldn't have gotten married, that is true, because I wasn't equipped for that, so I feel that was the flaw, because it was a conventional thing. I was very young, and I felt you have to get married, otherwise it's a terrible thing, if you were attractive and you went to school and you were pretty good and things, well, getting married young was a feather in your hat, or something like that. So I think that's really what I must say I wouldn't do. You see, that's a little too binding.

BLDD: That is by contrast to your very romantic nature.

LN: That's got nothing to do with it. Marriage is not romantic. Oh, I *am* romantic, and I think it's wonderful. I wouldn't want not to think that there was romance and all the mysteries and everything else, but how long can you stay married and have that? Two people? You know, when I was in Germany, I heard a song, it was a great song. "Two hearts beat as one." I think one heart beating as one is enough.

BLDD: Louise, are these the best years of your life?

LN: Well, let me put it this way. Do you think if you were seventy-eight you would think it's your best years? Nature is smart, and you can't beat nature. But if it's how you leave this earth, then I think I did a good job for myself, yes. I think under all circumstances, yes.

From audience: I was looking at a piece of your work and one of the things that struck me was the way in which the piece came in and out of the shadow, that the shadow of the piece and the piece itself moved around. I felt that this was something important. Is it?

LN: Yes, it is. You know, I think the shadow is more important than the piece. I really mean it. I think the shadow anywhere is . . . I call it my fourth dimension, because in the first place it appeals to me more. Well, if people are looking for nonobjective, you know, abstract, there it is, but

it's carried to a great degree, you don't even need so-called color and things. It carries you into another dimension, yes.

From audience: What is your view about the durability of our civilization? Are you optimistic about it?

LN: I am optimistic with my life, but I don't know because of the atom and the maniacs and the battles. I was saying the other day, "Of course there can't be a third world war, we've passed that. It would be stupid, just like going backwards." We are in great troubles, and actually I don't like to talk about it. People themselves should take some responsibility for this. You see, people don't, they don't.

From audience: Why don't you go to museum shows?

LN: I haven't got time, and why should I go to shows? I am a show myself!

I. M. Pei

(Architect. Born Canton, China, 1917. Came to U. S. 1935)

BLDD: One of the most distinguished architects in the world is I. M. Pei.

It's harder than ever to figure out what's happening in architecture. There is no dominant philosophy, and there has rarely been a time of more experimentation and ferment than there is now. Are you pleased? Are you distressed? Are you encouraged about what's going on in architecture today?

IMP: Certainly I am not distressed. We've just gone through one revolution, beginning after the First World War. You know about the Bauhaus, Gropius, Le Corbusier, Mies van der Rohe. That was a period of revolutionary change. I am not saying that we should have constant revolution, but there should be constant change. I think we've gone through one revolution; it's time for consolidation, for taking stock, and we are right in that period.

BLDD: What is the major design issue that faces us today?

IMP: To assess what we have learned from the past. I consider myself as belonging to the generation that followed those pioneers. They've given us a tremendous sense of confidence about what has happened and why it happened, and that confidence makes it possible for us to reach back into the past. In that sense, I am a conservative.

BLDD: Why don't we look back into your past for a while, and start about forty-three years ago, when you first came to this country from China, to study. Did you know where or what you wanted to study?

IMP: Very frankly, I didn't know anything about what architecture was at that time. All I was interested in was learning how to build. It's only after I reached MIT that I discovered that to build one could be a contractor, an engineer, or an architect. So I had to make a choice.

BLDD: When you first came, it was to attend another school?

IMP: That's true. I went to the University of Pennsylvania first; I stayed only two weeks and left. No reflection on the school itself; it was

and still is a wonderful school. I was one of the first to arrive. The dean was, happily for me, quite free, so he showed me around, and showed me those fantastic drawings done by students who had since graduated from the school. And in those days, under the Beaux-Arts system, they made elaborate renderings, beautiful drawings, Chinese ink washes, enormous canvases actually, and the more I looked the more discouraged I became, because I had no idea that architecture would involve this kind of skill.

What finally determined that this was not the school for me was the sight of an enormous drawing at the stair landing. The subject was a lamasery in Tibet. Now that's my country, and I had no idea how anybody with a name like Fitzgerald could do a lamasery in Tibet. I thought architecture must be something very different from what I had imagined, so I decided to go to MIT to be an engineer. That was it. Nothing was wrong with the School of Architecture of Pennsylvania. It's still one of the best.

BLDD: At MIT and then at the Harvard Graduate School of Design you came in direct close contact with some of the names that you just mentioned—Gropius, Mies. What was the prevailing philosophy?

IMP: That was an exciting time. To begin with, there weren't very

many young men around—they were all going to war—and I, being an alien at that time, was able to stay behind at least one year longer. There were some South American students, and many women architects, which made life interesting.

But what I prized the most was that the professors, such as Gropius, Wagner, and Breuer were able to spend time with us. One almost learned more from them outside the classrooms. Unfortunately that never happened again for the students that followed us.

BLDD: What was particularly striking to you during that period?

IMP: Trying to understand. Trying to understand why the Bauhaus, why the change, why the struggle. And you can't really learn it from textbooks. We learned by talking to these people who actually fought for the change. And that understanding served me well.

BLDD: Philip Johnson, who was one of the first to adopt the International Style, and surely one of the first to abandon it, terms the period that we are in now a postmodernist age. Would you agree with that description?

IMP: I think we may have a different interpretation of the term postmodern. While I agree that we are past the modernist period, we are not changing direction; rather we are continuing on into the next phase.

BLDD: And what is the next phase?

IMP: It's a continuation of the first. I don't see it as a break. I see it as something that's absolutely continuous. We are changing, as we should, but the battle that was fought after the First World War remains relevant.

BLDD: Several years ago you told a friend that you felt that you and your associates might be the last of a generation of conventional architects, that a very different kind of professional might soon emerge to shape the man-made environment. What will that breed resemble?

IMP: Did I say conventional architects? Well, I'll accept it. It must have been on record. What will the next breed be like? I think that the world must look a bit different from their point of view.

We can talk about all kinds of stylistic differences, but in the long stretch of history they will look very much alike. So I am not as concerned about the great change that some claim is now taking place in architecture. I don't see it.

BLDD: In the earlier part of your life you were on the faculty of the Harvard Graduate School of Design. What did you do during that period?

IMP: From 1945 to 1948 I was at Harvard. I really wasn't terribly serious about teaching, as I wanted to return to China. You can't very well go and ask for a position in an important office if you are living

from day to day, so teaching seemed to be the right thing to do. It wasn't until around 1950 or 1951 that I decided I had better forget about China and make a life in the United States. It was then that I came to New York and seriously considered being a professional.

BLDD: Several years before that an almost unique opportunity presented itself to you, an opportunity to change some of the urban landscape. I am thinking of William Zeckendorf's offer to you; he was then president of Webb & Knapp. What did you do for him during that period and what did you learn from him?

IMP: When I accepted the position I made it very clear that I could one day just tell him, look here, I am going to go back to China. He said, "That's perfectly all right with me, just come and stay as long as you want." Little did I realize that I'd stay with him for almost eleven years.

The first few years we really didn't accomplish very much. We talked a lot, we got to know each other, we planned a lot. It was during those years that he and I came out with this idea, which unfortunately was never built.

BLDD: That's the Helix Building?

IMP: The Helix, yes. And I designed his office, and that's about all.

BLDD: But that's to be expected for architects of any age. Much of it is certainly a "visionary" profession.

IMP: He was that kind of person. He sort of encouraged it. But from 1951 on I became serious, and he was ready also to become serious, so for better or for worse we built a lot together, not only in New York, but in Denver, and then in Washington, Philadelphia, Pittsburgh, Montreal. We designed and built almost half a billion dollars' worth of work, and in those days it was a lot.

BLDD: Was most of that work urban housing, repetitive housing that helped you develop a certain technological and design expertise?

IMP: That's the less important part. In the immediate postwar period, the concern of the American government was to find work for people. This is how Title One came about, which became a tool to rebuild our cities. This act provided for the federal government to pay two-thirds and the city and state the other third to redevelop our slums in the cities of America. Zeckendorf saw that potential and walked right into it, and I walked into it with him. I think that is more important than the technological side of building urban housing.

A good example of this post-World War II rebuilding of American cities is Society Hill in Philadelphia. The City of Philadelphia under the leadership of its several mayors—such as Clark and Dilworth—decided to take advantage of this Title One act. Ed Bacon, who was planning director of Philadelphia at that time, assisted these mayors to see what could

be done about it. The result was a competition, not among architects and planners, but among architect-developer teams. Zeckendorf and I won that competition.

Together, we built many Title One projects. Society Hill, in my opinion, is one of our best.

BLDD: Whatever happened to the promise of urban renewal?

IMP: Many mistakes were made. Many cities took advantage of the subsidy and started in a wholesale manner to demolish slums, and the social dislocation was tremendous. I think most people remember Jane Jacobs. She was one of the first to speak against it. This kind of slum clearance destroyed the social fabric of the community and there is no way of reconstituting it by rebuilding.

But the idea that the federal government should undertake to assist local municipalities to rebuild slums is still sound, though, because we can't do it without federal help.

BLDD: You and your firm have produced a series of remarkable buildings, in the last twenty years more than fifty projects, and something like thirty-four of them have won prizes. I. M. Pei has many, many associates. What is the philosophy of the partnership? How does the office work? I met a man the other day who told me it's the most efficient firm now operating.

IMP: Really? He should tell my banker that. We are not really an efficient firm. I wish we were. I wish there were an ideal way where efficiency doesn't stand in the way of creativity. We are not really a large organization, about 125 to 130 people, but it operates like a collection of small offices. The efficient way to run an office of our size is to organize specialized departments for planning, design, working drawings, construction supervision, and so on. That's the way to do it, because then fewer people can work at a larger number of jobs. We chose not to do that. For each commission, we set up a team with the requisite skills, and that team stays on the job from beginning to end. This way we do not get the benefit of specialization. What we get is a tremendous dedication of that team to that project.

BLDD: What was your interest in the Urban Development Corporation and your eventual withdrawal from their project?

IMP: The project you're referring to was really started by Mayor Lindsay. At the beginning of his second term, he asked me if I would like to do the project on Welfare Island. I asked for a week. A week later, I told him that we would be very much interested in doing the project provided we could build a bridge from Manhattan to the island. I cited Ile de la Cité as an example; because of bridge connections, it's become part of Paris. And the same would apply to Welfare Island.

In other words, Welfare Island should either be part of Manhattan—densely developed—or it should be a park, a recreational reserve for the people of Manhattan and Queens. Nothing in between would be acceptable.

BLDD: And what we have now is something in between.

Let us talk now of the Kennedy Library: that has faced just about every obstacle that a building can face. Can you tell us its present status?

IMP: The building is now under construction, and it will probably open in the spring of 1980. But we are still trying to shoot for the fall of 1979. It's no longer in Harvard Square. It's now at Columbia Point, next to the University of Massachusetts. Community opposition in Cambridge was the reason for the move. They were afraid that the Kennedy Library would attract large numbers of tourists to Harvard Square.

BLDD: Is there a study center in the library? What are the components?

IMP: I think that Kennedy Library is in a way a misnomer. I think Presidential Library is a misnomer. The library, to be sure, is part of it. It includes the archives of the historical records of that administration. However, the part that concerned the people in Harvard Square was not the library itself, but the museum portion, which undoubtedly will attract visitors.

The Kennedy Library has finally settled at Columbia Point, next to the University of Massachusetts. Together, they will do a great deal for that part of Boston.

I personally am sorry about having to leave Harvard Square. Having made peace with that, I am very happy to see the Kennedy Library performing another kind of service to another community such as Columbia Point. I think we will see some very exciting things come up around it.

BLDD: About ten years ago the National Gallery realized that it had outgrown its West Building. That building opened in 1941, a neoclassical Beaux-Arts structure designed by John Russell Pope, a traditional building. After many years of planning and dedication, on June 1, 1978, the National Gallery opened its dramatic new addition, designed by I. M. Pei. I wonder if you can tell us about the inspiration for the building and some of the constrictions. Why that piece of land, why that shape building?

IMP: The piece of land is at the intersection of Constitution Avenue and Pennsylvania Avenue. Constitution runs on an orthogonal grid, Pennsylvania runs on a diagonal. That plan was created by Major L'Enfant two hundred years ago, which gave the site a triangular configuration.

BLDD: You might tell us how you were given that piece of land.

IMP: Andrew Mellon asked Congress to reserve this piece of land for the future expansion of the National Gallery. He was very farsighted indeed, for it is the last available site. It is very difficult to design a building on a triangular site.

BLDD: Were you given any guidelines in designing the building?

IMP: We were given a simple program of the expansion needs of the Gallery. The Building Committee, however, also recommended that we use the same marble as on the façade of the existing Gallery.

BLDD: How did you find marble to match the existing building?

IMP: We haven't really succeeded in that. We had to go to Tennessee to open up new quarries. But each quarry, each vein produces a slightly different marble.

John Russell Pope may not have been a revolutionary, but he was an architect of great refinement in his design. He designed the original building with dark stones at the bottom, and then used lighter shades on the upper part of the building. The next time you go to Washington, you will see that the dome is almost white. But at the base of the building it's almost brown. We tried to do the same thing, but we have not succeeded. I would say that this is a disappointment to me.

BLDD: Even though you had the same quarry, the same marble man?

IMP: We engaged the same man who helped Pope to select marble for us. But we are not as successful in blending the gradations. However, it will improve with time.

BLDD: What was your approach to the interior? How did you determine what was the best way either to view pictures or to be a viewer of pictures?

IMP: I would like to stress that the majority of the people who visit this museum are not connoisseurs of art.

Once you realize that, you have a very different kind of challenge. I would like this museum to make the viewing of art an interesting experience. So our first challenge was to make it an exciting place to be.

BLDD: So you were really designing for a museum constituency of the last fifth of the twentieth century, more mobile, more numerous, less committed to the subject matter, and as a result certain design features reflect that.

IMP: Yes, a design for the young, particularly the young. We want them to feel that museum going is a pleasurable experience and then, having experienced it that way, I think they will linger a bit longer and perhaps look at art, and then the next time they'll say, I'd like to go back.

We hope that people seeing the building from the outside will be attracted to go inside. Once inside, there is an enclosed garden court, a

very large one, almost like a covered piazza, which admits sunlight and is cool in the summer and warm in winter. It's quite a lively space, and we have enough light to grow trees and flowers inside. People like to come into a place like that. Because the space is so large in scale, conventional art that one finds in a gallery is simply not big enough for it. Therefore we had to commission special art for that space.

BLDD: Can you tell us about some of those commissions?

IMP: We commissioned Henry Moore to do a bronze sculpture which is about eighteen feet high and about twenty-five feet wide—quite enormous. We also chose Calder to do a mobile. In fact, it's the last piece Calder did before he died. That piece has a reach of about sixty-five feet. you know how big that is. And it is suspended from the skylight and moves constantly in that space. That's the first piece we installed. And it's very successful. I think he would have been happy to see it there.

The third commission was a big tapestry by Miró. I had some reservations about that Miró in the beginning because I saw his retrospective in the Grand Palais in Paris about three years ago, and saw some of his new tapestries and I didn't like them at all; they were very crude, and it just wasn't like the early Miró, such as the Constellation series woven by Aubusson or Gobelin, which are quite wonderful.

Miró is a very, very alive kind of artist. He is constantly trying to find new forms and new ways to express himself. So when he came out with this idea of weaving this tapestry in Spain, using enormous yarns—big balls of yarn—I was worried about it. But it turned out very well. The Motherwell is a painting, a huge painting, that is, I think, thirty feet long, and that's a commissioned piece as well. It's after his *Spanish Elegy* series. it's a very powerful. graphic piece.

I would have liked, for instance, to see Oldenburg come and do a piece. And we may. But for the time being, the Gallery thinks we've got to get these major artists in first, and then I hope we can attempt to reach out.

BLDD: The National Gallery is on something like 8.8 acres, the building alone is 450,000 square feet, the entire plot of land is more than 600,000 square feet. It really is an enormous structure, and among the other astronomical things connected with it—you must forgive me—is cost. The latest estimate was something like $94.4 million. What did this cost the government and the taxpayers?

IMP: Nothing. The museum is the gift of Paul Mellon and Ailsa Mellon Bruce and the Mellon Foundation. It's almost a family gift to the nation.

The first National Gallery, designed by John Russell Pope. is 450,000 square feet. The new National Gallery building—the East Building—is

600,000 square feet. Okay? So it's very much bigger. The reason it doesn't look that big is because more than 20 percent of the building is underground.

This East Building is not just a museum. The museum portion is only half of it. The other half is the Center of Advanced Studies for the Visual Arts.

The National Gallery's trustees believe, and I think they are right, that the future is not just attracting people to the museum, but rather bringing art to the people.

BLDD: Are you a collector yourself?

IMP: No. I have some art, but I am not a collector.

BLDD: You collect a very esoteric kind of ceramics, I-Hsing ware. What is I-Hsing ware?

IMP: I-Hsing is a small town within one hour's drive from my native city. It's a place where they produced for centuries—maybe for thousands of years—tea kettles, because the area has a unique clay for stoneware, which is excellent for brewing tea. Not until the end of the Ming Dynasty, which is about Renaissance time, early sixteenth century, did the artists begin to be interested in this stoneware and start to make objects out of clay. So I think I was attracted by the uselessness of some of these

objects, and I collected them for that reason. But it's only very recently that people began to take interest in them.

BLDD: You lived in Hong Kong as a tiny boy. It's always been my theory that the influence of your banker father, building the tallest bank in Hong Kong then, must have been a source of inspiration for you to become an architect.

IMP: Not quite. That bank was very ugly. It was designed by a British firm. And now, by the way, it's the headquarters of the Bank of China in Hong Kong. It has an enormous banner saying "Long Live Mao Tse Tung" on it. Maybe that's removed now. But it's a very unattractive building.

After we left Hong Kong our family moved to Shanghai. It was there that I became interested in the construction of a new building called the Park Hotel. I couldn't resist looking into the excavation when they said that a twenty-five story building was going up. I was very much impressed. That's when I decided that I wanted to build.

BLDD: Robert Hughes was here a while back and he said that the heroic age of American museums is moving to a close. And you talk about a new museum public too. He said that museums should become temples of silence.

IMP: I don't see the difference. Why can't a heroic museum be also a temple of silence? Maybe so. He is much better at using words than I am.

BLDD: When does museum fatigue set in? What is the average length of viewing time for museum goers?

IMP: That's very important. It's not the measure of time or distance. It is the quality of that experience that counts. Museum going should be a pleasurable experience. I learned this actually from my own experience with my children.

We enjoyed going to museums and we would take them along. After a few visits, I discovered that the children loved to go back to the Guggenheim but not to the Metropolitan, although there are more goodies in the Metropolitan than the Guggenheim. We all know what is wrong with the Guggenheim, yet the fact that our children wanted to go back means there is something in the Guggenheim that excited them. Frank Lloyd Wright might have hit on something after all.

I have always remembered that. We will not have ramps, our pictures are not going to be seen on a slant and all that, but I would like to have some of that fun and games in our museum. Go to the East Building and see if you don't think it's a place children would enjoy visiting. I think it would be.

BLDD: A building of yours opened recently to great critical response—the Dallas City Hall project. Can you tell us about that?

IMP: Yes. Dallas is rather far away. Not many have heard of that project. It is not only a large building but an important one as well. In Dallas they have a great sense of their city, very different from the way we look at our city. We are very cynical about our city, about City Hall.

But not in Dallas, where they take city government very seriously, and there is a certain pioneer spirit that still exists. They are very proud of their city.

So when we were asked to do the City Hall, we didn't take our typical New York cynicism with us. We began to look at it much in the same way that they looked at the project, so therefore this building is a very important public building. I cannot imagine designing a city hall like this for New York. It would not be appropriate here.

BLDD: You are planning a building for New York now.

IMP: Yes. We are doing an investment building, and that's sort of a speculative building. I rather like that because I started in New York doing investment type buildings for William Zeckendorf. He and I once made a bargain—it's almost thirty years ago. I said, "I know how cheap buildings can be, and I know also that I cannot do a building cheaper than somebody else. That's not my interest. But if you are prepared to spend 5 or 10 percent more, I can do you a good building." And we shook hands on that, and for ten years we did just that.

We architects need that 5 or 10 percent more, and we will have that 5 or 10 percent more in this building. It will be finished maybe even ahead of IBM, although we started just six months ago, and certainly I think we'll be ahead of AT& T. It's at Park and 59th, a small corner lot, and we will try to demonstrate what one can do with a limited budget.

BLDD: Why haven't architects ever been able to communicate that to a larger public? Most people think that having an architect is expensive, and don't know if one really needs an architect.

IMP: I think clients determine cost, not the architect. We designed Kips Bay, and it only cost $10.15 a square foot to build in 1962. More important was the fact that we succeeded in persuading the FHA to accept a concrete and glass façade. Imagine, in those days the only kind of building they underwrote was brick walls with casement windows, like Peter Cooper Village or Stuyvesant Town. I firmly believe one can build good buildings without spending a lot of money.

The East Building of the National Gallery of Art is a different proposition altogether. It is finished with Tennessee marble inside and out. It has the most finely tuned air conditioning system anywhere. All floors are designed to take heavy loads, such as a piece of stone sculpture, anywhere in the Gallery. Also, it was designed to be as nearly security-

proof and maintenance-free as any building could be. It all added up to $81 million or $135.00 per square foot.

BLDD: You've designed everything from small, isolated museums to complexes that transform almost entire cities—projects in Australia, Singapore, Paris, all over the world. Of all these commissions, which is the closest to your heart?

IMP: In retrospect, it is the decade (1952–1962) of involvement in urban redevelopment with Zeckendorf that was particularly important to my professional life. Beginning with the 10th Street Mall plan for Southwest Washington to the Government Center development in Boston, our firm has played a part in the rebuilding of Philadelphia (Society Hill), Denver (Mile-High Center and Courthouse Square), Montreal (Place Ville Marie), etc. This kind of involvement gave me an insight into the social, economic, and political problems of center cities which is invaluable.

BLDD: You've been referred to as an urban diplomat. You have this uncanny ability to have competing forces come together for a common objective, and actually diplomacy is one of your great assets. If you had your life to do over again, would you choose any other career?

IMP: No. I don't know. It's hard to answer that question. I enjoy what I am doing, but I am sure there are so many other endeavors that are less exasperating than architecture and more rewarding financially. No, I think I would still do it. Is that encouraging? I hope it is. Architecture is an exciting profession.

BLDD: Given the state of urban economics, what will urban design look like five years from now?

IMP: I think the centers of our cities are beginning to come back to life. As far as the future of urban development in New York is concerned, I'm basically optimistic. You will remember, I am sure, the Paley Commission, the Madison Avenue Mall and the Roosevelt Island development of the Lindsay years. These were wonderful ideas but I don't think we are going to go back to that for quite some time. Already the many new projects under construction, in part due to zoning incentives, have demonstrated the increased emphasis on pedestrian amenities at the street level that alone will add a good deal to the vitality of city life. Still, one hopes for more. But given New York's fiscal problems, I do not expect to see ambitious urban development plans in the near future.

On the other hand, new cities such as Houston and Dallas are ripe for it. The future is there. If you are interested in urban design you should go to these new cities. They are doing it.

BLDD: But is there also a moral imperative to build cheaply?

IMP: No. I think of buildings as being more or less permanent and a few more dollars spent on construction will not matter much in the long run. The day when to build cheaply becomes a moral imperative, that is when I will go into film making or something else. I will not be interested in architecture any more.

Beverly Pepper and

(Sculptor, Painter. Born Brooklyn, New York, 1924)

Sarah Cushing Faunce

(Museum Curator. Born Tulsa, Oklahoma, 1929)

BLDD: Beverly Pepper is a sculptor of bold form whose zest for life and art is internationally known, and Sarah Cushing Faunce is the widely admired head of the Department of Painting and Sculpture at the Brooklyn Museum.

Beverly, your sculptures are known from here to Italy, where many of them are made—in fact, where you have lived since 1951. What was it like for a painter in the 1950s in Italy? Did you belong to any school? What did your work look like?

BP: I started in 1948 as an abstract painter, then in 1949 I went to school in France. When I got there, I was overwhelmed by the postwar problems. It left me with a sense that I had to communicate more with people, so I completely reversed the way I was painting. I began painting very figuratively, very committed social paintings, thinking that I could make a dent or at least pay my dues for what I hadn't done during the war. When in 1951 I moved to Italy I realized that that kind of painting talked to very few people and that it would be much better to do posters than to do any kind of social content paintings. Slowly my painting evolved, using more form and color, but always very dimensional. I realized that what I really wanted to do was to sculpt. About that time I took a trip that confirmed everything for me.

BLDD: I guess that trip you refer to is a trip to Angkor, where you went as a painter and returned as a sculptor. What happened to trigger that transformation?

BP: Well, it was the most extraordinary place I'd ever been to. I was lucky to get there before the Vietnam war. It was at the very beginning of

1960, and Angkor was a place where people went in and out in one day. You went from Thailand and got out of a plane and stayed one day—a quick tour. But I fell in love with it and stayed two weeks, and what was extraordinary wasn't just sculpture in the sense of colossal sculpture. I had already been very much seduced by Japan and Kyoto and was already beginning to understand that I was basically a sculptor. In Angkor the banyan trees had overgrown the various statuary, Angkor had disappeared, was unknown for years. You had a sense that endless time was within these pieces. I thought, "There is too much dimension that I am missing in my painting, and I have to enter into nature and find where nature and time meet."

There was the most extraordinary sense of being aware that I was changing at that moment. It was almost a spiritual experience. I went from there to Katmandu, stayed mostly with Nepalese and other Orientals, and met the Dalai Lama's brother, who wanted to tell my fortune, which made me leave immediately.

BLDD: You didn't want him to tell your fortune?

BP: I was horrified. I mean what if it came true? I would know my future! I made a date with him for nine in the morning and left at eight.

Then at the airport I couldn't get out because there was a fog, and I kept thinking they were coming to get me to tell me my future.

Fortunately the fog broke and I got out, and here I am sculpting. Maybe some people think I should have stayed there—I don't know.

BLDD: How did you make the transition from two- to three-dimensional work?

BP: I don't think things are done consciously. It happened. Everything is the totaling of the last experience. By the time I am finished I realize what I haven't done, that the present work is a means of leading to the next work, that each experience is integral to the next work. It isn't conscious. It's unconscious. The conscious is the censor.

BLDD: I see you are nodding in agreement, Sarah—I assume not only in terms of Beverly but of artists, in general. I would like to ask you about a show you were responsible for bringing to the museum that received a great deal of attention, the recent Women Artists, from 1550 to 1950.

SCF: First, I agree with what Beverly was saying—I don't think in general that artists work in a deliberate way or anaylzing-beforehand sort of way. It's more a matter of plunging in and then seeing what happens. As to the exhibition at the Brooklyn Museum, it was actually organized by two art historians, both women—Ann Sutherland Harris, who is now at the Metropolitan Museum, and Linda Nochlin, who teaches at Vassar—and it was quite an eye opener for a great number of people, particularly in this country, where we don't see that many old pictures and think of them as all done by old masters. To see these Dutch and Italian and French paintings of the seventeenth and eighteenth centuries that were painted by women was, I think, very instructive for a lot of people.

BLDD: And what do you see as the result of that exposure?

SCF: It's just one more step; people don't consciously think, well, now I know there was such-and-such an artist in the seventeenth century who did very wonderful pictures and it was a woman, but it's just an incremental thing, a part of a growing awareness which one hopes will become less and less self-conscious, and eventually, simply automatic. It should be a spontaneous awareness that when it comes to works of art and intellect, men and women are human beings together.

BLDD: Beverly, you've always had a very individualized approach to your work, to your life. How has the whole awareness of the role of the woman artist affected you?

BP: I think of myself as a woman, and I love being a woman. But I've never thought of myself as being a woman-artist. I am deeply committed

to art and committed to helping women. But I am against any kind of segregation. and I do not want to function as a woman-artist.

BLDD: There are other kinds of isolation, and sometimes it is geographical. I wonder if you could tell us what it's been like to live abroad for the last twenty-seven years, a period that was marked by the ascendency of American art. Artist after artist came here and told us, in varying degrees, how important New York was or is as a center for art. How has that affected your work?

BP: It was a serious problem for me, because I am a New Yorker and was raised in New York and everything I do is indigenously American. For a while, when I was working in the isolation of painting and my postwar commitment, the work I did was quite Europeanized, consciously Europeanized. The moment I began to sculpt I entered the twentieth century and exploited its technology. I worked in factories, and factories everywhere have no nationality, so I was free to be myself. Also, I began to live on both sides of the ocean.

In 1962, I was invited to participate in the Spoleto Festival of Two Worlds and worked in central Italy, in a U.S. subsidiary factory of ITALSIDER. Then I came here and worked in different factories with growing awareness of renewing my own culture. But it was a very difficult, chauvinist period in American history, and a difficult time for me. I have never suffered from being a woman artist. But I've suffered from being an artist who lived in a foreign country and was not paying her dues to the New York establishment. This had an effect. It made me acutely aware of my American roots. Now I work here a great deal. But I also live and work in Italy part of the time. People used to ask me why I lived abroad. I'd say it was the domestic situation. It was the fifties, and everyone thought domestic meant political, and I kept saying, "No, no, I mean domestics to take care of my children." It was a way of being free to work.

I think you cannot lose your roots easily if you are an artist. You may grow differently but always with the same roots.

BLDD: That was the period when ten sculptors were commissioned by a subsidiary of U.S. Steel to fabricate work. Among those ten there were three Americans: Alexander Calder, David Smith and Beverly Pepper. Perhaps you should tell us something about that time.

BP: Well, that's easy because I was so overwhelmed by finally belonging that it became a landmark for me, a milestone in my life. I had a show in Rome at the time. Giovanni Carandente, who was choosing artists for the Spoleto Festival, was very impressed with the work. I should explain that they were bronze, not fused bronze, but bronze that was inserted in the wood. He asked me if I could weld. I do come from

Brooklyn, so I asked why? And he said, "I am putting together this show and if you can weld, I think it'd be fantastic if you would be the third American." I asked, "When is this show?" It was going to be in June. Since it was only November then, I told him I could weld.

BLDD: And by June you could.

BP: That's right, I immediately went out and paid an ironmonger to hire me. He thought I was the craziest thing he had ever seen. We made round gates. Looking back, I think I couldn't have made curvilinear sculptures if I had hired out to a bridge builder instead of an ironmonger making round gates; but he was the man next door, so . . .

BLDD: So your very first work was characterized by a loopy openness.

BP: That's right, my first welded work. In Spoleto—actually it was in Piombino—I did works that were very strong, almost found objects. I cut up a railroad car, I cut up huge tanks. But I never showed them because I was ignorant of much that was happening in the American art world. I thought that since David Smith was doing found objects and Gonzales had done them, I obviously couldn't possibly do something that other people were doing. So I wouldn't show the pieces. David Smith strongly urged me to show them, But I said, "No, they'll say I took them from you." Now, years later, they don't look at all like David's, and they were my best early work. Instead I showed things that seemed more original to me. It shows you how an artist often can't really judge his or her work.

BLDD: Would you agree with that, Sarah? All your life you've come into contact with artists—at Columbia University, at the Brooklyn Museum, as a consultant to the Jewish Museum, as a curator of many shows. Would you agree with that appraisal of the self-evaluating capacity of most artists?

SCF: I think it is rare for an artist to be able to have that kind of detachment, just as it's rather rare for an artist to be able to really analyze and take a critical point of view toward his own work. It's a kind of a freaky quality, you might say. It's nice if you have it, but I wouldn't expect it.

BLDD: Then who knows best? The curators? The critics?

BP: The artist. In the end, the artist.

SCF: Yes, I think the artist knows best, certainly, about what he is doing and about his own work, but in a situation like the one you described someone who is more detached might have been able to come and say, "Look, this stuff is really what you should show." You mentioned David Smith, who in that situation was a critic or a curator—he was not functioning as an artist.

BP: Yes, but David at that point was relating to something else. In the end I didn't have enough experience. Today I would be much more

positive about what I would reject or accept because now I have a total body of work to look at.

What happens now—and I think this also happens with other artists—is that I'm always dissatisfied with a piece of work I've just finished because I am ahead of the work after finishing it. I can see what I *should have done*. Only in retrospect can I clearly evaluate a work.

BLDD: How much influence did David Smith have on your work?

BP: I was unaware that he had any influence on my work. He had a great influence on my personality in the sense that, living abroad, I'd never known many American artists. I lived in relative isolation. I didn't see many artists.

BLDD: What about all those writers that you were surrounded by?

BP: I was surrounded by writers and they were literary, not visual. They had a literary point of view. It took me years to rid my work of literature. I remember one day saying to my husband, looking at some Duccios in Siena, "I don't care who cut whose head off, I want to look at the forms and the shapes," because he was always telling me the story.

Then I got to Spoleto—and that's why it was a milestone for me—it wasn't just David Smith. There was Lyn Chadwick, there was Calder for a moment, there were all these other artists sitting around and talking and drinking and discussing what was going right and wrong. I discovered that we all had the same problems. Until then, I thought that my problems were different. Private. I didn't know how to tell them about my problems. It never occurred to me, for instance, that it was acceptable to do seventeen pieces of work in one month. So I didn't tell anyone that I did that many pieces. I kept it a secret.

BLDD: It was Menotti who once told me that during that period David Smith did so much work that at a certain point they had to stop him because his production was so great. Is that correct?

BP: Absolutely. I'll tell you what happened. We had everything one dreams about—including any help one wanted. You could tack-weld something together, someone else would finish the welding. I told you that I cut a railroad car apart. Well, I wanted to cut it apart. But—phhhht! They cut it apart. While they were cutting, I had ten other workers welding and shearing. The whole thing was unbelievable. It was also interesting with someone like Lyn Chadwick, who I think did one of his very best pieces of work there. He never repeated it because he had no kinship with it—his works were usually cast. He did a huge welded sculpture, an incredible yellow and black structure. But he was so unaccustomed to the technique that he felt uncomfortable with it. He seemed not to understand what he had done—as though it had nothing to do

with him. So he did one piece in that month because he was becoming acquainted with it.

I on the other hand felt great freedom, but I kept it a secret.

BLDD: What did the surface of David Smith's work look like then? Since you were so closely associated with him during that period, do you have any recollections of his intentions?

BP: Well, first I would like to explain that he was in Genoa and I was five hours away in Piombino. Sometimes I helped him as his translator, by telephone, but I only saw his work afterwards, when he brought it to Spoleto. He explained that he particularly wanted to retain the color of the metal and welding. He spent a great deal of time trying to find a way to protect the surface, and what I did was to find him transparent varnish that was a plastic protective coating called Isofan. He put from twelve to fifteen coats of this to make sure that discolorations as well as the original metal were retained. Cor-ten really did not yet exist for the artist—it was only the following year that cor-ten became part of the artist's vocabulary. David never used it, he wasn't interested in rust. He painted some of his work—but not the Voltri series.

BLDD: How important are critics to the work of artists?

SCF: I don't think that they are very important to the work of artists. They should not be too important to the *work* of artists, but they are important. . . . I think critics do a kind of selection process, because there's got to be a constant sifting. There are a great many people, particularly today, making art of one kind or another, and from one point of view—a subjective point of view—it's all a perfectly wonderful activity. But just as singing in the bathtub is not necessarily a public statement, a lot of sifting has to be done with every form of art, whether it's writing or painting. Critics make a great many mistakes—it's not a matter of being perfect all the time—but I think the critic has a public function. I don't think it should be particularly relevant to what the artist is about himself.

BLDD: Beverly, you are going to be part of that Sculpture International Forum in Toronto, and the panel you are a part of is entitled, Critic: Friend or Foe?

BP: Are they friends or are they foes? I think when you have a critic friend, yes, they are friends—better than Hungarians. Criticism for the sake of selling art—writing for daily papers that are linked to the marketplace—makes it a commodity and is very destructive for the arts.

Reflective criticism matures over a period of time and can be interesting and provocative for an artist. But consider how someone works for a year, or two, three, four, five years, on a number of works for a show. Then a critic walks in for fifteen minutes, walks out and writes ten lines for a daily newspaper or magazine. Then someone wanders in and buys or doesn't because of the review. I think that's extremely destructive. The concept of art being made easily accessible is destructive. It's removed some of the creative core of art.

SCF: That's quite true. The whole notion that people have now, the very connection of criticism with selling—even if it's not the case, people think that it is.

BLDD: Do you think this is an age of collectors rather than creators?

SCF: There are creators at work. As a cultural tendency, yes, I think it's an age of collectors, in the same sense that it is an age of anthologizers and packagers. There is an awful lot of that tendency, intellectually, in our culture.

BLDD: You may not be influenced by critics, but you are indeed influenced by architecture, and I am thinking of the size and the texture and the risks that you take in your work. Is that a reasonable thing for me to assume?

BP: I think anybody who makes art or does anything that's got to do with personal statement, whether it's three inches high or three miles high, takes risks. But if you are an artist you *must* take risks. If you don't

you might as well give it up. I am not much involved in architecture. I am interested in scale, not size, which is quite another thing.

BLDD: And what of the line pieces in New Hampshire, at Dartmouth College?

BP: Well, but I don't think . . . it is architecture. Architecture can be for sculpture what composition is for painting—but architects have to consider function, while sculpture *must not* accommodate.

BLDD: But there is an empathy.

BP: Yes. From that point it has to do with overlapping history more than it has to do with architecture per se. Sometimes with existential space, landscapes and nature, too.

SCF: I was thinking of the San Diego piece—I have seen it just in photographs—where the commission was to place a large sculpture in a given spot in front of a new building, which then had another building coming out at another angle and a sort of bridgeway across, and a gap in between. As you were telling me, instead of just coming in and designing a sculpture for a space you designed the whole space. It was really set in space. They made a mall and put the sculpture somewhere else. Which is an architectural thing to do, by the way.

BP: It's true, but they gave me an area that was to be surrounded by five sixty-foot trees.

SCF: And your solution was a space planning solution.

BP: Yes, it was to rework the allotted space and come up with a logical site. It became an environment—and, as such, experiential sculpture. You see, today's sculpture is no longer on a pedestal. The ground you walk on becomes part of the sculpture, it becomes an environment. I am particularly keen on the experiencing of a sculpture. The sculpture that Sarah is talking about was to be little more than an embellishment of an area. It was to use the government's 1 percent to make a sculpture on a pedestal before an overpowering grid structure.

SCF: It was a typical modern building.

BLDD: Your work is very often illusionary.

BP: Yes. It's an attempt to obtain a dimension of realism beyond the obvious reality of daily life. I try to go beyond that to a kind of realism that is not only my fantasy but also a shared fantasy.

BLDD: The need for haven, for shelter impels many of us much of the time. How did you come to choose your present location? What is it like to be an artist in Italy, and how does it affect other artists in that particular political environment at this time?

BP: Remember Italy is a country where they still name streets after artists. The violence is disturbing but I am not living in the middle of it.

Still, I am filled with anxieties about Italy because I love the country, I've lived there much of my life, and feel that I have no right to leave it now. I think every place is uncertain. It's very isolated where I live. I am alone most of the time.

The walls of my home were built several centuries ago. That's as far as you can get from cosmopolitan problems, and my studio is a small factory—my dream. Some women want mink coats. I always wanted a factory.

BLDD: We talked before about the relationship of your work to nature. Your sculpture is a part of the earth, in a sense.

BP: I just finished a sculpture at Dartmouth. It's set in an island area that students use a great deal.

BLDD: Grassy?

BP: A grass island, yes. I built a sculpture that is part metal, but with voids filled with sod; I reshaped the flat New England landscape to make an undulating area. And I painted the metal part white. In this way the sculpture has a seasonal relationship. Dartmouth has snow for five months of the year. In that period the sculpture disappears into the snow. As spring comes it slowly emerges. The grass reappears, at first somewhat brown, then slowly turns deep green and has a whole life of its own. The seasonal change stimulates an awareness on the part of the viewer. I asked someone at Dartmouth this winter, "Did you take any photographs of the sculpture under the snow?" and he said, "No, there was nothing to see, it disappeared."

BLDD: How did that work evolve? It started out in one scale and ended up in another.

BP: It ended up with me almost bankrupt. I designed a thirty-five-foot sculpture, but very soon it had a life of its own. It happens often with outdoor sculpture. No matter how big you make it it is never big enough. There are always buildings, the sky and so on. This sculpture needed to be much longer, and I kept adding one piece and then another. When it reached one hundred and fifty-odd feet, I brought it to Dartmouth and . . .

BLDD: It was fabricated in Italy and assembled here?

BP: Well, the metal elements were fabricated in my factory—my studio, then shipped flat in a forty-foot container. When I set the work into the landscape I wasn't satisfied and changed the elements—shortening it a bit. That can happen; when you assemble a site sculpture it really has to be flexible.

Also, I changed the direction almost 180 degrees when it was set in the ground. After we dug the trench, I felt there were too many elements

because of all the buildings around it, so I removed about twelve feet of sculpture.

BLDD: But you really want it to be a natural formation, so to speak, an earth work in a certain way?

BP: It's a site piece, not an earth work, because in an earth work the materials used are primarily geological. At Dartmouth I fabricated forms that were really solids that had to be filled by the earth—that had to be reconstructed on the site. I think that's very important. We talked about risk. When you are making site pieces you must face up to needed changes. I find that's the hardest thing—to remove already fabricated elements.

BLDD: To take it out?

BP: To take it out, particularly when it's a lot of high-priced metal!

BLDD: Sarah, you've said that one of your missions is to restore virtue to the word ornament.

SCF: I didn't put it in quite those terms. But yes, ornament, or maybe decorative even more so, because that tends to be the word that gets used as a put-down. "That painting is just decorative" is so often said about something that someone didn't like, and it's often very hard to describe, or what that word decorative means in the bad sense is not analyzed. I have some general interest in reclaiming decorative as a good word because of all the great works of art, from Matisse back to Giotto, which were great works of art but in one sense are performing the function of decorating the wall and providing an experience that makes you feel good when you walk into a room, before you stop to analyze anything. It's a sudden injection of pleasure, which I think true decoration does for you. And then you go on from there and see where it goes from there.

BP: May I ask a question, Sarah? How do you think your concept is affected by the time we are living in—a consumer society—with superb product design built into a way of life. How does it affect your concept of Giotto as decoration? That didn't just have to do with pleasing the eye. The Giottos are very spiritual. Today decoration is part of the consumer society—surface, exploitive.

SCF: Yes, that's true. Maybe the thing to do is to draw a distinction between decorative and ornamental and cast ornamental into that range of things that are pleasurable in a more trivial way.

BLDD: How does one get a commission, Beverly? No matter where I am, no matter what part of the earth, if it is in Brussels or Italy, if it is Israel or Dallas, there is a Beverly Pepper. How do you manage to get so many commissions?

BP: I get them in the mail. And since I never open my mail till weeks

later, sometimes I almost miss them. I really don't know how I get commissions. They have been coming from the NEA, the GSA, redevelopment agencies and so on. They have files of slides. There are various committees, and I am just one of the lucky ones. But commissions are time-consuming even before one begins the work.

From audience: I saw the sculpture at Bedminster, New Jersey, and I enjoyed it very much, but I felt it was too bad it comes in too close to the building.

BP: You are very perceptive. I now will say something I feel very strongly about.

One of the major problems—and Sarah knows it's one of my big gripes about that sculpture—is that that sculpture was designed almost 150 feet further away from that building. After I sited the work, they had a landslide. I wasn't there for the landslide, and nobody told me about the problem of the stability of the ground. Had they told me I would have changed the direction of the sculpture. This is one of the major problems in sculpture that do not have your fingerprints at all times. Also I was not there, not alerted—they arbitrarily moved it over one hundred feet closer to the building, and that's created the problem. In no photograph that you ever see of that sculpture do I show it with the building. After they

moved the sculpture, the weight was on the wrong side—toward the building. When I arrived there I said, "This sculpture is not in the position that I set it when I was there supervising the digging." They assured me it was, and I kept saying it was not, and not until there was about 15,000 tons of cement in the ground did someone *admit* the change. Yet I still feel it is an extremely successful, strong work.

From audience: Do you draw much?

BP: All the time, all the time.

From audience: Do you make sculptures from your drawings?

BP: Never, no, because if you make a drawing so detailed that it becomes a sculpture, it is a *sculpture manquée.* If you make a sculpture from a drawing you are limiting your freedom. The drawing is simply a way of allowing my mind to go wherever I wish it to go. Also I love drawing.

From audience: How do you present a work of such a large scale? Do you make a three-dimensional model?

BP: Yes, I work three-dimensionally, but even then I reserve the license to change it as I go along, as I did in Dartmouth. Also I may make four or five alternate solutions to a problem, but I never show the client— the government or whoever it is—more than one solution. I bring exactly what I think should be the solution because they are, after all, buying a Beverly Pepper. I don't conside their taste.

SCF: But you'll show them a model of the whole situation with the maquette.

BP: Yes, it's my idiosyncrasy. I make the frame, that is, if I know the site where a sculpture is going to go to be placed before a building such as we were talking about in San Diego. I have built a complete model of the area where the work is going. In that way, I can better grasp the innate obstructions. It helps me control the situation to some degree. But it doesn't always work. It's quite difficult to control certain spaces. For example, I did a sculpture on a wonderful median strip. Then I came back two years later and found it next to a garage. So you must always try to reserve some independence of the setting.

Also I've seen how sculptures that have been bought by collectors have been placed, and I've felt like crying. I saw a Noguchi put on a big rock and a David Smith on a huge long black platform.

Essentially you must make the sculpture for yourself, then hope it's going to be treated as you would treat it. You hope it's you alone out there, no matter whether you are making it for a whole city or whether it's just for a table top.

BLDD: You've said often that your work relates to man and nature and the environment, and you want this whole sense of participation,

both of the creator and the spectator. What do you mean when you say that?

BP: Well, it may be an attempt to defy the sense of alienation. Despair. Separativeness. But I want the participation as an extended art experience—not another Luna Park or playground. I live in the country, I live in Todi, an hour and a half north of Rome. One of the more positive aspects to living there is that I rarely read the newspapers and when I do, I know what I read belongs to the past, so my anxieties are calmed.

We are living in a very difficult time, and what I am trying to do is to make works of art that will have some kind of sense of the Querencia. You know, the idea of the Querencia? In the bull ring it's a spot where the bull goes to feel safe from the matador.

I think we all need a Querencia in our lives. I don't know how successful I am, but I try at least in many of my works to give people a sense of their own space—a space to go into. I also try, when possible, to bring nature into it, to link my work to the changing season which becomes part of the work. You might see the sky in reflection or find the work interlocked with land, or sand, the water, or whatever. That's what I mean by trying to relate man to his environment.

Robert Rauschenberg

(Painter. Born Port Arthur, Texas, 1925)

and Leo Castelli

(Art Dealer. Born Trieste, Italy, 1907. Came to U. S. 1941)

BLDD: It has been said that it's doubtful if the art of the sixties would have looked quite the way it did if Leo Castelli had not assembled his group of artists and promoted them into international prominence, since he first opened his gallery twenty years ago. Six years earlier, Robert Rauschenberg popped into American art with his first one-man show, what was then called a prophetic show of pictures, some white, some black.

What was the reception to that first show, and how did it come about? You had only recently arrived in New York. How did you get a show at the Betty Parsons Gallery?

RR: I was a student. I wasn't too sophisticated. And there were so many things that I didn't understand. I kept going back to the Betty Parsons Gallery not so much for answers as for questions.

I had reached a very serious impasse, and finally I just took a bunch of paintings and went up there and asked if I could see her, and she came out and said, "I only look at paintings on Tuesdays." This was Monday. I said, "Couldn't you pretend that it was Tuesday even though it's Monday?" And she said, "Aw, all right, okay, put them in there, in the small room on the side." Then I am standing there in this small room surrounded by these inferior creatures that I have made, trying to figure out whether I should just flee or whether it would be better just to stand there in this loneliness, and before I could make up my mind she was back and she said, "Well, what are these?" And I said, "These are my works." She told me, "You are showing them to me too fast." I was trying to get out of there. Then she said, "Well, I can't give you a show until May." I said, "I don't want a show." I just wanted her to see if there

was anything that I was doing that related at all to the energy in her gallery, because I was upset by seeing all those works.

So I had a show in May. But there is more to that story. Clyfford Still. He was part of the magic that was there in that gallery, and I wasn't influenced by Clyfford Still but he was part of my problem. About four months went past, and Betty Parsons came to my studio with this man and they sat and picked pictures for the show, and I thought it went really pretty smoothly.

Then I brought the paintings for the show a couple of weeks later, and she said, "Oh, I have never seen these." And I said, "Of course not. I just did them yesterday." And it was the truth because I was using the materials five times, ten times, twelve times, as many times over as I could, and I always thought that the next one was going to be better.

She said, "Well, Clyfford won't understand this," and I found out that Clyfford Still had been sitting there picking these things, and I had been scrutinized, my work had been scrutinized. It's funny that I didn't realize who he was.

BLDD: In the summer of 1948 you were a student at Black Mountain College. Soon after that you came to New York, and are credited with

having been an enormous influence, in fact the major conditioner of neo-Dada among the young artists of the New York School. I can recall a sculpture of yours, about two or three years ago, that is an homage to Marcel Duchamp. How heavily does he figure as an influence in your life and work?

RR: I guess heavily but too late to be a direct influence. I remember the first Duchamp that I ever saw was *Bicycle Wheel on a Stool,* and I saw it at the same time that I saw a sculpture by Aristide Maillol, in the Museum of Modern Art, and something there by Isamu Noguchi. I saw Noguchi, Duchamp and Maillol, and I didn't see any discrepancy. There was no conflict.

BLDD: Leo, you knew Duchamp in that period, didn't you?

LC: Yes, I did. I must have met him right after I got back from the war—let's say World War II, not to make me too old.

RR: That was my war too.

BLDD: Is that how you ended up in Paris?

RR: No. I went to Paris from the Kansas City Art Institute.

BLDD: And how did you get to Kansas City?

RR: I had a girl friend in Los Angeles. Her mother was sick. And she was going to go away, so she said, "If I can get you into the Kansas City Art Institute would you go?" And I said yes.

BLDD: How long did you stay there?

RR: Long enough to change my name.

BLDD: And what happened that made you change your name?

RR: I didn't like being called Milton.

BLDD: So from Kansas City you wended your way . . .

RR: To Paris. I went there and took all the courses they had. I ran from class to class, and I had three jobs at night, including some window work.

BLDD: You did window work in New York too, didn't you?

RR: Yes. Bonwit Teller's and Tiffany's. Anyway, I believed the joke that you have to go to France, because by then I was picking up some information that a great artist has to be French.

BLDD: Leo, how did you, a businessman from Trieste, start an art gallery?

LC: My first gallery was in Paris. For me it was much simpler because I had never been to America, I was in Europe, and to go from Rumania to Paris was not so difficult. I had studied in Milan and then I went to work in Trieste, for an insurance company first and then in a bank. That bank sent me to Paris, where they had a branch, so I was there in the bank, as dissatisfied as ever.

I had a friend who was a decorator and designer of furniture. At that time the furniture was what we now call art deco. One day, going by the Place Vendôme, he saw a storefront with a sign that the store was for rent, and to apply at the Ritz, which was next door. So this friend of mine and I, who had never done anything in art until then, went in. The place was just incredibly beautiful: one room after the other, all covered with velvet in soft colors, chartreuse and all that. Five marvelous rooms, something like fifty feet high, and there were windows on one side on the gardens of the Ritz. It couldn't be more beautiful. And it turned out that the rent was very, very modest for the first three years. They wanted to give us a chance to make good, and then of course the rent would be increased steadily.

BLDD: What was your first show there?

LC: My friend and I were very naive and very young, and immediately we were taken over by the surrealists. You see, I had a friend from way back who was from Trieste like myself, and she was called Leonor Fini. She found out that we had this marvelous place and she said, "All right, now let's see what we do with this." And she, Max Ernst, Tchelitchew, Dali and many others—decided that we had to do something very, very grand, and they even designed all kinds of things—panels, furniture; Leonor did some furniture too, but it looked awful next to theirs, which was so much more imaginative. And then we opened the thing in May 1939 with an enormous bang—it was a great event.

My gallery in New York started in 1947 or so. I came to America in 1941 or thereabouts.

BLDD: When did you two get together?

LC: I think we got to know each other at Betty Parsons', at the first show, which was in May 1951. Then he was in a show with Tworkov, Frank Kline, De Kooning, Pollock, and others. We did a great show together called the 9th Street Show, and this was in May 1951 too, right after he opened the show at Betty Parsons'. We had something like ninety artists in the show.

BLDD: Bob, I recall something that you said in 1963, that became a cornerstone of 1960s criticism. You were quoted by Alan Solomon in the catalogue of your Jewish Museum show in 1963 as having said that painting relates to both art and life. And neither can be made. "I try to act in that gap between the two," you said. What did you mean by that?

RR: I don't think any artist sets out to make art. You love art, you live art, you are art, you do art, but you are just doing something, you are doing what no one can stop you from doing, and so it doesn't have to be

art, and that is your life. But you also can't make life, and so there is something in between there, because you flirt with the idea that it is art.

BLDD: You are saying that in art, painting works more in ideas than in the painting itself?

RR: No, I think the definition of art would have to be more simple-minded than that, about how much use you can make of it. If you try to separate the two, art can be very self-conscious and a blinding fact. But life doesn't really need it, so it's another blinding fact.

BLDD: One thing that is often referred to is your iconoclastic approach to art, the fact that you rid yourself of the tyranny of a four-edged, two-dimensional surface. The first way in which you did that was to make what came to be called combines. Can you tell us of their evolution?

RR: It was economy. It was hard to get materials. I had to have this feeling before I would accept it because there were lots of other artists who could have done that, and I was embarrassed, during the abstract expressionist days, by some kind of self-pity. I didn't have anything to paint on. It wasn't an idea. I've painted on everything. Have you ever

tried to put a collage on a bath towel? It's hard. That was wintertime, so I didn't need a bath towel, because I didn't have water anyway.

BLDD: How did you come to use the quilt on the bed, the patchwork quilt?

RR: Because I lost my car; the quilt used to be over the hood of the car to keep the radiator from freezing. I moved to New York and my car wouldn't work.

BLDD: Now I think we know how you got the tires.

RR: Those weren't my tires. It was my quilt. It was my towel. They were somebody else's tires.

BLDD: Has New York been a source of inspiration to you?

RR: Absolutely, not only because it resists everything but also because it can hold everything. You can't hate New York. It's a marvelous place to grow up as an artist. It's marvelous from the viewpoint of a young artist. It's incredible. I have trouble walking around here.

BLDD: Is it the objects that lie in the streets that distract you?

RR: If there is something down there, I pick it up and see what I can do with it.

BLDD: You spend a great deal of your time now in another place, in an almost enchanted strip of land in Captiva, Florida. Why is that?

RR: I find it complementary. I couldn't live without New York. I think New York is just an incredible place; all along the line there are rewards in being here.

I used to tell people this before I was so sure that you have to go to New York. But now I really know it. Because there is no plan, there is no continuity, every change seems very dangerous and it's unexpected, but there is room for you.

There are only two restaurants on the island in Florida, and they are not really restaurants; they are two places where you can eat and not cook it yourself. And different people asked me about New York, and aren't you terrified to live there? And the only place I ever got mugged was the enchanted island!

BLDD: You said that you see yourself as a reporter, and that painting is one of the vehicles you use to give those reports. How much of your work is autobiographical?

RR: Probably all of it.

BLDD: And how heavily do you rely on technology—film, photography, all sorts of technological devices?

RR: As little as possible, but it is necessary.

BLDD: But it seems that film and photography and other technological things have absorbed you for a long while—your involvement in experiments in art.

RR: I am mostly involved in changing what I am doing. And sometimes it has been quite a strain. I got into both technology and theater and printing because I don't like the single ego.

BLDD: You've said that the work that interested you the most was working in some combined effort with other people.

RR: Yes, right.

BLDD: Is that an attempt to reduce the involvement of one ego? Why did that engage you so much?

RR: I just didn't want to have one. It might be good for some other artist, but for me some kind of self-assurance would be death.

BLDD: You told us how the combines evolved. Why don't we talk about the jammers for a moment? How did they occur?

RR: I was working with fabrics already, and doing transfers, and I'd been to India, and I had put off the idea of mostly working in trash. And the idea of a beautiful piece of silk, a beautiful color of silk, consumed with its own vanity and all that, didn't interest me. It wasn't until my second trip to India that I realized how that kind of excess worked, no matter how small a shred you have of it, how that worked into your life, to support you. There were people wandering around in mud, starving, and they have one little rag and they look better than we do. So I broke down that prejudice. It was a prejudice.

BLDD: Was it there that you became involved with those limp and sensuous fabrics that have come to be known as hoarfrosts, a rather apt metaphor for frosty, silken, almost veil-like layers upon layers that have photos and prints placed on the silk?

RR: I read the word in Dante. Hoarfrost is like mock frost, but it's a warning about the change of seasons.

BLDD: One of your characteristics is that you dare—that you dare to keep pushing the limit. One thing I know about your printing is its immediacy. How do you achieve that?

RR: By not making up your mind before you are going to do it. It has to be immediate if you don't know what you are doing. And you take that chance, and it can be very embarrassing. Sometimes you succeed, sometimes you don't. But you don't have the security.

BLDD: Do you plan your major pieces before you execute them?

RR: No. I just go to work, and I work every day, and I *never* know what I am doing.

BLDD: You work directly on the piece?

RR: Yes. That's one of my tricks; I never pay any attention to what I think. You get away from the house, you've done all your business, you've fed the dogs, everything, supper is ready, and everything is going to move very smoothly, and then it's time to go to work and you go, and

you trick yourself by saying, "Oh, I am really thinking of a really fantastic thing now." And then you make four or five lines and you say, "That's it!" And then you go over it.

BLDD: I wonder if there is something that you'd both clarify for us, Leo, about 1964, when Robert Rauschenberg won the top prize at the Venice Biennale, amid a swirl of rumors, most of them relating to some activities in a gondola, as I recall. Perhaps at long last you would give us your version of the events?

LC: It's very simple. Bob had just had a show at the Jewish Museum—that incredible show—and became obviously very well known even here in America. Before that he had had shows in Paris and his work had made a tremendous impression on French artists and on the French art world. Of course Alan Solomon had recognized Rauschenberg's merits quite early, I think in the late fifties, when he first appeared. He was director of a small museum up in Ithaca, at Cornell.

BLDD: His selections represented the United States at that Biennale?

LC: He put the show together. It was an incredibly complex show that Alan organized. He just put into the show all the important trends of the moment, trends that had come up after abstract expressionism. He had two key abstract people, Kenneth Noland and Morris Louis, and two

key—well, whatever they were calling them—new people, Rauschenberg and Jasper Johns, who had gotten away from abstract expressionism; they had used it too, but then were doing something entirely new. Well, these four were the major figures in the show. And there were six other artists, some relating to Rauschenberg and Johns and some relating to Louis and Noland. Clyfford Still, for instance, and Jim Dine, and John Chamberlain were in it. And Claes Oldenburg too. So you see, it was an incredibly well-constructed show that presented in Venice everything that we had to offer at that moment, an incredible feat.

BLDD: But what was the controversy about? What really happened?

LC: The controversy was about the fact that it seemed to many people that we had influenced the jurors who gave the prize to Bob. They couldn't believe, the Americans especially, that suddenly there was a prize here for Rauschenberg.

RR: And I had to keep arguing with Noland about who was going to exhibit on the island. That's the official place on the grounds, where the rules said you had to show. There wasn't enough room for all of us, so we kept switching, and finally I was off the grounds, so I almost won it illegally. I didn't know that one of the ground rules was that I had to be present, available. I was working for Merce Cunningham in the La Fenice theater, and living in a lousy little hotel where nobody could find me, but I knew everybody was looking. I just happened to be on the scene that day, wandering around.

BLDD: You've devoted much of your time to younger artists and artists' rights.

RR: I founded Change, Inc., which provides emergency funds for artists.

BLDD: You pointed out that many artists can't even get a credit card. How does Change, Inc. help financially distressed artists?

RR: We haven't really had an enormous sum of money, I think that the largest grant we've gotten is from the National Endowment, $10,000. Several artists got together and put out a portfolio for Mobil Oil; we got some money from that. And we are about to have a show.

BLDD: How does an artist in distress get funds from Change, Inc.?

RR: They write.

BLDD: Are you on that board, Leo?

LC: Yes. They get whatever they need, up to a certain amount of money.

RR: Our maximum is about $500.

LC: But then also they may just need $50 because they don't have enough to pay their rent.

BLDD: The artists' rights cause culminated at a highly publicized auc-

tion, when an earlier work of yours that had been originally bought by a collector for $900 was sold at auction—was it ten years later?—for $85,000 and, of course, you did not participate in any of that good fortune.

RR: It's all part of the same thing. My interest doesn't come solely from wanting back a percentage of my own work, but also from thinking about other artists in the future.

BLDD: How much of your time is spent on artists' rights?

RR: A lot.

BLDD: Do you think the government will ever establish some legislation?

RR: I think Carter is going to help us. He sent me a letter asking for my advice.

BLDD: What did he ask you to comment on?

RR: To help him figure out what to do for artists' legislation.

BLDD: Let me ask the next question of both of you. If you had your lives to live over again, what would you do otherwise?

LC: Well, probably I'd do all the wrong things, and my life would not have unfolded the way it did. I left very much to chance and to accident, and my whole activity still remains very accidental. I do not decide about shows much ahead of time. They will happen whenever sufficient material of one painter or another is available.

Sometimes we force the issues a little bit. For instance now, with Bob being so busy doing so many things, we decided to have a show of his, Ileana and I, one month after the opening of the MOMA show.

RR: I have six paintings already done. I am not bragging. Well, actually I am bragging. Some aren't quite finished.

BLDD: What are you working on now?

RR: A series of rather large pieces called either Spreads or Scales. It's my present to me. I just want to use anything. The Jammers were restricting, there was a kind of discipline, a restraint. I think excess is expressionless without restraint, and basically I have been excessive, so thanks to Josef Albers and my parents and all the people that tried to knock me down I've learned restraint. But I moved away from that by consciously saying to myself that I would like to just indulge in all the excesses, all the things that I had made available to me, and strangely enough I am starting off kind of stiffly.

BLDD: After all that freedom?

RR: You get freedom through it too. But I am working into it. I know it's going to be a very short period. Leo hasn't heard this. It's very hard, Leo. I mean, to be self-employed. You don't get a day off, you can't fire yourself, and what's a vacation? But I do enjoy it. I don't like everything, like traveling with a show, but it's necessary to me to be on the location

where something is shown and talk to the people who are looking at it. That encourages my growth and my openness. I mean I don't close the door on anybody. I invite people in, turn on the TV, the radio, lights, everything.

BLDD: You said that one of the values of the retrospective is that it brings you up to date, and that as a result you feel liberated. Is that what makes for the Spreads?

RR: It does. And then I will do something else, because you have a responsibility if you know things, I mean if you know something and you have a feeling that the information is useless unless you can share it. And I work through my work.

Larry Rivers

(Painter. Born New York, New York, 1923)

BLDD: About fifteen years ago a major magazine carried an important story about the work of painter Larry Rivers. It was written by Larry Rivers, who also happens to be a filmmaker, a video artist and a saxophonist. In that piece, you told about what interests you, what can never satisfy you, some of your immediate responses to your work, some history. Of all the pieces that I've read about you, I thought it the most eloquent and the most objective. You've certainly had a protean career that often dazzles not only the lay public, but your professional associates.

LR: I've never completely made up my mind whether I'm worth more attention; I mean, whether they should praise or criticize. But I guess that's the usual artist's paranoia that has a curve. Some days you feel as though all your critics are right.

BLDD: How does a saxophonist become an artist?

LR: I was a musician to begin with. I took piano as a kid, very young, and my father could play violin, some of those dances like mazurkas and polkas, and he actually had a very quick way of teaching me how to accompany him, which always felt much more thrilling, I'm afraid, than practicing and trying to get something that maybe was Bach or Beethoven. So I accompanied him, and in a way he killed the piano for me in a serious way. I liked doing what I did, but I took up saxophone at twelve, and that carried me into my twenties.

BLDD: You were a professional musician then?

LR: Yes. I actually traveled with bands during that Big Band era. I don't know if anybody remembers any of them, like Jerry Wald, Herbie Fields, Johnny Morris. The sort of bands that were pretty well-known. We played the Loew's State when it was still a vaudeville house. For a kid, a hundred and eighty bucks a week in the forties was all right—we lived around in hotels, and you got away from Mom or the girl you

married or whatever it was. So I considered myself a professional musician.

There was a time when we were up in Maine, we had a three-week stint. My first exposure to modern art, or art from a personal point of view, came when the pianist in the band married a girl called Jane and took her along. All the guys in the band played cards during the day, and I somehow didn't like that. It seemed to be boring. Jane and I began doing what was called modern art when they were playing cards. I used to go for walks alone with her, and she was very smart. She was the first girl I met where the female and the person were mixed. Aside from being a girl, she seemed to have a brain and I could talk to her, and I had all the usual Forties attitudes, I suppose. She was the first girl I knew who didn't wear high heels, and that made an impression. I thought it was sort of corny and unattractive at first, but it made me look at her in another way. I finally had to realize that she was something other than some sex object. At any rate I actually got interested, and when we got back to New York, from time to time, we used to see Nell Blaine, the artist. She had a loft on 21st Street. She was the first swinging Lesbian I knew, and she seemed to be really loving her work and things were going

on that were very interesting; she seemed to be dealing with a world that I thought was much more dimensional in certain ways than music.

BLDD: That was over thirty years ago, in about 1947. How did you make the transition from being a professional musician to an art student?

LR: I'd go up to Nell's with some musicians. She was into a kind of weird heavy outline and shape thing and was very certain of herself and had a lot of bounce. I think that when I came back to New York from the tour that we were on with the band, I decided that it was time to be a much more serious person. I had a big, a very big fat pompous streak, which over the years I succeeded in shading and masking—it exists, but it's taken other forms. At that time, I thought that art was a much more serious, important subject. Jazz was thrilling physically. It really was. With the drugs and everything like that, it was just beyond belief, what it felt like in those days, but at the same time, art did have an attraction, and I began reading, and this girl was very important in my becoming an art student. That was, I think, the beginning. Everybody at Hans Hofmann's school was trying to do the same thing, and I tried for a little while to get what they were up to. They had a very beautiful model, a twenty-two-year-old, fantastic blonde with a beautiful figure. To the average person, the ordinary person, she was some girl with a certain kind of figure, and you had a certain physical response. But at school, you dropped all that. It was like a monastery of some sort. We would come and talk about the fact that there's a certain amount of air between this face and this body, and she took up space in a certain way, which Hofmann wanted you to be cognizant of. It made you feel as if you were a serious person.

I enjoyed it for a while. One day there was one girl that was so beautiful that we actually sent a petition around to keep her for an extra week. I also decided at that point that I wanted to learn how to draw. I think Hofmann gave up on me at a certain point. He'd come around, he'd laugh a little, he'd look at it and say there's a certain kind of psychological impact, and so on.

Life took its various turns, and you know how people can be in their twenties. I went through all the ups and downs about love and life, and who am I and what am I and who loves me and who do I love and all that. Finally I moved away by myself and was painting down on the East Side, one block below East Broadway.

BLDD: On the Lower East Side?

LR: Yes. The place was so cold that I used to get up in the morning and rush out of my place into the street to get warm. Anyway, I started painting.

BLDD: And what happened to music? Did you continue to play?

LR: Yes, I went back to playing with bands. I was relatively broke, one of those people who was receiving twenty dollars a week—part of what was called the Twenty-One Club.

BLDD: Do you mean the Fifty-Two Twenty? For fifty-two weeks, veterans received twenty dollars.

LR: When I got out of the army—I got out earlier than most people for various reasons—I went to Juilliard under a special thing called Public Law 16. It wasn't the G.I. Bill, which was something else. Public Law 16 was a rehabilitation program, which meant that you could go to school as long as it took to get you to a point where you could somehow manage to support yourself.

Well, I stayed there, and I had a great time. I met Miles Davis, who was going to school at that time, and he used to come in every day and tell me about things. He lived with Charlie Parker. So those days, I met a lot of interesting people.

BLDD: When did you begin to show?

LR: That was very strange. I don't know if it had to do with the time, or my personality, or my work. I had my first show in 1949. I think I began painting in the fall of 1947, and I had a show. Not only did I have a show quickly, but I was reviewed by Clement Greenberg. In that article, to his unending embarrassment, he said I was already better than Bonnard. Considering our personal history after that, I think that he would like to have that suppressed.

At any rate, I did have that show at the Jane Street Gallery, a cooperative. All the artists chipped in a few bucks, something like that. It was up on Madison Avenue, and I think my work at that time was a lot out of Bonnard. I saw Bonnard in 1948. He had a show in New York. I took my mother to the show—I wasn't away from home that long.

BLDD: Did she help form your creative vision?

LR: She came into the exhibition. "That's lousy. That's pretty good. Why don't you paint like that?" She never saw any exhibition, I don't think, in the world, but she had an opinion about every painting. Perhaps I may have inherited some of those traits. I too have an opinion on every subject, perhaps with the same combination of ignorance and certainty.

BLDD: You once said you were the natural inheritor of bad taste but managed to survive it.

LR: I think the only art we ever had in the house was a big picture in a black frame. They must have bought it in the five-and-ten; it was of a Spanish woman, and she was sitting, and there was half a breast show-

ing. And we had a piece of tapestry, some forest scene. That was the art in my house, and my mother always thought that it would be a good thing to have art as a hobby.

BLDD: Obviously, the nude was a recurring theme, even then, in your life. In 1954–55, did your drawings of nudes really represent the first major attack on abstract expressionism?

LR: Sometimes I thought of it that way, but I'll tell you when I thought of that more. By 1951, 1952, I was probably feeling my oats more—at twenty-six, twenty-seven, you really think that you're getting old or that you understand or whatever, at some point there. It's zoning in on thirty when you really feel as if this is the time to really be serious.

I went out to the Hamptons. During the forties a lot of the surrealists who came from France, and American painters too, went out there. I don't know why. It was cheap. It was close enough to New York. And Pollock was out there. While I may not have been a great admirer of Pollock, I think I admired the fact that he was an artist. I mean, that he did this thing and did it all the time and was very serious. Had very large canvases. Had a barn in which he painted.

I went out there with Helen Frankenthaler and we did one of these very youthful things. We walked to the sea, where we promised each other that we would really devote our lives to art.

That was a turning point in being serious about art, and I think that I actually began contemplating moving out to the country. There was an incident, finally, in my private life which gave me a perfect excuse. I had one of those scenes, an ending scene with some girl; she had gone off with another man. I said, I'm through with New York, moved out to the country, and began to work out there.

So there is where I began. Now, about two years after that, Pollock became a kind of hero of the set out there, and even though to the general public he may not have been that well-known, he began to be touted very strongly and the whole thing of abstract painting, which was called abstract expressionist, began to be the only thing that seemed to interest people. Everything else was thought of as retrogressive or conservative or somehow wrong, and I think that the works that were termed avant-garde were probably in some way related to an idea of revolution, that it was always necessary to kind of keep our art boiling or bubbling, that there should always be something, some work going on which throws things into doubt and which keeps people sort of on their toes. I think that Pollock was given that role, along with de Kooning, and it began to dawn on me that there was no place for me.

I guess a very simple-minded way of really looking at it might have been that the painting that was publicly popular at the time was WPA or

social realist painting and that it was all tied up with the role of socialist thought in America. There was something about that that these people, like de Kooning and Pollock, had no part in. I thought to myself that I don't have that—I'm not rebelling against social realism, I don't feel that something about it is old-hat or to be destroyed. I didn't even think about it.

But I was confronted with Pollock on a social aesthetic level. I knew him. I saw him. I saw all these people. They were part of my milieu. So I think that my doing *Washington Crossing the Delaware* was more in the realm of pitting oneself against something that is annoying you. More than the nudes, which came later.

BLDD: What Mr. Rivers is making reference to is one of his most important contributions, the use of iconographic clichés of present-day life. For example, historical events, bank notes, the reworking of popular paintings, advertising images. All of these things, including *Washington Crossing the Delaware* and the Dutch Masters' paintings, were painted around 1953, well before the pop art movement. Do you see any connection between your work and that movement?

LR: Sometimes I do and sometimes I don't. I don't know. You said before that nudes were pitted against abstract expressionism. I think *Washington Crossing the Delaware* had more to do with that. That painting, *Washington Crossing the Delaware*, inspired a lot of my friends. Al Leslie did a thing called *Custer's Last Stand* a month later. Someone did Henry Ford standing next to his first Ford.

BLDD: Where did you get your idea for *Washington Crossing the Delaware?*

LR: While it may have sounded like I had thought up some idea that was really going to harass or upset abstract expressionism, that's not true. I told you that I had a fairly broad pompous streak, and Washington was related to literature. I was reading *War and Peace*, and interpreted it as a work based on a fairly known aspect of national history. All Russians knew about the invasion of Moscow, and maybe it happened fifty years before the book was written; the repercussions from it were felt all through Russia. I think that Tolstoy—I don't want to say cashed in—but he used that as the basis for his novel. I tried to think of a painting equivalent, and given my character I came up with *Washington Crossing the Delaware*, which was always considered to be a kind of joke.

BLDD: The Emanuel Leutze painting?

LR: No. Not the painting, but the idea of Washington crossing the Delaware. For some reason, a lot of public school plays were based on it. While Napoleon's invasion of Moscow seemed to be a serious part of European history, the movement of kings and the change from certain

kinds of society, one to another, why, Washington crossing the Delaware was sort of funny because of its corny public school patriotism.

BLDD: What determines quality and meaning in a painting?

LR: I don't know. But I just go on what interests me. A painting can be thought of in terms of a lot of radials, or spokes, and each one of them has some kind of interest for me. I was going to be America's *War and Peace* painter. I also felt, fuck the idea that you can't have subject matter. I had heard enough of it. I felt that if a man could actually put down paint, oil off a brush, there's some sort of ego involved, and I thought to myself, I'll do this, and who's to tell me that I can't do it, and I was interested in it.

I think that I decided quite early that I wanted to find something to do that took a long time to complete. Like in the difference between novel writing and poetry. The novelist is more attached to some structure into which he puts a lot of things, a lot of meat and information. Poetry is like a flame, more like abstract painting, which is about sensation. Maybe you could make all sorts of suppositions that it has to do with the work ethic, like my father. I always said I like my father, and if I tried to think of a reason, I used to say, "He got up at five o'clock in the morning." Now why should you like someone who got up at five o'clock in the morning and worked hard all day long? But I did like my father because he got up at five o'clock in the morning. And I worked with him years later in his trucking business. But I did want to do a work which required a certain amount of research—British uniforms, American uniforms—I didn't know what I was going to run up against.

BLDD: Much of your work requires at least some research for content?

LR: It's different each time. I don't know if you ever saw these things when I got completely bombed out by Japanese painting? I walked into an art supply shop and there was a book, a coloring book.

BLDD: You're referring now to the Japanese coloring book series that you've done?

LR: Yes. I saw this book, which was a coloring book. Obviously it couldn't have color and reproduced Japanese art without color, and for the first time I saw the drawing—the structure of Japanese painting. As a matter of fact, until then I hadn't liked Japanese painting too much. I know that Van Gogh was influenced by it, and I thought it was pretty and sensitive and informative, but it always looked faded, somehow it never made an impression on me. I began to do research, but I was never able to find a color reproduction of any of the works that were in that coloring book. Wherever I looked, I found other works of the painter. I would get lots of reproductions of this artist's work to get some sort of

idea of what he did, but actually it never helped. I finally made up the colors myself.

So, talking about research, I went to the Japan Society. I bought Japanese books. I called up the people who produced this children's coloring book. Well, that's some sort of research, right?

BLDD: Over a long period of time you have been interested in Africa, both in your work as a painter and as a video artist and a television person. What's that connection for a boy from The Bronx?

LR: We made a movie in 1968, and it was called *Africa and I.* There was a place in Africa, in Kenya, called Tree Tops. By now, it's a tourist stop. You go out in the afternoon and you stay overnight. I met an Italian television writer, female, that evening, in this place where you could look out into the dark with the headlights and you could see rhinoceroses. We're sitting back there. Finally, everybody's so stoned, they have a bar, and you're out there, looking at rhinoceroses or elephants. Zoos are the beginning of an interest in Africa, at least to me. I lived across the street from the Bronx Zoo. I played in the zoo every day from, say, about five years old till I was ten or eleven. For some reason, the cats interested me. Maybe they scared me. I saw these animals and on a nearby plaque it always would say Africa. It was always Africa, Africa, Africa. Then, of course, you have the movies, the Tarzan movies. Then you also have, in this country, a large black population, and that's African, too. I think probably a combination of all of those factors, its history and our relationship to Africa with slavery. Probably all of those things.

BLDD: How much of your work has been derived from your African experiences?

LR: A man asked me to go and make a film with him. The man who made *The Sky Above, the Mud Below,* a documentary. We had befriended each other and he asked if I would go, as some sort of idea man. But somehow, we clashed. He was, like, looking for old Africa, and it was so obvious that it had changed and that there was a lot that was interesting right there in new Africa. But we did do the film *Africa and I* for NBC. And I went back again in 1967, 1968 and 1975. I'm supposed to go back this year, too.

BLDD: How important is it to have a dealer?

LR: I think it's like protection, and it can be helpful.

BLDD: To the works of what painters do you most respond? Who influenced you?

LR: I liked Bonnard very much. That was the first strong period. He had a lot of nice beautiful colors. My early notion of it was that it didn't seem to require technical know-how, and I think I had some dreamy

idea about France and I was going to translate American experiences into postimpressionism. A silly thing, but I did it for a while. He was quite strong for a long time, and he was a beautiful painter, but I changed my idea of why he's beautiful.

BLDD: Can you describe that change?

LR: I see that he was much more peculiar than I thought he was. While he may be beautiful, his paintings seem to be about places and how beautiful landscapes look, or plates on tables and people in sunlit rooms, actually, when you begin to examine it, it's a fantastic interest in what makes some object look like it does. There are like fifty thousand colors in his things. He was an amazing man. He kept pushing in these colors that you would think would never work. His work wasn't that strong from the point of view of drawing. It was like an amoeba. Every part of the body, every plate, everything on the table seemed to be there and not there. It would move back and forth like that. It was pulsating, and I liked that.

But I then became more interested in sculpture.

BLDD: In whose work? What about Courbet?

LR: Oh, Courbet, all of those. I was such a nineteenth-century freak. I think I read all the literature. In 1953 alone, I think I ready twenty-one

novels of Balzac. I read Stendhal, all the Russians. An amazing amount of things. I think that I felt I had a very closed childhood. I didn't start reading till I was twenty-one years old, but I thought. All my friends, all the people that I liked were, like Frank O'Hara or John Ashbery, people who had college educations, who I thought were reading all the time, and I felt as if I were trying to catch up.

So I did a lot of reading, and I enjoyed the nineteenth century. It seemed very flamboyant.

BLDD: Did you read any art criticism?

LR: Yes, I read the weirdest authors. There was a late nineteenth-century critic, a very delicate man, who in a certain way has a relationship to Proust. Sainte-Beuve. I took it seriously. And I began to adopt poses that they did. I read the journals of Delacroix. I think it's like anything else, like asking someone, how important is affection and how important is criticism in the life of an artist? We go on being ourselves or we search, we look somewhere else.

BLDD: I once interviewed a caricaturist who, in his caricatures of music critics, never rendered the critics with ears. I wondered if you had a counterpart feeling about art critics?

LR: No, I think they're very important. I mean, everybody is a critic in a sense. We're all responding in some way to the work and thinking thoughts.

BLDD: But we also, of course, assign different weight to opinions, depending upon who the evaluator is.

LR: Well, that is something else. I think, much to the chagrin of art critics, their influence is not as profound as, let's say, a theater critic's or even a movie critic's. There are too many diverging interests for a critic to be that profoundly important in an artist's life, in his success or failure. Somewhere along the line someone has to like him. But then you have strange phenomena. You have Andy Warhol. I don't remember reading a single laudatory review of a show of his. In some way, he seems to be the epitome of the idea that criticism doesn't mean anything. He goes on. He does it. He's thought about. Sells his work.

BLDD: Critics have always said that you were a born draftsman and a powerful and painterly technician. You have recently taken up the tool of the photorealists, the air brush.

LR: Well, maybe the tool.

BLDD: When a draftsman as acute as you are uses that kind of technologically inspired equipment, one wonders what will happen to man-made art?

LR: It's still man-made. As a matter of fact, it's almost silly to talk about it that way. I think they were using air brush around the turn of

the century, before World War I. The air brush was a technique for fixing up photographs.

BLDD: But in terms of the fine arts, it is really the use of technology in the hand-made business.

LR: It's true that there's a pressure built up, there's air coming through the thing, there's a rod moving back and forth and out comes a thin spray. That's true, but almost everybody has used spray cans for painting. The air brush is just a little better, you can direct a little more accurately, you can be a little more precise.

BLDD: Is drawing the most important part of painting to you?

LR: I seem to like to draw. I'm not sure why, but I do. There were early works where I painted and I drew in it with charcoal. Now I've had a lot of criticism, people finally telling me the air brush looks very impersonal and I don't know, Larry, what happened to that other thing? That hand of yours? You know, it really was nice. And so, at first you try to say, okay, how long can you keep something up? I mean, I want to try something different. But maybe there is something about air brush work that is cold.

I feel I now want to draw and use the air brush, so I'm at the brink of what I consider to be a new period.

BLDD: You turn more and more from the world's history to your own personal history.

LR: Yes, well, both. I've actually begun taking things out of my own past, painting to sort of redo—I think it's been done before. I seem to be starting a painting called *Self-Portrait of Myself as Rembrandt's Polish Rider.* I mean, I've taken the Polish rider, I'm going to put my own face in the place of the man who's riding the horse.

BLDD: How do you work?

LR: I have to draw, or air brush. I have to make a drawing to create stencils. If I want to make a line with an edge, it's very hard with an open air brush, because you will still have a soft edge. But if I cut into a waxed piece of paper, put it over a canvas and just spray, when I take it away, you're going to have a very precise line.

So my drawings now seem to indicate things for me. I will get certain things down pretty surely. I'll know exactly where I want them. I use all sorts of pins and tape. I really know what's going on. I then begin to paint like you would with a brush, but only with an air brush. So I have to make a drawing first these days, which now suddenly seems very traditional. It used to be that I would just jump in. I would start to paint. Now I seem to want to know more what's going to happen—size, placement, and so on.

BLDD: When are you sure that a painting is right?

LR: When am I sure? I don't think I am. I just keep going and keep going. I more or less tell myself what I'm going to do. Say I'm starting this thing with the Polish rider. Well, I'm going to have a horse in it and I'm going to have a man on top of the horse, and there's a landscape behind this rider. I'm going to try that. There's a certain brown look in that work that I want to get. At the same time I want to come away with it looking like someone today did it. Okay, that's four things. Well, I'm going to start moving in the direction of trying to get that horse some way. I'm going to get that rider, and I'm going to do something about the landscape.

BLDD: What effect do you think your work has on the viewer?

LR: That's what I've always been amazed by. People have said to me that I'm like a technician, draftsman. I'm not—this is not from false humility. When I look at people who can, with shading, really make the most fantastic things, or the old masters, that's what I consider technically terrific guys. I am somewhat limited. I can't do everything. But it is something that I have received compliments for or people have said that about me. Not from all segments of the so-called art world. I think a lot of what other people call "technique" or "draftsmanship" has actually been held against me. I don't think that I have it, and I could be left out of certain drawing shows because that's exactly the look that they don't want in their drawing show. They want a guy who, for instance, takes a ruler and draws a parallelogram. There's a certain force in that. It doesn't try to emulate natural forms. My work seems to be related to that other school of drawing. But I don't feel it myself. I don't put any stock in it. I use it. I even make it easy for myself. I project and I trace. I don't particularly think that I'm going to win all the laurels by everybody coming along and thinking that guy's really a terrific draftsman. I don't think it means that much.

BLDD: You've often collaborated with writers and poets. In fact, when Tania Grossman started her press on Long Island, you were the first artist that she persuaded to work with her, in her attempt to resuscitate the art of lithography. How did that come about? You've since collaborated with Terry Southern and Kenneth Noland, among others.

LR: It certainly has to include the fact that I was going to Europe in 1950 in a very uncheery state. And I met this woman, Tania Grossman, who was going back to Europe for the first time after having had a fairly close brush with the Nazis. I listened to her stories of her life in Europe, and she listened to my woes about some female I was going with deciding somebody else was really more interesting. So we became good friends. Her husband's studio in Paris was still intact, and I actually painted in that studio. When we got back to America, she'd get in touch

every so often and we'd have some sort of reunion. She lived on 8th Street, so I'd run into her every so often. Her husband, I think, had a heart attack. She had to sell prints. I think she was selling Chagall prints. But I think that she comes from a family of publishers, and so she began thinking that maybe she should print. For her first project, she wanted to have a collaboration between a painter and a poet, and came around to ask me what I thought of this idea. It was 1957. That weekend, Frank O'Hara was a guest at my house and there began that collaboration, and in a sense maybe the career of Tania Grossman.

BLDD: She does credit you always.

LR: Yes. Whenever she's a little doubtful about me, and our twenty-year life together can produce a range of different feelings, whenever she sees that I'm either champing at the bit or a little annoyed or something, she always says, "My first-born, Larry. You are my first-born."

But she had the most fantastic career. I mean, there's a woman who within ten years became absolutely the greatest printer in America and actually changed the face of printing. I thought printing was for pipe-smoking, corduroy-jacketed "serious, profound artists," whose sight used to upset me. I couldn't stand that kind of person. And she changed it all. She had a really terrific way of dealing with artists. She's beautiful.

BLDD: Several months ago you visited the Soviet Union. Who invited you and what did you do while you were there?

LR: I was actually invited by the State Department, meaning someone called me up and said, "Listen, the Russians would like to invite you to spend two weeks in the Soviet Union as a guest of the U.S.A."—the Union of Soviet Artists. I never found out why I was invited. I never found anybody who really knew my work.

BLDD: If you had your choice, what works of art would you want to have?

LR: I love so many things. There's a Courbet of a woman on a floor. Up to a few years ago, every time I saw the painting I almost cried. I think it was his girl friend or Irish sweetheart, that was the gossip. And she's lying on the floor. Her hair is sort of flowing back on the floor and she has her hand up and there's a bird on her hand. At that time, I thought that was so lyrical and sexy and a lot of everything. It seemed beautiful.

BLDD: What is your most prized possession?

LR: It varies by the week. If I'm feeling particularly poor one week, I guess it's my bankbook. You mean art?

BLDD: I think we should confine it to that.

LR: I have certain kinds of attachments to some works of mine be-

cause they either remind me of a certain experience or because I think that I got something good.

BLDD: You've always said, in the end it's a question of some kind of love that makes you ultimately end up in front of that canvas.

LR: Or in front of a lot of things. Yes.

Robert Ryman

(Painter. Born Nashville, Tennessee, 1930)

BLDD: Robert Ryman came to New York twenty-five years ago as a professional musician and stayed on to become widely known and admired for his dazzling white canvases.

Mr. Ryman, having never studied art, having arrived here as a tenor saxophonist, how did you end up being a painter?

RR: I don't know exactly. I came here in 1952 and I was a jazz musician at that time; I came to New York for the music. I came from Tennessee and I'd never been really anywhere, I mean, outside Tennessee. So, coming to New York, I saw many things. I saw everything, just like all the tourists, and I went to museums and saw paintings for the first time.

BLDD: You had never seen a painting before?

RR: Well, I had seen reproductions of paintings, and I'd seen pictures of flowers and things like that, but nothing of any consequence. I became more and more interested in painting; I became involved with it, and after about two or three years, I gave up the music and decided that I wanted to paint. I wanted to investigate this thing more and really get involved with it.

BLDD: You made your living as a musician up to that point. After that, how did you manage to survive?

RR: I didn't really make a living as a musician. I might have if I'd kept up with it. But I did all kinds of flunky jobs. I worked in office buildings and did this and that and then ended up for a number of years at the Museum of Modern Art as a guard, which was one of my best jobs.

BLDD: I assume it was also a part of your art education?

RR: Yes, it was. I had the opportunity to see a lot, to spend a lot of time with paintings. And then I also worked at the Public Library, in the Art Division.

BLDD: And there you read a lot?

RR: Yes. I was able to read and look through the books and the

scrapbooks and the folders. I didn't go to an art school as such. At that time—this was 1954—there weren't any schools like Visual Arts. There was the Art Students League, but that didn't interest me, because right from the beginning I wasn't interested in painting realistically, painting landscapes or still lifes or the figure. However, I did do a little of that.

BLDD: What did your early work look like? Did it have the same scale or color?

RR: Well, when anyone is beginning anything—the first thing I did was find out how things worked. You find out what the paint does and how the brushes work and what's going to happen when you put things together, and how colors react together, and composition. There's a lot of experimenting and just trying. You try and see how things go together and the technical aspect of it. As all students do, I worked with composition and color and all those devices.

BLDD: Surrounded as you were at the Museum of Modern Art, how affected was your vision by all those cubists?

RR: Well, I would spend time with different painters. I would look at Matisse. I would be involved with his paintings maybe for a week or so. Then I would go to some of the cubists, the Picassos and Braques and Cézannes, and so I learned from all of those painters, and many others

also. Not just the ones that I saw at the Modern, but painters that I saw in galleries. And I learned from books, of course. Just general information, picking up whatever was of interest to me at the moment.

BLDD: At what point did your work evolve and change from the small drawings and paintings that you were doing?

RR: It was a gradual development. It's not something that happens—at least it didn't with me—overnight, or even in a year.

The more I worked on the paintings and the more I considered the problems, the more the work would slowly change. After a while I became not so much interested in the color, because I wanted to paint the paint, you might say. Of course, I wasn't painting pictures. I think maybe that's something that should be understood. I wasn't painting an image, in the sense that usually a painting is thought of as a picture.

BLDD: You say pictures are not what you make. You make paintings. Perhaps you can describe to us what you mean?

RR: Yes. Paintings can be pictures. Many times they are. At the beginning, paintings were mostly pictures of something, of a person, of a still life, of a situation, of an object. And these pictures involved a certain specific space, the space of the canvas, and usually they were framed to isolate that space from the space of the wall, and they were hung, and still are, on a wall at eye level so that they could be seen, looked at.

Now, that's all right, but since I was not painting a picture, I was not going to paint an image isolated in this space, then there had to be a different way of looking at it, a different way of seeing it. I wanted to make a painting without the image isolated within the space, so that the painting itself was an image. And also, its surrounding, later the wall itself, became very important. That interested me because it seemed to open up many possibilities, many discoveries for myself, because I knew that I could paint a picture and I knew that I could use composition, and I knew that I could use color and these devices, which I still do, but in a different way than is thought of in the usual picture making.

So this interested me very much, this approach to making a painting without it being picture making.

BLDD: You've said that you don't really make white paintings, that you use a lot of white in order to make other things happen with the paint. What does that mean?

RR: To anyone who has seen my work superficially, it could seem as if it were only white, that it was a white painting and that that was the purpose. That is not my primary concern, to make white paintings. I think many people have done painting in white for specific reasons, to solve a certain problem that they're working on. But really, once you've done that, once the problem has been solved, there wouldn't be much

interest in doing it again. I mean, it would become boring, just repeating the same image.

But I use the white because it's neutral—it's a paint that allows other things to come into focus with the work. The surface, the subtle colors of the surface, the texture, the painting as a whole.

BLDD: Do you use color under some of the painting?

RR: Yes. In fact, just recently, I did some paintings on a blue surface. The blue was the color in the surface. And also on some black surfaces, which, of course, will react with the paint and give it a certain depth and a certain movement that affects it. In this particular case, the material was very thin, maybe an eighth of an inch in thickness, so that an edge was left, so that there was a black line and a blue line, which was also part of the composition.

BLDD: You've said that perception relates to the way we're trained to see and do things. Is this perception the same that the impressionists had in mind?

RR: We're trained to see things that we see around us every day in a certain way; it becomes a habit. But there are other ways of seeing, other possibilities. Painters—well, their perception and their vision may be a little more highly tuned, you might say, because they work with those problems of seeing and how to see and what is possible and what problems can be worked on visually. It has to do with the development of a painter's work.

BLDD: What is your approach to your painting? Are your intentions clear when you start any new work?

RR: Oh, yes. There are definite problems, specific situations, problems that I want to try and work out with a painting or a group of paintings that I'm working on at the time. And I usually know what material I'll be working with and know pretty much what result I'm looking for, and it can be very easy. I mean, sometimes it works out very successfully, to an extent better than I had hoped for. At other times it can be more difficult and I run into problems that I hadn't considered, and I surprise myself by the result, and it's not really what I thought it was going to be. Maybe adjustments have to be made, maybe I have to abandon the type of paint, switch to a different surface, change the scale, change the texture. Maybe it has to do with the light reflection or absorption that isn't what I had thought. Many of these things come into it as the work is progressing. I never am sure of the result, at the beginning.

Then, if the work is successful, I always learn something by doing it, from what happens with the work.

BLDD: One of the problems that you've tried to resolve is that of edges. You work with edges, sometimes even emphasizing the painting

size with special brackets and fixing the paintings to the wall with special brackets, no longer framing them, in the traditional sense. Why do you do that? Are you redefining space?

RR: Well, maybe. I hadn't thought of it like that. The fasteners on the recent paintings I had made specially for the paintings, taking into account the scale for the paintings and the shape of the fastener and how it would work visually with them, its color, the light reflection of it if it was steel, or if it were plated with black oxide, or if it were cadmium-plated. But the thinking behind the fasteners has to do with the way a painting hangs on a wall; usually paintings, particularly if they're pictures, hang invisibly on a wall, because we're not so interested in that. It's the image that we're looking at in the confined space.

Now, since this work is not a picture, then it could hang visibly and I thought that if the painting were visibly attached to the wall, then it would become more part of the wall. Therefore, visually the wall could work much more with the painting. Also, what happens there too is that the painting doesn't exist unless it's on the wall, whereas with the traditional pictures, they can be leaning against the wall, you can look at them because they're always confined, defined in a specific space. My paintings don't really exist unless they're on the wall as part of the wall, as part of the room. A painting of mine consists of the painted surface and the composition, the light reflection and absorption, the edges and structure of the painting itself, whether it's canvas or plastic or whatever the material is that holds the paint, and then the visual composition of the fasteners, which we see, that hold it to the wall and make it part of the wall, which is also brought into our vision. That was partly the consideration with the fasteners.

I'm also trying to make very clear that the painting exists only on the wall, and once it's down from the wall, the fasteners are lost and so the composition is lost and the painting is not alive. You know, it doesn't exist until it's in a situation, it's in a room on a wall.

BLDD: In earlier work—in the now-famous show at the Jewish Museum—where a work was taped to the wall, you not only painted the canvas but let the paint spill over to the tape and ultimately to the wall. Perhaps you could describe the thinking behind that?

RR: There were a number of solutions that I tried then. Some were on vinyl sheets that were colors, different colors. One was a deep red, one was blue, I think. But in the case where the paint was applied to the wall, the surface was attached to the wall with tape, two at the top and two at the bottom, to hold the surface to the wall, so it could be painted. The surface was put on the wall to make the painting very thin, so that the

paint and the wall were just about one, you see, and it worked with the wall itself. The painting and the wall became one surface, and by that I mean the corner of the wall, for instance, was taken into consideration, and the floor and the ceiling, and then the fourth corner. So the scale of these units had to do with the size of the wall, the height and the length, and that would vary, depending on the wall. Also, the surface of the wall was considered because all walls are not the same. Some have a texture, rough. Some are smooth. And that has to do with it also. After this paint was dry, the tape could be removed, because it was no longer necessary to hold the material, the surface that was painted, to the wall, and when it was removed, you saw where the tape had been, and you saw the original surface, because that hadn't been painted where the tape was, and you saw the wall, and in this case it might have been deeper and you saw the soft edges. Well, first you saw the hard edge of the surface as it touched the wall, and then you saw the soft edge of the paint, which actually held the surface to the wall, as it left that surface and went on the wall itself. Composition-wise, within each individual unit, you had the soft edge and the hard edge and then the light-reflecting surface and the light-absorbing wall and the color and the texture of the original surface that was not painted because it was covered by tape.

Maybe the units were repeated in a series of five or nine or seven. Usually I tried to use an odd number because with an odd number, you always have a center visually, whereas with an even number, you have the walls as your center. And the odd number has a feeling of expansion, of continuing on, whereas the even number has more of a static feeling, more of a closed situation; I've used the even too, but not as much as the odd number.

BLDD: How do you title your paintings? They certainly do not have the usual descriptive titles that we come to associate with pictures.

RR: That is really a problem, titling. A picture is traditionally titled because it's an image of something or for something or about something, aside from the fact that the title identifies it, and you could distinguish one thing from another thing; for this, of course, it's still used. Many painters who work in the manner in which I may work use titles for identification. It's nice to know what painting you're talking about.

I want to talk about the word title. It's really not correct anymore, in my case, to use the word title. I prefer to say name a painting, because since I'm not painting a picture of something, the title doesn't really have so much meaning.

BLDD: How did you arrive at the name "General" for a painting?

RR: I tried to find names that were recognizable. You can put a lot of

letters together and make up a word, or you can say Number One and
Number Two and Number Three or A, B, C, D, and things like that, but
then that also becomes confusing, because you say Number Seventy-
Seven or J, or 1960 or whatever, and then you're not quite sure what it is,
but if you have a word for it, then your memory can keep track of it.

So I try and come up with names for the paintings that are somewhat
familiar and yet names that do not have too much association, such as
General. I picked it, actually, because I think it was the name of the
place where I got the steel. You know, it was called General something,
General Fabrication or something. But also, it's a name that is very
familiar, yet doesn't mean all that much. And there are others too, you
know. Capitol, for instance. Allied is another name, like Allied Shipping.

BLDD: Your use of industrial materials, the vinyl sheets, the metal
fasteners—does that impersonal material have a special significance? Are
you saying something philosophical as well as something that is a tradi-
tional painterly concern?

RR: No, no. I use these materials because of the different surfaces that
I can work with that give me the opportunity to explore, such as steel.
Actually, I didn't really want to use steel. I wanted a very thin material
that I could paint on, that was strong yet that I could work with in a

certain scale, with certain sizes, and that could fit very close to the wall. And aluminum wasn't so good because of the technical considerations of the paint and the aluminum. And paper wasn't really strong enough, cardboard was difficult, plastic was difficult, so it just came about that steel was decided upon. Then I worked with the gray surface of the steel, so that that became part of the visual surface. It also gave me a hard surface, unlike a stretched canvas, where you have a soft surface to work on, and it's just that certain things are possible on a hard surface that are not on a soft surface. But linen or cotton on a stretcher, properly done, is probably still the best surface, when you come back to it, because it's the lightest and it's strong and it can be constructed in all sizes and shapes. But in certain cases for certain approaches and certain things that I want to work on, the hard surfaces or thin surfaces become necessary, and that's why I choose these things, not because of any other messages.

BLDD: Why do you choose to stay in New York? Is this urban space important to your work?

RR: Yes. There's a lot of energy in New York, and even with the noise and the dirt and all the problems that New York has, still it's important for me to be here. I like it here because, for one thing, you have access to so much information that you would not have in certain other places. You have the museums and the galleries and the libraries and the art supplies, the concentration of artists and schools, so that you have the energy, the activity that would not be possible in other places, and that's important to me.

BLDD: Is there such a thing as New York light?

RR: Maybe so, but I don't know. I'm not so concerned with that. My paintings have to do with light, and they're extremely sensitive to lights, different light situations. But New York light doesn't matter.

There are places where the light has really been fantastic. Not in New York, but some places in Europe, where the light is extremely beautiful, you know, but I don't know why exactly.

BLDD: Where, for instance?

RR: Amsterdam, Holland, for one. But it really doesn't matter so much in my work, as far as what the light outside is, because I don't paint in that way.

BLDD: Actually, you don't make much of a fuss about many things, and you've used the expression "no fuss" to describe your own work. What do you mean by that?

RR: When I'm painting, it should be right the first time. If something has to be struggled over or fussed with, then I think there's something wrong, there's a problem; it never turns out very well and it's best to just abandon it. The approach should be direct and to the point and without

anything there that doesn't need to be there. So I think maybe that's what you're talking about.

BLDD: How does that square with your view of comparing the painter to the research scientist? That certain problems are selected and then one goes about trying to find solutions?

RR: I think that's what painters do. They try and solve problems—aesthetic problems concerning painting—very much in the same way that a scientist goes about solving certain problems. Scientists try to find solutions, and they pick one problem out of thousands to explore and work on. It's a similar thing, I think, that painters do. You can't work on everything, so you take what interests you most and you explore it, and you find what solutions are possible, what can happen with this, and where it will lead to, and one solution will set off a new problem that enables you to see something that you weren't able to see before, because you didn't know about it. Then you compare your solutions with other solutions in the same field, and see that someone else has solved a certain thing, so you take that into consideration, and that's where the exchange of information is important.

BLDD: There is a very widespread appreciation and commitment to your work in whole parts of Europe. How do you compare the European response, understanding and perception of your work to the American response?

RR: There is a great deal of my work in Europe, maybe more so than here. I don't know how that happened. Maybe at one time there was a little more interest there, or maybe the Europeans are more receptive to painting in general. I don't just mean my painting; there seems to be a lot of interest in painting in general. Maybe more than here. Here there's a great deal of interest in music, possibly more than in visual art.

BLDD: That's not the way many musicians see it. Are Europeans especially interested in the avant-garde, or what they take to be the American avant-garde?

RR: I don't know. It's always a small world, that of visual painting. I mean, there are always a group of people interested in it, but it's never a mass thing. It's similar to the opera.

BLDD: How influential is criticism on your work? How does it affect your work?

RR: Criticism doesn't really affect it at all. It's surprising sometimes. I mean, I learn some things that I hadn't really considered from reading certain articles. I remember at times being surprised at how someone came up with something that I hadn't considered or hadn't intended. But it really has no effect on the work because I'm always thinking ahead.

I'm always involved with what I'm about to do, rather than what I'm doing at the moment. That's why criticism doesn't have that much effect.

BLDD: Is it quite an intellectual process?

RR: I'm an intuitive painter by nature, I think. But there is a considerable amount of thinking things out, testing of technical approaches and what things are going to work with what kind of surface, how the paint is going to be and is it going to crack or is it going to stay there, how is it going to be applied, what kind of a surface do I want? You know, there's always that kind of intellectual part, and then there's the intuitive approach too, where I never, as I said before, really know what the result is going to be until I see it.

BLDD: How has public acceptance affected your life as a painter?

RR: Well, it has affected my life, because for one thing I have a little money now. I didn't used to, so that has helped considerably. And also, what may be even more important, it's very good to feel that what you do is liked by someone, even if it's just a few people—that they can see it and experience it and have an understanding of it, and that what you do is not just in a void, so to speak, that there is some appreciation. It's a very nice thing.

BLDD: To the works of what other painters do you respond?

RR: Oh, many, many. Matisse, I guess, was the biggest and most important painter for me at one time, but there were others. Cézanne, to a certain extent, and Rothko also, and any number of painters that I would look at from time to time. Mondrian. It always had to do not so much with *what* they were painting, but *how* they were doing it—how they were putting things together, and then *why* they did it.

Sometimes you can just pick up a little thing from looking at something and hardly realize where you saw that or how it came to you. It's a very subtle kind of thing.

BLDD: The only surprise in your list is the inclusion of that great colorist, Matisse. Do you envision the possibility of your returning to color or to even having a bound painting, your version of a frame?

RR: Well, anything is possible, I guess, but I don't think of my work as not having to do with color. I mean, it is true that I'm not really involved with color as a problem, the way some painters are, but the color is considered, the subtle surfaces and the colors that I use, and so I don't know that that would change. But it might. If colors—I mean specific colors, red, green, blue—were the solution to something, to a problem, then there's no reason why they couldn't be used. But I don't know.

BLDD: A number of your works seem very similar. What makes each of them unique?

RR: It's simply the way they're painted. Monet did a lot of waterlilies, and he also did some haystacks, a number of haystacks, that were very similar, but very unique, and I think it's the same with me. Every painter has his own sensibility, his own sense of working, his working sense, so that whatever he does, his approach is usually similiar. But unique.

Lucas Samaras

(Sculptor. Born Kastoria, Greece, 1936. Came to U. S. 1948)

BLDD: Lucas Samaras has made a considerable reputation by his inspired transformations of the commonplace and of the now, into art. Samaras is flamboyant, theatrical, obsessive, articulate, and unfailingly original. You were born in a small town in Macedonia called Kastoria, a city rich in Byzantine architecture. After spending the war years in Macedonia, you settled in West New York, New Jersey. That was 1948. Within seven years you had a scholarship to Rutgers University. How did that all come about?

LS: I was lucky that I was able to come here; my father had been here during the war, so he was able to get the papers. I was lucky that I had decent teachers who took an interest in me, especially Fabian Zaccone. I was also lucky at that time that the government had set up scholarships.

BLDD: You didn't expect to be an artist when you went to Rutgers, did you?

LS: I didn't know what I was going to do. I thought I was going to go into the army or something. I liked art throughout public school and high school, and I thought maybe I would go to college and take art courses, and then become a psychologist or a psychiatrist. Something dignified, you know. But when I went to college I took a course in psychology and it was full of statistics. So that killed it for me.

BLDD: Not only did you have some interesting teachers—you had some interesting classmates as well, and while at Rutgers became part of a group that certainly influenced your life. Can you tell us about them?

LS: It was a strange time. I sometimes go to lecture now at different universitites, and the art departments have four hundred students, six hundred, two hundred. We were about seven, including the art historians. It really was a dumpy little group. We had a nice little boarding-house type of thing and in the basement there were two tables, and that was the art school. It makes me squirm sometimes, when I go to these huge places with fantastic equipment.

We had two good teachers—Allan Kaprow was one, George Segal was the other.

Students? There was Bob Whitman, who was instrumental in the development of happenings in the sixties. We had another artist who made paintings, Bob Harding. At Rutgers then, the coed part was Douglass College, and Roy Lichtenstein was teaching there. George Brechet was also involved.

BLDD: How did the happenings evolve?

LS: Well, Allan Kaprow was a brilliant student of Meyer Schapiro's. He was an artist. I think he studied with John Cage at the New School. So through his art history researches he became aware of the avant-garde of the twenties and earlier. And he was interested in making people walk through painting, sort of. Once or twice I think he had shows where people crept through the gallery, and he had raffia, so these things would brush against them. The next step was of course to bring in people to perform. He did a nice performance called *Eighteen Happening in Six Parts,* or something like that, in 1959. That was more or less the formal beginning.

Now, meanwhile Red Grooms was also doing some kind of theatrical event in a dumpy little place downtown around Delancey Street.

BLDD: Why was this paratheater considered art?

LS: Why? Because artists were making it. As soon as I graduated from Rutgers, Allan Kaprow knew this young woman who wanted to start a gallery—the Reuben Gallery—because she had a sister who was a painter, and she wanted her sister to have access to a gallery. It was a terrific gallery.

So I showed there, and in the second year that gallery became a happenings gallery.

BLDD: What role did you play in the happenings?

LS: I appeared in Kaprow's because I liked him, he was a friend. I appeared as an immigrant in lots of them, not actually calling myself an immigrant, but they used my accent or my theatricality. Bob Whitman was a friend of mine, so I appeared in lots of his happenings, and later in Claes Oldenburg's.

BLDD: You are known for your celebrations of the self, an almost relentless self-involvement. Someone once described your work as the drama of self-encounter. So perhaps you ended up as a psychiatrist *and* as an artist. Why does so much of your work deal with yourself? To what extent is your personality the subject of your work?

LS: Because I was a foreigner I had to watch myself a little bit more than the rest of you. Why? I came here in 1948, and the climate was much different. It was after the war, there were flags flying, the Daughters of the American Revolution, McCarthy was just around the corner, the Ku Klux Klan, this incredible thing. You come from Europe and you see a picture of hooded people, lynching and what not. It was a fearsome place. If I didn't do the right thing I might wind up in jail. I had to watch it, although I was only eleven.

Therefore self-involvement was always with me. It was just a matter of professionalizing it. Somehow I wanted to take something that other people would consider an insult, turn it around and make it into a virtue.

Now naturally when you do something that is a little different than what was done before, the other professionals object to it, there's squealing and hollering and so on, but if it's done professionally, eventually you get things done.

BLDD: Is there still an obsession with self-referential imagery?

LS: Yes. You have to try to do what you are good at. Some people are very good at being teachers, some people are very good being social—mothers, fathers, and so on—they go out and they make other people happy. I am not very good at that, whereas I am good at investigating myself, and then at creating some kind of . . . some kind of what? Some picture, some device, something that other people can take from.

BLDD: Early on, your own self-exposure, self-revelation, and self-

examination were thought of as sensational. Now the feminist movement, the video movement, and the body art movement have, in a sense, diluted the shock value of your work. Does that intrude in the nature of your work?

LS: When you are dealing with taboos you have to face that once you break a taboo, then you are either going to find some others or else there will be none for a while.

BLDD: In breaking a taboo with your relentless self-investigation, and certainly it was a pioneering stance, there is an aspect that is almost Puritan in its denial, and almost conventional in its nostalgia.

LS: Sometimes I can turn the convention into a taboo, and then work with it.

Now, for example, I am asking people—friends, acquaintances and sometimes somebody I may meet only once—to come to my studio and take off their clothes, and I can take a picture of them with me. So I have a setup where I have a chair, and I have another chair, and in one chair I sit all the time, and the other is where my guests sit, only they have to take their clothes off.

BLDD: Your work reveals that you investigate not only the superficial and the manifest, but the interior and the intrinsic. You have exposed many bodies, and you have obviously exposed many psyches as well. What is the cumulative effect of this, pictorially and psychologically?

LS: I am in the midst of it, so I am not very clear about what it means. All I am interested in is that I have photographed people from the age of seventy-five to about nine. I don't know what the hell happens, it's like I am in a state of suspension or something, because I am embarrassed that there's some person there nude for the first time. Sometimes it's pleasing, sometimes it's unpleasing, sometimes there is a scar here, or a pimple or a wart. If they are in an erotic situation in subdued light, kissy-kissy and all that, it's much different. This is like a doctor thing—don't worry, dear, you look terrific, even though you may not.

While I am doing my photographs I am thinking, gee, I hope it comes out all right, because this person is going to say, "What a lousy picture you are taking." But after it's all done, I don't care what troubles I have, I am left with this wonderful human abstraction.

BLDD: You might like to explain why you call it an abstraction. You not only transform that body into a photograph, but within that medium you've created yet another transformation. Can you describe what you do?

LS: Well, the person turns into an abstraction, not a human being but an object. If you look at the photograph you begin to say, Well, look at that leg that I have shaped, or the color that I have used, or the foot. . . .

It begins to suspend the communication person to person, and you begin to look at the face, the flesh, the skin. So it's an abstraction—form, color and all that.

BLDD: You use a particular kind of camera, a gift from a camera manufacturer.

LS: You are talking about the Polaroid? Well, the nice thing about the Polaroid is that you have a picture within moments, you don't have to send it to be processed, you don't have to spend a couple of hours working in the laboratory. It's there, and I like that very much. Now they have eight by ten, so it's a larger format. They even have a bigger one, twenty by twenty-four or so.

BLDD: There's something that you do to disrupt the surface, a disturbance. It would be interesting for you to explain the process that you use. You use the SX-70, don't you?

LS: You take the SX-70, and it's a sandwich of many chemicals. A clear plastic on top, sixteen layers of chemicals in the middle and a black mylar on the bottom. You take a picture and there is a face. Well, that face is formed in sixteen layers of chemicals. By pressing upon it, you disturb the emulsion, so by pushing it a little bit I can give you a bigger nose than you have, by compressing it I can make your face skinnier and so on. Essentially that's what it is. It's a stupid thing. But you have to do it with some finesse. If you press too hard you get to the bottom, which is the black, so you get a kind of muddy situation. You have to have a very light touch, you have to be intelligent enough to set up the right situation so that with a little touching it will come out all right, and the other thing is that you have to use bright colors when you are photographing. You have to use reds and greens and so on, so that when I start pushing the Polaroid around, some color is lost but still you have a great deal of intensity. If you took a Polaroid now it would be kind of bland, whitish. Sometimes I like that, but most of the time I use lots of light, colored light.

BLDD: Your apartment is your own private, and in some ways, secret domain. It's where you eat, where you sleep and where you think. Someone described a very tiny area of your apartment—your kitchen, where you work a great deal—as an Aladdin's cave. How would you refer to this environment where you spend so much of your time? You obviously enjoy your solitude.

LS: I think it started because I come from a poor background—let's say middle lower—so for many years I had to work in my bedroom. We had a small apartment. My sister slept in the living room, my parents had their own room, and I had a smaller room. For many years I made art in that little bedroom, so it was stocked full of works.

BLDD: What were you making then?

LS: Until around 1964, paintings and feathers, plaster, pastels, whatever, lots of different kinds of things. That was in West New York, New Jersey.

When I moved to New York after college, I lived in a dumpy little place on East 77th Street. Again it didn't matter what it looked like, it was compact, it was mine, and the first day I remember going there and hoping that this apartment would be lucky for me, so I sat down and drew some nice things that later turned into an art work.

The same thing happened when I moved across the Park to the West Side. Again I didn't care what it was—I just wanted it to be lucky for me, I wanted it to be magical, the space where I would do something that would be good.

BLDD: Do you believe in these mysterious arcana?

LS: How can you not? I come from a lot of disasters and I am still here, so you have to believe in them.

I have a small, tiny little kitchen, but it's compact, and when the time came to photograph myself with the Polaroid, that was ideal, because it contained the stove, the table, the refrigerator and so on—the basic ingredients.

BLDD: You've created a universe right on that small table.

LS: Yes. I know some people, they have a studio and they have to take a car to go to it. But I sit down and I can work on my table and I can have a cup of whatever—everything is within reach. It's almost like in a spaceship or a submarine. And I liked that. I wanted to have that as a subject matter for the photography—part of the subject matter. This creature inside this space—me.

BLDD: Many people who are aware of your generosity and your warmth are continually surprised by your earlier works, art that so often dealt in danger—lethal knives, bent forks, razor blades, pins, all sorts of menacing devices. Why did the art you produced look like that then? Is that a theme that still absorbs you?

LS: I had a dream about a week ago. A relative of mine, she faced sort of in front of me, and I had a knife, and I was cutting off certain parts because they were too loose. I was cutting off a little chin and the blood wasn't coming out, and it was all right, she didn't seem pained or anything, and when I finished this chiseling she went and took a shower. Then I woke up and I said, wow, that was a fantastic dream. God! I hadn't done this before in my dreams.

BLDD: You seem to have done it in your art. Even the title of one of your shows was Reconstructions.

LS: I must have gotten up in the middle of the night, or maybe the

next morning, and I sat down and said, okay now, what do I do? Maybe I'll start writing about it. I did put down a thing or two in a little note-book, and then the question is, let me analyze it—what the hell does it mean?

And I remembered that I had two victims—I mean two models—the night before, and I was telling them, lift up your chest a little bit, because I didn't want the folds. So I was in a sense restructuring them without doing anything. And it worked very well. But then I decided I didn't want to analyze it. I mean I liked the idea that I had this dream, and I remember the image, let's leave it at that.

Getting back to your question concerning sharp things, knives and so on, I remember a dumb little safety pin.

BLDD: You transformed it?

LS: No, not quite. I just unbent it, that's all. I did touch it. I barely touched it. I didn't transform it but I touched it.

I may give you some answers about sharp things, but essentially I don't know very much about it. Don't you think people have to attack other people one way or another with words or actual physical attack or power or something? Don't you think there is a biological need for you to attack either me or somebody else? Don't you go around and say how

dare you, or whatever? Okay, with me, I want to attack. But I don't want to physically attack people. I can attack a chair or a cup or something, and then I get pleasure out of doing it, but at the same time I can create something new, and then I let it go, I let other people see it. But I have this need to confront objects or people or desires.

BLDD: Early on you studied with Stella Adler. Your theatrical training obviously has influenced your artistic fancies. I wonder if you would tell us how?

LS: Again it has to do with being aware of what you are doing. What was interesting about Stella Adler was that there you learned to be a star, to be special, everything you do is affected in some way. Well, I didn't have to do too much, because I was already affected, already a foreigner. I didn't want to be like everybody else, I didn't want to be like the average Joe, the "Hey, how are you, how is the wife," kind of person.

BLDD: You started out as an art historian, you studied with Meyer Schapiro after Rutgers. Why did you decide to be an artist instead?

LS: Because I was not very good, and because I think it's important to not do things that you are not very good at. Life is not long and you have to do what you can do very well. If you can't do something, let somebody else do it. You know, women sometimes have the problem of wanting to do too many things. They shouldn't—they should do one thing and do it fantastically, better than anybody else.

BLDD: Do men ever have that problem?

LS: Usually they don't—usually.

BLDD: I made reference before to an earlier show of yours called Reconstructions. In the catalogue of that exhibition there was a question, "What do you value in art?"

LS: Strangely, I value a lot of things. I value even things that are not art. I value folk singing. I can go down the street and see just images or whatever, and it could be junk. Some fancy places I don't seem to get much out of. But extreme situations I get things out of.

What do I value in art? I think I like to know that the person who did it was kind in the process of making it. I don't care if he was evil in other ways, but that making art for him or for her was a kind gesture.

BLDD: I might remind you of your answer then to that question: "Unpredictability." Do you still hold to that stance?

LS: Yes.

BLDD: You said earlier that some people, some women, do too many things, and that they should do one thing and do it well. One of the things for which you are celebrated is the diversity of your work, the fact that you work in so many different styles.

LS: Well, that's different.

BLDD: Why is that different?

LS: Why is it different? It has to do with doing them well. Now if a woman happens to do a lot of things well, fine, terrific, do it.

BLDD: Almost everything that you have done in some way is a transformation or a reconstruction. Last year you discovered a new material. That was literally, material, fabric—massive eight-foot and nine-foot canvases that have stitched fabric on them. How did you come to use that kind of material?

LS: When I was becoming an artist in college, I saw certain areas to go into. One had to do with the figure, finding some way of making art that would involve figures, people, not dogs, although I did paint a dog once, doing something nasty to a woman. All right, that's one thing.

Another thing was what to do with color, what to do with lines or dots, what to do with what Mondrian did, what Kasimir Malevich did, what Picasso did. I did do a Matisse, I did a Van Gogh, I did a Mondrian and so on. But while you are doing it you know that you can't get away with it. Your job is not to do "in the style of." Your job is to find out what you are involved with and then see if you can use that information, draw some information from yourself, and then invent something.

Okay, so this work called *Reconstructions*—the big constructions on fabric—I did a lot of my groundwork with works that I had done with pastels; in the previous decade I had done pastels, wall pieces and so on that had to do with the kind of structuring that was other than having a figure. That's one part.

The other part was something personal. Now I happen to make a lot of work out of things that are in the house or in the apartment. If I see a chair, that becomes a subject, and then I say, let me think what I can do about it. If I see a carpet, then I say, what can I do with the carpet? Because the carpet exists. I've seen magnificent carpets. And what am I going to do? They are bedsheets or bedspreads.

I had bought materials because I was photographing myself against these materials, and naturally I like to find many different uses for things, or for people even. I was talking to somebody who came to visit me yesterday from Polaroid, and I said, "You know, you are sitting there and I am here talking to you, but I am thinking how I can use you." Because he is from Polaroid, and I want him to give me film—because large film from Polaroid is very expensive—and I also want to photograph him, and also if possible I want to see what he is thinking, what kind of mind he has—maybe he can give me some ideas. I want to use people, you know, and then they can use me. I don't want them to just be dead. It's got to be active. Well, the same thing with these substances around me in the house.

So I wanted to do something with the fabric, because I had already used it and I wanted to use it again, and I made something that is still on the floor—monograms of my family, of members of my family, four people, my sister, myself, my mother and my father, just the initials. It was interesting. It had occurred a year after my mother died.

So when I was making fabrics, when I was making these initials, I realized that it was a little bit too simple, so I had to create other constructions that eliminated the initials, but the initials were there in my mind; I was chopping them up, I was making this goulash. But also I was making what seemed to me like a shroud, and saying, gee, I didn't see my mother, she was dead, I could wrap her in one of these, and it would be a nice gesture that the son makes to the mother, you know what I mean? So that gave me a humane, familial instinct to continue, to pursue this.

Then it was a question of clicking your mind and saying, okay, now, you'd better come up with something good, because you are going to wrap your mother with it. You know what I mean? It's a serious event.

BLDD: Why do you work in so many styles? And where do your ideas come from, Lucas?

LS: I work in many styles because I am greedy. After I do something nice with some one thing, then I want to stop it, and I want to do something else. It's not even a question of wanting to stop it—I can't do any more, I am bored, I am repulsed, I feel like I am making money then when I do more. You know what I mean by making money? Okay. I don't want to make money. I want to make glory.

BLDD: Do critics affect what you do?

LS: Yes, it means there's another person out there talking to you about your work, and about the idea of art.

BLDD: But you do not always, or often, accept those judgments?

LS: No. But it's very good. It's a dialogue. There's a human being talking to you about this abstraction, this wonderful thing that we are devoting our lives to.

BLDD: You started with happenings, and then you worked in boxes. Soon after the time of your mother's death you created some special sort of sugar-spun-looking objects that I assume had their roots in your own ancestry. The word seems very important to your work. Do you write a great deal? *Is* the word important to you?

LS: Yes. I write stories and so on. Sometimes I write on my work. In the early sixties it was nice to find the words love, or I am. But now it's kind of boring. Everybody can say love or art. It was nice at the time, but now what can you do? How can you find some meaningful words or sentences? It's very hard.

BLDD: It's been said that you've always made a shrewd use of clinical psychology in your own work. Would you agree that you have, both as an artist and as a writer?

LS: I wouldn't think of myself as a psychologist, but I was interested in psychology, in some of the concepts involved. You see, I am not an academic, I don't remember things. I read, it goes into my head, and then eventually it comes out one way or another. I can't tell you specifics. I just know that I am affected by it. The same thing with art works.

You asked before how does my work evolve. I don't know, it just happens. I do a lot of pushing, I get up a lot of times, I spend weeks or months, sometimes I don't know what to do, I pace my floor, I have arguments with people because things are not happening, but eventually something happens, and I go with it. In the beginning it's crude, then gets a little better, I have a flowering of this event. Then it seems like I've done just the right amount, and I go on to something else.

BLDD: How do you know when a work is completed?

LS: Well, you invite your friends, and they make a comment or two. They come, they go, you remember what they've said, you gauge. Now let me see—is that true? Maybe it's not. You invite another friend, another point of view.

BLDD: Until you find one who agrees with you?

LS: Yes, but then if they agree too quickly you don't like that either. It's tough. They have to be very careful.

As you are developing into an artist you also have to develop as a critic. You can't depend on somebody else criticizing you—you have to do it. So criticism is important, very important.

BLDD: To the works of what other artists do you most respond?

LS: At the moment it's kind of dead, so there's nothing much to respond to. Usually I respond out of jealousy—if I think somebody else is doing something better than I am.

BLDD: You say that nothing is happening. How *would* you evaluate the current art scene?

LS: I am hoping that it's very good. I am hoping that it's like the late fifties when nothing was happening, a lot of imitations, a lot of garbage, but it was the time when this new movement began. So I am hoping that in the eighties—1980 or 1981—something will happen.

BLDD: And what do you expect that will be?

LS: Oh, I wouldn't dare! It's none of my business. It's none of anybody's business. Let it happen, don't push. It has to come by itself.

BLDD: If you could choose any object, regardless of price or availability, what would it be?

LS: I buy things, but in order to use them, to photograph them or

something. I really don't want to have anything for itself. I don't want the responsibility of preserving it and all that. I doubt that I would get anything.

BLDD: Do you see the role of museums as changing considerably? Do you see them as educational institutions? Do you see them as so beleaguered by financial crises that their focus and direction will change? Is the museum still so important?

LS: Well, the older I get the more unaesthetic museums become, the more banal. When I was younger they seem to me more magical. But maybe it was youth. Now they are kind of seedy, and they don't seem to be grand.

From audience: How does one become a professional artist, making a living from his work?

LS: It seems strange to be an artist or a professional artist. In my experience I've come across a lot of people who are artists but who don't show their work—maybe one or two people see it—and who do not make a living out of their work. They have a wife or a husband to support them, or they do something else. A professional artist is an artist who sells his or her work—not a big thing. I started selling my work in college. I sold one painting for $25, as I remember. Then I don't think I sold anything for a long time. I was fortunate to have an exhibition right after graduation, and I must have sold something, I don't remember what, but I was living with my parents, that's how I took care of the problem. By the time I left home I was able to make $1,000 or $2,000 a year, and that was enough.

How do you do it? Somehow I went into it automatically. I had shows once a year or once every two years, and automatically I sold one or two or three pieces.

BLDD: What about dealers: Some of them—at least the ones I've met—have a genuine passion for art. When they deal with a piece of art it's more than just commerce, more than just making money. They love it—the work, the involvement, the knowledge, the beauty. Is that your experience with dealers?

LS: I happen to have picked good ones. I don't know what a bad dealer is. My first dealer, Anita Reuben, had a fantastic gallery. My next dealer, Dick Bellamy, was terrific. My present one, Arnold Glimcher—the best.

A lot of people hate galleries. I don't object to them. Well, what is wrong with them? If they like your work they'll sell it. Now the selling part I detest. The work doesn't sell itself, it never sells itself. You need a salesman. You have to have somebody to tell lies about your work in order to sell it. You have to compromise in a way. Well, you hate it, you

hate all that stuff, but there is no other way. The only other way is to be a rich prince, and then you don't have to worry about selling your work to make a living. But I am an artist, not a prince. I think so far it's very good, because it's clean. I think it's relatively clean, I don't feel dirty, I haven't done things that a prince would have to do. So I feel okay and that's good.

George Segal

(Sculptor. Born New York, New York, 1924)

BLDD: George Segal rose to international prominence with his elaborate tableaux. He is best known for life-casting contemporary figures in everyday settings. Can you tell us how a painter's concerns are successfully pursued in sculpture? Why did you abandon painting for sculpture?

GS: Well! You don't believe in asking simple questions, do you? I seriously studied painting in New York, at NYU. My art teachers were William Baziotes and Tony Smith. Baziotes used to get after me and say, "Jump on the bandwagon of the history of art with us, throw those tiny paint brushes away, buy five-inch housepainter's brushes, stretch a couple of big canvases and paint these big abstract paintings." And I didn't know how.

BLDD: What did your work look like then?

GS: Apples and bananas. My earliest paintings looked like very stiff derivative Cézannes. I started out loving Cézanne, Matisse, and ended up worshiping de Kooning. I thought abstract painting was magnificent. I was in my early twenties, couldn't understand how honestly paint to that way, and it's peculiar because I think I was shaped by the painters of that generation, admired them enormously. I found them philosophers, passionate, intense, intelligent, couldn't understand a stroke on the canvas, couldn't understand what the abstraction was about, but I loved their studios, I loved their throwing away materialism, and I loved their enormous ambition to make great art. You know, they really wanted to challenge and surpass the School of Paris, which I willed also.

They shut too many doors for me. I didn't even know my own nature. I am tactile. I love to see things, I love to touch things, I love to grasp them and possess them, I am sensual, I do believe in the world immediately outside my skin, I am knocked out by the look of things. I am still in love with the look of New York. And I got it into my head that their

paintings were about what was inside your skin. They were trying to make concrete or tangible or visible what was inside their heads.

I struggled, floundered—you know, this acceptance/rejection of these men, and I love them, I love their work, I love them all.

BLDD: You spent a lot of time with them at their club?

GS: Yes, and I think if I am going to be honest we'll get down to the bottom line: I felt pushed to invent my own way of working that satisfied my own demands. I wanted to be as much involved with what was outside my skin as with what was going on inside my body.

BLDD: For more than thirty-five years you've lived in rural New Jersey, very close to Rutgers University and very close to a man who is a long-term friend of yours, and I assume an influence as well. I am referring to Allan Kaprow.

GS: Kaprow was and still is a close friend. Kaprow was a young painter in those years and a young art historian who had just gotten a job teaching history of art at Rutgers, fresh from Meyer Schapiro and Hans Hofmann. We were introduced to each other and he discovered that I had gone to NYU, that we knew about a dozen artists our own age in common and that we had never met at the time when both of us were

studying in New York. So we had this great common ground and he also accidentally moved in a mile away from me. I was a chicken farmer at the time. That's how I was making my living. I was painting. Kaprow was painting, and we knew the same people, liked the same kind of art— so we got together.

Kaprow would call me up at something like one o'clock in the morning: "I've just finished a new painting, come on over and look at it." And I'd get there ten minutes later, and we'd be talking till four in the morning. It was that kind of friendship and dependence on each other. When you are that young, that unsure, and your parents, everybody sane and rational, think you are crazy,you are forced into the company of other idiots, so we were that kind of friends, and we needed each other pretty badly.

We had the same reservations about abstract art, and we were both determined to forge an art theory and a way of working that would challenge and surpass abstract expressionism. Good heavens. And we self-mockingly called ourselves the New Brunswick School of Painting.

BLDD: For a long time people referred to you as a pop artist, and your earlier work I guess was described as frozen happenings. Was that ever an accurate description? How did you react to that?

GS: Kaprow did invent happenings, you know, the whole idea of painter's theater, which was live people performing a series of movements or actions in real space with real objects, except that there was no narrative, there was no word logic, and it was about aesthetic imagery, had a lot of rhythm, and was based on a set of ground rules—well, you have to go to Marcel Duchamp, you have to go to surrealist theory, you have to go to some of André Breton's ideas, you have to go to Italian futurism, you have to go to Marinetti. There is a long history, a long line of things that have been done in Europe, rather obscurely, with different intentions, by some marvelous European artists that were at the root of a lot of American art, if you are going to be straight and honest about it.

I quarreled with Kaprow about the ground rules of happenings. I didn't want to do it that way. I hated the idea of stopping to work with my hands. You know, my whole objection to abstract act was that I had no room for my own tactility. I wanted to keep working with my hands. I didn't like the idea of becoming a movie director or a play director, I didn't like depending on so many other people outside of myself to do a brief performance. I wanted to make work that I could come back to later and enter, walk around, contemplate. So in that sense everything was arbitrary in those years. We were all of us floundering and struggling to set up a new set of ground rules to make work that would fulfill our own natures.

BLDD: So that casting became for you a device for self-discovery.

GS: It started out as a self-correcting device. I really wanted to get rid of my own ego. Logically I was backed into a corner. I stopped painting, because I felt the injunctions of repressing figuration and keeping the canvas flat were absolutely arbitrary limitations. Who said so? Who was the authority? Why was that so critically necessary to twentieth-century avant-garde art? What did that have to do with the way I was feeling inside? And I was angry—I was angry at what I thought was an arbitrary restriction. If I had gone into the canvas there would have been an illusion and Renaissance space, the Renaissance window on the world. If I'd stayed flat and had no room to deal with all my sensations and responses, the only place I could go was forward, and I decided, again arbitrarily, to go into my own space. This was space I could step into.

BLDD: One of the things you did in the interim, when you decided to stop painting, was literally to go into your own space. What was a nice Jewish boy like you doing being a chicken farmer?

GS: Ha! Trying to survive! It was pretty simple and natural, if you look at the history. My father was a butcher in the Bronx, and you know, like a lot of immigrants of his age, he was overeducated for his work; he was a Zionist, he was a socialist. One of the great dreams of his life was to buy his own land and farm his own place. When I was about fourteen, he sold his butcher shop in the Bronx and bought this little swampy piece of ground that no self-respecting farmer would farm and he built buildings for chickens. I moved out with him and by the time I finished all my schooling, my parents were dead set against my being an artist—and from a financial point of view they were absolutely right.

BLDD: But not for long.

GS: Oh, for a long time. A long time. There was no history at that time that American artists—fine artists—could make a living selling their work. If you were foolish enough to decide you wanted to do that, you knew that you had to figure out some other way to support yourself. So I lied and cheated my way through art school. First I told my parents I'd signed up for commercial art and I didn't. Then, finally, when I got bounced around to different schools, I went to NYU because the abstract expressionists were teaching there, and I took art education courses.

BLDD: So that you could always teach?

GS: Teach, yes, and it was terrific, it was just like today. By the time I graduated there were no teaching jobs. I was married, my wife was pregnant, and about the quickest thing I could do was to build my own farm, so I did that. I was living in a house across the street from my father's, and I had three acres. I knew how to do all that stuff, so I built my own farm buildings, raised chickens, sold eggs, and painted in my attic.

BLDD: And you used some of the chicken wire for casting the original forms?

GS: Yes, literally so. I think a lot of my education came from building the farm buildings. I became a halfway decent carpenter, and I knew how to use all kinds of tools. I built buildings, literally, so by the time I decided not to paint and go into sculpture—I'd never taken a sculpture course in art school, everything was painting—I said the heck with it, I don't have to study sculpture technique.

BLDD: How did the work evolve to its present form? How did you arrive at plaster as a material?

GS: I was flat broke. Where was I going to find marble? Who could afford bronze? Plaster was then about eight cents a pound. My happening friends were con artists. They were always looking for someone with eight hundred bucks or one thousand bucks to finance a happening. I felt it was demeaning to go around begging that kind of money for a one-time shot, and I'd go to a junkyard and buy old furniture or beatup stuff—part of a bus, a piece of a diner, a restaurant booth. I'd buy a whole booth for eight bucks.

BLDD: There is a story about a former student of yours who introduced you to plaster-impregnated bandages. How did that occur?

GS: It's reasonably accurate. I'd made about eleven sculptures by hand. You know I slammed armatures together out of two-by-fours, bent chicken wire around and dipped burlap strips into plaster and wrapped it around. A very fast, good method of building up a form. Oh, they were very expressionist-looking figures, looked like Germaine Richier or something like the de Kooning figures, and I was disgusted with expressionism. I was hungry for clarity, a hard edge, I had made thousands of drawings and lots of paintings, and every time I made a drawing I would make a self-portrait. The drawing, this nude, would come out with a thick neck, stocky, overweight—looked exactly like me. And I said, it's ridiculous. You know there is so much talk in art about expressing yourself, but if I was going to look outside my skin I wanted to see what was there. So I started using real chairs, real furniture, because I liked the hardness of it. And then I was looking at the furniture as a pure form— what's the space like between the legs, for instance. When the plaster bandage thing came up I grabbed it.

BLDD: How did it come up?

GS: I was teaching a painting class in a local community center. One of the women in the class had a husband who was a research chemist and had just developed this new material at Johnson & Johnson, which was located in New Brunswick, and they offered me fifty dollars to play with it. I never took the fifty dollars, I took the free plaster-impregnated bandage, and took it home and instantly had my wife cover me head to feet with the stuff.

BLDD: Those bandages were the first instance of life casting?

GS: Yes, because I had made about eleven hand-built figures and I was too impatient, I had too many ideas to spend the two or three months to finish them meticulously. I was interested in realistic proportions, but for another purpose—not for a Renaissance purpose, but to punctuate my own real space. So I had a lot of ideas, and I didn't want to spend a lot of time on meticulous technique because I came from art school—you don't have to spend all that energy proving that you can draw. I twisted the abstract expressionist injunction. I can model, I can draw, I've had all that art training, but I felt and I feel that it's very often beside the point. It's not the critical quality necessary to make good work.

BLDD: What *is?*

GS: What is? I think anything that you see that's made by an artist that's a convincing vision of the way that person sees the world.

BLDD: How important is the décor that your figures are situated in?

GS: What you call the décor is critical to the work. The figure is a single element in the entire space; the figure is only one of the things that punctuates the space. I work for a long time and eventually there is nothing I can subtract; whatever is left there has to be there.

BLDD: Are the figures a metaphor? What is the comment that you are making?

GS: Yes, they are a metaphor, and no, I won't tell you.

BLDD: One critic who has written at great length about Rodin says that you are obviously concerned with the same subdivisions of the body.

GS: You can keep going. Another wrote extensively about the connection between me and Degas. And another wrote extensively about my connection with Hopper.

BLDD: That's right. Interestingly enough, your work has not only been compared to sculptors but to painters as well. Was Hopper one of the traditions that you were influenced by?

GS: Yes. To be honest, my answer would have to be yes to everything. You see, ancient Egypt is pretty important to the way I resolve or try to resolve things. A lot of Greek ideas are very interesting, as are Michelangelo and even Rodin, *et al.* I find myself bumping into the history of art that I love when I work.

BLDD: Are the figures Everyman?

GS: Everyman? Yes, they are, but I am very perverse and contradictory, because I want the figures to be quite specific to the person who poses. If you say everyman, that implies a generalization. Sure, I am interested in generalization, but the specific truth about a particular individual is also incredibly important. I don't think it's an either/or choice.

BLDD: Was your original impulse to make a total environment?

GS: Yes. I remember it was somewhere early on. Kaprow and I had done a lot of talking about Jackson Pollock's paintings looking like limitless or infinite universes. We were talking about space, enveloping space. I saw a Rothko retrospective at the Museum of Modern Art that absolutely floored me in its beauty. Rothko had divided the space for his show into a succession of very small rooms, and he hung his paintings very close together, and it looked like luminous bands of light shining from the wall, and people never looked more beautiful to me than they did in those rooms. That had a big effect.

If you are going to change the ground rules arbitrarily, you make them up and step forward from the canvas, so here is yourself and here is the canvas on the wall, it's really dealing with the space between you and the wall, and it's inside a room. It doesn't have to be a room, it can be anywhere. Where is the limit, where is the boundary? I don't know. But you make a move or a couple of moves in the space to intensify it, and you are free to walk around and bump into all those interruptions from different points of view. It's like being very literal about cubism, being very literal about a lot of ideas in modern art.

So yes, I am interested in total environment. I've had a private scheme, you know. I make individual sculptures and my greatest private delight is setting up whole shows.

BLDD: Do you do them in your studio as well?

GS: Yes. I look at my finger or a hand and see how incredibly complete any part of the human body is. So if you are making an art work that has a lot of parts and pieces, you say, this is a finished work; why can't I put three, four, five sculptures together privately in my head? That's another finished work.

BLDD: After the initial experience with your wife wrapping you in bandages, was it then that you decided to use your body and those of your friends to cast with?

GS: Yes. I thought that plaster casting would be a shortcut, you know, a speed-up of technique.

BLDD: How does it work?

GS: Helen covers me from head to foot with the plaster bandage stuff. I knew nothing about the fact that plaster sticks to hair, and I am hairy from head to foot, so it's like pulling off a giant bandaid. But after I put the thing together I made a strange discovery–that certain details came out exquisitely well. I'd been taught or it's been part of the literature for years that plaster casting is cheating, that you have to draw from nature. If you are a Renaissance artist your success is measured by how closely you resemble the object that you are copying. But don't use any photographic techniques.

Then I discovered Vermeer used photography, Degas used photography, there was this camera obscura. Cellini had recipes for life-casting. I went to the Met and I saw casts of toes and fingers, then I went to take a second look at a black basalt Egyptian carving, and here was the outside form that looked like a perfect Henry Moore, and the ear and the nose absolutely looked like they had been taken from the plaster cast of a specific person. So all the way through the history of art I saw all this evidence.

BLDD: Do you ever use photographs as a preliminary to your work?

GS: No, I just get real things. I just work directly on the body. Then I began to discover something else. The real thing has a size and a presence that I need. I've got to work full scale, full size. I don't have to draw. I just have to go at it.

BLDD: Your talk about working full scale reminds me of your recent first public commission, a frieze of figures, that is now in Buffalo, New York. It is a long way from plaster casting to a bronze frieze in Buffalo.

GS: Last year was the first year I ever did bronze. For years I'd been

working in plaster. Plaster traditionally is a step on the way to bronze.

BLDD: Now you use something called hydrostone. What is that?

GS: It's simply a harder plaster. It's used industrially. Dentists use it. It's very hard; it won't last outdoors, but indoors it will last indefinitely.

BLDD: You said you must work in human scale but obviously on a very grand scale, too, as in much public art.

GS: Last year the State Department sent me over to Russia to meet my counterpart. The Russians are so literal, they are more literal than I am. They introduced me to the few sculptors who do the outdoor monuments. These fellows, they all looked like young Khruschchevs, very broad, stocky, powerful guys; they slap their knees and drink a lot of vodka, and they are all making forty-foot Lenins, either Lenin tipping his hat or waving his hand or striding, and it's alway on this King Ludwig-type pedestal.

Okay, so what's the public art? In Russia the public art is this strengthening, reinforcing of the government system. In the United States, in this time, what kind of public art do we want? I think it would be appalling to lose our sense of privacy. If we feel that the art in the museums is valid–the School of Paris, abstract expressionism, whatever has happened in American art since then, which is based on valuing individuals, individuals artists and their own peculiar, quirky personal responses in their studios–if there is a validity in that I think it should influence our ideas about public art.

BLDD: How do you feel about the government, particularly the General Services Administration, the country's largest landlord and commissioner of works of art, becoming the benefactor of artists? The GSA is now permitted to spend one-half of one percent of the cost of the construction of federal buildings for art. Do you have any anxiety about that, particularly if the nature of art to begin with is private and idiosyncratic? Also, how do you react in terms of your early socialist background?

GS: I think our entire generation of artists or intellectuals–you can include half of Europe–were all schizophrenic in that sense. All the people who talk about private, personal, idiosyncratic visions, no one is willing to give up social security, everyone wants to extend Medicare, everyone wants job security, nobody wants to worry about rent, everybody wants their art to be seen. We all want everything, so there is a streak of all of that in all of us.

BLDD: Did you meet with any obstruction from the GSA?

GS: The GSA was marvelous. I am hoping that it doesn't turn out to be a brief flash of the Golden Age. GSA tackled about fifty commissions,

told each artist, you've got this commission, do what you want, show us what you are going to do, and we'll only check it in terms of permanence and safety, but aesthetically you call the shots.

And I thought that was incredibly enlightened and I had no trouble at all.

BLDD: Astonishingly enough it's the experience of every artist I know who's had a major commission for a GSA building.

GS: And the only problem was in Baltimore. Objections came from the judges who occupied the building who took a dislike to abstraction and thought it was going to be a haven for assassins to hide in to murder them.

BLDD: Resistance has occurred with municipal sculpture throughout the country, from Chicago to Dallas. But within a very short period of time the logo of the city has frequently become the monumental work of art, and often with widespread enthusiasm.

GS: That's right, and it doesn't frighten me. I'd like to see it happen. If you go to Europe and you walk in any Italian town, any small Italian town, you stumble over art works, and if you can't find enough you'll find them in the restaurants, and certainly in the churches, and walking the streets of Rome is incredible. You have to travel vast distances in the United States before you stumble over an art work outside. We are incredibly empty as far as that goes.

BLDD: The Buffalo sculpture was the first work that you ever did in bronze. Are you contemplating any other?

GS: Yes. All that is in the talking stage. It may be a year away, but I am part of a large group of people working on plans for a memorial to FDR in Washington.

BLDD: That has been a long time coming. How many sculptors are involved in that project?

GS: Four. The plans have jumped the major preliminary hurdles, the FDR Commission, which has been rejecting designs for twenty years. The FDR Commission has approved and the Fine Arts Commission has approved. Now it has to be presented to Congress for approval and budgeting. That's the famous bottom line.

BLDD: Do you think of yourself as an abstract as well as a representational artist?

GS: Yes, very much so. I think it's necessary to deal in abstraction. I have been questioning, most of my life, how people arrive at abstractions.

BLDD: Until now your figures have been of almost dead white plaster. Of late you have begun to use intense colors that at least for me are

reminiscent of some of your early paintings. How did that come about?

GS: How did you manage to see my early paintings? Only about twelve people in the world know those early paintings.

BLDD: How do you use the color on plaster? Is it a stain transfer technique? Can you tell us about that?

GS: Oh, that's a great idea–stain transfer technique. I am going to try that one, too!

BLDD: Your imagery is still very heavily influenced by New York. Why do you choose to live in New Jersey?

GS: Because if you want to visit me and interrupt me in my studio you have to make a big effort.

BLDD: Do you think New York and its environment is still the place for artists to be?

GS: Absolutely yes, yes. I've been working one hour outside of New York for years. Most of my friends start out living in the city and at some point they get disgusted with the whole thing, they run four or five hours out of New York, and then they come back.

BLDD: You have the best of both worlds?

GS: Yes. I need the privacy and I need the city, and I can't predict the rhythm of it.

BLDD: How significant are words in your sculpture?

GS: I have an enormous respect for words. I do love poetry, I do love good literature. When I started working realistically, the furious objections that the abstract expressionist painters made were an indication that if I was going to reintroduce subject matter, I wanted that subject matter to be on the highest level of the literature I admired most. So I do like words and I think that they are valid, they can be used beautifully, poetically.

BLDD: To the work of what other painters or sculptors do you most respond?

GS: I have great friendship with the artists of my generation, even the pop artists. Oldenburg, Dine, Lichtenstein, Johns, Rauschenberg–we know each other, I respect their work enormously. I think that critical definitions of pop art were too limited. They were never quite broad enough to handle the range of what all these artists were interested in.

BLDD: Do you have more regard for pop art now than in the period when you lived through it?

GS: My regard for my artist friends never flagged. My regard for the partying, fashion types, the socialite types, the hysteria of art critics who were supposed to make profound or long-lasting judgments and deluded themselves, was never great. I wasn't interested in the parties, I wasn't interested in the hysteria, the discothèques. The rock music was terrific at

a certain point, and then it degenerated very badly, but at a certain point it was of incredibly high quality. There was nothing wrong with the art that was produced. I think that the problem was with the audience.

BLDD: How do you feel about the audience now?

GS: Quite relieved. I am relieved but it's painful that it took three assassinations, almost the beginning of a civil war, a generation fight. And now there's the threat of economic disaster–it's very hard to get a job for young kids–and the grimness. So yes, there is a different aura now, people are much more for real.

BLDD: For several years now we hear that the vanguard is over, that the field has been mined. Where do we go from here?

GS: There are a lot of places for young artists to go. The urge and the urgency are as great as they always were for the young artist.

I cut my teeth in relation to the generation that preceded me, the abstract expressionists. I quarreled with them, I argued with them, but I still have enormous respect for their dreams and their ambitions. I've been to Europe I don't know how many times. Without a doubt the best art in the world is even yet being done in the United States. This is not a chauvinist statement. I would be the first to admit if I saw work that I respected in some other country.

A young painter who had a trucking business brought one of my works back from a show, and I said, "What kind of painting do you do?" And he answered–this was years ago–"I work in the gap between Stella and Judd." I was devastated, and I felt a lot of compassion for the guy because he'd been trapped by the art magazines. If there could be some restoration of the original huge goals that one individual, one artist can carve a way of looking at the world as a lot of pieces that can take every facet of his or her personality into account, take their specific nature into account, and it is done by the vision of one person, then that's okay. The art historian and the art critic have to deal with the nature of abstraction. They have to see 200 or 2,000 or 20,000 building blocks and each artist becomes a single building block for their vision of modern society, so that even the art critic or the art historian is involved in this vast conceit, the same conceit that an artist wants to be involved with. And everybody is in competition, everybody is babbling, and everybody is getting measured or tested–how persuasive, how convincing is your way of looking at the world? How truthful is it? How relevant to my experience? How long-lasting?

Okay, let it be difficult. But the ambition to make art must be restored.

BLDD: Since the end of World War II, the definition of sculpture has changed considerably to encompass not only painting but the involvement of all the senses. How would you define sculpture?

GS: I won't, I can't. I'll hide behind a generic. If definitions of art change it's only for the convenience of people driven to make their own statements of their own experience.

BLDD: Did you ever think of casting the ideal man or the ideal woman?

GS: The ancient Greeks had the idea of the perfect leaf—or Plato did. When you see the torso of a Greek boy there are the pectorals and all the musical relationships of all the muscles, there is no fat, there is no age, it's a perfect boy, it's the mathematics and the musculature, they reflect a Greek idea of perfection. We still believe in it because in every generation Hollywood is looking for the most handsome movie star and starlet, looking for the handsomest people in the country. Democracy was an idea that was introduced into human thinking much later than the Greek ideas (you know, the Greeks had all these great philosopher-geniuses who were 10 percent of the population, and the other 90 percent were slaves), and democracy involves the value of individual human beings.

I started casting because I'd gotten a display mannequin and I started to try to work with it. I said, this looks disgusting. I couldn't get any life sense, I couldn't get any rhythm into it. Then I asked around and I discovered they had taken someone's perfect knee, someone's perfect face, someone's perfect breasts, and someone's perfect thighs, put them together and made an abomination. Without the Greek glue. Because the mathematics was missing.

And then, when I started casting people, I discovered that ordinary human beings with no great pretensions of being handsome were somehow singing and beautiful in their rhythms. The people that I prefer to use again and again as models are friends with a very lively mental life. I've occasionally used young kids who are pretty imaginative, and they come out stiff. Go explain that. It shouldn't be, but it is. I discovered in my experience that it is. I discovered that I had to totally respect the entity of a specific human being, and it's a whole other set of insights, a whole other set of attitudes. It's a different idea of beauty and it has to do with the gift of life, the gift of consciousness, the gift of a mental life. Maybe the Greeks are wrong.

Raphael Soyer

(Painter. Born Borisoglebsk, Russia, 1899. Came to U. S. 1911)

BLDD: Raphael Soyer is one of America's most respected realist painters, whose inspiration for over sixty years has been the streets of New York. Some call him the Isaac Bashevis Singer of the painting world because of his honest vision and ability to capture the beauty of human nature. Did I see a quizzical response to that introduction, Mr. Soyer?

RS: Yes. This is the first time that I was called the Isaac Bashevis Singer of painting, and I really don't think there is any similarity or any relationship at all. I always was a nonparochial painter, and I painted only what I saw in my neighborhood in New York City, which I call my country rather than my city.

BLDD: Actually several critics have referred to you that way.

RS: Did they? Well, I don't think too much of critics. I don't have a great opinion of the critical writing in this country.

BLDD: How important is the work of a critic to an artist?

RS: In my life the critics were not terribly important as far as my work was concerned. I never paid attention to them, and I always worked the way I wanted and the way I chose to, for better or for worse, and if I had had to listen to critics I don't know what would have happened to my work.

BLDD: Why don't we begin at the beginning. Will you tell us of your early life in Russia? A childhood of delight in art and in literature, but fraught with frustrations. At a very early age your family was expelled from Russia, and you emigrated to the United States when you were twelve. What were the circumstances of the departure?

RS: My father was very much involved with the student population of the city we came from, Borisoglebsk, and he somehow was involved with some of the progressive students. In Czarist Russia that was an offense. Also, we were Jewish, and Jewish people didn't have much citizenship at that time in Czarist Russia. So my parents were told to leave the country

There was a very small population of Jewish people there, but they all had to have a document called The Right to Live, and they took this document away from my father. He had to leave Russia, and we came to this country, like many, many people in those days.

BLDD: Was it not rather unusual for you and members of your family to be so involved, even at such an early age, with art?

RS: Yes, but my father was the intellectual of that town, and he was very much interested in literature and in art–in Russian literature, Hebrew literature. He also loved art, and he encouraged us. All people draw when they are children, but he encouraged us to draw and we pursued this; he himself drew a little bit, and that's how we became involved in art at a very early age, the three brothers—I and my two brothers.

BLDD: How did you first become involved with drawing from life?

RS: A neighbor of ours—a young man whose name was Ivan Ivanovich, who also loved to draw in a self-taught way, became acquainted with my father, and one day he came and drew my father. He made a large, large drawing, I still remember it, like a Russian icon, it had the quality of it. To me it was a revelation, because I had never seen anybody draw a living person—children draw from imagination. And this is

how I became very much interested in drawing from life. I was so impressed by the drawing of Ivan Ivanovich that for a while I didn't draw, and then I asked my father to pose for me like he had for this young man, and I made a drawing from life. The drawing was praised, and from that time on I drew from life. I didn't draw like a child any more, from the imagination, which I think is unfortunate, because somehow I did not develop my imagination. Even today, although I know how to draw—I know how to draw a human figure—I still rely a great deal upon life, upon working from the real.

BLDD: When you came to this country your family moved to the Bronx, where you stayed for about five years before you moved to Manhattan. You referred to it not only as your city, but as your country.

RS: Yes, New York City is where I lived from childhood, from the age of twelve on. I went to many other places but I always returned to New York because New York has the quality. I mean New York and I are part of each other.

BLDD: What were the circumstances of your early training?

RS: I went to school for a while. I went to public school and for about a year and a half to high school, but we were a very large family—six children, father and mother, also a grandmother—and sooner or later I had to go to work. I worked during the day and went to art school at Cooper Union, my first art school, at night.

BLDD: What did you do during the day?

RS: I worked at all sorts of jobs. Later on I worked in factories, I worked as a messenger boy, I worked as a newspaper seller—I did all those things, all the jobs that one had before the 1920s, you know, the characteristic jobs of that time that many people of my generation had.

BLDD: You were a teacher for many generations as well.

RS: Yes. When I had my second one-man exhibition, I was invited to teach at the Art Students League and I taught there for several years. In those days they would invite artists to teach at the League. My colleagues were Yasuo Kuniyoshi and Alexander Brook, and shortly before I came there Guy Pène du Bois and Max Weber were there. All the painters who taught there at that time had reputations, and that's why I considered it a great honor to be invited to teach at the Art Students League.

BLDD: What was it like teaching art students then?

RS: In those days, most of the students were very young people. They were the so-called professional art students, and they had hopes of becoming full-fledged artists with reputations, and so forth. Today schools are different. Of course there are some young people there, but also a great number of middle-aged and elderly people who have leisure now and come there just to pass the time, for therapeutic reasons, for enjoy-

ment. I remember when I was a student at the academy there were no older people there at all—everybody was young, kind of neurotic, had great hopes of becoming an artist; they thought in terms of immortality and so on. We would choose our teachers because of their reputations. I liked Guy Pène du Bois and became his student.

BLDD: Art certainly wasn't a usual way to earn a living.

RS: I didn't think in terms of earning a living, but I always thought in terms of becoming an artist. Earning a living never bothered me until much later. It was a very romantic idea to become an artist. Only much later did I begin to think in terms of making a living.

BLDD: Your brothers were all involved in art, and I guess we are most familiar with Moses and Isaac. Was having that kind of family environment a help or a hindrance to you? Did you help each other in your explorations in art? Was that a supportive experience?

RS: No. First of all my brother Moses was my twin brother and we always had a struggle for identity. Each one of us wanted to be himself, and that was a big problem, because we looked alike and there was a family likeness in the work we did, and therefore each of us really had to struggle to become himself, and from very early on Moses and I decided to go to different art schools, not to have a studio together, and I think we succeeded in becoming ourselves. There was this struggle, this sibling rivalry always, from childhood on. Each one wanted to be better than the other one, and that is a feeling that never subsides. But we also profited by showing each other our work and we criticized very severely sometimes, and learned a great deal from each other.

BLDD: Your work is known not only for the quality of the painting but for its psychological acumen.

RS: I attribute this psychological element in my work to the fact that I have three cultures: I have the Russian culture, I have the Jewish culture, and I have the American culture. The Russians especially are great psychologists. If you know their literature and their paintings, they always looked deeply into the so-called soul. From childhood on I read everything that my father had in his library. We studied some Hebrew when we were in Russia, but our mother tongue was Russian, and I read everything—I came here at the age of twelve, and by then I had read everything that my father read: Chekhov, Gorky, Dostoevsky, Gogol, and so on, and I would call them all psychological writers. They delved very deeply into the human psyche, and I think this insight of mine into the human psyche is part of that environment, part of my childhood.

I just want to say something else. Now very often when I think of the American artists, like Edward Hopper, Charles Sheeler, or Georgia

O'Keeffe, I call them the aristocrats of the so-called indigenous American art. When you see an exhibition of these artists, Niles Spencer and others like him, there is a lack of humanism, a prophylactic quality about their work—I mean their houses, their clean streets, their architectural things—and even in a Hopper painting there may be one figure. It's like a desert, there are hardly any people there.

Now I am a different kind of an artist. I think people are the important subject of art.

BLDD: I can recall some of your early work, when you were also that kind of a painter, where many street scenes were painted.

RS: No. I painted streets, but there were always people there. I painted, for instance, some side streets of New York City, where only the bums used to gather, and I painted them lying in the sun or in the shade. But my streets were always inhabited. I never painted just a street like, say, Charles Sheeler would paint. When he paints a factory, for instance, and he did paint factories, there is never a human being in the factory. He paints the outside of it, or the machinery of it, but never a human being. And the same thing with the other artists—and I think they are very great artists. They are always so clean and so meticulous, almost prophylactic. It's unlike the pictures I do. And I think this is how I do add something to American art, in my way. It's my addition.

BLDD: Your palette is very distinctive—those blues, those ever-present blues—a subtle palette that is often subdued, actually chromatically unified, and very carefully controlled.

RS: I have a very simple palette. I have very few colors, and some artists who come to my studio to look at my palette are amazed, there are so few colors. Too many different colors confuse me, and I am satisfied with just a few. I mix them and I do get the results I want. Once in a while I try some different pigment and it confuses me.

BLDD: What are the colors that you use?

RS: The basic colors: yellow ochre, white, black, blue, burnt sienna, green, and that's it. I use practically one yellow—yellow ochre. I don't use the other yellows, which is unusual.

I remember a time when I had to get cerulean blue because I had to paint Isaac Bashevis Singer's eyes, and they are very, very blue. To paint his eyes I actually had to buy a tube of cerulean blue.

BLDD: And he himself did a portrait of you—I assume that it's his only existing art work.

RS: Yes, he did a drawing of me.

BLDD: In the thirties and forties you painted troubled times, the uncertainties of the Depression, and World War II, and in the fifties and

sixties you gave us life in the East Village, the Vietnam protesters and flower children. Now many of the people that you paint are dressed in blue jeans. Is it what they symbolize, or is it the color that lures you?

RS: I always painted what I saw. In the Depression days I saw people sitting, and they were dressed very dingily, the colors were dingy; they were sitting in parks or, in summer, lying down in parks, and I painted them. I always relied upon my eyes. Later on I was on Second Avenue— that was in the sixties, I guess—and that was the East Village at that time. I got to know many young artists there, many young poets and writers, and I painted them. Now I am on Columbus Avenue uptown, and I see all these people dressed in jeans. At the time when they wore miniskirts, I painted them in miniskirts. I paint what I see.

BLDD: How do you select your subjects, and what is the method by which you work?

RS: I like to paint people—again coming back to this element of psychology, looking deeply into the human being. I know many artists, and I paint them because I know them and I love to paint them. And I paint my wife and my daughter and my friends.

When I was young I painted on commission. I did many portraits of men, and women and children especially, for money. In those days, if I got twenty-five dollars or fifty dollars or one hundred dollars, I'd paint these people for money, but I never enjoyed it, I never loved to do that, because it always inhibited my style, it always curtailed me, I wasn't as free as I am when I paint people I know and they are not commissions. I paint to please myself. When I did those commissions, I had to please the mother of the child, or the husband of the wife and so on.

BLDD: Are the subjects often pleased, no matter who paints them?

RS: No, no. Just today I was reading about Oscar Kokoschka—he painted a wonderful portrait of an old scientist, a man with a beard and those wonderful hands; neither he nor the family liked the portrait, yet it's one of the masterpieces of modern European art. No, commissions are not always accepted by those who commission portraits.

BLDD: Have you ever had the experience of a commission rejected?

RS: No, but I can tell some very funny stories about some of those commissions. For instance, I painted a woman once, and she had a long-ish nose. Then she changed her nose, and she wanted me to repaint the portrait.

BLDD: Did you?

RS: No. I am not a plastic surgeon. Then it happened that I painted a middle-aged man, and when I painted him he looked very haggard and very unhappy; he didn't feel well when I painted him, but it was accepted. Then he went to Florida and when he came back he was fat and

brown, and he said, "You know, Mr. Soyer, the portrait you did of me is right above the sofa where I usually sit when guests come, and they always say, 'What's the matter with you, Charlie? Were you sick when you posed?' " And he came with the portrait and wanted me to repaint it, make him fat and, as he said, kind of prosperous-looking, and I refused.

BLDD: When was your first exhibition in New York, and what were the circumstances that surrounded that?

RS: My first exhibition was in 1929. I was friendly with my instructor at the Art Students League, and after I left the school I went to see him and show him my work. He said, "Take this painting to the Daniel Galleries and tell them that I sent you there." So I did that. I took that picture over to the Daniel Galleries, and they told me that if I would have twelve such pictures they would give me a one-man show. It took me a year to make twelve pictures like that, because at that time I still worked during the day, and I painted only weekends. And I had a one-man show. The Daniel Galleries at that time was a very well-known gallery.

BLDD: What other artists were exhibited in that gallery?

RS: Kuniyoshi, Peter Blume, John Marin, Niles Spencer.

BLDD: So it was quite an accomplishment for a young man.

RS: Yes, it was a big thing for me to be in that gallery. From that point on I considered myself an artist, and I began to get studios, first with some friends, and then my own studio. My studio now is off Columbus Avenue, on 74th Street. It was a building where many artists lived and worked at one time or another. But now people live there, and they have converted the studios into homes. I think I am the only artist left there who just uses it as a studio.

BLDD: How often do you go to your studio?

RS: All the time. My wife says that people ask her, "Does Mr. Soyer go to the studio every day?" And she says, "Yes, every day, including Christmas and Yom Kippur." I am there about 9:30 A.M. and I work till about 5 P.M. But a lot of time is taken up by washing brushes, cleaning the palette.

BLDD: To the work of what artists do you most respond?

RS: The artists I respond to are the great classical artists, the great traditional painters. Of course you think of Rembrandt, you think of Courbet, of Degas, of the Flemish painters, Van der Weyden, Van Eyck, and the American painter Thomas Eakins. These are the painters that have influenced me and my work. They are my painters.

BLDD: Is there the work of any artist that is always in your head when you yourself paint?

RS: Yes, there is always some artist in back of my head when I paint,

specifically Degas, Thomas Eakins, Corot, Courbet. These are the people that are always in my mind when I approach a canvas. I think it's the human quality of their work, their interest in people, their interest in human beings that always attracts me.

BLDD: You have painted throughout this city for more than sixty years. What about the city continues to nourish you?

RS: The people of the city, the people of New York. We just came back from Los Angeles, for instance: people don't walk there, they are always in cars. Here the city teems with people, and I watch those people. When I walk now along Columbus Avenue I watch them. I look at the men and the women both, I study their gestures. Every once in a while an idea occurs to me: I am going to make a painting, and I will call it *Columbus Avenue.* When I walked on Sixth Avenue once several years ago an idea occurred to me, and now it's called *Avenue of the Americas—* that's a wonderful title for a painting. But actually they are all the same— Columbus Avenue, Avenue of Americas, the people—and the façades of houses are secondary.

BLDD: Do you ever paint out of doors?

RS: I paint landscapes, yes. I haven't done it for some time, but in Maine and in Massachusetts I painted quite a few landscapes. I haven't shown them very much.

BLDD: You referred to the work of Charles Sheeler and its rather antiseptic quality. Sheeler, of course, was a photographer as well. Do you ever employ photography in any of your work?

RS: No, never. I paint directly from life. I can't see those photo-realists. I cannot appreciate them. I don't like their work. I don't even know how they do it. It just does not interest me because the personality of the artist is not there. It's the camera. It's not even the human eye, it's the eye of the camera that does most of the work.

BLDD: There are several other schools of painting that do not interest you very much, as well—in fact, that is a rather charitable way of putting it.

RS: No, that's not charitable. I don't detest them, I don't decry them, but the fact is that they do not interest me.

BLDD: How would you describe yourself? As a social realist?

RS: No. I am a representational painter as opposed to the non-representational painters. I paint representationally. Realism again became a kind of a word that they played with too much. But I represent things, I see something and I represent it on the canvas.

BLDD: There was a period in the 1950s when you and some of your colleagues were almost invisible in terms of the critical community. You felt that art was becoming the preserve of a handful, and you called a

meeting of a number of other artists. Can you tell us some of the circumstances of that meeting and that period?

RS: That was during the ascent or the advent of abstract expressionism, where there was something like a concerted 'effort on the part of the critics, museums, and the so-called cognoscenti to put it over, I mean just to put it over, and they did a wonderful job; overnight all these people whom I knew (they were actually my contemporaries) became geniuses, and the other artists were neglected. You heard only about these abstract expressionists all the time, and there was a tremendous approval of them.

Some other contemporaries of mine would meet me in the street and say, "What's happening to us? What's taking place now? Look at all these abstract artists who became so famous while we are forgotten."

I said, "But it's not a question of just us, it's a question of art. What's happening to art? Let's discuss it, let's talk about it."

And I just sat down, and wrote a couple of postcards, to Edward Hopper, to Ben Shahn, to Yasuo Kuniyoshi, and to other artists of that time, and we began to gather.

BLDD: Where did you first meet? Who attended?

RS: We met in some kind of restaurant on the West Side, and it was wonderful, I mean we got to know one another—Edward Hopper, Isabel Bishop, and some younger artists, they were younger then, like Jack Levine.

BLDD: Did you know many of these artists whom you invited before you came to meet with them? Did many of those artists know one another?

RS: Some I knew, some I did not know too well, but we got acquainted, and we discussed art. We were not bitter, we were not very critical—I mean in a personal way—of these people like Jackson Pollock or Mark Rothko. But we tried to understand what was happening to American art. Then we began to publish a little magazine called *Reality*.

BLDD: What was the purpose of *Reality?*

RS: We had some kind of a manifesto that critics are not the only judges of art, and museums are not the only judges, that the artists themselves have an idea of what art is and so on, and we tried to get together with the Museum of Modern Art and discuss the art situation and what was happening to art. We were accused of being communist in those days. Those were the McCarthy times.

BLDD: Who accused you of that?

RS: Who accused us? The editor of *Art News,* many people. They accused Kuniyoshi, Edward Hopper. I don't know what Hopper was, he had great integrity, but I don't know what his politics were. Also Kuniyoshi and the others. But they accused us all, and they threatened us.

BLDD: Who threatened you?

RS: Again the art magazines, and even the Museum of Modern Art, and some people who were very anxious to be members of this group—of the *Reality* group—seceded. Some people got scared and left the group.

BLDD: Who was that?

RS: Ben Shahn, who was one of the most eager people, wrote me a card, "Oh, Raphael, sure I'll come, it's about time that we should get together." And then the moment that we got this letter from the Museum of Modern Art—it was sent to me, by the way, with a messenger, a threatening letter—Ben Shahn left, and I got a telegram in the middle of the night from Abe Rattner that he didn't want to have anything to do with the group any more since he had heard from the Museum of Modern Art, and so on.

BLDD: What was the nature of this threat from the Museum of Modern Art?

RS: There was no overt threat. The threat was that they would not be in the good graces of the Museum of Modern Art, and to be in the good graces of the Museum of Modern Art was very important to a man like

Ben Shahn, very important to a man like Abe Rattner and to some others. To a man like Edward Hopper it didn't matter—he was very honest and very staunch. He was what he was. It didn't matter to me.

BLDD: Do you think your career has suffered as a result?

RS: No, my art didn't suffer, therefore my career didn't suffer.

BLDD: About the very time of your first exhibition in 1929 was the year of the founding of the Museum of Modern Art. I wonder if you would comment on the genesis, evolution and current status of the museum.

RS: Oh. I didn't follow it too well. I think all the museums have changed. You have no idea how the Metropolitan Museum changed, how the Whitney Museum changed. The very first time I was taken there by a cousin of mine. I was about fourteen years old. It was filled with Meissonier, Jean-Léon Gérôme, paintings of that kind, and the American paintings were nothing but pictures of pretty women with flowers or pretty women reading fairy tales to their children. That's what the Metropolitan Museum had in those days. But it has changed greatly. All these museums have put on wonderful exhibitions at one time or another. I have seen the first exhibition of Chaim Soutine, of Oscar Kokoschka in the Museum of Modern Art. And the Metropolitan Museum put on, I think, the very first Thomas Eakins exhibition. I learned a great deal in museums, and I am a museum fiend.

BLDD: You've said that in the course of your career you have changed as well. What has changed, your technique, your point of view, your state of mind? And how has it changed?

RS: I said that I hope it's changed. I saw an exhibition in Vienna. It was called—I still remember the name—*Polarität*, whatever it means—polarity. It had paintings, beginning with Delacroix. I think they had a de Kooning. There were a couple of paintings by the American abstract expressionists, no realistic American painting, no representational American painting.

Now, when I seen an exhibition like that, I question where I belong. My painting wasn't there, of course. And I question, where do I belong in the world of art? My paintings are not seen in such exhibitions, they are not seen in exhibitions in Rio de Janeiro or in the Venice Biennale. I have changed. Certainly my work is of today, because I live today, I am a product of the aesthetics of today, of the life of today, of the art of today and so on, and I do hope that my work reflects the spirit of today, as it should. Although I don't belong to any of those isms, nevertheless I hope that my work does express the spirit of our time.

But if, to be an artist of today, one has to be an abstract expressionist or a nonrepresentationalist, then I choose not to be an artist of today.

Ingrès said to his detractors, "They say I am not of this century," and then he continued, "If I don't like my century artwise, must I belong to it?" And I say that about myself: if that is the art of this century I would rather not belong to my century. I paint the way I paint.

BLDD: Did it ever occur to you to experiment with abstract expressionism?

RS: No, it wasn't too much of a challenge for me, because as I said before, these abstract expressionists, I knew them all, they were my contemporaries, and I knew what they were before they became abstract expressionists.

BLDD: What were they?

RS: What were they? They were, well, not geniuses, to be polite. Some of them were a little mediocreish. I knew them all, I liked them all as people. I knew especially Arshile Gorky, whom I liked very much, and I think that he was probably the most poetic of them—he had a certain lyrical quality in his earlier work; no matter whom he emulated, there was always this element of Arshile Gorky in his paintings. I always defended him, and I just deplored the fact that he finally became an abstract expressionist.

BLDD: Are there more and more people that are accepting representational art today?

RS: Maybe. I think that some young artists became a little sick and tired of what was going on, and they are trying very hard to get back to representationalism, but they have lost a lot of time, and it shows. It will take a little while. If that trend goes on it will take a little while for them and for art to redevelop again.

BLDD: Do you think that profound, thematic, contemplative painting is something that is becoming extinct?

RS: I think what is really the problem is that what the artist used to do, what was expected of the artist, is done technologically today. At one time a person went to Van Eyck or Van Dyck and said, do my portrait. Now they can go to the photographer. When the inauguration of Napoleon took place, Jacques-Louis David painted this great painting that is now in the Louvre. Today, when the inauguration of a president takes place, there is a camera, there is television, there is everything else, but not the artists. When the war in Vietnam took place—at one time artists would go and make drawings, like Winslow Homer during the Civil War. Today there's nobody but the photographers.

In other words, our technological society can do without an artist. The artist is not needed in our society, and therefore I think he has lost his function, and he does not know what to do with himself.

BLDD: Is there anything that you haven't painted that you would like to?

RS: Well, I would like to paint the Justices of the Supreme Court. Like Franz Hals painted those huge paintings. Why not? It would be wonderful.

BLDD: How do you know when a painting is finished?

RS: I really don't know. That's a problem. At times I overdo a painting, I work too much on it, and I lose the initial quality of spontaneity.

BLDD: By contemporary standards, you may be conservative in your choice of painters, but surely you are not in your choice of writers. Why do you not apply the same standards to experimental writers as you do to experimental painters?

RS: Well, I think the experimental writers make more sense than the experimental painters, because I haven't seen just a blank page and someone would call it a piece of writing, but I saw a blank canvas and someone would say this is a work of art.

BLDD: Your work has been known to be very sympathetic to the female figure.

RS: Yes, I like the female figure. I like it very much. I like the architecture of it, if you can say that.

BLDD: And the male figure?

RS: The male figure does not interest me very much. The face, yes, but not the figure. For some reason it has a way of embarrassing me. I am never embarrassed in front of a female figure, but in front of a male figure I have a vague sense of embarrassment. It's interesting.

From audience: You describe the International Style as being contentless. What do you mean by content?

RS: What is content to me? Again I must say the simple word "people." People—that's content to me. People within the context of their daily life, or the objects that the human hand touches. Humanity, humans, people. That's what I consider content, and I think that if you just put a lot of brush strokes and maybe a nice color or sometimes a disagreeable color, to me that is contentless, no matter what name they give to those pictures.

From audience: Isn't it true that either the abstract or the representational could adopt classical art as their founder?

RS: Yes, well, you see, a Vermeer or a Rembrandt—and I can add other artists too—they had many elements in one painting: the abstract element, the storytelling element, the human element, the quality of the paint, so many things. They say that Vermeer is probably the most abstract of all traditional painters, of all classical painters—well, he even paints a pregnant woman reading a letter: isn't that a story?

The element of abstraction is present in all great works, certainly. But the abstract painters extract this element and they make it into a big thing—they make it the painting, and nothing else is there, just that.

Artists try, some of them very sincerely, to find a way, they are groping to express themselves. I once met Jackson Pollock, and he said, "What are you trying to do? Now it's a different world, there is photography and everything else, and you are still painting like they used to paint in the days of Courbet or in the days of Corot." I said, "Well, I still enjoy that, I still do that, again for better or for worse, whether I am needed or not. I just paint my own way."

If this is the art of my century, I would rather not be an artist. But I'll quote Ingres again: "If I don't like my century artwise, must I belong to it?" That's how I feel.

I too in my own way do try, in spite of our civilization, in spite of the technology, to find a way to express my time, to express my civilization, and I think I do it a little bit. Even the gestures of today are a little different from the gestures in the days of Courbet, and the dress, the facial expressions. People do change a little bit, but nevertheless they remain human beings always, and to me that's the most interesting to paint.